# ·B·L·U·E·
# RIBBON

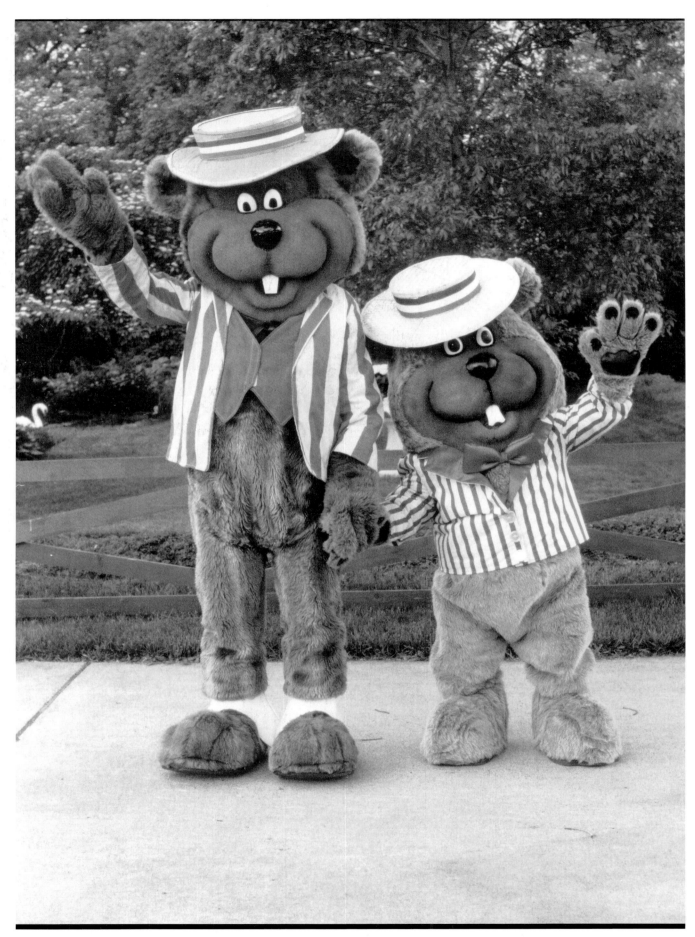

*Fairchild, official state fair mascot since 1966, and his nephew, Fairborn*

# ·B·L·U·E·
# RIBBON

## A SOCIAL AND
## PICTORIAL HISTORY
## OF THE
## MINNESOTA STATE FAIR

### Karal Ann Marling

MINNESOTA HISTORICAL SOCIETY PRESS
ST. PAUL

MINNESOTA HISTORICAL SOCIETY PRESS
ST. PAUL, 55101
© 1990 by Minnesota Historical Society
All rights reserved

This publication is printed on a coated paper manufactured on an acid-free base to ensure its long life.
Manufactured in the United States of America
10 9 8 7 6 5 4 3 2 1

International Standard Book Number
0-87351-251-0 Cloth
0-87351-252-9 Paper

Library of Congress Cataloging-in-Publication Data

Marling, Karal Ann.
    Blue ribbon : a social and pictorial history of the Minnesota State Fair / Karal
  Ann Marling.
      p. cm.
    Includes bibliographical references.
    ISBN 0-87351-251-0. — ISBN 0-87351-252-9 (pbk.)
    1. Minnesota State Fair — History. 2. Minnesota State Fair — Pictorial works. I. Title.
    S555.M6662S76 1990
    630ʼ.74ʼ776 — dc20                                                          90-5738
                                                                                CIP

# CONTENTS

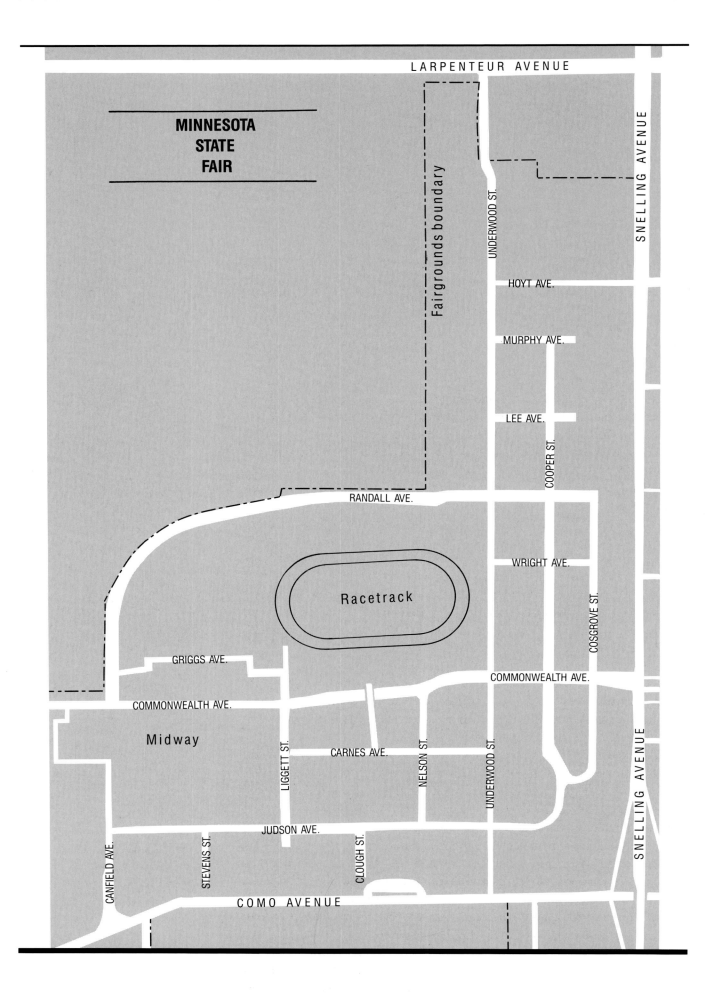

**MINNESOTA STATE FAIR**

LARPENTEUR AVENUE

SNELLING AVENUE

Fairgrounds boundary

UNDERWOOD ST.

HOYT AVE.

MURPHY AVE.

LEE AVE.

COOPER ST.

RANDALL AVE.

Racetrack

WRIGHT AVE.

COSGROVE ST.

GRIGGS AVE.

COMMONWEALTH AVE.

COMMONWEALTH AVE.

Midway

LIGGETT ST.

CARNES AVE.

NELSON ST.

UNDERWOOD ST.

JUDSON AVE.

CANFIELD AVE.

STEVENS ST.

CLOUGH ST.

COMO AVENUE

SNELLING AVENUE

## PREFACE

I'VE ALWAYS LOVED FAIRS, much to the chagrin of my long-suffering, East Coast parents, who never found the mingled aromas of pig on the hoof and hot dogs especially alluring. They took me to lots of little county fairs in upstate New York, though, and endured the smells, the brassy barkers, the rickety rides, and the twangy, pre-Nashville "cowboy" music endemic to such pockets of rural survival in the late 1940s and the early 50s.

As a grown-up, I was always the first in line to attend any vaguely fairlike entertainment. Church carnivals, itinerant midways, world's fairs: I was there. In 1976 my life as a sawdust junkie reached an apogee of sorts when I was invited to award the blue ribbon in the art competition at the Dutchess County (New York) Fair.

Then I moved to Minnesota, just at the start of the annual twelve-day "fair week," a long, pungent hiatus from the normal rules of time and good sense during which, I soon discovered, the midwestern summer ends (along with the growing season), election campaigns begin in earnest, and anything that can be affixed to a stick and deep fried may be eaten with a clear conscience. Of course, I was hooked. I went every day that summer, and every day of every summer since. I learned most of what I know about Minnesota at the fair. And it was there, among the grain-auger demonstrations and the sellers of plastic dust mops and the jars of jelly the color of an angel's smile that I learned to love Minnesota.

I have written this history out of love, intense curiosity, and a growing conviction that the Minnesota State Fair is our central cultural institution — the place where all the varied strands of immigration, agriculture, commerce, politics, aesthetic preference, and moral standards meet and mingle; the place where our collective past is preserved in the language of the premium lists and our collective future manifest in the project of the littlest 4-H'er.

This is, therefore, a sort of collective history of "fairness," not a chronicle of the great mustachioed gentlemen who founded the first agricultural societies, bred the first fancy stock, wrote the first premium books, squabbled over a suitable permanent site, and generally promoted the cause of the Minnesota State Fair in the nineteenth and early twentieth centuries. They are here, the forefathers of the fair, but so are their wives and children, their less prosperous and less famous neighbors — the merchant, the clubwoman, the salesman, the manufacturer, the home economist, and the showman — all of whom seem equally pertinent to understanding the genesis and the enduring appeal of the "Great State Get-Together."

Nor is this a history much given to isms, although students of consumerism, for instance, will find ample evidence herein of a shift from a fair centered on home production to one awash in things to buy. If there

has been a single, guiding principle in my consideration of what to look at, it has been the fact that fairs are meant to be looked at — that they are, at bottom, visual experiences. The character of displays, demonstrations, shows, and the judging of items ranging from cakes to cattle depends upon the ways in which a culture sees and what it chooses to observe. I have tried to be sensitive to Minnesota's style, to our taste and how it mirrors our sense of self. To me, the arts of animal breeding or quilting or self-expression through acts of purchase and use are all truly arts, susceptible to the same modes of analysis that find meaning in Leonardo's *Mona Lisa*.

My first effort to write about the fair concerned the art of butter sculpture, its origins, and its meaning to the Minnesotans who perfected and have steadfastly preserved the genre for more than a century. My article on butter art appeared in the Summer 1987 issue of *Minnesota History,* the journal of the Minnesota Historical Society (MHS). And it is the Historical Society that has nurtured my work on the state fair throughout several years of research, writing, and revision.

I am grateful to the MHS for financial support and for faith in the value of the enterprise. John McGuigan, former managing editor of the MHS Press, and Russell Fridley, former director of the Society, helped me frame my first outline; their successors, Ann Regan and Nina Archabal, along with Jean Brookins, Assistant Director for Publications and Research, and Anne Kaplan, my editor, have kept me at the task ever since. I am also grateful to the Graduate School of the University of Minnesota and to the College of Liberal Arts for additional funding. In 1985 Dean Fred Lukermann named me one of the first batch of Scholars of the College; the stipend carried by that award was particularly useful in completing this book.

The reader is entitled to wonder, of course, just what kinds of expenses a scholar could possibly incur while sitting at a word processor, especially when the intercampus bus to the fairgrounds is free! Well, most went to the care and feeding of a squad of resourceful and tenacious research assistants. Tracy Smith and Peter d'Angio checked library references; April Schultz and John Bloom worked in the communications office at the fair, searching out, copying, and classifying newspaper clippings about past fairs (see "A Note on Sources," page 317).

In the summer of 1987, equipped with a university car and a list of the county fairs of Minnesota, I visited more than thirty such gatherings, to deepen my understanding of how the mechanisms of judging work and of the relationship between the state fair and its small-scale cousins in greater Minnesota. Laura Lindstrom did the driving (and scouted out the best Sno Cones). Celeste Brosenne navigated, speculated, interpreted, and steered us to a score of local and county historical societies, where staff cheerfully combed the collections for word of rest cottages, prize cakes, and potato palaces and for fairtime artifacts ranging from faded ribbons to a jar of murky fluid rumored to contain the remains of pickles put up for the state fair of 1892.

In 1987 the state fair was photographed intensively for this book by four skilled festival documentarists, who are also longtime fair buffs: Joe Bensen, Donna Terek, Bill Beattie, and Rob Levine. Donna and Bill, then living in Michigan and California respectively, made real sacrifices to come home for the occasion; the whole crew, however, worked for expenses and not much else because of their commitment to the subject, and I am grateful. Joe Bensen, who has been taking pictures of the fair for years, also gave me access to his personal archive of images and helped me select the best

historical photos to accompany the text.

But all the picture taking and driving and digging in the library probably wouldn't have amounted to much without the help, the kindness, and the unflagging interest of Jerry Hammer, communications supervisor for the Minnesota State Fair. Jerry let me and my students root around in the fair's attics and basements; he got the camera crew members into the odd crannies they just had to photograph; he supplied copies of old photos on a moment's notice; he even ran a taxi service back to the St. Paul campus on cold days when the snow had drifted deep across the Midway exits. Most of all, he provided nonstop, intelligent conversation about the fair. Jerry asked great questions, noticed quirky details in pictures, told fascinating stories about old-timers, and helped me to recapture, every time we talked, the enthusiasm that made me want to write the book in the first place.

If you count all the nice people who dropped what they were doing to tell me how to fry a cheese curd or keep a bull from twitching in the show ring, then the list of my intellectual creditors would run to the size of a middling phone book. But most of my kindly informants remained anonymous. As for the rest, let me begin with Marilyn McGriff of Braham, Mr. and Mrs. Anton Peterson of Mora, and the Seldon Foss family of Kenyon, who shared generously of their firsthand experience as fair exhibitors and competitors. Jeff Tordoff and Hilary Toren of the museum collections department of the MHS helped me to locate important fair-related objects with stories of their own to tell. Frank Gohlke lent me one of his vintage fair portraits. Rene Taylor, editor of *Blue Ribbon Gazette*, sent along copies of her intriguing newsletter on foodways at fairs. Tom Trow contributed pictures of Bill King's old Minneapolis fairgrounds, in the Seward neighborhood, where Tom now lives.

In August of 1988, as I was struggling to get things down on paper, KARE-TV 11 called and asked me to do some "stand-ups" out at the fair. The following week, I did a segment of the "Minnesota Issues" show with Karen Boros for Channel 17. Both of these interviews forced me to be more concise and clear about what really matters in fair history. And I went through the whole process again with Al Inness of KTCA-TV just as I was finishing the manuscript in the spring of 1989, with similar and wholly salutary results.

In between these brushes with stardom, I was asked to give filmmaker Jonathan Demme (then visiting the Walker Art Center) an informal fair tour. This, too, was a powerful learning experience, since Demme's finely tuned eye helped me to see even more clearly what the fair was showing me. In addition, it was gratifying to note that he liked the Ladies' Sheep Lead almost as much as I do — and that's a whole lot!

The Minnesota State Fair, after all, remains populous and prosperous because we like it, because it's fun. And so, most of all, I'm indebted to my fellow fairgoers, who showed me how to have a good time there — to Rob Silberman and Tim Garvey, to Colleen, to Joe, to Liz and Daniel, to Michael . . . . □

# ·B·LU·E·
# RIBBON

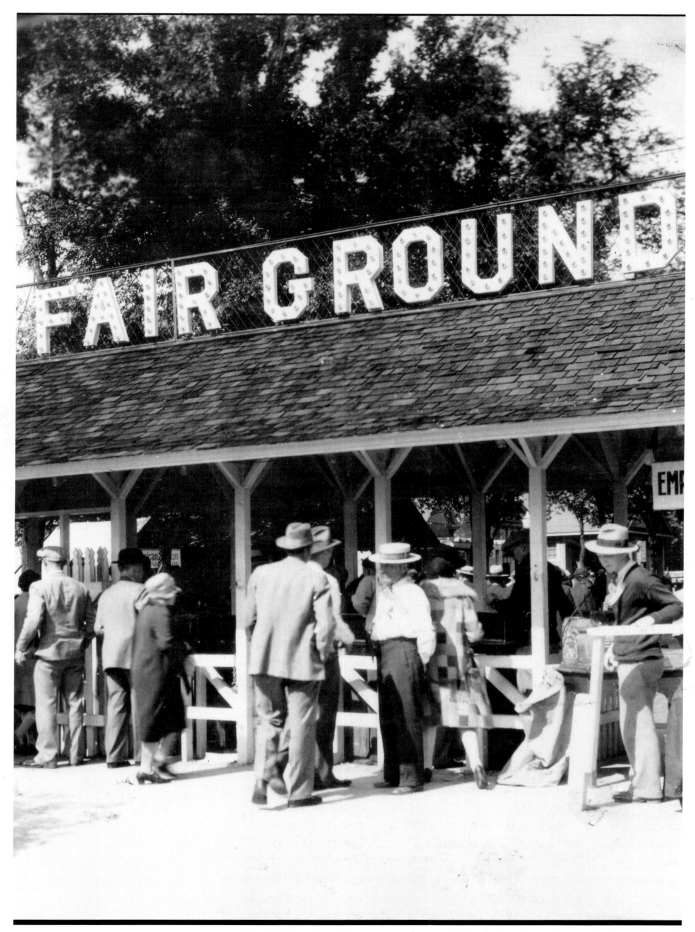

*Turnstiles and vigilant gatekeepers in 1928, a time when the steady flow of unpaid guests put a financial strain on the operation*

CHAPTER ONE

# MORNING COMES
# TO THE FAIR

MORNING COMES EARLY TO the Minnesota State Fair. For twelve glorious summertime days at the end of every August and the beginning of every September, dawn breaks over the 350-acre fairgrounds in St. Paul too late to awaken anyone — except, perhaps, an irate rooster. Stealing in at the Snelling Avenue gate, creeping down Judson Avenue toward the Cattle Barn and the Midway, the sunshine spreads itself across the whitewashed facade of the Sheep and Poultry Building. Back in the 1930s, when even the fair felt the pinch of hard times, the Works Progress Administration (WPA) built this gleaming monument to chickendom, and over the big front door Samuel Sabean of the Federal Art Project sculpted a medallion bearing the official seal of the State of Minnesota. The design features a farmer with his plow and, in the sky above him, *l'etoile du nord,* the North Star, casting its beneficent rays down upon the farmer and the doorway of the building and the cages of Silver-Spangled Hamburgs and Yokohamas within. A weary hen, a competitor in the statewide laying contest, opens one eye, cackles, and deposits another egg in a nest of fresh straw. One by one, the sleepy roosters around her wake to the touch of golden light and cock-a-doodle-doo in furious cacophony. In the grooming rituals of the night before, feathers had been unceremoniously plucked from bedraggled tails and combs rubbed with kerosene to produce today's fiery luster. Belatedly, the self-important cocks announce the coming of morning to the Minnesota State Fair.

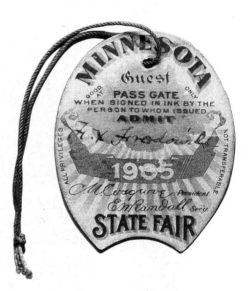

In places like Olivia the day can begin at 4:00 A.M. for dedicated fairgoers. Long before first light, glazed hams, watermelon pickles, potato salad, baked beans, hard-boiled eggs, glorified rice, and homemade apple pies have all disappeared into commodious baskets; state fair picnics are apt to be substantial affairs, spread out in the shade of one of the big trees that surround the Agriculture-Horticulture Building. Folks from outstate have to get up early to find the best spots for picnics, but would-be cake champions, whether from far-off Wadena County or suburban Minneapolis, admit to staying up all night before starting out for the fair. That way, in theory at any rate, baked goods are sure to reach the judges at their peak of freshness. There's nothing better than a slab of sweepstakes-class chocolate cake devoured at five o'clock in the morning when the aroma of fresh-brewed coffee begins to waft out of the cookshacks along Commonwealth Avenue and Underwood Street. Near the corner, the first shift of the Methodist church volunteers who will serve fifteen thousand home-cooked meals during the annual run of the Minnesota State Fair have just put on their aprons. In the midst of beating new-laid eggs for breakfast, the ladies of the Hamline Methodist Dining Hall pause for just a moment and smile when the roosters begin to crow.

By six o'clock, purveyors of burgers (beef or buffalo), hot dogs, deep-fried cheese curds, and all manner of comestibles-on-a-stick have begun to raise the awnings on their concession stands. Onions and peppers and spirals of sausage are arranged in tempting patterns on blackened grills. Supplies are checked in anticipation of the morning's grocery delivery. Lemons, potatoes, rolls, fresh meat, and the rest come by truck from the farthest reaches of Block 42 where, tucked in behind the Poultry Building, stands the fair's own commissary. The rumble of the engines sets off a fresh round of clucking and crowing among the irate fowl, and now, as screen doors squeak and slam and the first cars growl their way into the parking lots behind the Grandstand, the mounting wave of noise rolls up Machinery Hill, past the spot where a pair of Paul Bunyan's giant overalls—a sort of trademark of the fair—once danced and dangled in the summer breeze. At the very top of Machinery Hill a little boy tumbles from his three-tier bunk, way up on the third floor of the 4-H Building.

The 4-H'ers stayed up late last night, determined to see and do it all: the "plush joints" on the Midway, where stuffed unicorns and velvet bears were to be had just for pitching a ball into a basket; the new Huss Rainbow ride and the old Skyride over Kiddieland; the man purported to have skin like an elephant's; the world's smallest horse; the free show at Heritage Square; and the fireworks, the glittering finale to the whole, awesome spectacle. But daylight promises a different array of delights. Giant Percherons, wet from morning baths, clip-clop their way up Liggett Street for the 7:00 A.M. horse competition. At 7:30, according to the schedule posted over the mailboxes and much discussed over fresh-raised doughnuts and milk in the second-floor cafeteria, comes the 4-H dairy cattle judging in the Coliseum. Contestants for ribbons are expected to wear such clean white shirts and pants as have survived the rigors of an evening on the Midway or a night in the barn.

Knowledgeable spectators like to get to the Cattle Barn early to inspect the permanent waves in the tails of the Ayrshires—curls carefully held in place by hair spray—and the cow-stall suites of their nervous grooms, complete with bedrolls, coolers, campstools, and tiny TVs tucked in among the bales of hay. By 8:00 A.M., when the swine are slated to be prodded into the show ring to squeal and do battle with each other and their handlers, city people are suddenly in evidence, pulling wagonloads of toddlers toward the Milking Parlor, to see where breakfast really came from. Milking is the first official event listed every day on the program printed in the morning paper. And it is the first event that most readers of Twin Cities newspapers know they can explain to their kids without feeling ignorant of country ways. Down Snelling Avenue and across Como they stream, bound for the Midway district, midway between the rival principalities of St. Paul and Minneapolis, bound for the Milking Parlor and a day at the Minnesota State Fair. The managers used to boast that they hired Paul Bunyan once a year to drag the ends of all the state's highways together right there, at Como and Snelling, so the crowds would always be huge.

The surging crowds start a new day for some professionals whose yesterdays on duty were long indeed. The state fair police squad is mustered and inspected. Out on the Midway, around nine o'clock, bleary-eyed pitchmen with the Royal American Shows start "grinding" again for their improbable games of skill. And in the space under the Grandstand consigned to vendors of encyclopedias, spot remover, easy-wring mops, hand-blown glass, heat-massage chairs, juice extractors, and memberships in the Legion of

## COME TO THE FAIR!

In 1885, after almost twenty years of being an itinerant pumpkin show held wherever local boosters could offer the most attractive inducements, the state fair settled into permanent quarters on the border between Minneapolis and St. Paul in what was then known as Hamline, Minnesota. The problem that would face all the fair's secretaries and managers thereafter was how to convince outstate Minnesotans to make the long trek to the Twin Cities every August.

Promotion of the annual gathering was sometimes subtle. Early in this century, for instance, an official poet laureate of the Minnesota State Fair was appointed once a year, and her hortatory verses (the honor *always* went to a woman) were circulated under the guise of news:

Come all ye lads and lassies gay,
We're off unto the fair!
Come all ye gents and ladies, too,
We'll all of us be there.
Give work and labor once a rest
And come unto this fair, the best!

Besides such gentle persuasion, as early as 1887 the report on the fair's expenditures, issued by the Minnesota State Agricultural Society, routinely listed four full pages of paid advertisements placed in such small-town newspapers as the *Mazeppa Tribune*, the *Delano Eagle*, the *Waseca Radical*, and the *Fergus Falls Farmer*. "The true object of a state fair," wrote an officer of the society in 1890, "should be the benefit of the rural population of the state." The ads were beamed especially at farm families, to whom the pictures and the prose held out the promise of big-city thrills — "A World of Amusement," "spectacular pyrotechnic exhibitions," and all manner of "DARE-DEVILS" — along with cash premiums, an extensive showing of crops and cattle, and reduced fares on the railroads.

Because the state fair promoted immigration and the sale of the vast tracts of land in northern and western Minnesota owned by the lines, railroad companies were eager to cooperate. Exhibits were "carried at half-rate." If fairgoers purchased a one-way ticket to St. Paul, the return trip was free. For many years, livestock bought at the fair was delivered by train to the purchaser at no charge. Eleven railroads promised to deliver the traveler direct-ly to the new Great Northern depot on the fairgrounds via a spur line. Once on the grounds, "Nels and Christine" and the "Hiram T. Radebushes, from out Anoka way" were assured of "a good comfortable cot or bed" in the Farmers' Tent City, a free campground that flourished during the first decade of the century. But in 1902, despite the free tents and the low fares, ticket takers estimated that fewer than half the people who pushed the turnstiles came from Minnesota's farms. In 1908, a year when the harvest was good and earlier than usual, an observer counted fifteen thousand "country folk" passing through the depot on the first morning of the fair. There was no consistent pattern in their attendance — or in their stayings home. Did rural Minnesotans want better entertainment? Bigger prizes? More machinery? A vacation? An education? Just what was it that made the farmer come to the fair? □

## THROUGH THE TURNSTILE

All fairs, whether big or little, share two architectural features: perimeter fences and the gates that let paying customers through them. But as a keen observer of human nature noted in his commentary on the 1906 fair, "the wall hasn't been constructed that will keep out the true American youngster if there's anything worth seeing inside." How to thwart the "pestiferous" small boy who scales barricades "with the ease of a Peking Zouave" was the gatekeepers' perennial problem. And if the racing program was an attractive one, the vulnerable outfield fence beyond the Grandstand track was often breached, too, by female enthusiasts displaying "feline agility and more or less hosiery."

More serious, however, were instances of graft and bribery among the ticket sellers at the gates. In the first decade of the century, the state fair hired Pinkerton detectives to mingle with fairgoers and observe how admissions were handled. To the horror of the management, the undercover agents reported that many "persons" were being passed through free of charge after exchanging nods with the guardian of the portals. A good cigar slipped into that officer's pocket, they noted, could also influence the price of admission.

Agility and venality are not easily remedied by fiat. But in 1932 Secretary Raymond A. Lee took steps to make sure that the fair would not lose control of the gates altogether. For some years concessionaires, politicians, assorted guests, prominent implement dealers — almost anybody who might transact legitimate business on the grounds — could be granted some manner of courtesy pass. Lee's draconian "Everybody Pays" policy, which went into effect in 1933 and was regularly affirmed by his grateful successors thereafter, solved a serious problem and helped officials keep more accurate records of the attendance. Thus it was possible, for instance, for members of the Agricultural Society board to gather at Gate 5 off Snelling Avenue at 7:06 P.M. on September 5, 1955, to greet the millionth fairgoer of the year, Robert Karklin of St. Paul. Mr. Karklin was presented with a wristwatch and a silver trophy engraved with a replica of his admission ticket — for which he had paid in full.

The regulation received its only significant challenge one sultry evening in September 1971. The Carpenters, a brother-and-sister singing duet, were doing two shows at the Grandstand that night. Between performances, they had driven off the fairgrounds; with a seven-member entourage in tow, they approached the Commonwealth Avenue gate expecting to be waved right through. That is, until John Perham, a Faribault farmer who had worked on the gates for twenty-three years, described the "Everybody Pays" rule to the driver of the lead car.

The manager of the act protested loudly. Then to Perham's absolute astonishment, the man gunned the car's engine and drove directly at the ticket takers, who leaped into the air to avoid being maimed. With Perham clinging to the trunk, "banging and hollering" all the way, the car sped along for three blocks until the fair police finally pulled it over. The show went on. The manager was released on the grounds that he was a tourist, ignorant of the Lee Doctrine. The Carpenters and their friends left that night for the Du Quoin State Fair in Illinois, where the rules, presumably, were a lot less stringent. □

Mary and the Walker Art Center, an electric organ and a blender begin a twelve-hour duet. At ten o'clock sharp, pretty Princess Kay of the Milky Way dons her rhinestone crown and goose-down jacket and climbs into the refrigerated, revolving glass "studio" in the back corner of the Dairy-Animal Products Building (renamed Empire Commons in 1989). There, spinning slowly around so that onlookers can study the effigy-in-progress from every angle, she and the ten members of her court of regional princesses will be sculpted in eighty-five-pound blocks of pure Minnesota butter. Swaddled in mittens and a woolly hat, the artist works all day in thirty-eight-degree temperatures.

The tailings are distributed to the audience; those who skipped breakfast in their haste to get to the fair seem content to relax a little, to stand and watch the carving — so long as plates of butter and crackers are being handed 'round, that is. The sky outside is a dazzling blue. The sun hangs high over the Space Tower now. But in the Dairy Building, you can tell that morning has *really* arrived when a state fair brunch of creamery butter is served up, free of charge, on soda crackers! □

## AUTOMOBILITY

The automobile revolutionized life in rural America. Anybody could go anywhere — including the state fair. Always a force for modernization, progress, and change, the fair exhibited an "electric horseless carriage" as early as 1897. Auto races were held for the first time in 1907. The ground floor of the new steel-and-concrete Grandstand, dedicated in 1909, housed what was said to be the first state fair auto show in the nation.

September 1 at the 1902 fair was designated Good Roads and Labor Day, in recognition of the campaign by the United States Department of Agriculture to improve transportation, communication, and mutual respect between farm and city. Although farmers, by and large, bridled at taxes to pay for roads of which they were by no means the sole beneficiaries, both fair and Agricultural Society officials proselytized vigorously in favor of highway improvements in Minnesota. The principal address at the society's 1903 meeting, for example, was delivered by J. H. Brigham, the assistant secretary of agriculture, who made the trip from Washington to pump for the work of his agency's Good Roads Division. The days of the old comic-paper farmer with the high-topped shoes and the billy-goat whiskers were clearly numbered, concluded one prescient commentator: "A few more years, and we shall be coming to the fair in automobiles!"

New roads and new Fords made the trip to the fair from Lake of the Woods County or Luverne easier and more pleasant, to be sure. Such advances also encouraged visitations by a rising class of tourists, restless auto gypsies who wandered from one midway to another in search of adventure, with tents and bedrolls strapped to their car's running boards. A Mr. and Mrs. J. W. Nevells of Brawley, California, won a fifty-dollar prize in 1917 for having made the longest drive to the fair, narrowly beating out a couple from Los Angeles. To accommodate the traffic, the Minnesota Farm Bureau Federation organized a Tourist Camp that replaced the old Farmers' Tent City in 1931. Like the primitive motel where Clark Gable wooed Claudette Colbert in the 1934 film, *It Happened One Night*, the state fair Tourist Camp had its own grocery store, showers, toilets, and communal cooking facilities. When tourism replaced the rigors of travel, getting to the fair became part of the fun. □

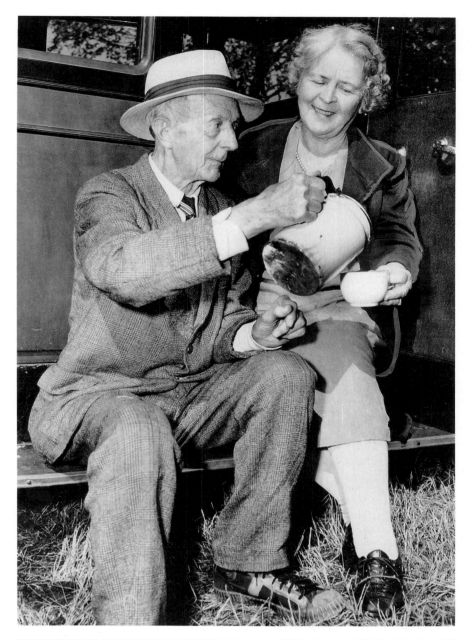

*Early risers at the auto camp: William and Sadie Pankonin of Stillwater, veterans of fifty years at the Minnesota State Fair, sharing the first cup of the day on the running board of their car, 1944.*

*"Tent city" near Farm Boys' Camp on Machinery Hill, about 1925*

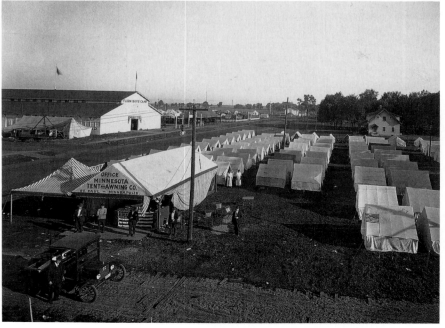

*At 6:00 A.M. the breakfast menu goes up at Epiphany Country Diner, 1987.*

*Just off the school bus from Coon Rapids, members of the Epiphany congregation pose before the morning rush begins, 1987.*

*Syl Schmaltz making the French toast, Epiphany Country Diner, 1987.*

*The dormitory stirs, 1947*

*Those who spent the night with their animals rise early to bathe and brush them before the judging begins, 1980s.*

*Carving a butter sculpture of Princess Kay of the Milky Way, the state dairy princess, the morning after her selection, 1987*

*Presenting homemade baked goods in good time for judging, 1953*

*Henry Krabbenhoft of Pipestone, 1961: guardian of the bleacher gates for twenty-five years; competitor in fruit, hay, corn, grain, and vegetables; winner of more than one thousand ribbons.*

*Setting up the Midway, 1980s*

*Fair-bound boosters from Le Center, arriving in the Twin Cities by train, 1936*

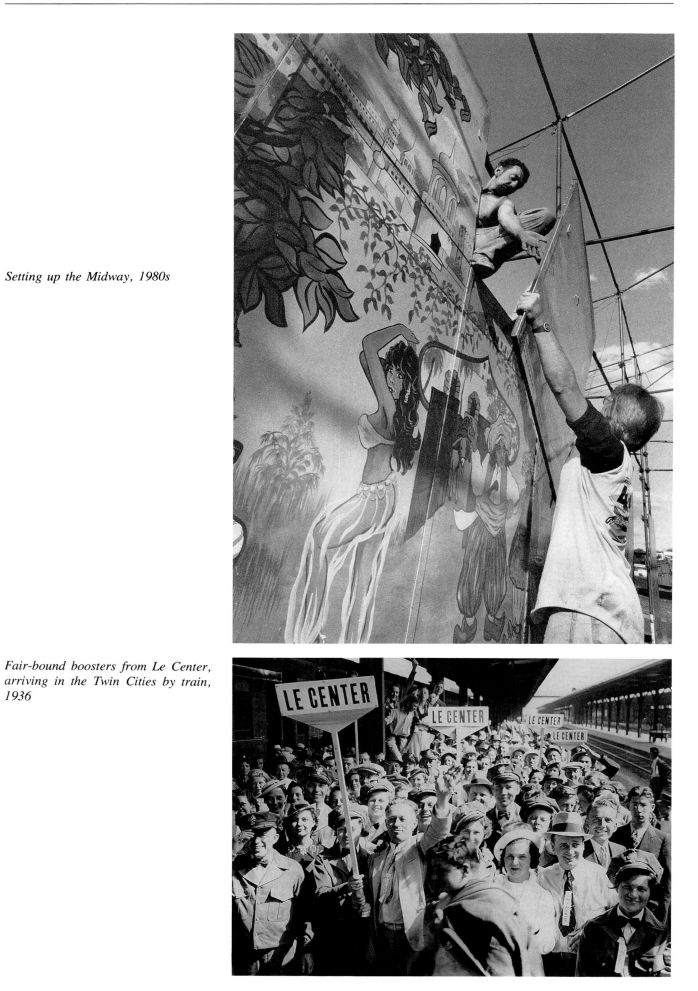

*Some continued to come on foot, 1962*

*Motoring and camping at the fair, still popular in 1968*

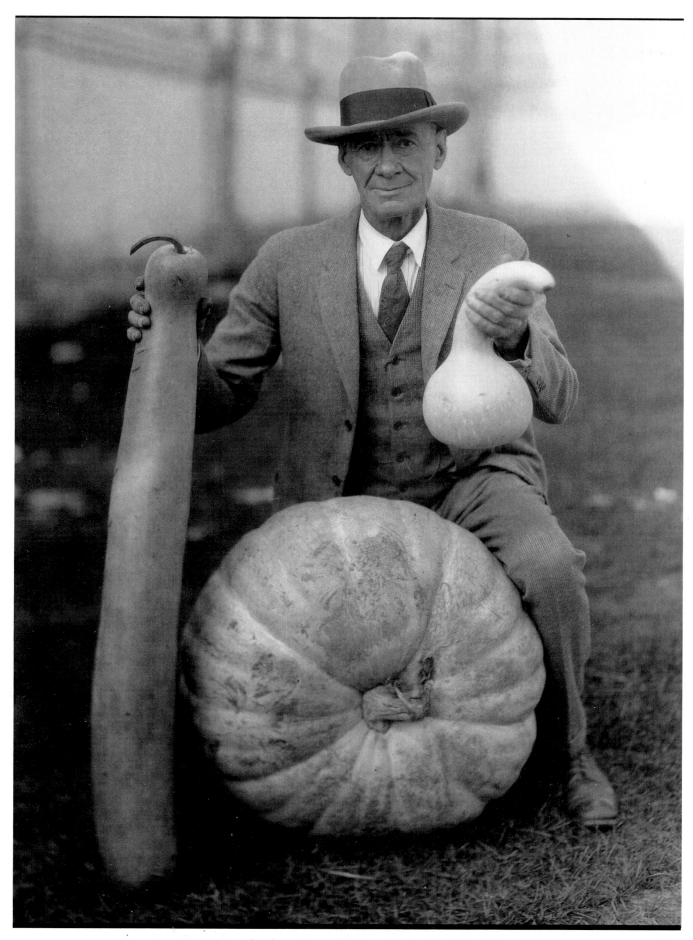

*Produce champ, 1926, continuing the old tradition of raising enormous vegetables, testimonials to the fertility of Minnesota's soil*

CHAPTER TWO

# THE FIRST FAIR

HE WAS THERE when it all began, bragged James S. Hough as he prepared to inspect the 1897 state fair. "As I look over these spacious grounds, covered with buildings and containing thousands of exhibits, the products of farm and factory, of the school and of the laboratory, and note the multitudes of people, I cannot but contrast it with the first fair ever held in Minnesota during the territorial days in 1854."

Back in 1854, the old man continued, Sherwood Hough sold the tickets. His son Jim had been the ticket taker, admitting fairgoers to the three rooms on the lower floor of the territorial building in Capitol Square, which held an assortment of big squash and pumpkins and some tall stalks of corn, all from Ramsey, Benton, and Washington counties. There was no fruit, he explained, "none being grown here in those days." There was no Woman's Building either, of course, since there were only about fifty ladies resident in the district, few of whom had the time to do the fancywork traditionally displayed by wives and daughters at agricultural shows back East. But there was a sewing machine up on the second floor. A clumsy affair, it was still "the first one seen here" and quickly gathered a crowd that gawked at "the mystic needle as it rapidly put stitch after stitch in a piece of cloth."

Outside, surrounded by a high board fence, the livestock division consisted of crude sheds holding a couple of horses and several head of cattle. D. T. Tanner, it was decided, owned the champion colt. "Privileges" had been sold by the management, and here and there on the lawn concessionaires dispensed gingerbread and cider. In the absence of a brass band, a church choir provided musical accompaniment to the festivities. On opening day, Governor Henry H. Sibley gave a rousing speech, in which he stated that the products on display demonstrated "the prosperity of the territory and the industry of its inhabitants." On the morning of the second day, a traveling aeronaut named Marco (William Markoe) made a daring ascension, dangling in a basket beneath a giant balloon that had been filled at the gas plant in St. Paul. He floated away and landed without incident, as Mr. Hough remembered it, in the vicinity of Lake Phalen.

There is some reason to doubt the complete accuracy of these recollections. Sibley became governor in 1858, Markoe seems to have landed in the vicinity of Forest Lake, and the event described bears a striking resemblance to the Third Territorial Fair of October 1857, otherwise known as the Balloon Fair, in honor of the first appearance of that craft in Minnesota. Because of the Panic of 1857, St. Paul's Balloon Fair had been a catastrophe of sorts. Those who pledged financial support could not meet their obligations; premiums were paid at 50 percent of face value, and many diplomas were issued in lieu of cash awards. But however muddled in regard

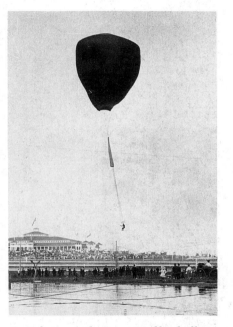

*Aerialist parachuting out of his balloon over the fairgrounds, about 1903*

## ELKANAH WATSON: THE FATHER OF THE AMERICAN FAIR

Paradoxically, it was the Industrial Revolution that led to a more systematic study of agricultural methods and to the genesis of the state and county fair. By concentrating workers in cities, industry created a new demand for the fiber and foodstuffs produced by those who had stayed behind on the land. In England the production of textiles was among the first crafts to be affected by the machine. Sheep bred for a particular quality of wool increased in value.

In the United States the creation of native manufactures was widely regarded as a mark of national maturity in the years following the Revolution. Gentlemen farmers like George Washington Parke Custis, the adopted grandson of the nation's first president, understood the nationalistic and commercial implications of raising fine wool for cloth. Beginning in 1803, Custis hosted annual sheepshearings on his estate at Arlington, Virginia. The forerunners of later fairs, these festivals encouraged American self-sufficiency in textile production and helped to introduce American agriculturalists to an increasingly competitive world market.

A textile merchant and manufacturer, Elkanah Watson retired to a farm in western Massachusetts in the early years of the nineteenth century seeking peace and "rural felicity." His essays on agricultural improvement soon began to appear in the *Berkshire Reporter* and some time around 1807 he brought two of his rare Merino sheep into Pittsfield and tied them to a tree in the public square. The farmers in the district soon gathered to examine Watson's stock. "If two animals are capable of exciting so much attention, what would be the effect on a larger scale, with larger animals?" he wondered.

By the autumn of 1810, Watson had persuaded twenty-six local farmers to sign an "appeal to the public" announcing the first annual Berkshire Cattle Show which, owing to the timidity of his neighbors, consisted of

to dates and economic conditions, James Hough's story hits unerringly upon the key features of the nineteenth-century agricultural exposition in the Midwest. The board fence, the prize animals, the giant produce, a few machines, a speech, provision for the interests of the ladies, musical entertainment, and a climactic spectacle along with a parade, perhaps, or a horse race, or a trial of "female equestrianism"—these were the requisite ingredients of the displays mounted by a succession of agricultural societies in Minnesota in the years just before and after statehood.

Fairs—and the societies that sponsored them—were products of the need to attract immigrants. When the territory's first agricultural society was incorporated in Benton County on March 5, 1852, there were fewer than ten thousand white settlers in the whole of Minnesota. Many of those were preparing to move on to California, with its gold and perpetual summertime, leaving behind "an hyperborean region, swarming with wild and savage Indians, and a soil where you can't raise wheat." In 1855 Governor Willis A. Gorman, who was concurrently serving as president of the Minnesota Territorial Agricultural Society (chartered in 1854), suggested one reason for the sluggish pace of settlement in a message to the legislature: "I have received almost innumerable letters from the middle states . . . desiring to know if our winters are not very long, and so exceedingly cold that stock freezes to death, and man hardly dare venture out of his domicil [*sic*]," he confessed with evident alarm.

For the most part, the men who established Minnesota's first agricultural societies in the 1850s were not farmers but bankers, Indian traders, merchants, and public figures like Governor Gorman. They concerned themselves with wheat and cattle in order to "boost" Minnesota. The theory was simple: once the outside world heard of the existence of bona fide agricultural societies in the territory, rumors of a frozen wasteland beyond Lake Superior would quickly fade away. Instead, immigration and commerce would grow apace when potential settlers read reports of the learned discussions of blooded stock and seed being conducted in Minnesota under sanction of law; such a place (or so any reasonable person would have to infer) must be a farmer's paradise! Agricultural societies, along with agricultural fairs displaying grain and produce raised on native soil, were blatant advertisements for the natural resources of the Northwest.

One of the chief selling points of Minnesota in the age of wheat was its suitability for that crop, a subject best described by farmers, not bankers or businessmen. Colonel John H. Stevens, builder of the first house in Minneapolis and an authority on early Minnesota farming, was a practical stockman and grower as well the prime mover behind the series of institutional maneuvers that led by incremental steps to the creation of both the Minnesota State Agricultural Society and the annual Minnesota State Fair, authorized under the terms of the society's constitution. In 1853 Stevens helped to found the Hennepin County Agricultural Society; in 1854, along with Oliver H. Kelley, he signed the call to the historic meeting in St. Paul at which the Minnesota Territorial Agricultural Society was formed; and, assisted by James Baker of Blue Earth County, he drafted the so-called state fair law that replaced the territorial organization with a State Agricultural Society on February 16, 1860. Baker became the first president of the body; Stevens, as its first secretary, promoted fairs, the improvement of Minnesota stock, and a sound understanding of conditions favorable to larger yields of wheat.

In his history of the region, entitled *Personal Recollections of Minnesota*

*and its People,* Stevens traced the effort to grow grain, from experiments at Fort Snelling in the 1820s to the three hundred bushels harvested from twenty-five acres on Grey Cloud Island in 1831 by James R. Brown, "the first white man to raise wheat successfully in Minnesota." In January of 1854 the delegates meeting to organize the Territorial Agricultural Society listened as a representative from Washington County told of raising two hundred bushels from only four of seed. In an era of uncertain science, another member of the assembly boasted of having grown wheat on his farm for eleven successive years without a single application of manure. These stories, and others like them, proved that Minnesota soil was fertile and well suited to the most desirable of all cash crops. Inspired by their testimony, Governor Gorman closed the session with several buoyant predictions. Minnesota, he opined, was destined to become "a great wheat growing country." Winter and spring wheat alike would soon be cultivated with greater profit in Minnesota "than in any other part of the Union."

However crude their methods, the growers who met in St. Paul in 1854 were experimentalists, eager to hear what others had done to improve the production of wheat. John Stevens, meanwhile, was experimenting with the improvement of scrub stock. In partnership with John P. Miller, he imported the first full-blooded Devon cow and bull to Hennepin County in 1853 at the unheard-of cost of two thousand dollars. The Devons proved an expensive failure, but Stevens had better luck with horses. Among Minnesota's pioneers, his advice on "general farming and stock-raising . . . was freely sought by the agricultural public." And the fairs he advocated soon became the major instrument of agricultural education in Minnesota.

Those in need of advice on stock, seed corn, cheese making, local industries, and any number of other topics could get a tacit object lesson simply by visiting Minneapolis during the great Joint Fair of 1855. Held in October under the auspices of the Hennepin County and the Territorial Agricultural societies, the fair was said by the newspapers to have drawn "the largest crowd of whites ever assembled in the territory," including many ladies. People came from as far away as the James River, beyond Big Stone Lake in Dakota Territory, and although exhibits were drawn only from Hennepin, Ramsey, and Washington counties, there was still plenty to marvel at in the way of fancy livestock. Hogs were deemed mediocre, but E. L. Larpenteur of Ramsey County showed a three-year-old Durham bull (and won the first premium), and J. G. Lennon took the prize for sheep with a Leicestershire, a famous English variety.

While the draft breeds — Percherons, Clydesdales, and Belgians — were still unknown in the territory, several Morgans competed for honors as the finest horse in Minnesota. Even the poultry came with pedigrees bearing exotic names, like Chittagong, Brahmapootra, and Shanghai. Nor were novelties in the vegetable kingdom neglected. The Reverend Gideon H. Pond submitted three Minnesota-grown apples. Stevens produced a cornstalk seventeen feet tall, and further attention was drawn to that crop by a display of Yellow Dent corn said to yield eighty-five bushels to the acre.

On the one hand, the harvesttime display had serious educational and social consequences. Fairs served the cause of progress in frontier agriculture by exposing Minnesotans to new types and breeds. Ownership of an imported animal also had considerable prestige value in an evolving culture that lacked established standards for stratification — a prize Durham could help to identify a community leader, a man of gravity and substance. But much of the produce displayed in the 1850s and 60s falls into the category

Watson and a couple of his purebreds leading a procession of cheering supporters on a march around the Pittsfield square. By 1811, however, Watson's ideas no longer seemed quite so outlandish. He succeeded in setting up a Berkshire Agricultural Society, and the second annual show was a rousing success. It also set the pattern for all subsequent American agricultural fairs.

The key feature of the so-called Berkshire Plan was the competitive display of animals and produce; substantial cash prizes or premiums were offered for the best specimen in each class. An oration on the importance of farming to the nation, the moral dimensions of agriculture, or some similar theme was a second prerequisite for a successful fair. The parade introduced an element of pure showmanship, as farmers marched along with cockades of wheat stuck in their hatbands, bands played, sixty yoke of oxen drew a plow guided by "two of the oldest men in the county," and primitive floats constructed from stagecoaches gave mobile demonstrations of the use of the spinning jenny in British and American manufactures.

In 1813 Watson broadened the prize list to include domestic manufactures by women, heretofore indifferent to the enterprise. Although they sent their quilts and jellies, however, the ladies would not appear in public to receive their awards until Watson's wife personally invited them to join her in the exhibition hall. Thereafter, an Agricultural Ball was added to the program of events, and with provision for the social needs of the community, the design of the American fair was at last complete. It would be an inclusive affair, with activities for the whole family. Centered on agricultural competition, it would also be a showplace for local industry, an occasion for uplift and education, a source of wholesome amusement.

The fair spirit followed the pioneers westward. New York held its first state fair in 1838. Ohio followed suit in 1845 and Illinois in 1853. By 1860 Elkanah Watson's fair had become part of the social fabric of the State of Minnesota.
□

## HORACE GREELEY GOES WEST

"I remember that in [1861] we were to have the fair at Fort Snelling, and expected that Horace Greeley would deliver an address," John Stevens stated many years later. "It was extensively advertised, but a few days before the date set for the opening Mr. Greeley was called on to go into some of the border states and make Union speeches, and could not come to Minnesota."

The Civil War and the Dakota conflict played havoc with Minnesota's fairs throughout the 1860s. Yet this was also a period of innovation and change, both for agriculture and for showmanship in the Northwest. The 1861 baby contest falls into the latter category. When the state fair was canceled that year, attention shifted to the fair in Blue Earth County, where a gold locket was presented to the most comely infant. Not only was this the first fair event exclusively for children, but it was also a harbinger of the rash of "Better Babies" contests that dotted the fair circuit in the 1910s and 20s. The premise behind such inspections of rural youngsters was, of course, that the principles of genetics operative in the breeding of prize animals were applicable to midwestern farm families, too.

When the Minnesota State Fair resumed operations in 1863, the subject of breeding received much attention. Merino sheep made their first appearance on the frontier, along with a few Southdowns raised by Cassius Clay. The main attraction that year was Garibaldi, a majestic Devon bull that Charles Hoag had recently purchased from Clay for three hundred dollars. The introduction of new kinds and breeds of livestock into Minnesota demonstrates the experimental fervor of the state's early agricultural leaders. It was such men of vision who persuaded Horace Greeley, publisher of the *New York Tribune*, to take his own advice and "go West" to Minneapolis in 1865 to address the state fair.

Greeley gave two major speeches on successive days, the first describing "The Education of the Farmer" and

of vegetable freaks; in addition to the blooded stock and the corn, the Joint Fair of 1855 featured Larpenteur's twenty-eight-pound cabbage, an eighteen-pound radish submitted by Mr. Finch of Hennepin County, several turnips "as large as peck measures," and some monstrous beets.

Today, when crops are judged on strict conformity to a market standard and an eighteen-pound radish is dismissed as an aberration, the attention nineteenth-century fairgoers lavished on oversized specimens seems quixotic. Yet the historical record invariably sets down the dimensions of such freaks of nature and notes that they "astonished even the natives." However grotesque and strange to modern eyes, the eighteen-pound radish and its swollen kin proved that Minnesota was a land of bounty and boundless opportunity. Almost anything would grow in Minnesota—to proportions undreamt-of in less fortunate climes. With such impressive testimonials, the territorial fairs continued to boost the unique advantages of life in Minnesota.

Fairs boasted and educated; in addition, they served as indicators of changes in mores, manners, and manufactures. The 1855 fair, for instance, showed Minnesota to be an altogether civilized place, rapidly losing the crudeness of pioneer days. A genuine artist—Joel E. Whitney of St. Paul—won a ribbon for his daguerreotypes. A taste for the finer things was represented, too, in the division reserved for "the ladies," who competed in needlework, "fancy articles," houseplants and flowers (the products of a newfound leisure), and in homemade carpets, each class with its own female supervisor. And for "the first time in the history of the upper Mississippi Valley, the dairy interest was represented" by a display of cheese made by Mrs. Joel B. Bassett of Minneapolis and a number of butter entries submitted exclusively by women. Oren C. Gregg, the father of the Minnesota dairy industry, would not arrive in Lyon County until 1865, but the butter and cheese exhibits suggest that the concept of agricultural diversification was not unknown in wheat country before his coming. The female monopoly, on the other hand, identifies the dairy as an ornament to gracious living rather than an economic necessity of midwestern farming.

Finally, of course, fairs entertained and amused patrons and by doing so lent color and dimension to frontier lives that were often isolated, narrow, and harsh. In 1856 diversions at the Second Territorial Fair included a horse race in which a trotter named Young America circled the course in a time of 2:56. At the Balloon Fair of 1857, William Markoe's aerial feat was the chief drawing card. The Union Fair of 1859, presented once again by the Hennepin County and the Territorial Agricultural organizations (although Minnesota became a state in 1858, the latter society was not reorganized and renamed until 1860), featured a brass band that played on and on, despite a driving rain.

At the Joint Fair of 1855, the featured novelty was a contest among local women riding the best mounts in the neighborhood. Twenty-five hundred spectators turned out to witness a complicated event in which the prize did not always go to the jockey of the fastest steed. Instead, as in the modern beauty pageant, points were awarded for imponderables like poise, costume, and dash. Because the winner often seemed to be determined on subjective grounds and because each competitor had her own vocal claque of admirers, community feuds readily began around the racetrack. Thus, despite its obvious attractions, female equestrianism gradually fell into disfavor and was banned in many venues. The committee charged with the judging in 1855 was careful to avoid controversy by issuing a statement confessing to the

extreme difficulty of choosing a single champion from so talented and so fair a field.

Another controversial subject over the years has been the matter of which should properly be designated the first state fair. James Hough thought that 1854 marked the inaugural year—or was it 1857? Purists have always given pride of place to the somewhat lackluster affair of 1859 (the one with the brass band and the rain) because, given the cancellation of festivities for 1858 on account of a general economic depression, it was the first held after statehood was conferred. Old John Stevens harbored fond memories of the fifteen-acre fairgrounds laid out in 1859 at Sam Hidden's place, at the corner of Marquette Avenue and Fifth Street; when he made his annual pilgrimage to the new Como Avenue site in the 1890s, his status as the last living founder gave Stevens the right to insist that the great Fort Snelling Fair of 1860 was actually the second annual Minnesota fair.

If not the premier event by all methods of reckoning, the 1860 fair *was* the first sponsored by the Minnesota State Agricultural Society and the very best to date. "Of all the fairs in history, from Donnybrook to Nijni-Novgorod, there was never one that gave greater satisfaction to those that witnessed it," wrote Minnesota's earliest chroniclers of such events. "The weather . . . was remarkably fine. The features were of real interest and attraction, there being a liberal display of the practical, the useful, the novel, and the spectacular."

The principal novelty was the chosen site. In those days Fort Snelling, the first outpost of American settlement in Minnesota, was owned by Franklin Steele, who had subdivided the property in hopes of profit only to be caught in the Panic of 1857 and the ensuing depression. While waiting for business to improve, Steele grazed sheep on the land. At night, with a fine disregard for historical pieties, he penned up the flock inside the walls of Fort Snelling. Steele was only too happy to lend a portion of his holdings to the State Agricultural Society, which planned to use the parade ground as the racetrack and showplace for farm implements, while the barracks "were transformed into repositories for fruits, jellies, butter, cakes, and other products of peace and feminine skill." With the prospect of civil war firmly in mind, Governor Alexander Ramsey used his address of welcome to allude to the piquant contrast between war and peace underlined by the Fort Snelling fair. "We take possession of the best fortress in the United States," he bellowed across the dusty expanse of the parade ground, "and make it subservient to the cause of agriculture!"

Because 1860 was an election year, partisan sentiment bulked large in the search for a suitable fair orator. Accordingly, the Republicans (their candidate, Abraham Lincoln, would carry Minnesota by a two-to-one margin) imported the Honorable Cassius M. Clay of Kentucky, announcing, however, that he wouldn't "talk politics." A noted breeder perhaps best known to Minnesotans as the man whose white Durham bull was said to have been the first blooded animal ever brought to the state, Clay may or may not have stuck to the agreement. His two-hour speech was inaudible to the greater part of the audience; those who could make out the words found the language too flowery for plain good sense. After a spattering of polite applause, the onlookers rapidly dispersed to savor the old, familiar pleasures of fair going—and a few brand-new ones.

Among the traditional aspects of the 1860 fair was a race in which a horse named the Flying Dutchman trotted a brisk mile in just over four minutes. His performance, it was hoped, would compensate for the absence

the second outlining "The Progress of Agriculture" in the bright and boundless future of postwar America. "Men of the West!" he declaimed, "You have the noblest region on earth. You have turned your backs on the past and may trample tradition under foot. Let the development of ideas be even with the development of material wealth." Among the ideas Greeley himself proposed was the use of peat, harvested from Minnesota farms, as the fuel of tomorrow. He predicted that rain would soon be produced on demand by firing artillery shells into the ether. And he foresaw the day when steam plows would break the sod of the western plains.

Several of Horace Greeley's prognostications could still rivet fairgoers to their seats today, and his faith in technology was perhaps justified by the accelerated pace of mechanical progress in the Union states during the Civil War. In 1862 St. Anthony and St. Paul were joined by rail; the coming of the railroad meant that the flow of Minnesota wheat to world markets would no longer cease when ice clogged the Mississippi. New means of transportation further intimated that the days of the horse were numbered— except insofar as nags like Sleepy David (he dropped dead on the Grandstand course in 1866) might still be worth a fifty-cent wager at a state fair meet.

The annual meeting of the State Agricultural Society in 1868 centered on wheat and horses. A resolution was adopted asserting that "the continual cropping of wheat year after year, in the same field, without even a change of seed, is bad farming and ought to be discouraged." A second motion, attempting to suppress "speed trials" at the fair, was replaced by a milder measure forbidding "any gambling or jockeying whatever." Plainly, then, Horace Greeley was not the only East Coast import of the 1860s. Like the older states along the Atlantic seaboard, Minnesota—through the agency of the state fair—was forced to come to grips with the corruption of her infant institutions and the depletion of resources that had so recently seemed limitless. □

## 1860: WHAT'S GONE WRONG WITH OUR FAIRS?

The Minnesota State Fair began at the moment when several eastern states considered banishing such expositions because they encouraged vice and had ceased to promote the cause of diligent agriculture. Consider, for example, the report of the New Hampshire State Agricultural Society, which disbanded in 1860 upon issuing this denunciation of the fairs it once sponsored:

We allow horse racing to monopolize all the large premiums and nearly all the time and attention of visitors at our fairs.

By a systematic application of stimulants we render our young ladies ambitious for public applause on the race course, where the low jests of the vulgar mingle with the huzzahs of the crowd, rather than to become good housewives and produce articles which give beauty and comfort to life and home.

We offer more to him who will run around the course quickest than to him who raises the best acre of corn.

We offer twice as much for the best display of jewelry as for the best bushel of wheat. □

of the lady riders; the managers reluctantly decided to omit that event because of the habitual fractiousness of the crowd. But contests of mammoth produce proliferated. The usual giant squash and radishes were much in evidence, alongside onions having a girth of sixteen inches, Irish potatoes well over a foot long, and cabbages so large that "one could not be crowded into a flour barrel." The loudest gasps of astonishment, however, were reserved for a 640-pound Chester White barrow, the largest hog ever seen in the Northwest. Owned by Wyman Elliot of Minneapolis, the pig was sold on the spot to Mr. Lamb, a St. Paul butcher, for nine cents a pound, illustrating the role of fairs in promoting the cause of commerce.

In fact, several commercial exhibitors appeared at Fort Snelling, including a traveling salesman from Rockford, Illinois, who made a public trial of John H. Manny's combined reaper and mower. Of the thousands who paid their quarters to gatekeeper Ike Conway that late September afternoon, most had come to see farm machinery for the very first time. Yet machines, like horses or lady riders, were far more appealing to the nineteenth-century fairgoer if competitions of some kind could be arranged among them. The pretext of conducting a scientific "test" or "trial" justified horse racing (and pool betting), stunt flying, stock-car racing, and tractor pulls at state fairs for the next century. The crowd at Fort Snelling derived no end of pleasure from observing a spirited contest of long-distance pumping in which three fire engines (two from St. Anthony and the famous Hope from St. Paul) demonstrated their capacities — and also gave St. Paul and St. Anthony boosters a chance to demonstrate their hometown loyalties by laying sizable wagers on the side.

Although the profits amounted to only eighteen cents, the 1860 fair was a financial success. The announced premiums were paid in cash from gate receipts. Expenses of more than one thousand dollars had been met. Indeed, like many fairs mounted thereafter, the first Fort Snelling event was a vast, exuberant celebration of Minnesota's prosperity, a collective well-being symbolized by the great pigs and pumpkins of the harvest season. In his address to his fellow Minnesotans, the governor had alluded to recent hard times in agriculture and to a bright vision of the future. Before the crisis, he noted, the state had exported one hundred thousand bushels of wheat a year: "Now she has 5,000,000 bushels . . . to relieve the famishing people of the world." But statistics were not the only cause for optimism about Minnesota's tomorrows. As Governor Ramsey beamed down upon the fairgoers, he saw "the talent and the beauty and fashion of the young State" standing contentedly before him in the sunshine, "the men with big bell-crowned hats, Prince Albert coats, Marseilles vests, and elaborate neckerchiefs; the ladies arrayed in Mantillas, pretty little bonnets, and ample crinolines twelve feet in circumference." He saw pioneers who had overcome the hardships of the frontier. He saw a hard-working people, come together to rejoice in the fruits of their labor. Minnesotans have done so every year since that first state fair back in 1854, or 1859, or was it 1860? □

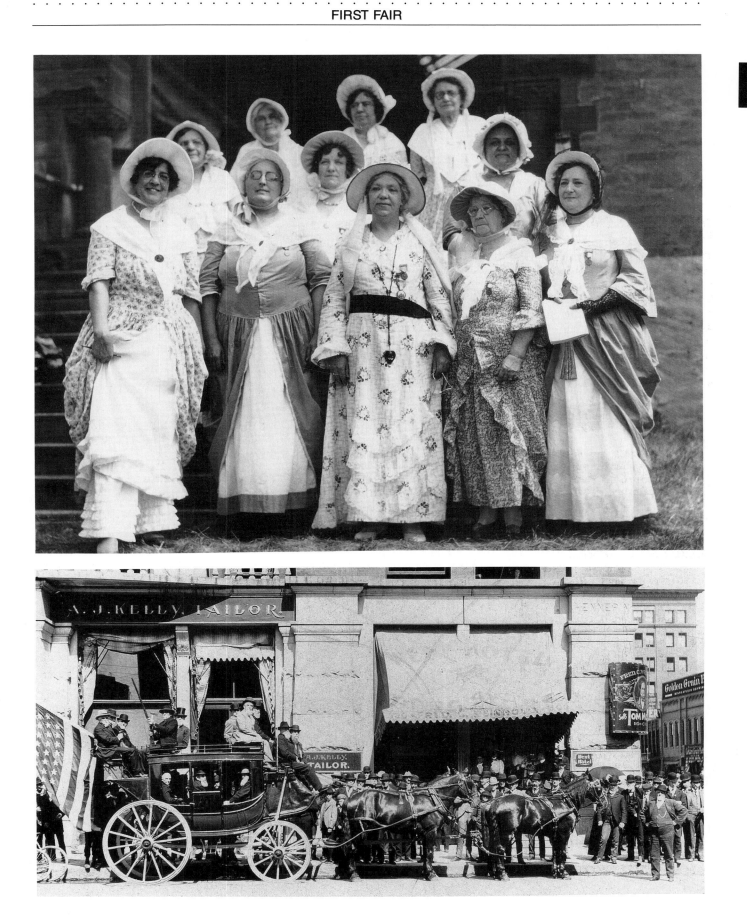

*Female members of the Minnesota Territorial Pioneers, 1931, who routinely attended the fair dressed as their ancestors*

*To honor their hardy forebears, state fair founders leave for the fairgrounds by stagecoach, Minneapolis, May 11, 1900.*

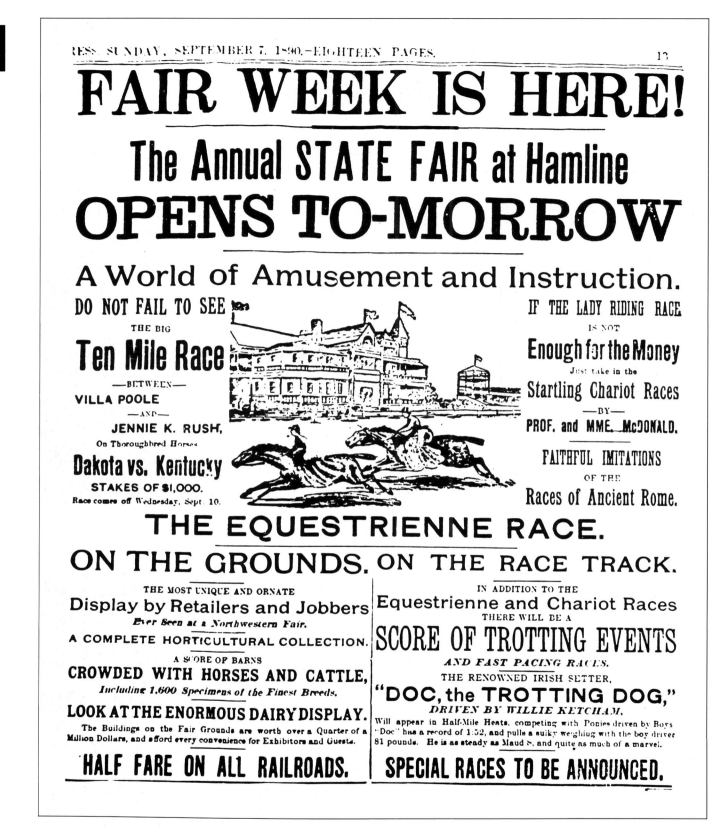

PRESS, SUNDAY, SEPTEMBER 7, 1890.—EIGHTEEN PAGES.                                    13

# FAIR WEEK IS HERE!

## The Annual STATE FAIR at Hamline
## OPENS TO-MORROW

### A World of Amusement and Instruction.

**DO NOT FAIL TO SEE**

THE BIG

**Ten Mile Race**

—BETWEEN—

VILLA POOLE

—AND—

JENNIE K. RUSH,

On Thoroughbred Horses

**Dakota vs. Kentucky**

STAKES OF $1,000.

Race comes off Wednesday, Sept. 10.

IF THE LADY RIDING RACE

IS NOT

**Enough for the Money**

Just take in the

**Startling Chariot Races**

—BY—

**PROF. and MME. McDONALD.**

FAITHFUL IMITATIONS

OF THE

**Races of Ancient Rome.**

## THE EQUESTRIENNE RACE.

## ON THE GROUNDS. ON THE RACE TRACK.

THE MOST UNIQUE AND ORNATE

**Display by Retailers and Jobbers**

*Ever Seen at a Northwestern Fair.*

**A COMPLETE HORTICULTURAL COLLECTION.**

A SCORE OF BARNS

**CROWDED WITH HORSES AND CATTLE,**

*Including 1,600 Specimens of the Finest Breeds.*

**LOOK AT THE ENORMOUS DAIRY DISPLAY.**

The Buildings on the Fair Grounds are worth over a Quarter of a Million Dollars, and afford every convenience for Exhibitors and Guests.

**HALF FARE ON ALL RAILROADS.**

IN ADDITION TO THE

**Equestrienne and Chariot Races**

THERE WILL BE A

**SCORE OF TROTTING EVENTS**

*AND FAST PACING RACES.*

THE RENOWNED IRISH SETTER,

**"DOC, the TROTTING DOG,"**

*DRIVEN BY WILLIE KETCHAM.*

Will appear in Half-Mile Heats, competing with Ponies driven by Boys "Doc" has a record of 1:52, and pulls a sulky weighing with the boy driver 81 pounds. He is as steady as Maud S, and quite as much of a marvel.

**SPECIAL RACES TO BE ANNOUNCED.**

*Advertisement, published in the* St. Paul Pioneer Press, *September 7, 1890*

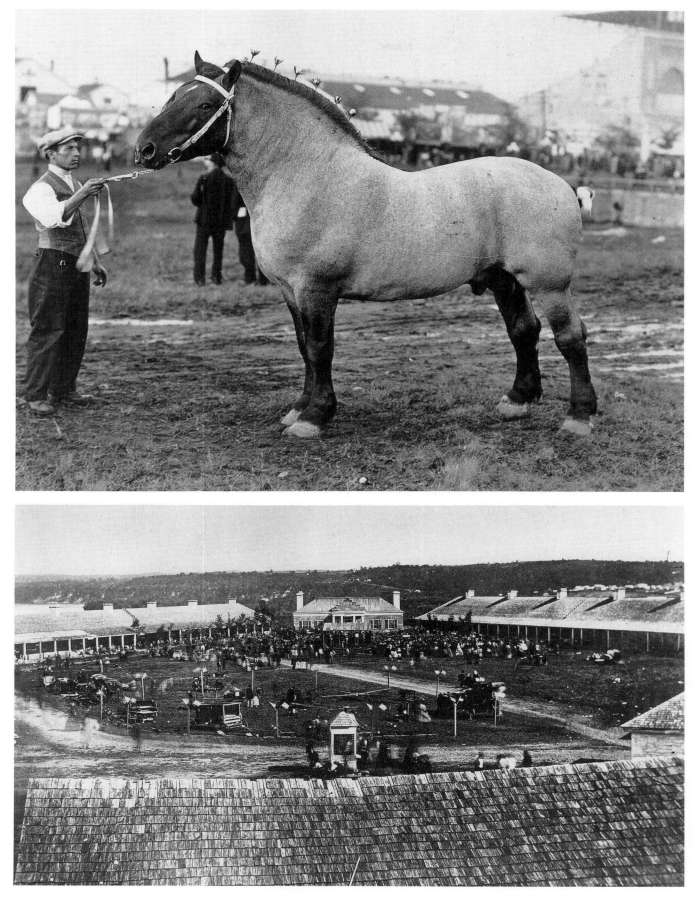

*Belgian stallion, the 1911 state-champion work horse*

*The Honorable Cassius Clay addressing the crowd at the Minnesota State Fair, Fort Snelling, 1860*

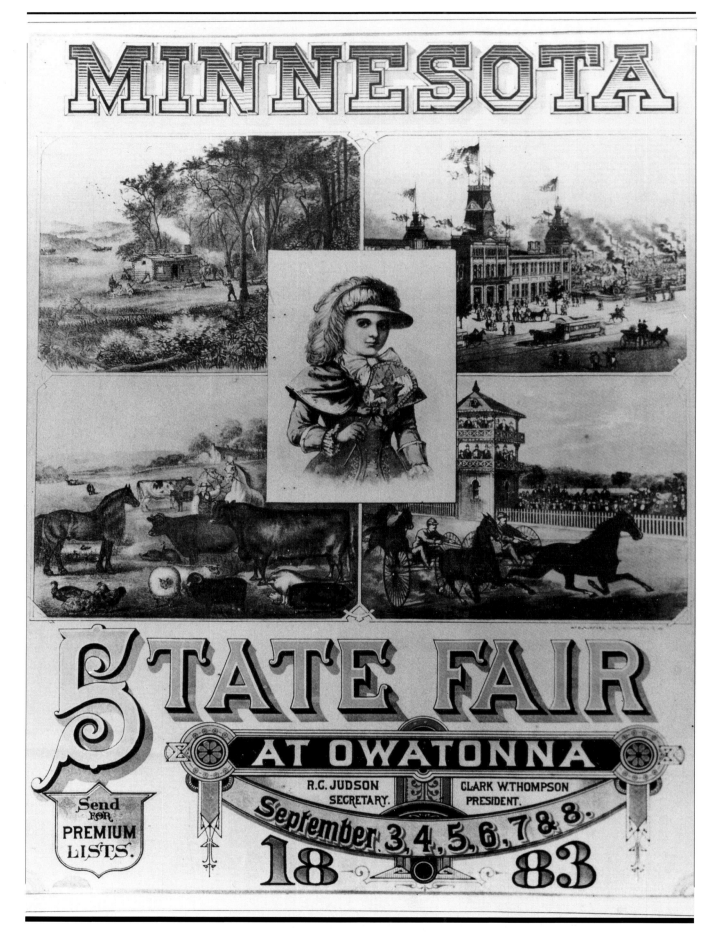

*Fat stock, fast horses, burgeoning commerce, a pretty girl, and a place in the wilderness for new immigrants—the Minnesota dream.*

# THE FAIR ON WHEELS

AGRICULTURAL THEORIST and historian Kenyon L. Butterfield called the period from 1850 to 1870 "the golden age of the fair" in America. Yet while that era witnessed the birth of the Minnesota State Fair, it was also a time of turmoil in which technology, the growth of large urban centers in the Midwest, and changes in the character of Minnesota wheat farming all conspired to give the fair a precarious existence "on wheels." From 1864, when its protracted statewide tour began at Red Wing, until 1885, when the Agricultural Society constructed a great wooden-domed Main Building on the present fairgrounds, the exposition wandered from town to town. Sometimes the weather was fine, the subsidies offered by local businessmen generous, the lady riders dashing, the pumpkins gargantuan beyond all telling, and the managers either competent or lucky. In those years, the state fair prospered whether it settled for the season in Rochester, Owatonna, Winona, or the Kittsondale Driving Park on the main road between Minneapolis and St. Paul. But by 1880 the backlog of unpaid premiums totalled four thousand dollars, and there was widespread sentiment in favor of abolishing an institution whose peregrinations had robbed it of both financial stability and the sense of continuity that its educational mission demanded.

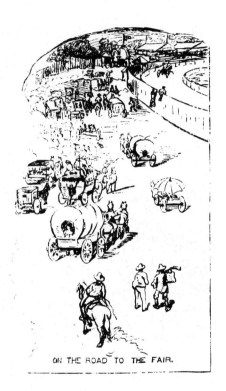

ON THE ROAD TO THE FAIR.

The railroads — or rather, the absence thereof — helped to set the fair on its wandering course. By 1878, when *Harper's Weekly* sent an illustrator to Kittsondale to show the folks back East a team of tame elk trotting in harness and Indians in blankets admiring the prize vegetables, the railroads bulked large in the reckoning of most fairgoers. Reliable connections from every region of Minnesota converged upon the Twin Cities, and *Harper's* pictorial spread gave due prominence to a display of produce grown along the Northern Pacific right-of-way and shipped to urban markets in NP boxcars. But a decade earlier the situation had been different indeed. Construction of a rail system was just beginning; the fairs held at Fort Snelling were difficult for outstate farmers to attend, especially when the water was low on the rivers that were the most reliable routes to Minneapolis and St. Paul. If the fair were to serve the interests of the Minnesota farmer in the 1860s and 70s, it would have to move to farm country.

The Minnesota farmer during those years was likely to be a grower of wheat, and his land lay to the south and southeast of the Twin Cities. There the traveling state fair first pitched its tents. So eager were community leaders in the southern district to attract the fair (and the financial benefits of tourism and possible immigration) that the quarters provided were often sumptuous. Rochester's bid for the fairs of 1866, 1867, and 1869 included construction of a Floral Hall for the ladies, a Horticulture Building, an array of stock pens, and a large Mechanical Building.

*State fair potato trophy, often awarded to the Duluth Commercial Club, reflecting the importance of the crop north of the Twin Cities*

Provision of the latter suggests the importance of new machinery to large-scale wheat production. In many cases, too, the reapers, the mowers, and the balky self-binders were products of a burgeoning local industry in implements tailored to Minnesota crops. The 1869 fair held a respectable show of farm machinery made within the borders of the state. Throughout the 1870s harvesting machinery for wheat remained the state's leading import, however, and the Agricultural Society sponsored plowing matches, reaping and mowing contests, and serious tests of new kinds of agricultural equipment at the annual state fair and at special fall field trials conducted for several years near Owatonna. The industrialist — in the person of his agent, the implement salesman — became almost as crucial to the success of the Minnesota State Fair as a good wheat harvest.

In years of good harvests, the state fair was generally a success. And good harvests no longer seemed determined by good fortune alone — modern science had the ability to predict a bad year or even widespread failure of the wheat crop. Toward the end of the 1860s experts began to question the practice of planting a single crop every season and the same crop every year. The Agricultural Society issued condemnations of soil-depleting procedures among wheat growers in 1868, and at the Rochester fair of 1869, Cadwallader C. Washburn of Wisconsin, the featured speaker, advised prudent farmers to raise less wheat and more livestock. In 1873 Minnesota harvested twenty-eight million bushels of wheat, including a stand of winter wheat grown in Howard Lake, to the north of the traditional grain belt, that yielded forty-two bushels to the acre and sixty-two pounds to the bushel. But during the following fall, when the Agricultural Society announced another bonanza year for wheat, its secretary also noted that grasshoppers had appeared on the western frontier, and a professor from the university cautioned members about soil exhaustion and a general improvidence in methods, urging them to heed the counsel of science before it was too late.

To those who heard that lecture, the speaker must have seemed a prophet of awesome vision when the insects arrived in 1875 and gobbled up all the wheat. While scientific foresight could not have prevented the hardships of "the Grasshopper Year," the disaster did prove the wisdom of diversification as a defense against the risks of single-crop agriculture. Accordingly, a smattering of new crops, including a "native Minnesota sugar" fabricated from corn stalks and sorghum, began to appear at the state fairs of the late 1870s and the 80s. Railroad exhibits from the northern counties suggested fresh possibilities for the potato as a cash crop.

In 1882, when the production figures for wheat began to fluctuate wildly and then slide downward, diversification began to make real headway, even in the southern part of the state. A Minnesota Dairymen's Association had been founded in 1878; the Minnesota Butter and Cheese Association was organized in 1882. The Owatonna State Fair of 1883 is best remembered for an enormous stock show. Hogs concentrated corn and skim milk on the hoof, cutting storage and shipping costs. Cattle grazed on the prairie grasses that enriched the soil. The farmers' mounting interest in seeing and breeding animals of quality marked the beginning of a major change in the philosophy underlying Minnesota agriculture.

If the age of wheat hastened the growth of the Twin Cities with their mills, exchanges, and shipping facilities, the shift away from wheat helped to break the power of the southern counties and dissipate the agrarian influence that set the fair on its erratic summer circuit in the first place. As early as 1870 the centrifugal force of Minnesota's economy had begun to

## THE "CIRCUS-WAGON FAIR" AND ITS ITINERARY

**1864.** *Red Wing.* Shows of horses and of manufactured goods from throughout the state were deemed exceptional. The crowd awarded a prize of its own to a young woman who lost the four-way equestrienne riding contest.

**1865.** *Minneapolis.* William G. Le Duc, the Minnesotan who became commissioner of agriculture under President Rutherford B. Hayes, exhibited a flock of Cashmere goats recently imported from Nashville.

**1866.** *Rochester.* Although the fair was held in wheat country, the grain displays were disappointing but the fruit was excellent. At the conclusion of the fair, the Minnesota Fruit Growers Association was founded.

**1867.** *Rochester.* Political oratory provided much of the excitement as the gubernatorial candidates — William R. Marshall for the GOP and Charles E. Flandrau for the Democrats — made stump speeches to fairgoers.

**1868.** *Minneapolis.* A large display of fabrics woven by the Minneapolis Woolen Mills took the first premium for manufactured items. At its annual meeting, members of the Agricultural Society first questioned the practice of allowing gambling on the races at the state fair.

**1869.** *Rochester.* This fair included a show of farm machinery made in Minnesota. The finals of the state championship in baseball were played there too. The contest between the Rochester Gophers and the St. Paul Saxons ended in a 54-54 tie.

**1870.** *Winona.* A contest for the title of "Plowboy of the State" was won by the local favorite, T. M. Busbee of Winona County.

**1871.** *St. Paul* (Kittsondale). Bill King organized the first of his rival fairs in Minneapolis.

**1872.** *St. Paul.* Iron ore was shown for the first time. Henceforth, agriculture, manufactured products, and natural resources all became permanent features of the state fair.

**1873.** *St. Paul.* The Panic of 1873 meant lean receipts; the Agricultural Society finished the year in debt.

**1874.** *St. Paul.* The state fair made only three dollars, but the Northern Pacific found it profitable to build a rail spur directly to the fairgrounds. Opposition to horse racing surfaced again.

**1875.** *St. Paul.* Another poor fair, blamed by some on "the Grasshopper Year." Percherons and Normans were shown as a novelty, but these draft horses were considered "too large and clumsy and would cost too much to maintain to be of much use to Minnesota farmers."

**1876.** *St. Paul.* The state fair was held in October in hopes that attendance would improve after the harvest. Cold weather and rain kept people away, however, and the Agricultural Society finished the year in debt. Support from businessmen in both cities was disappointing.

**1877.** *Minneapolis.* King turned a handsome profit. Streetcars brought merrymakers directly to the fairgrounds. A twenty-mile riding race between a man and a woman was another great selling point.

**1878.** *St. Paul.* King's fair in Minneapolis featured Senator James G. Blaine from Maine. President Hayes spoke at both events.

**1879.** *St. Paul.* The cities again presented competing fairs, neither one of them comprehensive — or very profitable. The livestock at St. Paul was generally held superior, while Minneapolis excelled in manufactured goods.

**1880.** *Rochester.* Amid suggestions that the state fair be abandoned, the southern counties snatched it back.

**1881.** *Rochester.* The Agricultural Society called for a "reunion" of the feuding parties whose quarrel had driven the fair out of the Twin Cities. But two fairs were held again — the second in Minneapolis — both of which lost money.

**1882.** *Rochester.* A more successful venture, climaxed by a "great barbecue day" with a 1,800-pound ox roasted on a spit. Two enormous steers from De Graff, Minnesota, (one weighed 2,350 pounds, the other 2,450) also occasioned comment. Meanwhile, in Minneapolis, King drew even larger crowds by putting on display three of the chiefs who had taken part in the massacre of Custer's command at Little Big Horn in 1876.

**1883.** *Owatonna.* This was the last year for King's Minneapolis fairs, since discussions over a compromise site were underway. The Owatonna fair included a good stock exhibit, although most of the entries were show animals, trundled from state to state like circus elephants.

**1884.** *Owatonna.* The last state fair "on wheels" illustrated the problems of bringing crowds to points remote from the Twin Cities. Passenger coaches were in short supply on the line to Owatonna, and people were forced to ride in boxcars. Lacking hotels, they slept among the exhibits. Fairgoers without picnic baskets and provisions from home went hungry. The venture lost nineteen dollars. □

*Prize pigs, 1892, representing the ideal of porcine excellence in late-nineteenth-century Minnesota*

carry the state fair back toward the falls of St. Anthony, toward the confluence of the Minnesota River with the Mississippi. Author Wayne C. Neely, in the first systematic study of American fairs, dubs the years between 1870 and 1890 "the period of adjustment." In Minnesota during that time, St. Paul and Minneapolis battled for precedence and prestige, with the state fair as both the prize and one of their most important weapons.

At the Agricultural Society's annual meeting in 1870, Colonel Stevens of Minneapolis, a delegate from Hennepin County, opened the hostilities by comparing the meager receipts of the 1869 fair at Rochester with the larger sums collected in Minneapolis a year before. Other delegates excused the fiasco at Rochester on the grounds of bad weather. They noted that in the Twin Cities day trippers came in great numbers but only stayed long enough to be amused; the fair, according to those who rose to refute Stevens's argument, was not intended to make money on pleasure seekers. It was an instrument of education and reform, and as such, best situated "where agriculture was almost the sole pursuit of the people." City dwellers, including those urban leaders who maintained farms and imported stock for show, were asserting the legitimate claims of business and industry for inclusion in the program when they struggled to bring the fair back to the Twin Cities. The complicating factor was a growing rivalry between St. Paul and Minneapolis: "unworthy and reprehensible" jealousy precluded the kind of joint action that might have settled the future of the fair in short order. And so in 1871, when the society voted by the slenderest of margins to occupy the Kittsondale Driving Park in St. Paul for the season—with dissent from the Minneapolitans, who then comprised about 10 percent of the population of Minnesota—Hennepin County set out to sink the state fair.

The moving spirit behind the plan was William S. King, better known as Bill King or "Old Thaumaturgus," feisty editor of the *State Atlas,* a Minneapolis newspaper, and indefatigable promoter of his beloved Flour City. In 1870 he had led a delegation from Minneapolis to the annual St. Louis Fair, a mixed stock and industrial exposition. There, King paraded his herd of blooded shorthorns—"the finest collection of . . . animals ever led into any show ring," according to one report—and several well-known manufacturers displayed Minneapolis-made woolen blankets, flour bags, and the like. The trip was a triumph. Minnesota was advertised to the world at large in all its diversity. The exhibitors brought home a cache of ribbons and medals, much to the delight of the citizens of Minneapolis. Even before John Stevens made his belligerent speech to the Agricultural Society, there had come together a number of "public-spirited citizens determined that Minneapolis would show the world what she could do with a fair of her own."

When the Agricultural Society ceded the fair to St. Paul, Bill King and his friends were ready. A lot was borrowed near the junction of Third Avenue South and Fourteenth Street. Horace Greeley was retained as official orator. A race between Goldsmith Maid and Lucy, the queens of the American trotting track, was hastily arranged. Farm products were a little sparse, but the prize-winning Minnesota manufactures and cattle direct from St. Louis would, it was hoped, compensate for that minor defect. Better known as the Minneapolis Fair, or Bill King's Fair, the revived Hennepin County Fair was slated to open two weeks before the announced dates of the Minnesota State Fair in St. Paul.

To all appearances, King had every intention of destroying the state fair rather than letting it fall into the clutches of his Ramsey County rivals. When his own exposition closed, he made a great show of shipping his shorthorns

## CYCLONE: DISASTER HITS THE OWATONNA FAIR

In 1883 resident Clarke Chambers convinced Owatonna to accommodate the state fair for a two-year period while negotiations for a permanent site in or near the Twin Cities dragged on. Fairgrounds were laid out and fenced in. The necessary buildings were erected.

But on July 21, at ten o'clock in the morning, a tornado touched down outside Owatonna and headed straight for the fairgrounds. The amphitheater was blown down. Bits of fencing were strewn over miles of surrounding countryside. The new Main Building was a wreck and Floral Hall had somehow been twisted out of shape. Of the twenty-five painters and carpenters at work that day, eleven were badly hurt.

directly to the Illinois State Fair, denying fairgoers in St. Paul the opportunity to see a major attraction. But despite King's best efforts and a small deficit, the Kittsondale fair was more than satisfactory to its backers. Stimulated by the challenge from Minneapolis, the state fair of 1871 addressed industrial as well as agricultural issues. Bricks, safes, and carriages took their places alongside seventeen-pound beets. The next year, after the Agricultural Society had ousted its Minneapolis-bred secretary on charges of having done damage to the enterprise in St. Paul, the fair stayed at Kittsondale, where the railroad land departments erected a large building especially to display new crops and products. Thanks to the Northern Pacific, the ores of Minnesota's iron ranges were put on exhibit for the first time. In the end, despite the bad feeling created by the intercity tussle, the character of Bill King's 1871 Minneapolis fair had helped to broaden the commercial mission of the Minnesota State Fair, lending it some of the characteristics of a big-city trade exposition.

Among the advantages of holding the state fair in one of the Twin Cities was the huge, built-in audience. As officers of the Agricultural Society frequently noted, however, the urbanite was drawn to the fair by attractions different from those that proved tempting to the farmer. Despite the almost universal incidence of horse racing at county fairs, "jockeying" and betting were thought to be city vices. The demand for amusements of any kind, however innocent, was also credited to the Twin Cities and held to be a distraction from the higher purposes of the fair. The clash between rural and urban values — or between the mores attributed to each group by non-members — marked the "period of adjustment."

In 1874 President William W. Folwell of the University of Minnesota, an ex-officio member of the Agricultural Society, offered a resolution abolishing racing at the fair and instructing the executive committee "not to revive or tolerate it under any form or pretense." The motion lost on a tie vote, but members agreed to call races "trials of speed" in the future, in order to discourage the attendance of shady characters and to perpetuate the fiction that racing revolved around the improvement of equine breeds — of questionable value to most Minnesota farmers.

The 1874 state fair, the first to offer "trials of speed" in lieu of racing, was a flop. Some Agricultural Society members maintained that Puritanism — entirely too much "high moral principle" — was to blame. Judge F. J. Whitlock said the people wanted "racing, beer, and everything attractive." Surprisingly, it was John Stevens who defended the new order, attesting that "the ideas of horse trotting and drinking were repugnant to a large majority of the people of Hennepin County." Perhaps Stevens's remarks were calculated to ensure the ruination of all state fairs held at St. Paul while giving Minneapolitans the satisfaction of a moral victory. Whatever his motives, the Kittsondale fair failed again in 1875 and 1876. To stave off another disaster, the whole enterprise was handed over to Bill King and Minneapolis in 1877. And neither King nor his Hennepin County supporters seemed averse to drink, speed, and good times.

At the meeting that preceded King's elevation to the presidency of the Agricultural Society, one disgruntled St. Paulite, banker Truman M. Smith, questioned the morals of stock breeders like King who pumped for "fast horses and . . . horse racing." But the public shared his idea of a good time. For "Bill King's Big State Fair," the trotters were back in force performing before the largest crowds ever assembled on Minnesota soil. "Beer stands were plentiful, 'side-shows' numerous, and other so-called attractions were

Owatonna rallied. A public subscription paid for repairing more than three thousand dollars in storm damages, and the state fair opened in its new quarters as scheduled. Then, the summer's second disaster struck: the exhibits were awful! The produce was negligible, the dairy display "inferior," and attendance sparse.

The local lumber dealer who had supplied the building materials seized the take. The local churches that ran the cook tents on a privilege arrangement complained of poor treatment by the management. Prominent citizens "said the fair had been a failure and really an injury to the town, because it brought in a lot of thieves and pickpockets and other bad characters of both sexes." A local pastor fulminated against the corruption of Owatonna's youth by the hangers-on who came to town in the wake of the state fair.

By the time the following summer rolled around, public enthusiasm for holding the fair again in Owatonna was meager. Chambers, a longtime official of the Agricultural Society and superintendent of horses at the state fair, was forced to offer his own private driving park as the venue.

The horses set no speed records at Colonel Chambers's fair, however. It rained for days on end, and the mud and Chambers's short track dampened enthusiasm for racing considerably. And the park was really too small to hold much of a crowd, had a crowd appeared. But many potential fairgoers were lured away by a wayward circus that arrived unexpectedly and pitched its tents in downtown Owatonna.

That night, a special policeman was killed when a "canvas man" from the circus hit him with a club. That incident, coming on the heels of the immoral goings-on in 1883, naturally "created great excitement and indignation against . . . show people." Owatonna had had its fill of traveling shows, including the Minnesota State Fair. ☐

presented in great number and variety." Whether it was the beer, the races, or the harvest—cries of "Minnesota, 40,000,000, No. 1 hard wheat!" were heard among shippers and processors that September—the state fair of 1877 was the stuff of legend, "a grand sweeping success." On the strength of that performance, King and the pro-Minneapolis faction attended the Agricultural Society's 1878 meeting in full confidence that the fair was theirs forever.

It was not to be. St. Paul regained control, and an infuriated William S. King promptly became president of a Minnesota Agricultural and Mechanical Association, which scheduled a "grand exposition" at Minneapolis for state fair week. As usual, his racing program was superb: Smuggler, Bonesetter, Rarus, and Hopeful, the most celebrated horses of their day, were imported for the occasion, and King took in more than thirty thousand dollars. The state fair was less spectacular and closed its books with a profit of eleven dollars, but the premiums that year were handsome and the St. Paul gathering was also judged a success. What the two competing shows shared was the appearance of President Rutherford B. Hayes, who spoke at both.

Full of numbers and statistics, the speech was not universally praised in either city. But in his peroration, Hayes departed from the text to discuss the circumstances that compelled distinguished visitors to perform at two separate fairs in one sovereign state. "The truth is . . . that St. Paul and the neighboring flourishing city of Minneapolis, whatever you may think, are one in interest," he insisted, "one great city, in spite of the present difficulty." As the climactic battle in the war over the custody of the Minnesota State Fair took shape, the president's conciliatory words were all but forgotten. □

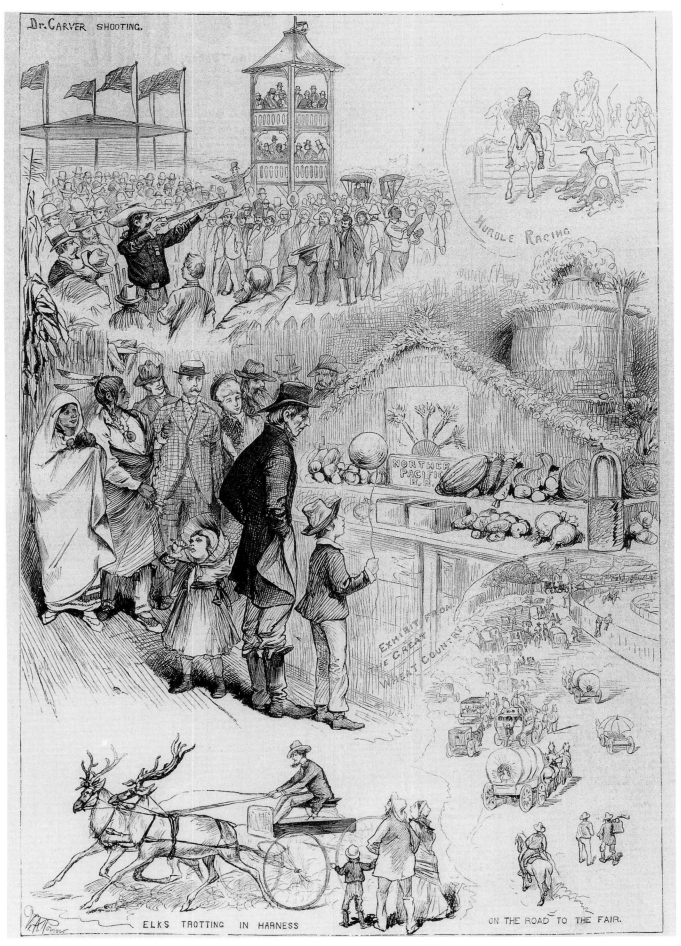

*W. A. Rogers's rendition of the fair for* Harper's Weekly, *September 28, 1878*

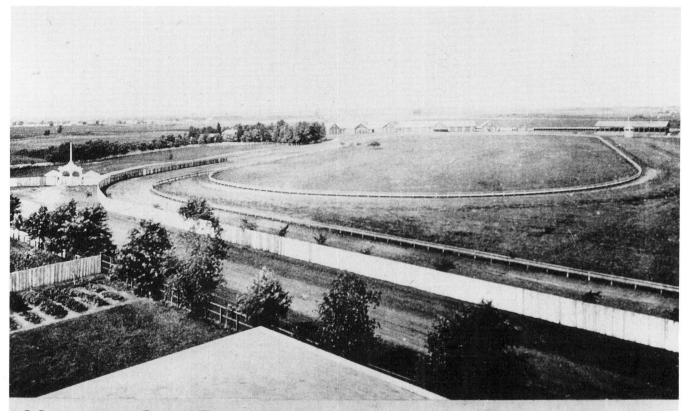

MINNESOTA STATE FAIR GROUNDS—KITTSONDALE, ST. PAUL 1871—76

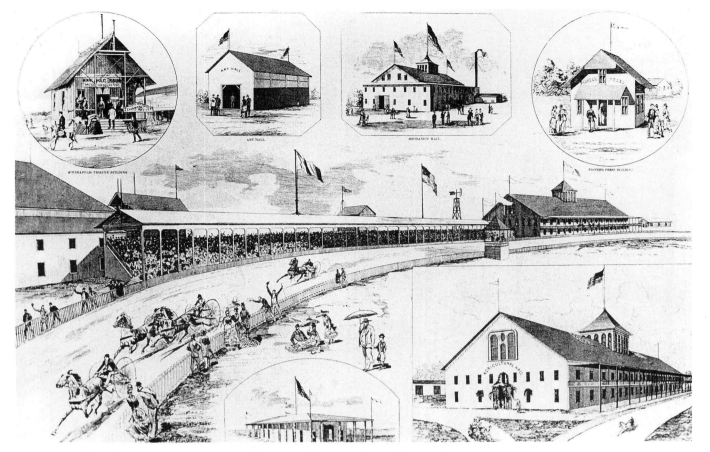

*Amenities of the Hennepin County Agricultural Society's fairgrounds in Minneapolis,
site of the 1877 state fair*

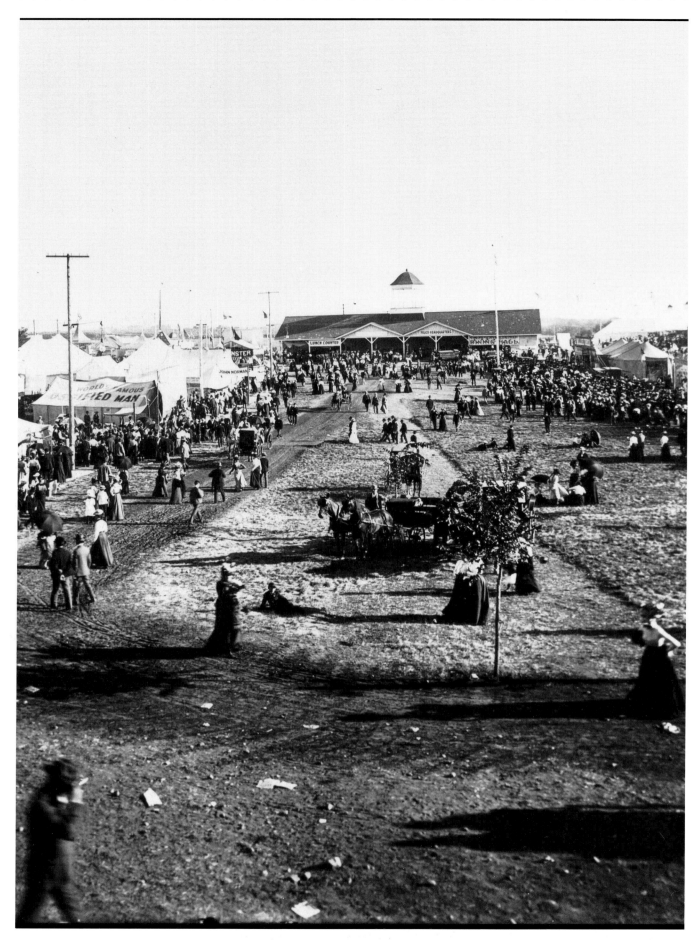

*Bustling 1908 Midway, leading to the Grandstand and offering the Ossified Man, a human monster, and other marvels of the universe*

CHAPTER FOUR

# THE FAIRGROUNDS
# AT HAMLINE

IN 1877 THERE HAD BEEN TALK of finding a spot for permanent fairgrounds close to the Twin Cities; a committee was even appointed to confer on possible sites with the Minneapolis Board of Trade and the St. Paul Chamber of Commerce. That brief moment of interurban truce passed without agreement on a suitable property, however. Instead, the animosity between Minneapolis and St. Paul took a vengeful turn in the late 1870s and the early 80s with the persistence of the Minneapolis fairs.

Cutthroat competition from King was one of the major reasons the state fair resumed its wandering ways, but having chased it out of St. Paul, Minneapolis seemed determined to pursue the fair southward for the coup de grace. In 1883, for instance, King announced that he would not hold his annual exposition. Yet as soon as the Agricultural Society set the dates for a state fair at Owatonna (and St. Paul businessmen agreed to participate), King changed his mind and opened his show as usual, with the clear intention of undercutting Colonel Chambers's enterprise.

Had the tornado, the circus, the rains, and the belief that public entertainments were damaging to the morals of "youth and maiden alike" not combined to deal a mortal blow to the Owatonna state fairs of 1883 and 1884, there is still good reason to believe that the "fair on wheels" had outlived its usefulness. The railroads met at the Twin Cities — and nobody had to get there in a boxcar. Because of the concentration of goods and services along Hennepin and Nicollet avenues in Minneapolis, and across the river at Wabasha and Third, most farmers and merchants conducted business in the Cities at least once a year anyway; a metropolitan locale would work no undue hardship on rural Minnesotans who timed their annual excursions to coincide with the state fair. Giving fairgoers from the iron ranges, the southern counties, and the Red River Valley unlimited access to machinery and other kinds of merchandise distributed through city wholesalers was, in the end, one of the strongest arguments in favor of an urban fair.

Another important factor in shaping the emerging consensus on permanent fairgrounds near the Twin Cities was the new professionalism of Minnesota agriculture. The 1870s and 1880s witnessed the formation of a whole series of organizations devoted to specialized aspects of farming, including a state poultry association (1874), a wool growers' association (1879), and the stock breeders' association that cosponsored King's 1877 fair. These societies generally looked with favor on agricultural fairs. Founded in 1882 in Rochester, the Minnesota Butter, Cheese and Dairy Stock Association went on record as finding the state fair "indispensable to the prosperity of the agriculturalist, not so much for the premium money . . . as for the advantage he has to see the products of other farms and be able to select intelligently for his own." But organizations like this one also provided alter-

*Pin sold at the 1896 Minneapolis Carnival, deliberately scheduled to coincide with the state fair*

natives to the kinds of social, educational, and inspirational services once dispensed solely by fairs.

For members of such groups, a perambulating fair was of little interest, even if it did call itself the state fair. The professional breeder demanded a strong, stable institution with the prestige to draw prize animals from all over the state and the nation. The professional dairyman needed an institution with a proven track record to assure dealers in equipment of comfortable exhibition space and an enthusiastic audience, year after year. Any farmer already accustomed to the fellowship of his particular association looked for something extraspecial at the state fair: a hint of broader horizons, a larger scale of operations, a faster pace, the thrills of a trip to the city.

If professional organizations tended to favor a big, professionalized state fair, the old-fashioned, pumpkin-show approach to agricultural exhibitions was also challenged by the slick trade fairs that bolstered claims of regional superiority in the industrial Midwest in the 1870s. William King had learned the tricks of successful exposition management in St. Louis in 1870. In 1873 several Minneapolis concerns attracted national interest at the giant Interstate Industrial Exposition in Chicago.

*The Angel Gabriel in sheet iron, which once embellished the 275-foot tower of the Minneapolis Exposition Building*

M. G. Hubbard, for example, exhibited the "Hubbard standard" combined self-raking reaper and mower, "of late hailed as the champion of the harvest field." The firm of Gibson & Tyler submitted a glass case full of Minnesota-made blankets — an *"exclusively* home production, the sheep having been raised and fed in Minnesota by home capital" — commissioned by the Palmer House Hotel, George Pullman's sleeping-car "palaces," and the Indian agents of the United States government. By 1883, when the Agricultural Society met to review the debacle at Owatonna, it had become obvious that Minnesota needed an urban fair on a par with the Chicago model — a state fair that could function as a gathering place for jobbers and drummers as well as breeders, a state fair splendid enough to garner nationwide attention for *all* of Minnesota's products.

The society discussed the "Midway Plan" for holding the fair at an undetermined site somewhere between the Twin Cities. King and the Minneapolis boosters were said to favor the idea; this intelligence naturally alarmed "certain St. Paul citizens" who were convinced that what was good for Minneapolis must work to the ultimate detriment of St. Paul (although nobody was quite sure why or how). In any case, the search for a tract of one hundred acres or so halfway between the two cities was abandoned before it had properly begun, and King redoubled his efforts to scuttle the state fair.

In 1884 the Minnesota State Agricultural Society took the first decisive action to end the quarrel and settle the migratory fair on a single, mutually agreeable spot forever. At that year's annual meeting, C. H. Whitney of Marshall introduced a resolution authorizing a committee to negotiate with representatives of St. Paul and Minneapolis interests for the free use of a suitable piece of land on a long-term lease. Not a voice was raised in opposition. Minneapolis had had its fill of open-air expositions and wanted a permanent showplace, indoors. St. Paulites were tired of supporting fairs outside their area. Despite well-founded mutual suspicions, both cities needed a state fair placed where everyone could derive maximum benefit from it. A site in the Midway district near University Avenue, the *St. Paul Globe* at last conceded, "gives an opportunity to unite the wealth and enterprise of St. Paul and Minneapolis with that of the whole state. . . . It will do more to advertise and make known the great advantages and resources of Minnesota than any other means that can be devised."

## THE MINNEAPOLIS EXPOSITION

The selection of a Midway district site was supposed to put a stop to intercity hostilities. The business communities of both towns agreed to support the 1885 fair. But during fair week an angry editorial in the *Minneapolis Tribune* urged local leaders to break with "the alleged State Fair," to "erect an exposition building during the coming year, and [to] hold an industrial exposition that shall rival [those] of Chicago."

The railroads, the newspaper charged, were discriminating against Minneapolis by selling half-rate tickets to the state fair valid only for passage to St. Paul. By this ruse, "country people" were barred from doing business in the city of their choice and virtually propelled into the clutches of St. Paul merchants. According to tradition, the regulars in William Regan's restaurant were inflamed by the editorial and called a mass meeting at the Minneapolis Produce Exchange to discuss the exposition scheme. A public subscription list, headed by the name of William S. King, quickly raised one hundred thousand dollars. Stock in an Exposition Association was sold. A commanding site on the east bank of the Mississippi overlooking St. Anthony Falls was chosen and purchased; the old Winslow House was demolished and an architect hired. Meanwhile, the building committee set off on a quick tour of St. Louis, Chicago, Cincinnati, and Milwaukee to look at structures used for similar purposes.

The cornerstone was laid on April 29, 1886. On August 3, the ornate building, fashioned of pink Mankato stone and cream brick, with eight acres of usable floor space and a ring of electric lights along the roof line, was declared fit for occupancy. On August 23, the first of eight annual Minneapolis Industrial Expositions opened for business with great fanfare. A "Grand March" composed especially for the occasion was played. Visitors were tempted through the turnstiles by an art gallery featuring 236 plaster casts of famous masterpieces of antiquity acquired from the Metropolitan Museum in New York City and an electric light department containing "over 1,500 incandescent lamps . . . by means of which any picture may be lighted in the manner best calculated to bring out its peculiar beauties."

In 1886 the Minneapolis Exposition ran for thirty-six days and admitted 338,000 paying customers to inspect the wares of eight hundred participating commercial firms, whose displays were illuminated, spun about, and variously powered from a central plant. Eugene Blot of Paris, France, showed "groups of statues, pictures, and terra cotta." Fares A. Ferzan of Kansas City had "oriental goods" for sale and D. S. Grimes of Denver offered "cacti, native curiosities and mineral specimens." Waltham watches, Colt rifles, Spalding baseballs and bats, Baker's chocolate, Corticelli embroidery silks, and Columbia-brand bicycles were also in evidence. But "in view of the fact that Minneapolis [was] the center of the railway, mining, flour and saw-mill, engine and general machinery trade for the entire Northwest," the managers were proudest of the steam pumps, the milling machines, the grain conveyors and elevators, and the wheat cleaners that comprised the huge Mechanical Department. A net profit of almost twenty-two thousand dollars suggested that the potpourri of art, entertainment, familiar or intriguing products, and proof of local industry was an appealing one.

Determining the components and proportions of the mix was the responsibility of the general manager, Lewis B. Hibbard, late of Chicago, one of a new breed of itinerant professionals (also active on the state fair circuit) who took charge of hiring press agents, securing favorable rates on the railroads, booking sopranos and concert bands, and weeding out purveyors of dubious gadgets. In turn, they were credited with almost miraculous powers. To Hibbard and his successor were attributed a marked rise in the population of Minneapolis: the emigrants were former exposition visitors charmed by the climate, the elegance, and the enterprise of the city.

The Minneapolis Exposition offered much to charm even the most fastidious connoisseur of such nineteenth-century market fairs, and the attractions became more elaborate and costly as the years passed (to the amusement of the St. Paul press, which took such expenditures as signs of growing desperation). For the 1891 edition, local scenic artist Peter Clausen was engaged to paint a background for a cotton-picking tableau featuring a working cotton gin. Additional lights were added to the exterior of the building. Inside, an ersatz precipice one hundred feet long and forty feet high was constructed to house an educational display of "Cliff Dwellers' Relics." Sales of reserved seats for a nighttime spectacle entitled "The Siege of Vera Cruz" were brisk.

Despite such dazzling additions to the annual catalog of novelties, in 1893 the Minneapolis Exposition closed its doors forever. The enormous success of the World's Columbian Exposition held in Chicago that year contributed to its demise; anticipating a loss in revenues, the Minnesota State Fair had wisely suspended operations for the season. At least one history of Minneapolis maintains that the exposition was strictly "a product of the period," and was, therefore, doomed by an inevitable diminution in a young city's demand for extravagant expressions of its go-getting spirit. But the growth and development of the state fair played an even greater role in the decision to abandon the Minneapolis Exposition.

The exposition had "The Siege of Vera Cruz" and eight acres of goods and machinery. The fair had "The Burning of Manila," Machinery Hill, a garish "Midway Plaisance" modeled on the entertainment zone at the Chicago World's Fair, business booths, retail displays, countless concessionaires with products for sale—and more than a hundred acres of Minnesota grain, fruit, and livestock besides. The state fair alone had the resources to compete with the spate of world's fairs that dominated American popular culture at the turn of the century. And in the 1890s the Minnesota State Fair would join that competition with gleeful abandon. □

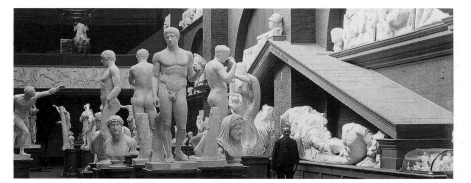

*Sculpture Hall, Minneapolis Exposition Building, 1886*

At first, the representatives of the Twin Cities on the "Union Fairgrounds" committee got along famously; there was even talk of setting up a joint stock company and cutting the Agricultural Society out of the fair business altogether. When it came to an actual decision on a site, however, Minneapolitans and St. Paulites swiftly parted ways. Each delegation wanted the fairgrounds "as near as possible to its home city, but with smooth dissimulation and an assumption of extreme fairness endeavored to conceal its real intention."

For its part, the Minneapolis Board of Trade had settled on Minnehaha Falls as the ideal location and argued that the majesty of the setting even justified building a new state capitol in among the fair buildings there. Ansel Oppenheim, a St. Paul committee member, stirred up opposition to the Minneapolis plan on the practical grounds of cost, arguing that the owners were sure to demand ten thousand dollars or more for such a scenic spot, particularly if a state agency expressed interest in it. In the meantime Henry S. Fairchild of the St. Paul Chamber of Commerce proposed the Ramsey County Poor Farm at the corner of Como and Snelling avenues, just outside the northwest limits of the city.

Public opinion was divided along wholly predictable lines. "They're trying to steal the State Capitol!" thought St. Paul. "The Poor Farm is practically in St. Paul!" Minneapolis concluded. So Minneapolis vetoed St. Paul's favored site and vice versa—although, at the last minute, the Minneapolis contingent feigned interest in a "compromise" tract fronting on University Avenue about a mile south of the Poor Farm. Minneapolitans therefore emerged from the collapse of negotiations insisting that they had sincerely *tried* to be accommodating. But, of course, if St. Paul didn't really want a state fair in the Midway. . . .

What happened next is veiled in oblique language and abrupt resignations from office on the grounds of ill health. The Ramsey County Board of Commissioners was persuaded to offer its two-hundred-acre farm to the Agricultural Society as a gift. Because the land was free, the state legislature was wholly sympathetic. Chapter 174 of the General Laws of 1885 records grateful acceptance of the deed and an appropriation of one hundred thousand dollars for buildings. "No longer should the 'State' fair be in effect a mere local exhibition," wrote the Agricultural Society's official historians. "No longer would it be hauled about from town to town, like a wandering circus, putting up its tents in the locality which should agree to pay most, or 'offer the best inducements.'" The state fair had finally found a home.

Construction began immediately on the old poor farm in the township then known as Hamline. Wells were dug. The Great Northern ran a spur to the fairgrounds to bring in the lumber and the nails and put up a state fair depot. During a ninety-day flurry of activity, ample stock pens and a two-tier grandstand fronting on a mile-long racetrack appeared. The centerpiece was Main Building, designed by St. Paul architect James Brodie. Resting on four radiating wings faced with brick, the immense wooden dome (it was often said to be the largest in the world) rose 120 feet into the sky and was visible for miles around.

Until an agriculture building was erected two years later, the cavernous reaches of Main Building housed everything except the animals, and thereafter its generous scale invited commercial displays of breathtaking size and ingenuity. In the early 1890s, Pillsbury Mills erected a huge pagoda of polished barrels and flour sacks in the rotunda under the dome, but there was room left over for a fifteen-by-thirty-foot model of Minnehaha Falls

## "PEERLESS MINNE" vs. THE SAINTLY CITY: THE BATTLE OF FAIR WEEK

"The annual State Fair has always been the occasion of a sharp and legitimate rivalry between the Twin Cities whose people fully realize that the thousands of strangers who annually visit this great agricultural and industrial exposition will naturally seek to spend their evenings and find accommodation in that city which offers the greatest attractions and public festivities," noted a St. Paul trade journal in 1897.

This secondary fair-week rivalry reached its climax in the 1890s. Beginning in 1885, St. Paul staged a nighttime "illumination" of the downtown streets while the state fair was in progress. Stores sported decorated windows and stayed open late; gaslight filtered through tubes of colored glass lent a festive air to nighttime promenades. In 1890, when the cost of electric wheat sheaves and a "blue dome" of light at the corner of Third and Cedar streets reached six thousand dollars, the entertainment of fair visitors became a serious bone of contention between St. Paul business leaders and their thrifty aldermen. The former, of course, favored the gala.

A twilight bicycle parade (riders were supposed to carry candles) and a "floral" parade open to bearers of bouquets were added to the program. In 1891 King Borealis Rex, mystic leader of the Winter Carnival, made a warm-weather appearance during the illumination and soon became a fixture of this fair-time carnival, along with the apparatus once used to light up his ice palace. Demands for a summer gala in St. Paul reached their peak in the mid-1890s, when agitation for a revival of the great ice palaces of the previous decade was also mounting. The same St. Paul businessmen and boosters who masqueraded as Vulcans during the Winter Carnival were the prime exponents of a "harvest festival." During quarrels with tightfisted local politicians over appropriations, they often cited the financial benefits accruing to St. Louis as a result of its annual Veiled Prophet parade and street fair.

Despite examples of profitable civic entertainments elsewhere, St. Paul's promoters had a hard time of it. The city failed to install the lights in 1892. In 1895, after much debate over whether to erect a wheat or an ore palace as the centerpiece of the celebration, the harvest festival was canceled in favor of a masked street carnival. In 1897 the focal point was supposed to be Lake Como, site of a water parade, but subsidiary events, including a Virginia barbecue and another bicycle parade, overshadowed the "Venetian Carnival" of boats.

St. Paul's Venetian Carnival of 1897 coincided with the Carnival of Polaris in downtown Minneapolis, a frolic conceived in open competition with the New Orleans Mardi Gras, the nascent Pasadena Tournament of Roses—and whatever St. Paul might have to offer Minnesota fairgoers. The whole of downtown was abuzz for months with preparations. In a "den" at the corner of Eighth Avenue and Sixth Street, "Karnival Krews" were building papier-mache floats in secrecy under the direction of well-known Minneapolis artists. Although Peter Clausen was given the edge in terms of experience, the Fournier brothers were said to have found a new way to light up their rolling tableaux by electricity. Walter Heffelfinger of the North Star Shoe Company (variously known as Polaris, King Pudge Primus, or Walter I) was crowned King of the Carnival and Consort of Ceres, goddess of Minnesota wheat. His first official duty was to rally the fashionable women of the city to adorn their carriages with artificial flowers for a competitive Floral Parade (distinct from the main float parade with its anticipated ten thousand costumed marchers). Fireworks, concerts, plays, and events for bicyclists rounded out the week.

Souvenir manufacturers expected to make a small fortune, especially on items for out-of-towners, decorated with pictures of Minnehaha Falls.

In 1899 the Minnesota State Fair completed the illumination of its own grounds and scheduled its first evening Grandstand show, followed by a display of fireworks. There was no reason for the visitor to scurry back to a hotel in St. Paul or Minneapolis as soon as the sun went down. So, exhausted by their efforts, Minneapolis civic leaders were only too happy to cancel their carnival when Secretary Eugene W. Randall asked them to do so for the good of the fair. For its part, St. Paul showed signs of reviving the public illuminations in 1906, 1907, and 1908, when a "Way of Light" was picked out with electric stars suspended over the major intersections on Ninth Street. In retaliation, Minneapolis promptly announced plans to bring back the Carnival of Polaris. And once again, fair officials intervened.

C. N. Cosgrove, secretary of the Agricultural Society, condemned "those who must needs despoil the fair of legitimate attractions . . . in open defiance of state loyalty." The fair, he concluded, "has accommodations for all and attractions which deserve all of the sight seers' time." Minnesota's fairgoers agreed with Mr. Cosgrove; because they lingered at the fair long after dark, the urban carnivals soon vanished. □

*Souvenir medallions encouraged attendance at the rival Minneapolis Exposition.*

*Gaslights, arranged to form triumphal arches and other fanciful shapes, made a fairyland out of downtown streets, as reproduced on this 1887 commemorative medal.*

constructed entirely of Minnesota grains by the Great Northern Railroad. In 1895 the Towle Syrup Company built therein a full-size log cabin "which was a constant reminder of their favorite brand of that condiment which makes buckwheat cakes so acceptable." In 1903 the same space, decorated with potted palms, held Miss Nellie Hope's Ladies' Orchestra and the "uncommonly rich displays" of the leading Twin Cities department stores: Powers Mercantile Company, Donaldson's Glass Block, Schunemann & Evans, and Mannheimer Brothers.

In 1885, during the greatest state fair thus far held in Minnesota, 74,508 people swarmed over the new Main Building in the six days of the official run, pausing to admire 107 kinds of apples and 376 varieties of potatoes. The attendance was a marvel for its time, and the receipts — more than twenty thousand dollars — went toward improvements to the physical plant. A fireproof art building, a dining hall, and Agricultural Hall were added in 1887, and in 1888 the little son of Superintendent of Machinery William M. Busnell pushed an electric button and set 841 machines in motion all at once. Displays revolved. Sewing machines raced across yards of dress goods. Millstones turned. A mile and a half of shafts and belts humming like a giant factory beneath the great dome of Main Building, the state fair whirred and chugged and snorted its way into the modern era. □

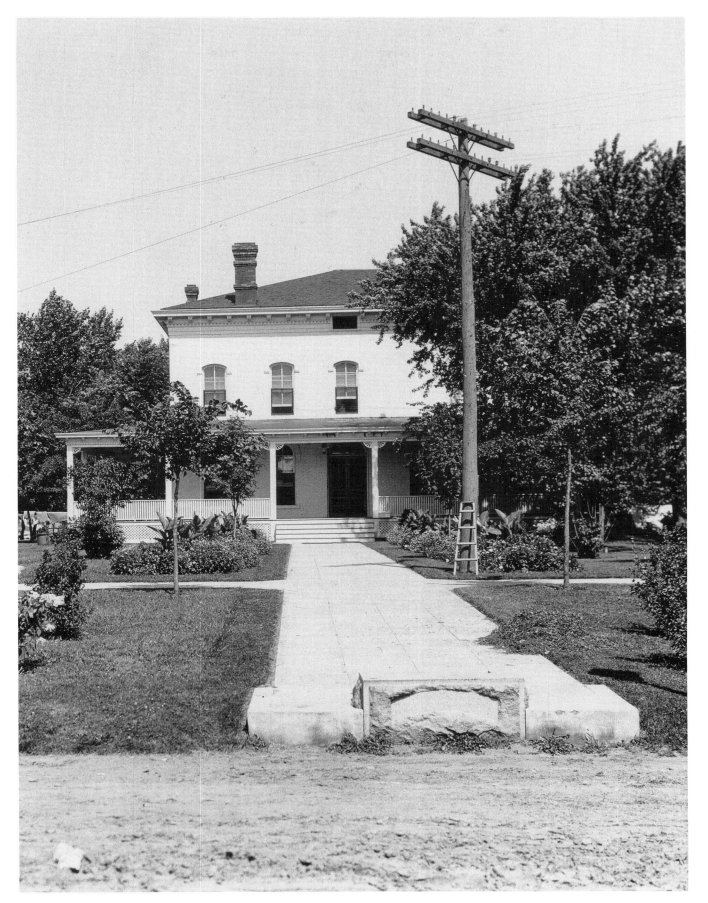

*The fair's first Administration Building, 1906; erected in 1870 as part of the Ramsey County Poor Farm, it was razed in 1951.*

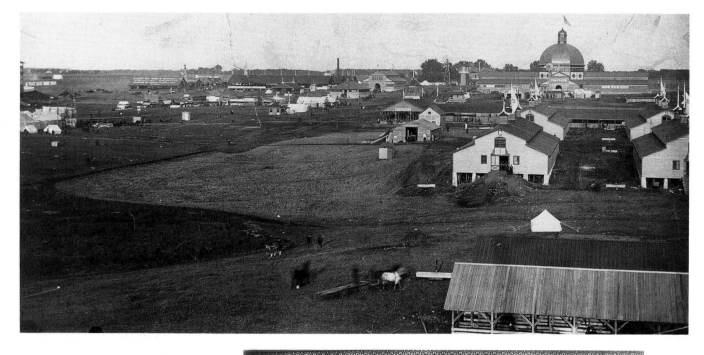

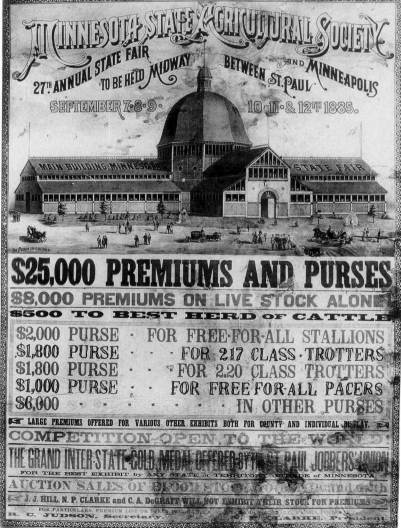

*Improvements by about 1890 included stock barns, open-air concession buildings, and Horticulture Hall, but the layout was haphazard, many elements were still under canvas, and there were no paved walkways.*

*Poster for the first fair at Hamline, showing the domed exhibition hall*

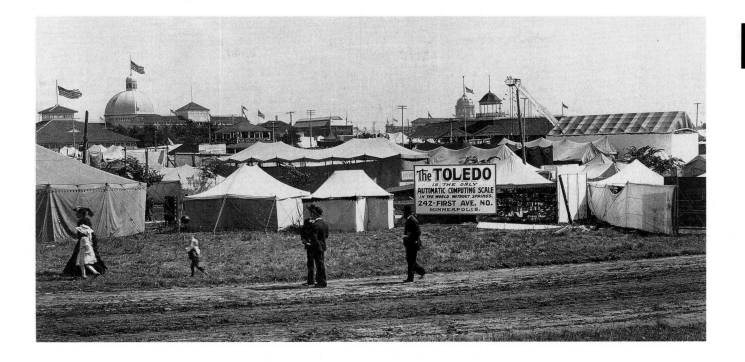

WELL, I HAD A GOOD TIME, ANYROW.

*Tents still clustered around the fair's more permanent buildings in 1903.*

*Editorial cartoon,* St. Paul Pioneer Press, *September 11, 1897*

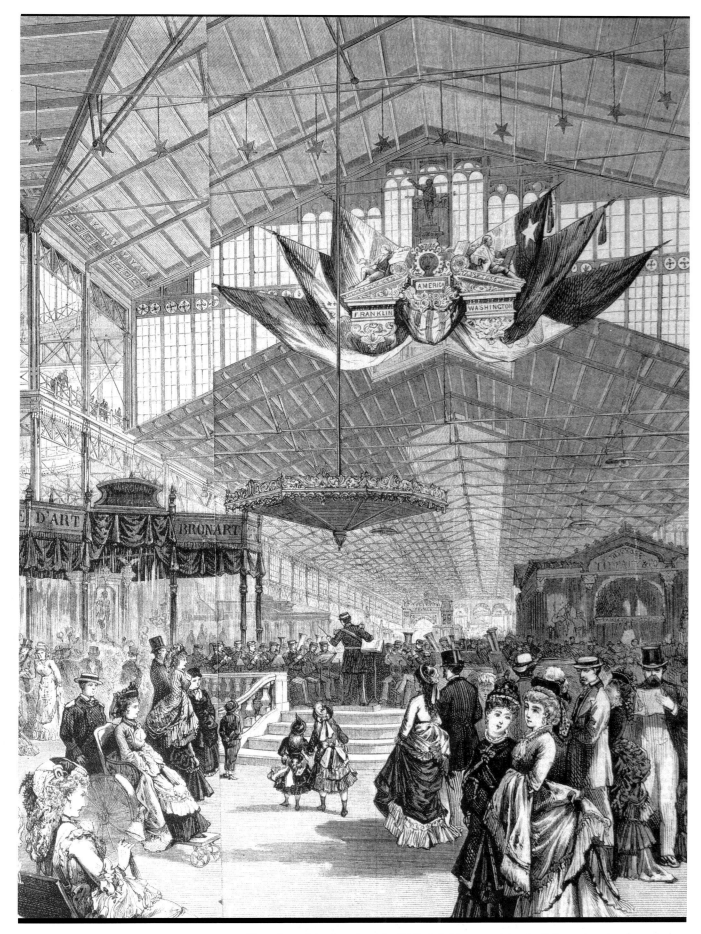

*Drawing of the interior of a Philadelphia exposition building, showing how domes and vaults created large areas of uninterrupted exhibition space*

# MINNESOTA AT THE
# WORLD'S FAIRS

EVER SINCE ANTIQUITY, traders have gathered on holy days to display exotic wares, and fakirs have entertained their customers — fairs are as old as civilization itself. During the Middle Ages, merchants bound for the fair could come and go freely between warring states. Spices, fine cloth, and other rarities thus found their way into lives of those bound in service to the land. The fair was their window on the whole wide world and its wonders.

In the nineteenth century, the fair became a show window for the display of new industrial products and the machines that made them. It also became an instrument of national policy, expressing a pride in native manufactures through competitive displays with the goods of other countries. The first real world's fair — the great Crystal Palace Exhibition of 1851, organized by Prince Albert and held in a vast, domical building of glass in London's Hyde Park — was designed to bring together the "Industry of All Nations," including raw materials, the manufactured goods created from them, and the art used in adorning the finished product. In the United States, where the desire for self-sufficiency in manufactures had been a crucial element in the genesis of the agricultural fair, an Americanized version of the British world's fair was hurriedly mounted by eastern business interests. New York's Crystal Palace Exhibition, in its own iron-and-glass hall on Reservoir Square, opened for public scrutiny in 1853.

During the winter of 1852, the once-a-week pony sled that carried the mail up the river on the ice from Prairie du Chien brought an advertisement for the Crystal Palace show into the hands of young William Le Duc, a lawyer and bookseller who had settled in St. Paul two years before. "At once I saw in the world's fair," he wrote, "an opportunity to attract attention to our territory, then practically unknown, and to induce immigration to move in our direction." With those words, Le Duc became the first in a long line of governors, nurserymen, railroad magnates, butter makers, resort owners, and other businessmen who supported Minnesota's vigorous participation in such expositions.

From 1853 through 1915 (the Panama-Pacific Exposition in San Francisco), the community of nations indulged itself in an orgy of world's fairs. Many were held in the United States, which was beginning its climb to industrial hegemony, but whether the current international event was quartered in Paris or St. Louis, Minnesota was sure to be represented. From the world's fair circuit came many of the display techniques and the amusements featured at the Minnesota State Fair. At the world's fairs, the products of Minnesota agriculture and industry deemed meritorious at the state fair competed in a global arena.

Like the enthusiasts who came after him, William Le Duc launched his

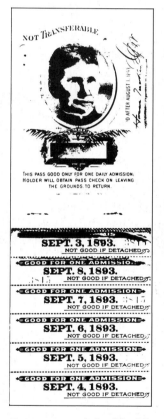

*Pass to attend the World's Columbian Exposition in Chicago, 1893, belonging to Mrs. F. W. Crosby of the Women's Auxiliary Board, Minnesota State Board of World's Fair Managers*

*Lifelike display, including a stuffed moose, stressing Minnesota's recreational opportunities, St. Louis, 1904*

drive to make the Minnesota Territory prominent at the Crystal Palace with an appeal for funds. After Governor Ramsey and the legislature pledged three hundred dollars, Le Duc, newly appointed commissioner to the fair, waited for spring and then set out to collect "such an exhibit as would attract attention to Minnesota." He went first to Cottage Grove where Joseph Haskell, James Norris, and Joseph and Theodore Furber were proving the fertility of Minnesota soil by growing small grains; he came away with samples of wheat, rye, oats, barley, and corn. Next it was on to Mendota and Henry Sibley's trading post for furs. And finally, Le Duc traveled to the upper Mississippi for a lump of copper ore, an Indian canoe of birch bark, and a supply of *manomin,* or wild rice, an almost unknown "grain of great food value."

With these items in his possession (as well as an ill-tempered bison), Commissioner Le Duc began the arduous trip East—downriver by boat to Galena, St. Louis, and Cincinnati, and onward by rail to Buffalo, Albany, and New York City. There he set up "as attractively as possible the . . . canoe and other Indian curios, the furs, my small stock of farm products, and a number of interesting photographs of Fort Snelling, the Falls of St. Anthony, and views of dog trains and Red River carts taken by Joel E. Whitney, St. Paul's first photographer." Finding considerable space left over, he repaired to a leading seed store and purchased samples to serve as standards by which fairgoers could judge for themselves the richness of Minnesota soil. He arranged for *manomin* to appear on the menu of the gala opening banquet at the Metropolitan Hotel, where President Franklin Pierce would dine on the delicacy from Minnesota. Then Le Duc called on Horace Greeley and persuaded the editor to come and see what could be grown in a place he had once "derided as a barren and inhospitable region, unsuitable for farming, fit only for logging operations."

In his collected writings on the Crystal Palace Exhibition, Greeley was particularly critical of the scarcity of American agricultural products. The crowds gaped at scenes of Greenwich Village streets constructed of spun sugar and towering statuary made entirely of chocolate, but there was little to be seen of foodstuffs "in the raw or natural condition of their growth." Le Duc's display of seed was the singular exception, and Minnesota was, said Greeley, "the only section of the United States making any pretense toward a show." In an editorial in the *New York Tribune*, Greeley also recanted his earlier position and praised the farming potential demonstrated by the Minnesota seed comparison, thereby earning his invitations to the state fairs of 1865 and 1871. "This notice in the *Tribune*," Le Duc maintained in 1916, "started a tide of immigration to Minnesota which has continued in a steady stream ever since that day."

In 1867 Minnesota took an honorable mention at the Exposition Universelle in Paris for a display of cereals, although a state mineral collection and the wooden buckets made by J. B. Bassett & Co. of Minneapolis received no prizes. Far more important in attracting attention to Minnesota's rapidly diversifying agriculture, however, was the great Centennial Exposition held in Philadelphia in 1876 in honor of the one-hundredth birthday of the nation. Winter and spring wheat, corn, and oats grown in Fillmore, Blue Earth, Faribault, Stearns, and Olmsted counties figured prominently in the Agricultural Department. Among the manufacturers, Elias Stangeland of Rockdale, Minnesota, was commended for the "efficiency and simplicity" of his feed steamer, and a Minnesota Holstein Company listed among the concessionaires suggested the beginnings of intensive dairying. It was

in horticulture, however, that Minnesota gave witness to the maturation of pioneer farming and the salubrity of the climate by submitting no less than fifty varieties of apples, ranging from the Ben Davis and the Caldwell to the Jonathan, the Painted Lady, and the Westfield-Seek-No-Further.

At Philadelphia, the rows of apples (and papier-mache models of apples that had shriveled away in the summer's heat) were not particularly eye-catching. Fairgoers preferred the showy displays of the confectioners, such as a sweetmeat George Washington sent by a New York firm. There is also evidence that purveyors of other products had learned the tricks of the candy butcher's trade by the time of the Centennial Fair. William Dean Howells, for instance, was captivated by a glass case displaying a brace of sugar-cured Cincinnati hams canvased "not in ordinary yellow linen, but in silk of crimson, white, and gold." The Kansas and Colorado display featured a Liberty Bell made wholly of western grains, grasses, and brush, with a gourd for a clapper. The critic for *The Nation*, who deplored the tendency to display the nation's agricultural bounty as so many pyramids of tin cans, bottles, and barrels, lauded the ingenuity of Iowa, which had represented the fertility of the land by four-, five-, and six-foot sections of prairie soil encased in graceful columns of glass.

As world's fairs grew in numbers and size, nations and states alike increased their appropriations for expositions. In some quarters of Minnesota, a good showing at the Columbian Exposition of 1893 was deemed crucial to the future prosperity of the state. The state fair had been canceled for the year in anticipation of a huge turnout in Chicago and members of the Board of World's Fair Commissioners appointed by Governor William R. Merriam bent their efforts toward producing the kinds of spectacular displays that had proven popular in Philadelphia. So Minnesota had its picture "painted" in grain over the stairway of the state headquarters, its "arabesques" of grasses draped about the Minnesota pavilion in the Agricultural Building, its heap of plump, silk sacks of Minnesota flour, and its tracery of vines that Mrs. G. H. McDowell of Minneapolis sculpted in pure Minnesota butter on a maroon cloth placed over ice. Although these marvels could not quite compete with a thirty-two-foot lighthouse of oranges from Los Angeles or a mounted knight in prunes from Santa Clara, they did serve to enhance the serious accomplishments of Minnesotans at the Chicago World's Fair.

The women of the state, who were represented by their own auxiliary to the board of commissioners, won medals for welfare work, traditional needlecrafts, and a prototype of the official state flag worked in silk. But they were most prominent, perhaps, on the honor roll of the Dairy Department, in which Minnesota won forty individual butter medals. Wheat and flour still constituted the bulk of the displays, to be sure, but when newly elected Governor Knute Nelson addressed reporters and honored guests in Chicago on Minnesota Day, he seized the opportunity to brag about "288 creameries, and the 50,000,000 pounds of butter" made that year in his home state.

There was no butter sweepstakes at Chicago (unlike the 1885 New Orleans World's Industrial and Cotton Centennial Exposition, where Minnesota unexpectedly carried off the national "Butter Banner"); nonetheless, it was clear that Minnesota excelled at a new kind of mixed agriculture. If wheat was still supreme, dairymen had achieved great prominence in remarkably short order. H. F. Brown, whose purebred cattle won the herd premium at the 1890 Minnesota State Fair, took the Chicago sweepstakes for the "best ten head of shorthorns" bred by the exhibitor. "The unprofitable

## THE ST. LOUIS BUILDING

Gorgeous and glorious though they often were, most structures erected for world's fairs were temporary affairs, made of a plaster-and-fiber compound called staff. When the last medal had been distributed, the "white cities" and the beautiful lagoons which they adorned vanished overnight, as if by magic. But from the beginning, Minnesota's delegation to the 1904 Louisiana Purchase Exposition hoped to construct its headquarters in such a way that the building could be "returned to the state and rebuilt in the State Fair grounds."

Plans for the Byzantine-style bungalow, with terraces and porticos suited to the warmth of a St. Louis summer, had been drawn up by the firm of Reed & Stem of St. Paul, architects of the New York Central Terminal Station. But when bids were submitted for executing the plans in concrete block, taking the house down, and rebuilding it in Minnesota, the cost far exceeded the budget. So did a second set of estimates for construction in staff with no reconstruction. Only when "all of the elaborate features were relentlessly cut out and the size of the building greatly reduced" could the board of managers afford to contract the job to a St. Louis company.

Despite the economies, "visitors had only words of praise for the [staff-and-stucco] building. Many considered it among the most artistic on the Plateau [of States]." Electric fans and ice-water taps added to the enjoyment of tourists from back home, and the official hostess, Miss Adelaide Murphy of St. Cloud, was solicitous of their comfort. When the time came to reduce the Minnesota Building to rubble, nobody had the heart to give the order.

So the "St. Louis Building" was dismantled, piece by piece, and shipped back to Minnesota, where it was reconstructed on the state fairgrounds. At first, it served as a clubhouse for newspapermen; the big windows with their ample provision for cross ventilation helped to dissipate the cigar smoke. In 1913, "the rural women of the State were invited to take possession of the large airy rooms, broad verandas and pleasant lawns which had heretofore been a mere showplace." The building became the fair's Rest Cottage and Day Nursery, a place where women could "rest, talk, read or sleep" between bouts of "seeing the fair." Altered almost beyond recognition, the old landmark ended its days in the 1960s as the headquarters for KSTP radio and television. □

'scrub' has given way to the full blood or high grade bovine" in Minnesota, the board of commissioners stated in its final report, "and the change in this particular has many times increased the profits of the dairy."

All in all, the 1893 fair was a triumph for Minnesota. In addition to the prize shorthorns, Minnesota-bred Galloways, Jerseys, Guernseys, and Brown Swiss were all noticed in Chicago. N. P. Clarke of St. Cloud won a medal for his Clydesdales. The state received an award for flax, 105 growers were recognized for the excellence of their wheat seed, and seventy-five firms were commended for the quality of their flour.

Bursting with pardonable pride in Minnesota's fine showing, the Agricultural Society petitioned the commissioners to transfer the exhibits to the state fair at the conclusion of the Chicago gala. There, according to the text of the formal application, the flour booth, the dairy display, the forestry collection, and the big agricultural booth, along with many of the decorations from the Minnesota building, would "be preserved, [so] that the people of the state could have the opportunity of seeing [them] . . . making altogether a very useful and ornamental collection, that will be valued highly on account of its having been a part of the great Columbian exposition." Installed beneath the capacious dome of Main Building, the Chicago relics served two other purposes as well. They honed the competitive instincts of Minnesota growers and promoters to a keen edge for the upcoming Pan-American Exposition in Buffalo. And they stimulated Minnesotans to experiment with ever-more dramatic methods of display.

It took a genuine novelty to win the admiration of the jaded fairgoers who toured the Buffalo Exposition in 1901. But Minnesota succeeded in four spectacular exhibits. One was the state's booth in the Agricultural Building, an edifice topped by "The Woman in Grain," a statue fashioned from seeds and stalks. Another was the flour booth, which daily bestowed on passersby some 1,500 "choice rolls made of Minnesota flour," each one lavishly "graced with Minnesota butter." Then there was the scale model of Fort Snelling—eighteen feet tall, twenty-nine feet in circumference, and electrified for steady revolution—made of ninety bushels of Wealthy apples from the Jewell Nursery of Lake City, with cannon constructed of contrasting crabapples and gun loops "trimmed with mountain ash berries." Finally, the pièce de résistance: an eleven-by-five-foot replica of the new state capitol in St. Paul carved from a giant lump of Minnesota butter.

Seed art of all types had been a staple at the Minnesota State Fair since the early 1890s. Free samples were another popular feature. Such attractions were by no means unique to Minnesota, however; they had become part of the repertory of American exposition advertising. But the rotating tower of apples and the massive butter sculpture were unusual enough to make the national press sit up and take notice in 1901, and evidence suggests that the details of these memorable displays were painstakingly worked out over several years of experimentation at the state fair.

Fort Snelling, for example, was the work of J. M. Underwood, proprietor of the Jewell Nursery and longtime horticultural supervisor at the state fair. Underwood had prepared for the Pan-American Exposition with several trial versions of the apple fort and other similar structures; by 1901, his elaborate constructions had become a regular attraction at the Minnesota State Fair and were judged superior to run-of-the-mill pyramids of oranges and prunes not only by virtue of their motion but also because of Underwood's care in providing ample stores of fresh fruit for replacing blemished specimens.

## THE MIDWAY PLAISANCE AND THE MERRY PIKE

The modern outdoor amusement business began in Chicago in the summer of 1893. The architects of the Columbian Exposition created a designated zone in which lighthearted or light-minded diversions from the serious, educational displays were located. Here the kinds of sideshows that once clustered on the unofficial flanks of the Crystal Palace were invited in but were confined to a single, mile-long thoroughfare known as the Midway Plaisance.

The carnival along the Midway included exotic foods—a New England kitchen of "ye olden tymes" served baked beans beside a booth vending "Ice Cold French Cider"—strange sights, unusual people, and thrills aplenty. A California ostrich farm rubbed elbows with the World Congress of Beauty ("40 Ladies from 40 Nations"). A show offering a glimpse of a thousand parrots imported from Hamburg adjoined a "Nudist Colony" where the unsuspecting mark paid a fee to peep through a hole in the wall and see himself reflected in an unrevealing painting.

There were Oriental bazaars, a Lapland village, live Eskimos, a Chinese joss house. Little Egypt did the hoochy-koochy; soon, naughty Fatimas and Zazas from one end of the Midway to the other found that they had invented burlesque. And towering above the whole, gaudy spectacle was the steam-powered, sixteen-story wheel built by George Washington Gale Ferris, head of the Pittsburgh Bridge Company, who invented the Ferris wheel for the Chicago Fair to rival the Eiffel Tower, centerpiece of the 1889 Paris Exposition.

By 1896 the Minnesota State Fair had a sixty-foot Ferris wheel. By 1897 there was a full-fledged state fair Midway, with a merry-go-round, a fortune-teller, a "grinning Ethiopian" who stuck his head through a piece of canvas and dared comers to hit him with a ball, a strong man, a fat lady, and an illusion that permitted a look at the insides of a genuine, transparent "x-ray woman." Hot dogs, popcorn, and lemonade of a violent pink hue were sold throughout.

While all these come-ons reappeared at the St. Louis World's Fair of 1904 (Ferris even moved his original wheel to the spot), the "Merry Pike" had its own store of novel attractions. The ice-cream cone was invented there, for example, and fairgoers enjoyed a much wider selection of rides: dark, scenic railways that ran through a maze of tunnels, the Magic Whirlpool, and Creation, a water voyage that featured the lovely Miss Gladys Morrell in "artistic" poses representing scenes from the book of Genesis. The Minnesota State Fair, "right up to date and abreast with the times," announced in July of 1904 that it had jettisoned its old Midway in favor of "a full-fledged 'Pike.'" Management pledged that "any man who goes over the pike at the next state fair will have seen everything that might be seen at the Louisiana Purchase exposition in the similar department," including duplicates of most of the best rides.

Creation was promised, along with a Ferris wheel with red plush seats, a hall of mirrors, and an act called "The Little Girl from Up There," in which a naked statue turned into a living American girl before one's very eyes. The Gaskill Carnival Company, which was currently trying out the show in Chicago, would be carefully supervised by the managers of the Minnesota fair "and the tone will not be allowed to drop below the proper level." Nonetheless, it was going to be a good, "snappy" show, albeit one removed to an enclosure where the unsuspecting would not get an eyeful of some wayward Fatima, doing her ballyhoo. But "when you visit a 'Pike,'" squeamish Minnesotans were reminded, "you don't have the idea you are going to a Sunday school picnic." □

## JURY AWARDS TO THE WOMEN OF MINNESOTA AT THE 1893 WORLD'S FAIR

- Mrs. E. H. Centre, Minneapolis—Design of State Flag
- Fjelde Sisters, Minneapolis—Silk Embroidery of State Flag
- Miss Madeline Hasenwinkle, St. Paul—Carved Tea Table
- Women's Auxiliary of Minnesota—Collection Exhibit in Winged Frame, Records, Photos, etc.; Wild Flowers and Grasses of Minnesota
- Miss Arnold, Minneapolis—Case of School Work by Girls
- Becker County Auxiliary—Case of Homespun
- Miss Laura Tinsley—Covey of Prairie Chickens
- Women's Work Exchange, St. Paul—Case of Needlework and Decorated China
- Miss May Dauer, New Ulm—Bohemian Lace in Process of Making
- Mrs. J. K. Werle, St. Paul—Hand Knitting
- Literary Clubs, Minneapolis—Decorative Chart
- Mrs. M. V. Tomlinson, St. Peter—Case of Work by Insane Women
- Mrs. E. R. Mendenhall, Duluth—Model of Turkish Baths in Homes
- Mrs. Hall, Stillwater—Self-threading Sewing Machine □

John K. Daniels, architect of the capitol-in-butter, had also "done some notable work in butter for the state fair" in preparation for his debut in a refrigerated glass case at Buffalo. Whereas the ladylike scale of Mrs. McDowell's work for the Columbian Exposition represents the norm for the medium, Daniels's efforts at the state fair had led him to adopt the bold and weighty manner that was the real source of popular fascination with his model. The sheer size of the Minnesota display staggered those who encountered it. Butter was expensive and fragile, yet here it was used with a prodigal abandon to simulate a structure of enduring stone. People found the whole concept of a building made of soft, yielding butter mesmerizing (and, one suspects, delightfully repellent). In any event, they came back to the case, time after time, just to see if it had gone rancid or melted away. It was, said the delighted managers of the Minnesota effort, "a marvel and a gem."

Like the tower of apples, the butter building was also a potent symbol of abundance, fertility, and prosperity. Governor Samuel Van Sant, in his Minnesota Day address to boosters gathered one warm June afternoon in the state pavilion in Buffalo, declared that "we have changed our name from the Gopher State to the great Bread and Butter State of the Union." The "Woman in Grain" and Daniels's amazing edifice supported his claim. Everyone who saw the latter, reported Minnesota's delegation to Buffalo, "carried away with him or her the impression that Minnesota was a great and enterprising state." And after viewing Minnesota's pomological wonder, the Buffalo newspapers decided that "at no distant day Minnesota will be as famous as a fruit state as it is now as the Bread and Butter State."

Minnesota won the silver medal for butter at Buffalo. (The judges, some thought, showed blatant favoritism in giving the gold to New York.) But the state capitol in butter did win a gold medal, as did Fort Snelling in fruits; the "Woman in Grain" finished with a bronze. Many of those directly responsible for the success of the endeavor promptly found themselves knee-deep in preparations for the Louisiana Purchase Exposition in St. Louis, upcoming in 1904. Underwood was one of the three managers appointed after a special session of the legislature was called in 1902 to discuss arrangements, and John Daniels would be his principal designer.

"The St. Louis Exposition," the managers later commented, "was an exposition of models," and Minnesota had its share of them: a tiny, working version of the Fayal, the great iron mine on the Mesabi Range; and a highly realistic game-and-wildlife diorama depicting three moose emerging from a pine forest. The displays for which Minnesota would be best remembered, however, were objects noteworthy for their colossal scale. One of these, installed by Underwood's nursery, was a full-size Dutch windmill of apples — its apple-covered blades whirled about, too — that "excelled in elaborateness of design, beauty and size 'Fort Snelling' . . . which won the state much notice at the Pan-American Exposition." The second Minnesota exhibit seemed to be just another academic sculpture. About twelve feet tall, it consisted of a three-dimensional grouping showing a mother giving her child a slice of bread, the pair perched atop a tall pedestal adorned by allegories of Agriculture, Education, Mining, and Dairying, and by medallions bearing the features of Sam Van Sant and Alexander Ramsey. The only odd feature about the statue was that, upon close inspection, it turned out to have been carved by the redoubtable Mr. Daniels in "nearly a ton of the best creamery butter made in Minnesota."

The work for which Daniels took his gold medal in 1904 was more

astonishing yet: a life-size tableau depicting Father Louis Hennepin stepping ashore at St. Anthony Falls. The priest, his Indian guide, a voyageur with a paddle, their canoe and the bush to which it was tethered, and the rippling waters of the Mississippi had all been fabricated of butter. "These two splendid and thoroughly artistic butter models . . . fixed Minnesota in the public mind as the leading butter exhibitor at the Exposition, and consequently as the great butter state of the Union. . . . the other states, practically without exception, in making their butter models, used plaster casts, covering them with a thin coating of butter," the managers remarked with evident disdain. "Minnesota, we believe, was the only state showing models carved from *solid* butter."

Minnesota won the St. Louis "Butter Banner," of course. The Pillsbury-Washburn Mills of Minneapolis were awarded the grand prize for flour (and a silver medal for Vitos breakfast food). Thomas Canfield won $966 in premiums for Minnesota hogs. And recognition was also forthcoming for the state's efforts in areas ranging from mounted game fish and physical culture to the manufacture of refrigerators and artificial limbs. The stated objective of the legislature in providing funds for exhibits in St. Louis had been "to bring into the state capital for investment, settlers to make homes, and visitors to its beautiful lake region." Displays of mineral and industrial resources, agricultural bounty, and natural attractions were calculated to woo the capitalist, the farmer, the tourist. That balance of interests — still skewed heavily, to be sure, in favor of the agriculturalist — also defined the character of the Minnesota State Fair as the new century began. □

## TWO THOUSAND DOLLARS WORTH OF DEAD FISH

Through its presence at the St. Louis World's Fair of 1904, Minnesota hoped to attract investment, immigration, and tourism. Displays of iron ore and other mineral resources were designed with the investor in mind. A special illustrated booklet emphasizing farming, taxes, transportation, and public education was directed at the potential settler. The tourist was the focus of ambitious plans laid by the state's game and fish chief, Samuel Fullerton.

In 1904 pleasure seekers came to Minnesota in the summer to enjoy the lakes. People bathed. They pottered about in boats. But primarily, for men and women alike, a lake vacation meant going fishing. Accordingly, one of the largest and most expensive displays constructed in St. Louis consisted of eighty-four running feet of aquaria "planned to show not only the state's trout and small fish, but the large game fish that are found here."

Six towns in prime fishing regions subscribed to the project, and the tank was to have been divided into six parts, each one clearly labeled and stocked with fish netted in lakes adjacent to the town in question. Pennsylvania lent its custom-built fish car — the only such railroad coach in the nation — and the first shipment of walleye, pickerel, "muskallonge," bass, northern pike, and rare white trout (then Minnesota's piscatorial specialty) arrived in St. Louis on Minnesota Day and was transferred to the appropriate tanks without incident.

"By morning only three were alive, and these died during the day." The Minnesota managers laid the blame squarely on the exposition officials, who had promised to supply cool, pure well water for the aquaria but substituted tepid and muddy river water clarified by the alum process, always fatal to fish. In this brackish medium, Pennsylvania contrived to keep its specimens alive for Pennsylvania Day. Even the State of Missouri found it impossible to sustain its fish in Missouri water.

Despite vigorous protests and promises of fresh water supplies, the problem was never corrected and Minnesota estimated its losses at two thousand dollars. Potential vacationers, meanwhile, had to content themselves with mounted fish and a mock-up of a segment of the northern woods, inhabited by stuffed moose, deer, caribou, bear, wolves, foxes, porcupines, and grouse. □

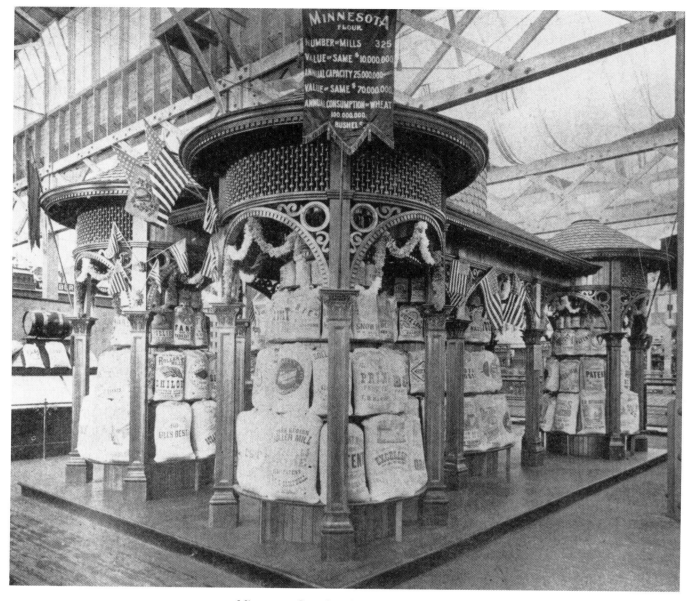

*Minnesota flour booth at the 1893 Chicago fair, brought home and reassembled under the dome of Main Building one year later*

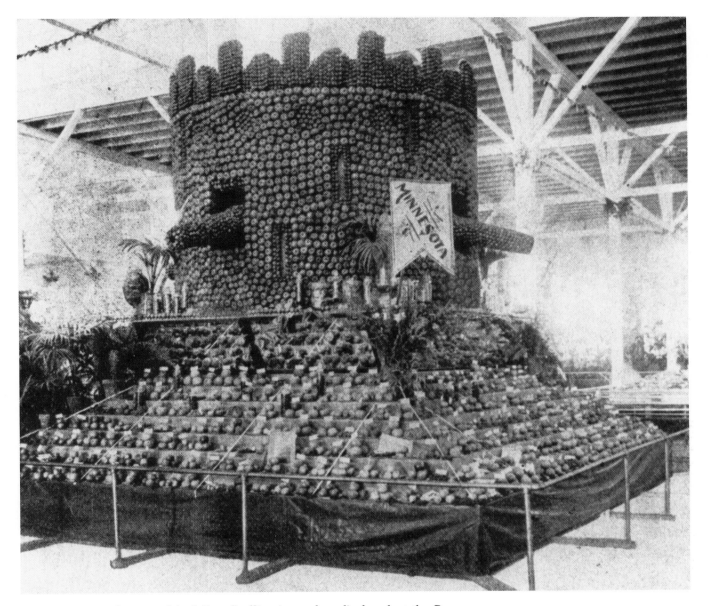

*The famous revolving model of Fort Snelling in apples, displayed at the Pan-American Exposition in Buffalo, New York, 1901*

*Minnesota's first foray into butter sculpture, Chicago, 1893*

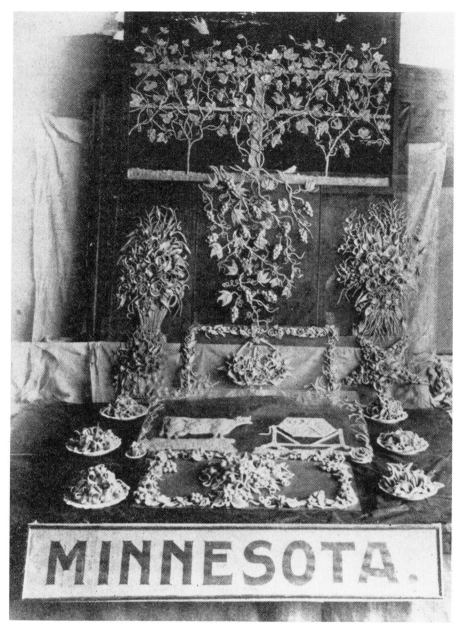

*John Daniels's model of the Minnesota capitol in solid butter, Buffalo, 1901*

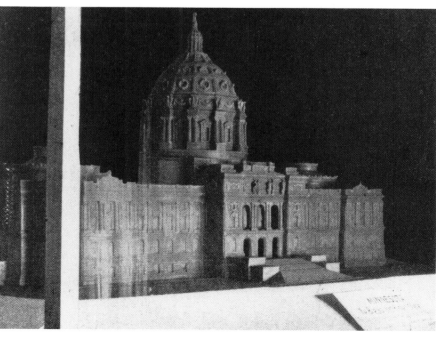

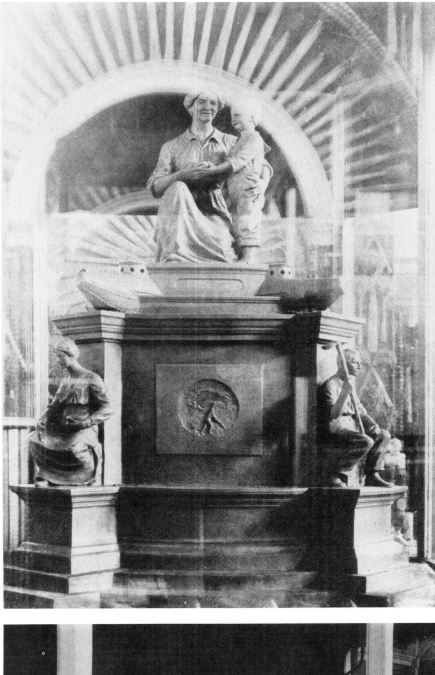

*Butter masquerading as bronze or marble represented Minnesota dairy interests at the St. Louis fair, 1904; the state seal is carved in relief on the pedestal.*

*Daniels's prize-winning "Discovery of St. Anthony Falls," St. Louis, 1904*

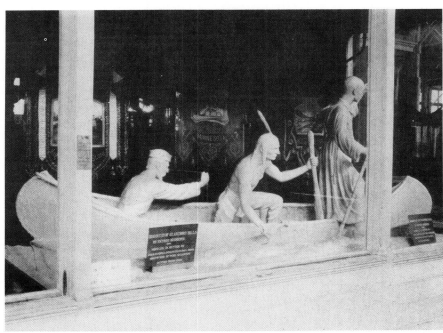

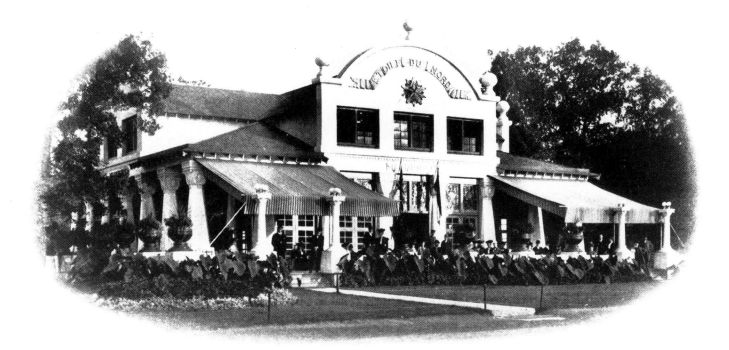

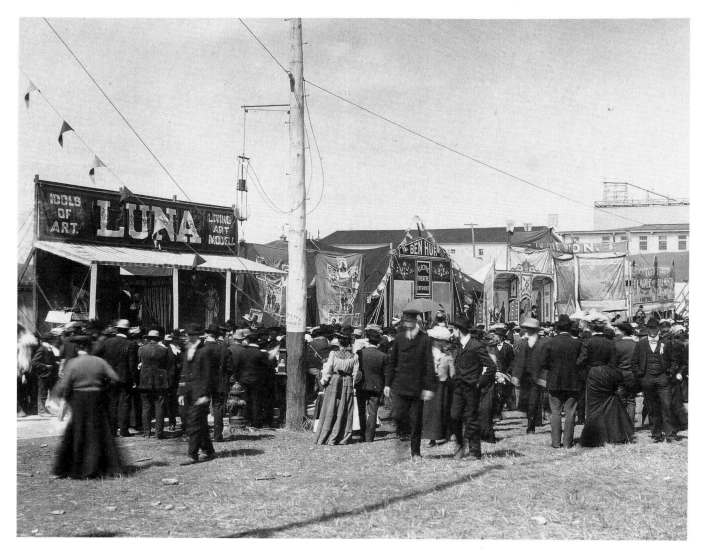

*The Minnesota pavilion from the 1904 Louisiana Purchase Exposition in St. Louis, relocated to the grounds at Hamline*

*Midway, Minnesota State Fair, 1903*

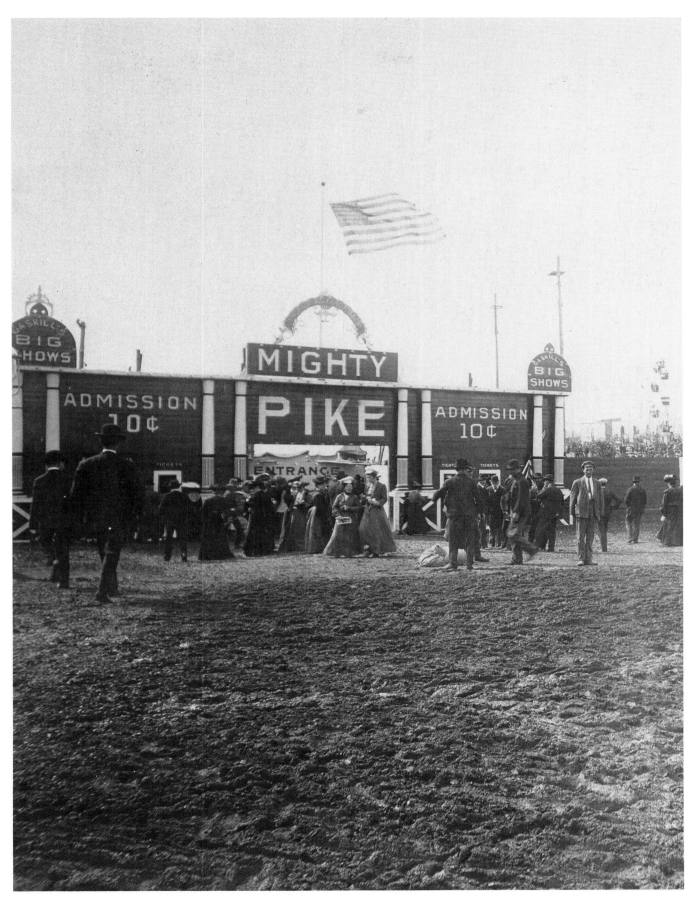

*Gaskill's touring midway of shows and rides, including a Ferris wheel, pictured
in its first season at the Minnesota State Fair, 1904*

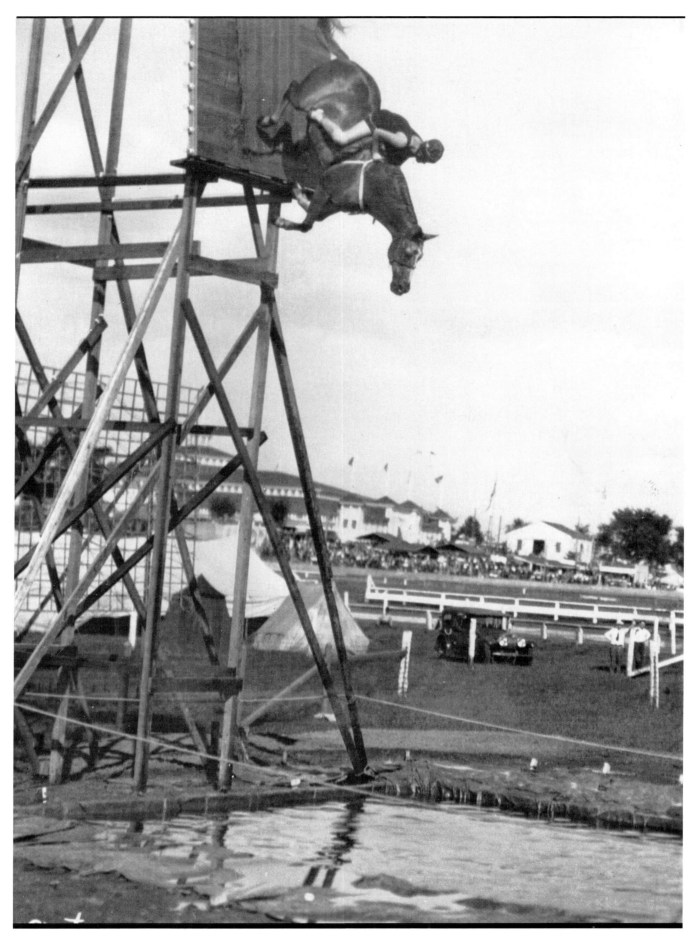

*Leona Carver, the "girl in red," riding her diving horse, 1934*

# "THE GREATEST STATE FAIR
# IN THE UNION"

IN 1900 THE MINNESOTA STATE FAIR began a long reign atop the statistical tables; in numbers of exhibitors, in the elegance and refinement of its sprawling physical plant, in financial returns, it surpassed those of "Illinois, Iowa, and every other single State." It was, according to its proud supporters, "the greatest State Fair in the Union." Reviewing the recent history of the fair for a group of Twin Cities businessmen in 1904, Eugene Randall, the secretary and resident manager, noted a steady annual increase in admissions after 1893 and attributed the growth of receipts to excellent facilities — gas lines to the restaurants, freshly painted stock barns, a brand new Manufacturers' Building. "The Minnesota fair," Randall asserted, "is more than twice the size of its nearest competitor. . . . While there are others which have more money invested there is none which can compare with it in the matter of attendance."

But the benefits of the fair, he continued, could not be described strictly in terms of numbers. Although the many farmers in town for the week did spend money at local businesses, the real value of the state fair came from visitors' exposure to new ideas. Because of the fair, "farmers are applying more modern methods to their farming, are varying their output, and are raising better grain, fruit and stock," and "when the farmers are successful and prosperous the general business of the country is correspondingly good."

At the turn of the century, the state fair itself waxed fat and prosperous. Energized by the spirit of competition with a seemingly endless succession of world's fairs, Minnesota officials strove to build attendance to new peaks by recreating the beguiling mixture of pedagogy, promotion, and sheer pleasure in which those celebrated expositions had bathed their clientele. Sophisticated press agentry concocted irresistible come-ons, for however important the educational features of the state fair might be to the future health of the Minnesota economy, the effort to supply sound information (on such subjects as the riskiness of soybeans for pasturage) was wasted if nobody came to Hamline in the first place. And so potential fairgoers were wooed by the prospect of being married, free of charge, in an elaborate ceremony replete with costly wedding presents, fancy clothes, and unlimited numbers of guests.

Public weddings were a popular feature of Minnesota county fairs in the 1880s, and the nuptials cosponsored by the state fair and the *Northwestern Agriculturalist* in 1907 differed from those prototypes mainly in degree. Both the journal and the small-town press papered the Upper Midwest with a call for photographs of potential brides and grooms. If selected as the "Prettiest Farm Girl" and "The Lucky Man of Her Choice," the couple was promised a clergyman and a band, flowers, a "wedding breakfast," a ride

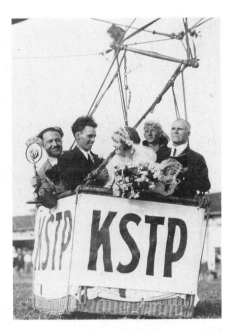

*Public nuptials at the fair remained popular for decades; on September 8, 1928, Dorothy Landis and Archie Phillips of St. Paul were wed in a balloon hovering over the Grandstand infield.*

## COSGROVE STREET, UNDERWOOD STREET, LIGGETT STREET, AND RANDALL AVENUE

In 1906, when the Minnesota State Fair was "the most successful of the state fairs of America" in attendance, gate receipts, number of exhibits, premiums paid, race purses, and "general popularity with exhibitors and the public" alike, four extraordinary leaders served together on the board of the Agricultural Society. The principal streets of the fairgrounds have been named after "the men behind the State Fair" in its glory days.

"C. N. Cosgrove . . . although born in New York, has passed most of his life in Minnesota. He first lived at Wabasha but moved to Le Sueur many years ago, and for years has been known as one of the most prominent merchants of the prosperous Minnesota valley. Besides his mercantile interests he has much to do with farming and especially cattle breeding, and his influence has been very large in the state fair's work of education along the lines of stock raising and diversified farming. . . . Mr. Cosgrove is a most enthusiastic state fair man and knows the institution and its affairs in every detail.

"J. M. Underwood . . . has also lived in Minnesota for a great many years—since his boyhood—and during his entire business life has been the head of the Jewell nurseries at Lake City. He took up this business years ago when it was struggling for existence and has built it up from a farm of sixty acres to one of 1,200 acres and a capitalization of $100,000. For a long time Mr. Underwood was president of the state horticultural society. . . . He was a member of the Minnesota Commission for the St. Louis exposition. He has been a member of the fair

in an automobile, free shrubs from the Jewell Nursery, a massive bride's cake prepared by the N. A. Matson Baking Company of Minneapolis, and brand-name gifts, donated by corporate well-wishers, that ranged from a pair of mattresses and a new range to a pair of stout shoes for the gentleman.

At noon on September 5, 1907, Miss Mildred Nulph of Wyandmore, North Dakota, wearing a light-blue gown and trailed by a phalanx of flower girls, married Jules E. Watkins of Walcott on the porch of the *Northwestern Agriculturalist* cottage at the state fair. Twenty-five thousand spectators streamed out of the stock barns and the Midway at the appointed hour to serve as guests. "We're going right back to the farm," the new husband vowed. "Neither of us like the city very much."

Like the "Missing Man" promotion begun in 1906 by the *Minneapolis Daily News* (it required fairgoers to identify a mystery man in the crowd from fragmentary photographs and written clues), the wedding stunt was simply that: a stunt, a novelty, a piece of promotional genius designed to increase interest in the fair. But masked by the hearts-and-flowers trappings of the "Agriculturalist Wedding" were a number of serious social issues, including a pervasive anxiety about the status of the American farm.

The Country Life Movement of the early twentieth century promoted discussion of the narrowness, the isolation, and the backwardness of rural people, with emphasis on the privations of women and children. The latter were fleeing to the city in mounting numbers and, according to observers like Daniel Buck of Mankato, who addressed the state fair's Farmers' Institute in 1891, all things connected with the farm had become "distasteful to the rising generation of Americans." The corn and canning clubs established in the rural school districts of Minnesota just after 1900, forerunners of the 4-H Club, aimed to bring new ideas into the farm home and to interest boys and girls in staying on the land. By celebrating the continuity of the farm family, the state fair wedding of 1907 was an act of faith in the future of American agriculture. Yet it was also a tribute to a new style of agriculture dominated by automobiles and shiny machinery, factory-made comforts, newfangled ideas, and hoopla—the very best features of the Minnesota State Fair!

In the mechanical line, there were the seventy-five acres of farm machinery and implements that included the stock of 350 separate makers by 1905, when the display declared itself fully comparable to those at the "so-called world's exhibitions." Despite periodic boycotts of fairs by the manufacturers of harvesting and threshing equipment on grounds of expense, Minnesota's Machinery Hill was turning would-be exhibitors away, and the demonstrations were, in the words of the superintendent of machinery, "the most interesting and instructive for the farmer that have ever been presented." By way of creature comforts for residents of the up-to-date farmhouse, the state fair offered stoves, sewing machines, enamel bathtubs, Paris gowns, electric pianos, Turkish carpets, and a whole buildingful of washing machines. Among the new ideas debated long after the fair was over was the judges' startling condemnation of the overstuffed Poland-China as a mere "lard hog." What the progressive grower wanted (or so the verdicts strongly intimated) was a leaner, trimmer, and altogether more modern "bacon pig."

State fair hoopla included a whole series of brilliant displays adapted from the world's fairs and from Iowa's spectacular corn, coal, and bluegrass palaces of the 1880s and 90s: an American flag of vegetables contributed by an association of horticulturalists; a cabin built from pumpkins, potatoes, and King Philip Red Flint corn by Northrup King & Co.; models of the

state capitol and "The Gates Ajar" (a popular motif of the era, referring to a preview of life in heaven) rendered in white onions by the Growers' Association of St. Paul; Jewell Nursery's revolving fort of apples; seven-foot statues of farm madonnas, stubborn cows, and "Roosevelt's Rough Riders" wrought from butter by E. Frances Milton and John Daniels under the auspices of the Milton Dairy of St. Paul. But the provision of such stunners was by no means limited to wealthy corporations or to associations with well-traveled officers. Artistic arrangements of produce were most visible at the state fair in the booths constructed and decorated by Minnesota's counties during an annual competition for cash premiums.

Conceived on the model of a world's fair booth, the sweepstakes for the "best display of any county or local Agricultural Society in Minnesota of stock and culinary vegetables in twenty distinct species of not less than three specimens each" was first offered in the 1880s as a way of letting the districts of the state flaunt their attractions before land seekers. During the 90s, however, the fair began offering considerable incentives for entries: the premiums were increased to cover the expenses of assembling a comprehensive exhibit and to encourage participation by older and richer counties without much vacant land for sale. The object now was a "good-natured competition" between the counties, a sport in which an elaborate scorecard awarded points not only for the quality of the produce but also for "design and taste in arrangement."

Hardheaded officials figured that when a county competed, enough local backers visited the fair to cover the cost of the higher premiums. Like the public wedding and the search for the missing man, the contest boosted attendance. But the effort expended on the booths and the attention they received suggest that the exhibits were important sources of community renewal, solidarity, and pride for rural Minnesotans. The displays also revealed a keen eye for the physical beauty of farm products and a delight in their formal manipulation. Consider, for example, Anoka County's grand 1890 corn palace; so tall it almost touched the ceiling of Agricultural Hall, the structure was decorated on one flank with an American eagle worked in seeds and on the other with "the three little maids from school" in cornhusks. For the next several years, Anoka County experimented with the building format. In 1891 came another miniature palace. In 1892, "a house battened with corn and thatched with wheat." In 1895, an "Irish shanty" covered in potatoes. In 1898, "a house walled and roofed with grain." An expression of community spirit, the Anoka booth also became a source of historical continuity as successive squads of volunteers executed their annual variations on a theme established years before.

The feelings engaged by the county sweepstakes ran deep. An 1895 editorial in the *Mankato Review* complained that, since Blue Earth County had shown the best produce at the fair, its loss of the ribbon for want of "artistic arrangement" was patently unfair. A year later it was the *Carlton Vidette*, declaring that those in charge of the local effort had let the county down. The fairgoer could be forgiven for concluding "that Carlton county is peopled with a lot of Rip Van Winkles, too sleepy to take any interest . . . or it is a sterile and barren spot." In 1899 it was the *Fergus Globe*, berating millers for their refusal to contribute sacks of flour to the Otter Tail County booth. In 1901 it was the *Hawley Herald*, disgruntled because Clay County had made no entry at all. In time, and under some pressure from its constituents, the fair modified the rules so that areas with similar produce would be judged together. A separate sweepstakes for "beauty" was

board for about ten years and has served much of this time as superintendent of the agricultural and horticultural division.

"Col. W. M. Liggett, senior member of the board of managers, is an Ohio man who came to Minnesota in the 80s. He won his military title in the Ohio National Guard. . . . He settled in Swift county near Benson and for a time conducted a stock farm, and his interest in farming and stock breeding brought him into early connection with the state fair. He was secretary in 1890 and ever since that time has been a member of the board of managers and superintendent of the cattle division. As an authority on cattle and agricultural matters generally he stands high. In 1891 he was appointed to the railroad and warehouse commission, serving for seven years and finally resigning to become dean of the agricultural department of the state university and director of the experiment station. His work as head of the successful agricultural school is known the world over.

"E. W. Randall, secretary of the fair for a dozen years, is a native of Minnesota. He was born in Winona county. . . . became first principal of the high school at Morris and later engaged in newspaper publishing and editing, gaining on the Morris Tribune an experience and acquaintance which has been invaluable in later years. . . . His first connection with the state fair was in 1890, when he was assistant secretary. As the active executive officer of the fair he has shown a large business ability as well as remarkable success in dealing with all sorts and conditions of men to their entire satisfaction."

— *St. Paul Pioneer Press*,
July 15, 1906 □

also created. The changes allowed for more winners, of course, and thus underscored the importance the counties attached to the contest.

Provision for gathering materials and arranging the display varied. In some places, a prominent citizen undertook the task alone and even bore the expense. In others, large committees took the lead. In Stevens County during the 1890s, the women of Morris Township were put in charge of the arrangements and garnered high praise for a banner bearing the likeness of an "immense rooster made wholly of agricultural products." Their participation on an equal footing with men was, if not unprecedented, at least unusual for the day. Makers of butter and the occasional female beekeeper were the exceptions to the unwritten rule that segregated the competitive activities of the sexes. Men could do almost anything, but the ladies were conceded supremacy only in the realm of jellies, bread, quilts, and Battenberg lace. In 1907 that traditional division was given clear symbolic articulation when the commercial displays moved into new quarters and the Manufacturers' Building became the permanent Woman's Building. It was only in Agricultural Hall, amid replicas of the battleship *Maine* made of squash, a full-size lady ("Miss Minne Sota") in grain, a Ferris wheel of apples, and a chewing, snuffling "bacon" hog fashioned from macaroni wheat, that the men and women of rural Minnesota asserted their mutual stake in the art and the science of living in a thoroughly modern way.

"What I like about the state fair," exclaimed a woman admiring the quilts and the fancywork in 1905, "is the ideas it gives you." She was referring to a homemade portiere of varnished acorns but, in fact, any number of new ideas were abroad in the fair's feminine precincts. At the entrance, for instance, sat a three-hundred-pound loaf of bread, said to be "the biggest . . . ever baked in Minnesota." Little by little, as the fair wore on, it was nibbled away by hungry visitors. Even in its pristine state, however, the loaf was an ambiguous presence. On the one hand, it stood for the basic task of the housewife, a skill honored by a large class of premiums and special awards from milling concerns. To be the bread-baking champion of the state fair was to win an accolade worthy of statewide notice. But the huge loaf of 1905, modeled on the latest in oversized world's fair comestibles, was also a harbinger of modernism. Prepared by a commercial bakery, it signaled a major change in the old-fashioned role of women, whose most arduous chores were being lightened and even eliminated by machinery.

Anxiety over women's place in the new order of things is also implicit in the gingerly discussion of sex roles in the ladies' pages of several Twin Cities newspapers between 1904 and 1907, occasioned by a spate of male submissions in the needlework classes. And finally, although the number of entries remained constant throughout, accounts of the state fair sewing competitions during the first decade of the century constantly predicted the imminent demise of the quilt in "this . . . faster age." It was not among the corn sculptures or the old-time quilts that the wide-awake farmer sought to admire female enterprise to its fullest, however. Instead, he was to be found somewhere along the Midway, peering up at an elevated platform where Circassian slaves, Egyptian veiled princesses, and "powdered ladies with bleached hair perform[ed] some dancing feats in abbreviated costumes more advanced than the bloomer" worn by venturesome but wholesome lady bicyclists. With their spangled tights and daredevil ways, the women who came to town to entertain at the state fair were a different breed, it seemed, from Minnesota's wives and daughters.

Even at their most domestic — parachute jumper Blanche Lamont was,

## "BIG HORSES, FAST RACES": DAN PATCH ON THE GRANDSTAND TRACK

One sure sign of modern times was speed. Ease of motion across vast distances separated Minnesotans of the 1890s from the pioneers of a generation before. Although the first horseless carriage made a rather late appearance as a "great curiosity" at the state fair of 1897, the decade as a whole was marked by an obsession with the fleetest of creatures and conveyances. Increasingly, county fairs became adjuncts to a schedule of horse racing that often included trotters, flat racing, and contests between eight-horse Roman chariots. The Kanabec County Fair of September 1896 staged all three events on the main street of Mora, and the harness races at the Goodhue County Fair were so popular that in Zumbrota "many thought you couldn't have a . . . fair without them." The balloon ascensions regularly conducted between the highlights of the racing program answered the same need for demonstrations of unfettered movement, freedom of action, swift and effortless acceleration. It is one of the ironies of the modern condition that the horse became the major symbol of locomotion just as its practical value as a puller of people and machines was being undermined by steam power and the internal combustion engine.

Despite periodic attacks on the frivolity of racing (and the questionable morals of those who bet), "trials of speed" were the principal entertainment the state fair had to offer in the 90s. So great was the public appetite for such exercises that in addition to the usual trotting races, the 1890 fair also advertised chariot races and an appearance by "Doc" the Trotting Dog, an Irish setter who, while pulling eight-year-old Master Willie Ketcham behind him, bested a field of pony carts. In 1891 the trotting card was supplemented by a bicycle-vs.-horse race, a steeplechase, and two "gentle-men's cup" dashes for the social luminaries of St. Paul and Minneapolis. In 1892, however, such novelty acts were all but abandoned when Nancy Hanks and Jay Eye See came to the Minnesota State Fair on the recommendation of the president of the Agricultural Society, just returned from a tour of inspection of the important eastern tracks.

The "celebrated mare" Nancy Hanks was a trotter; that is, in her racing gait a diagonal pair of legs moved forward together. In August of 1892, at Washington Park outside Chicago, she had dethroned Maude S., "reigning queen of the turf," by running the mile in 2:07 1/4 (Maude's best was 2:08 3/4). Jay Eye See, formerly a renowned trotter, had been turned into a pacer by his trainer—when a pacer runs, both feet on one side of the body leave the ground at the same time— and now ranked with the best of them. Records were expected to fall if the weather held and the track at Hamline stayed "fast and smooth." St. Paul had recently lost its bid to host the Democratic National Convention; a new record by Nancy Hanks, some civic leaders thought, could earn Minnesota just as much fame. Alas, on the appointed day—Wednesday, St. Paul Day at the fair—Nancy Hanks fell a full two seconds shy of her own latest record, set at the end of August in Independence, Iowa. Jay Eye See did no better. But their appearance inaugurated the era of "big horses" running against the record book at the Minnesota State Fair.

Because the competitive element was minimized and the trainers received substantial fees for agreeing to run trials on the Minnesota track, this was a cleaner mode of racing, well suited to the reform spirit of the times. Indeed, Secretary Randall did not hesitate to publicize his trips to engage horses for the state fair. Even those who had supported the purification campaign found no fault in the appearance of horses that had not been "procured . . . by gambling." As one agricultural paper put it in 1901, grandstand racing now included "no features that will be in the remotest degree discreditable to a fair that has achieved an enviable reputation for moral cleanliness."

Dan Patch was the biggest of all the big horses. A seven-year-old pacer with a record time of 1:59 1/4, he had been purchased in December 1902 by M. W. Savage of Minnesota for the huge sum of sixty thousand dollars and spent the winter in Minneapolis preparing for an assault on his own best time. Although attractive inducements had been offered Savage for making the attempt elsewhere, Dan Patch was widely considered a Minnesota horse. As such, the stallion ran for the record at the 1903 state fair and was, for several years thereafter, its single greatest drawing card. That first summer, despite excellent track conditions, Dan Patch set a new state record but fell short of the world mark. Things went better in 1905 when, on the last day of the fair, he ran one heat in 1:59 1/2 and another in an astonishing 1:57 1/2. "A few years ago state fair racing was regarded as insipid" and "Eastern tracks used to set the records," noted a turf reporter for a St. Paul paper. But Dan Patch had put the Minnesota State Fair on the racing map and kept it there with a series of breathtaking runs. In 1905 and 1906, he set new world's records at Hamline. (His time on September 8, 1906, was 1:55 flat.) In 1907 he tried again in bad weather but failed—several days before the state fair held its first automobile races. In 1908, an elder statesman of the track, Dan Patch was put on display in his own luxuriously appointed tent. Although offspring of the great horse still drew a crowd in Minnesota as late as 1928, other horses owned by Savage—Cresceus and Minor Heir were the best known—came to set the records, and interest in horse racing began to flag.

In 1900 automobiles exhibited on the Grandstand oval had spooked the horses; the "chauffeurs" had refused to remove their vehicles in a timely fashion, and a day of racing was spoiled, much to the disgust of the spectators. By 1907, however, the names of Walter Christie, Barney Oldfield, and the other daredevil auto drivers of the new racing circuit had all but replaced those of Dan Patch, Nancy Hanks, and the old equine royalty of the Grandstand. Speed had become the attribute of the machine. □

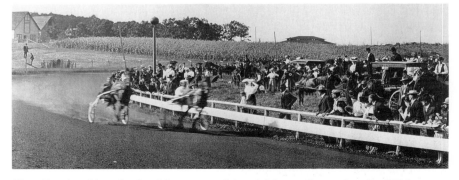

*Dan Patch taking the lead in a state fair trial heat, September 8, 1906*

in real life, the demure Mrs. Carrie Sanders of St. Paul, an excellent seamstress — the lady riders and "fire divers" and aeronauts betokened a new freedom from constraints, a self-reliance that challenged conventional definitions of proper female comportment. On the first afternoon of her engagement at the fair. Miss Lamont escaped the crash of her balloon with cool aplomb. On the second, charged by the Humane Society with "refined cruelty" for planning to leap to earth with her pet poodle, she defied public outrage and tossed the dog to its doom to spite her tormenters. The poodle, on inspection, proved to be "a woolly dummy." But Lamont's pluck, wit, and independence were real enough. As the Minnesota State Fair embarked upon the twentieth century, the attributes of the "New Woman" would figure on the list of uniquely modern problems that venerable institution would be forced to confront.

Another such problem was the widening gulf between urban and rural mores. In the city, people worked by day and played by night. The addition of gaslights to the fairgrounds in 1899, along with a big, nighttime show, catered to an audience that was accustomed to a wide variety of live entertainment, the saloon, a friendly wager on a sporting event, and the exaggerated claims of advertisers. The gaudy electric sign at the main gate beckoned the clerks and laborers of the Twin Cities to a world of spicy sideshows, blind pigs, gambling stalls, and "bunco baubles" sold by slick-talking pitchmen. And by and large, they liked it, as they always had.

There were occasional outcries against the undue influence of gambling interests, as in 1892, when the Agricultural Society struck a deal with the Twin City Jockey Club to build a new, fifty-thousand-dollar grandstand in return for certain off-season concessions. But things went along pretty much as usual until 1895. Wheels of fortune were spun in out-of-the-way tents. Dispensers of "hot tea" slipped bottles of spirituous liquors to favored customers. Jewelry of "genuine gold" turned fingers green on contact. Then in 1895 a stormy meeting of the Agricultural Society installed Randall as manager of the fair at the head of a clean-up ticket. The dubious bargain with the Jockey Club gave the reform movement its impetus, but longstanding complaints from rural districts exerted a strong, cumulative influence of their own. The delegate from Isanti County had not been alone in 1890, for example, when he urged enforcement of the drinking rules, noting that "Cambridge is a temperance town, and the sentiment throughout the county strongly favors prohibition, no saloon license having been granted for several years." When rural and urban values clashed at the state fair, as two competing ways of life battled for ultimate control of the new century, it was the difficult task of Secretary Randall and his superintendents to accommodate, somehow, the tastes of *all* Minnesotans.

The antivice crusade was supported by the legislature which, late in its 1894 session, passed a series of laws forbidding "pool playing and liquor selling on or near the grounds." The popular county booths were shifted to the cavernous chamber beneath the Grandstand formerly occupied by the sanctioned bookmakers. (In 1892 gamblers gave the Agricultural Society $750 for the right to operate during the fair, whereas the next highest "privilege," paid by a prominent manufacturer of tinted photographs, was a mere fifty dollars). Secretary Randall pledged a clean fair "free from fakirs and gamblers" and demon rum.

During the first summer of reform, a citizens' committee of prohibitionists called the Midway Minute Men rooted out no less than twenty "soft" drink vendors willing to spike the pink lemonade with stronger waters. In 1897

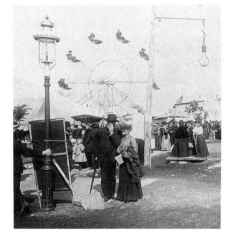

*Gas and electric lights on the Midway, 1904*

## THE GRANDSTAND SPECTACLE

On September 17, 1887, the state fair celebrated Grand Army Day with a sham battle for Camp Ramsey on the infield of the racetrack. Fought by veterans of the Civil War (the Grand Army of the Republic got thirty-five thousand dollars or half the gross), the battle was part reunion, part tense drama. In the end, the Union troops won, but only, it was said, by courtesy of the make-believe Minnesota Confederates.

The action claimed its casualties, too. George D. Knox, an old soldier from Mower County, was nearly blinded by a blank charge, and the Agricultural Society paid for corrective surgery. In the Grandstand a near-riot ensued when paying customers took every available space and the crowd kept coming anyway. People scaled the fences, pushed past the guards, and sat on rooftops in such numbers that every creak brought fears of collapse. Eighty thousand persons surrounded the battlefield and twenty thousand more milled about on Machinery Hill, disgruntled and unable to find a vantage point. The mock battle broke all the old attendance records for a Grandstand event and inaugurated a new state fair tradition of military spectacles.

The Agricultural Society justified the enormous expense involved in feeding and housing the combatants—the attraction had cost $11,982.75—on educational grounds. "For most of the [audience] it was their first real conception of . . . the awfulness of . . . war," wrote Secretary H. E. Hoard of Montevideo. "It was an object lesson on a gigantic scale—a tragedy played out with such fine acting as to force the conviction that it was real." And because of the unquestioned appeal of the lesson, another battle was arranged

for 1888, this time between "red" and "blue" armies made up of state militiamen, GAR veterans, and regulars from Fort Snelling.

Perhaps because of the expense, however, the next battle pageant awaited 1898 and the so-called Spanish-American War Fair. The fairgrounds that year had become a real-life Camp Ramsey, a mustering point for Minnesota volunteers bound for Cuba and the Pacific. In order to illustrate the dangers they would face in combat, the 15th Minnesota Volunteer Infantry, fresh from camp, proposed to refight the Battle of Santiago for several hours to the accompaniment of "the boom of artillery." Their performance was realistic to a fault. During the grand finale, when the attackers "charged the nonexisting bulwarks . . . shouting at the top of their lungs," women shrieked, small boys cheered, and a horse bolted, dragging behind it a bakery wagon that landed upside down between two church eateries, to the considerable alarm of the diners.

In 1899, when the buildings and grounds were illuminated for the first time and fair officials were casting about for a way to fill the Grandstand at night, the idea of a nocturnal battle was put forward by Porter's Minneapolis Fireworks Company. These technicians seem to have witnessed a pyrotechnical version of the battle of Santiago staged by the rival firm of Pain Pyrotechnics for the Minneapolis Exposition in 1898; in any case, their "Burning of Manila" was grander but basically similar. Rudimentary sets were built facing the Grandstand, and they were wired with explosives. Actors were trained to charge and retreat on cue. Cherry bombs and fireworks of all varieties simulated artillery, fires, explosions, and bombardments. When

darkness fell over the Minnesota State Fair, the city of Manila was razed by Dewey's victorious fleet for the edification of jubilant Minnesotans.

The ever-more-spectacular night Grandstand shows of the early 1900s, orchestrated by B. E. Gregory, a Pain designer who became the fair's superintendent of amusements, drew their themes from famous military encounters, with the occasional natural disaster thrown in for a change of pace. These fireworks pageants suggest a certain exuberant chauvinism on the part of Americans of Theodore Roosevelt's generation, as well as a healthy curiosity about world affairs on the part of midwesterners. But the spectacles also suggest that the modern fairgoer demanded noise, color, thrills, excitement—something a good deal stronger than a harness race, a balloon ascension, or a rousing speech. In 1933 the Minnesota fair officially dropped one day of horse racing to make room for a designated Thrill Day program—the first at any fair—that began with an infield train wreck. From the first mock battle of 1887, fair entertainment had increasingly catered to a taste for vicarious danger. The anarchic thrill show was the underside of that orderly, state fair milieu of classes, categories, graded ribbons, and stolid accomplishment. □

*Volunteer infantrymen reenacting the battle of Santiago, 1898*

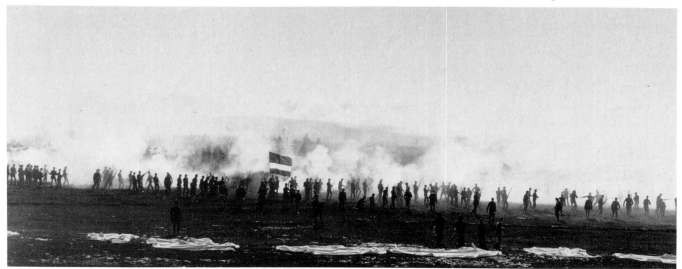

Superintendent Underwood and his state fair police raided a number of innocent-looking lunchrooms where a password would get the diner a beer in a teacup. Randall himself discovered a so-called temperance tent that sold the genuine article under the name of "hop tonic." By 1898 plainclothes detectives were on the fairgrounds, "winking" at venal concessionaires in hopes of uncovering stores of contraband.

Sporadic raids on the fair's blind pigs made good newspaper copy and convinced concerned segments of the public that the management took morality seriously. Yet even though most of those arrested for liquor violations had local addresses, reporters and officials alike persisted in blaming vice on the transient population of the Midway, with its bespangled ladies and fast-talking gents. Until Secretary Randall moved to "prevent the promiscuous mingling" of concessions and legitimate exhibits, that 150-foot-wide corridor of tents and ballyhoo platforms leading from Agricultural Hall to the Grandstand was thought to be a snare for "an unsuspecting class . . . from the rural districts." Beguiled and thoroughly fleeced along the way, some farmers hadn't seen a prize calf or a bacon pig in years—or so indignant country editors maintained in their annual tirades against the Minnesota State Fair.

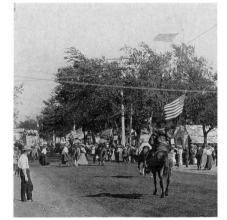

*Prohibition parade, about 1908*

Celebrated cases, such as *L. B. Mackay v. the Minnesota State Agricultural Society,* which was heard by the Minnesota Supreme Court in 1902, did nothing to convince them otherwise. Mackay had paid one hundred dollars to stage a Midway vaudeville show during the previous summer, but after two days of operation, his act was "incontinently bounced off the grounds" because Randall and his colleagues thought it "a disorderly and obscene affair." The impresario sued to recover his money, and the case wound its way through the courts largely because it was not clear if the society (was it a public corporation under the law?) *could* be sued. Eventually, Mackay lost on the merits of the case but not before helping to remind Minnesotans that an undercurrent of the not-quite-respectable remained one of the charms of fair going. Reformers, after all, needed something to reform.

Reform was also a matter of unflagging vigilance, supported by continued public interest. Clearly, the spirit had waned somewhat by 1903, when the legislature took up the so-called Hanaford Amendment, a measure that would have restored pool selling at the fair and brought back the infamous fraternity of "pikers, tipsters, confidence men and stable boys." Although it died in committee in 1903, the bill came up again in 1905, thinly disguised as a plan "to encourage the breeding of thoroughbred horses in the state," and was beaten down only by statistics showing that the "clean" fairs of recent years had made a great deal more money than the questionable ones of old, "without the pillaging of a farmer's son." "The Greatest State Fair in the Union" had become the richest fair in all the land by providing a forum in which old-fashioned country ways could coexist with newfangled ideas, where grave farm women rubbed elbows with incipient flappers and suffragists, where purebred cows, the latest thing in ladies' corsets, a clean horse race, and a clandestine drink might all be enjoyed with equal relish.

☐

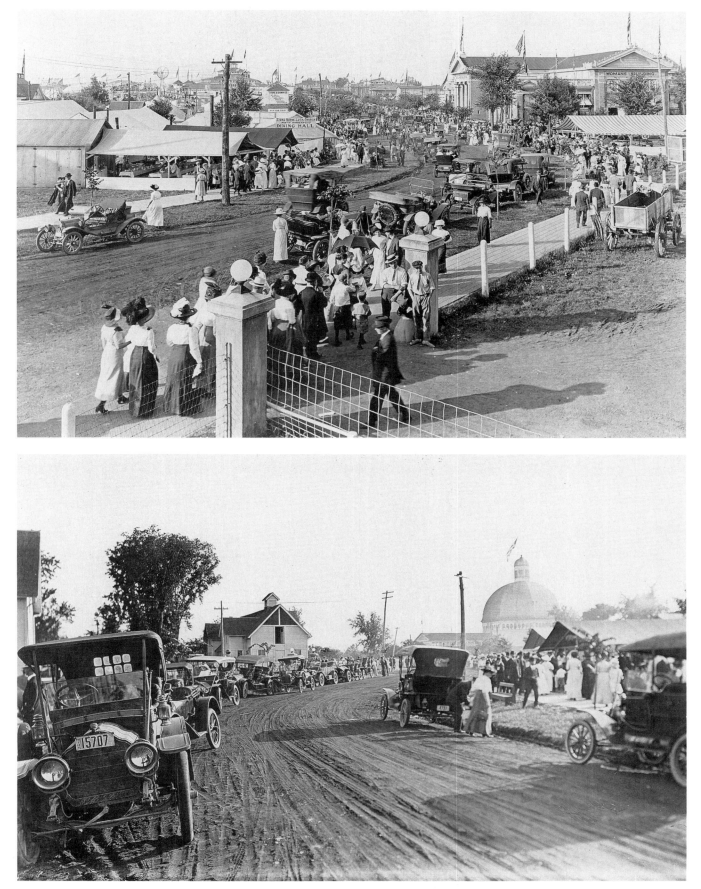

*The fair in 1912, when the ladies wore huge hats and the parking was casual*

*Nascent traffic jam, 1912*

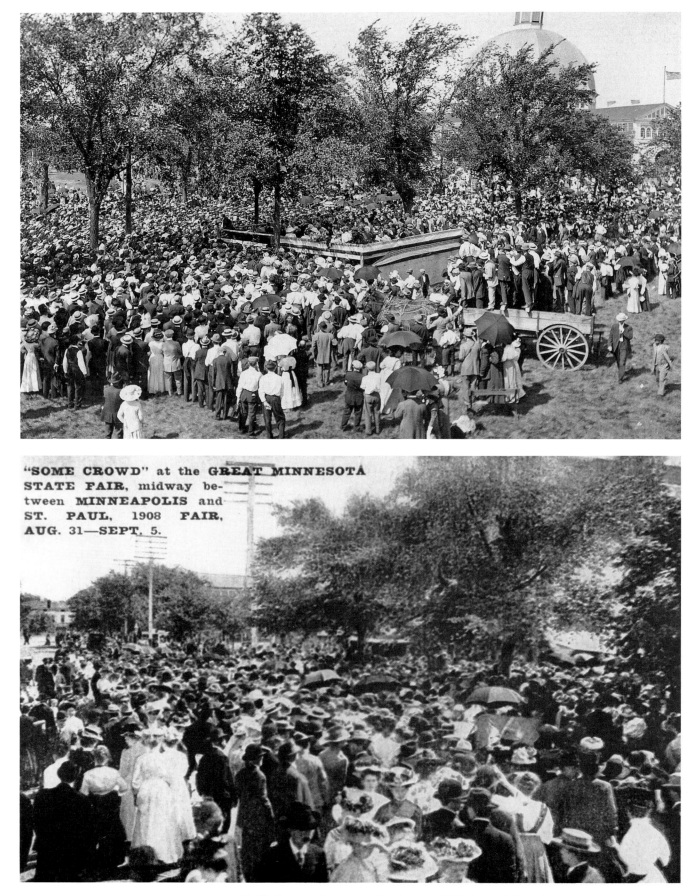

"SOME CROWD" at the GREAT MINNESOTA STATE FAIR, midway between MINNEAPOLIS and ST. PAUL, 1908 FAIR, AUG. 31—SEPT. 5.

*Teddy Roosevelt was a major draw in 1912, but it didn't take celebrities to guarantee a big turnout; crowds were often part of the spectacle.*

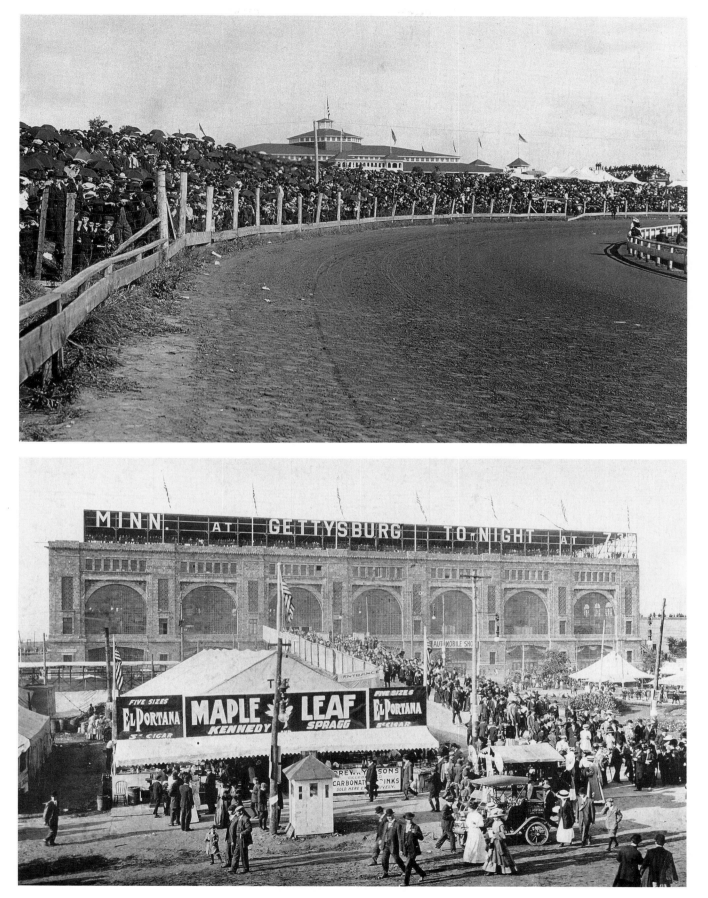

*Horse racing packed them in, 1905; Machinery Hill looms in the background.*

*Crowds streaming from the Grandstand at the conclusion of an afternoon program, 1909*

*Cabin of premium seed corn at the fair, about 1905*

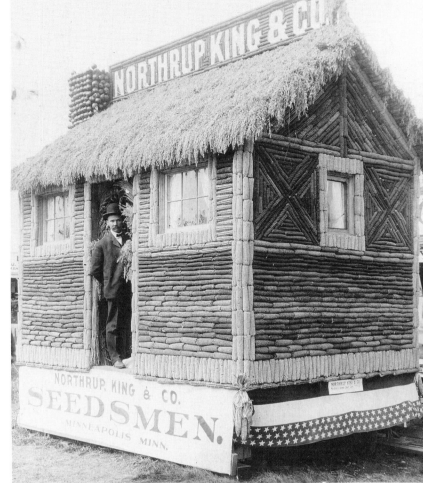

*A 1906 model of the new state capitol in onions, a variant on the produce palace*

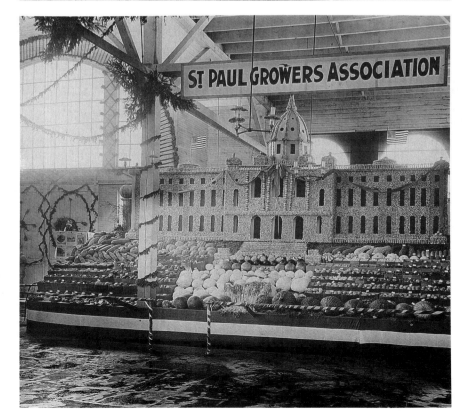

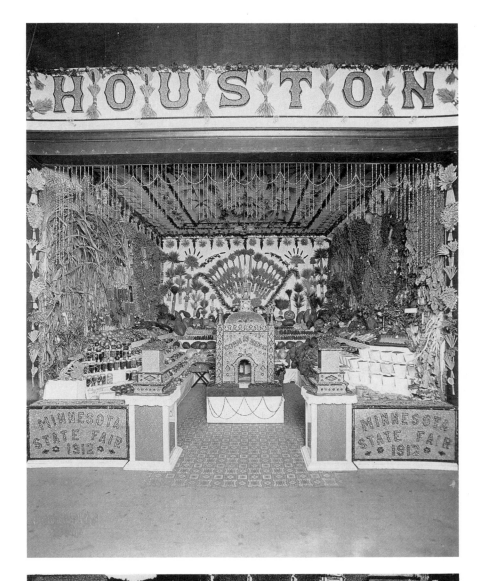

*Houston County's entry in the 1912 county booth competition, centered on a little corn palace*

*Communities copied state fair displays for local fairs and festivals. Anoka erected a splendid structure of corn and potatoes for a 1907 street fair.*

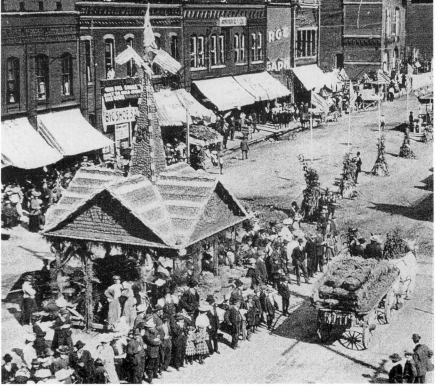

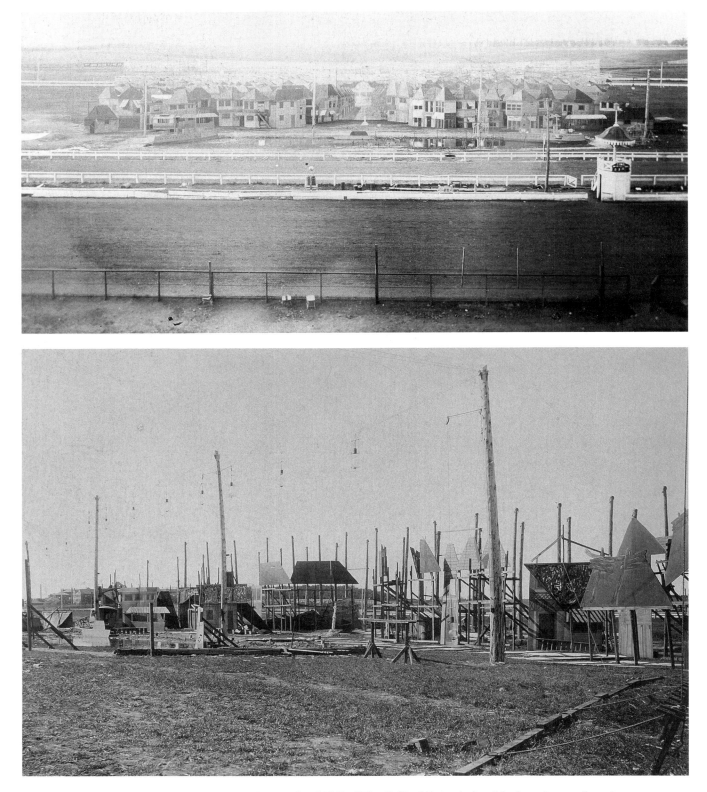

*The set for 1905's "The Fall of Port Arthur," before the mayhem began*

*Port Arthur, after the pyrotechnics were done; note the remains of a cardboard battleship stranded in a puddle at left.*

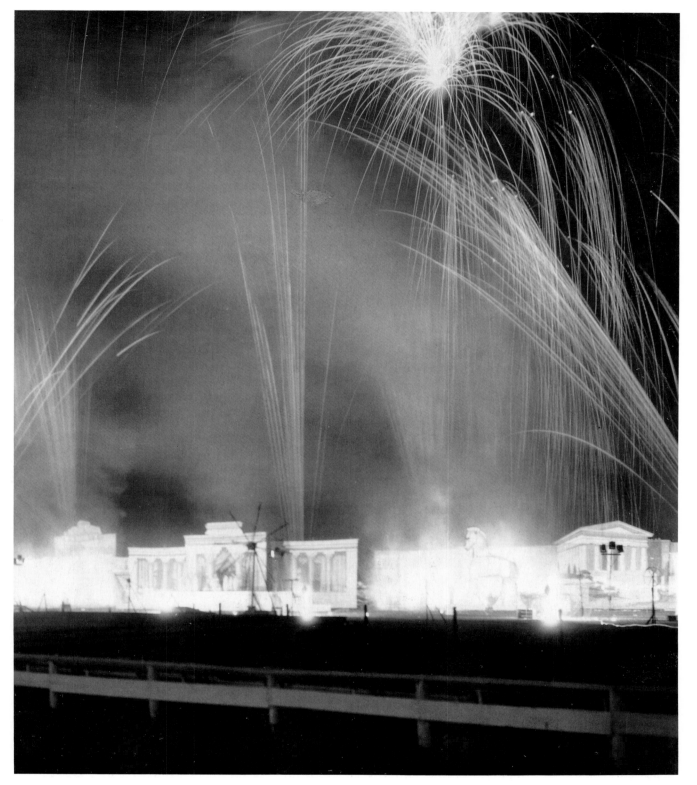

*The 1927 Grandstand finale: Troy falls again.*

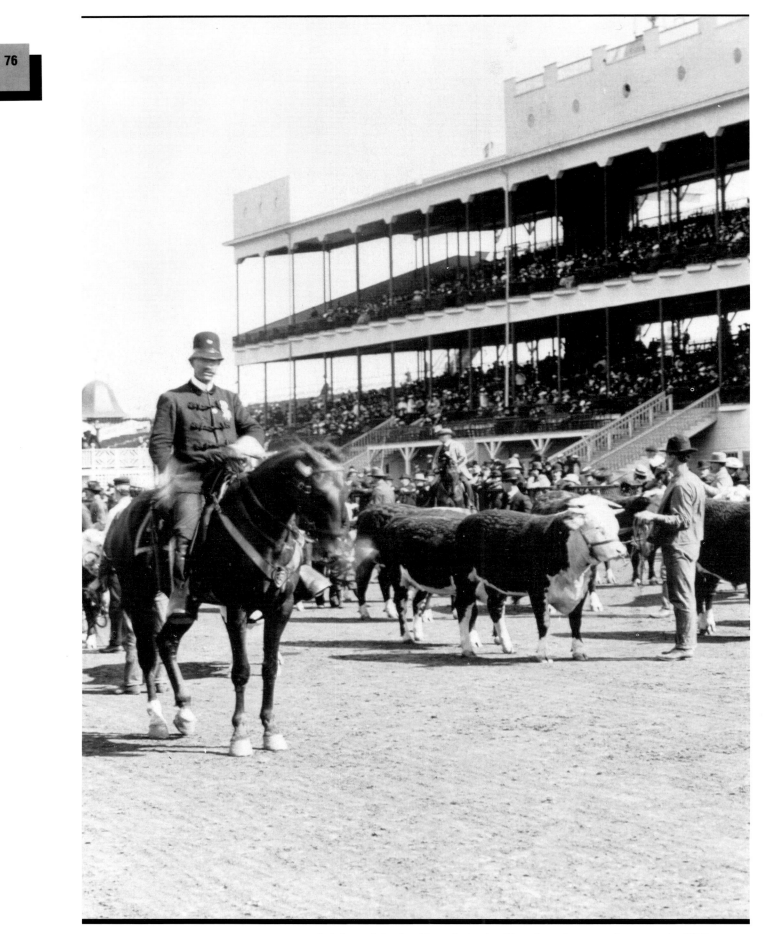

*Judging of the beef breeds in the Grandstand, a popular event in 1902*

# THE PRIZE BULL

THE AMERICAN AGRICULTURAL FAIR is an institution of mixed bloodlines — part Roman carnival, part medieval market fair, and part English cattle show. During the 1870s, according to the director of one prominent British show, the exhibition circuit was suddenly swept by a "mania for shorthorn pedigree stock," and the fashionably bred animals were snapped up at inflated prices by agents for rich American and Canadian fanciers. Those cattle would soon compete for ribbons at the Minnesota State Fair.

Before the mania for shorthorns became visible in the barns and pens at Hamline, blooded stock had been the subject of mild, intermittent interest to Minnesota fairgoers. Old Colonel John Stevens had imported a Devon cow and bull to Hennepin County from Iowa in 1853. Some maintained that the white Durham bull that James Baker purchased from Kentucky politician Cassius Clay was, in fact, the first blooded animal in the state. Whatever the order of precedence, however, it is clear that pedigreed stock was a novelty item at the early state fairs. Visitors who admired Garibaldi, the famous Devon bull shown at the 1863 fair, were most impressed by the fact that Charles Hoag had spent the princely sum of three hundred dollars to acquire him.

So long as wheat remained the cash crop of choice, stock was a minor consideration for the farmer, who might keep a cow for milk and a pig for meat. The market hog awaited the march of the corn belt northward from Iowa into south-central Minnesota. Animals like the 640-pound pig displayed at the 1860 fair were freaks of nature comparable to the bloated vegetables always amassed at early fairs to prove the special fertility of the soil. If a giant hog symbolized a land of plenty — living off the fat of the land, as it were — then the prize bull showed that Minnesota harbored men of wealth, scientific learning, and leisure who could devote themselves to an expensive hobby. "Manicured, marcelled, [and] scrupulously bathed," blooded cattle were significant markers on the road to cultural maturity.

Of all the great men of the nineteenth century, perhaps Minnesota's greatest was James J. Hill, railroad builder, president of the Great Northern Railway — and cattle fancier. At first, the railroads had promoted large-scale wheat farming in Minnesota. The lines carried the new machinery that made the bonanza farms of the Red River Valley possible, terminal elevators sprouted at every station, and traffic flowed toward the great flour mills of Minneapolis. But Hill became an early advocate of diversified agriculture, reasoning that the cause of heavy volume over the Great Northern was best served by high population density along the tracks, regular shipments of a variety of farm products, and a stable economy impossible in the boom-or-bust atmosphere of wheat, wheat, and more wheat.

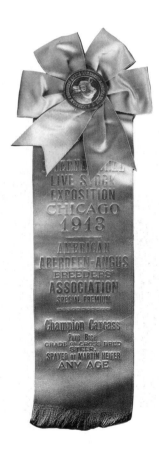

Special Great Northern trains rolled from county to county, bearing demonstration exhibits and free seeds. Hill himself spoke tirelessly throughout the Northwest, exhorting his audiences to plant feed crops and raise stock. He became the Cassius Clay of his generation, the orator of choice at county fairs in all sections of the state. And in 1883, a year of drought and poor grain yields in the north, "Hill began a spectacular ballyhoo for purebred livestock by importing costly bulls and presenting them to Minnesota farmers for free service to their herds."

In January of 1904, during the first annual meeting of the Agricultural Society devoted exclusively to the interests of breeders and feeders, Hill looked back upon the failure of his great experiment more in sorrow than in anger. He had tried to nudge wheat farmers away from single-crop agriculture, he recalled, by giving them splendid, purebred swine, beef, and dairy cattle imported from England and Scotland. But the farmers sold the cows and ate the pigs. "A lot of designing demagogues, rank demagogues, who care no more about the farmer than they do about the wind that whistles . . . told the farmers that I was trying to reflect upon the wheat growing state of Minnesota — trying to injure its good name by bringing the best stock I could find and distributing it free of cost to the people of the state."

The setback by no means discouraged Hill, however. He continued to show Ayrshires bred on his North Oaks farm at the Minnesota State Fair and experimented with feeding steers fodder raised on the spot. A "hatful" of gold medals won at the annual fat stock show in Chicago convinced him that Minnesota could compete with Illinois, Missouri, Nebraska, and the other great feedlots of the nation. One of Hill's Minnesota-fed animals held the current record for the highest percentage of dressed-to-live weight — an incredible 74¾ percent.

At its 1904 meeting, the Agricultural Society also heard from a host of other experts, theorists, amateurs, and agricultural observers. Governor Van Sant, who had just returned from the International Fat Stock Show and would shortly depart for St. Louis to sing the praises of his "Bread and Butter State," already believed in the economic advantages of Minnesota dairying and now found himself excited by the prospects of a local feeding industry. A professional feeder from Illinois recounted spending sixty dollars on wages for the hired man who "fitted" his cattle for the International. But "that won't be one-tenth of the premium you will win," he told his delighted audience, "and won't begin to pay for the fun you have."

A hog breeder from Illinois commented on the unscientific conservatism of some farmers who stuck to their old, fat pigs "thus losing all the improvement in the early maturing and feeding qualities of our modern hog." Senator W. A. Harris Linwood of Kansas, who was wildly applauded for pronouncing the shorthorn "the scale of character and quality" for all decent cows, began his address with an impassioned plea for diversification: "You cannot go on forever with a special crop. Nature will not permit that kind of farming!" A specialist on the composition of premium lists for fairs concluded his speech with a ringing call for the kind of rigorous breeding program fostered by the public judging of animals. "Let us try and get our ideas fixed clearly in the mind," he urged. "Get thoroughly fixed in mind the shape, size, and type . . . you are trying to produce, and [then] be true to it, stand for it, work for it as long as the Lord gives you strength."

By the time the experts gathered in Minneapolis to endorse diversification, it had been a fact of Minnesota farming for the better part of twenty years. In 1883 David Maxwell Fyffe, a Pipestone County farmer, saw "fine"

# A GLOSSARY OF FAIR TERMS

PREMIUM LIST. The Bible of the fair. A paper-covered booklet or a supplementary section in the local newspaper with pages of ads, schedules, instructions (and fees) for entering, rules, the prizes offered for the various places, and lists of competitive categories.

OPEN CLASS. Adults compete in this class. Some fairs also feature a special junior class for those between eight and eighteen and a senior-citizen class for persons over sixty-five. Anyone may enter the open class, but the others are restricted to their respective age groups. Future Farmers of America and 4-H competitions are open only to members of those organizations.

DEPARTMENTS. The broad divisions into which competitive entries fall. Departments usually listed in the premium books of county fairs in Minnesota are dairy cattle, beef cattle, swine, sheep, goats, poultry, rabbits, horses, grain and seeds, horticulture, garden and vegetables, plants and flowers, domestic- and fancywork (once called "women's work"), fine and applied art, and pantry stores and cooking ("culinary arts").

CLASSES. Lists of possible entries in a given department. The beef cattle division, for example, might include separate classes for breeds: Hereford, Shorthorn, Aberdeen Angus, Charolais, Limousin, Simmetal, Chianina, and "Other Breeds." Livestock classes are further subdivided according to the age and sex of the entry. Large animals, because they are costly to raise, transport, and show, are always eligible for the highest premiums awarded.

CHAMPION. Best in its class. The second-best is called the Reserve Champion.

RIBBONS. The blue ribbon goes to the first-place winner in a class. Red indicates second place, white third, and pink fourth. In livestock competition, provision is sometimes made for ranking animals down to the sixth- or seventh-best. But in other departments, judges seldom go beyond a third- or fourth-place ribbon. At many fairs, there is no cash award below a white ribbon. Recently, at some county fairs, green "participant" ribbons have been affixed to the entries of nonwinners or those who prefer to exhibit without competing.

SWEEPSTAKES or GRAND CHAMPION. This special, best-of-show award is symbolized by a purple ribbon. Each division makes its own rules for awarding it. In the case of livestock, it often signifies an animal so superior to all others that the judge ignores the careful distinctions between classes and determines that the prize Hereford is a more perfect specimen of cattledom than the prize Shorthorn. In cooking, vegetable cultivation, and other similar categories, the winner of the purple may be determined by the total number of blue and red ribbons or the amount of cash awarded to a single competitor in a given division.

PREMIUM. A prize awarded in competition, usually cash. A colored card or ribbon also indicates the nature of the award.

"SPECIALS." Prizes (merchandise, trophies, and the like) or premiums offered by a seed company, a breed association, an equipment firm. Those competing for a "special" in baking,

for instance, may be required to use specific, brand-name products.

OPEN JUDGING. The rule in livestock competition, open judging is done before an audience that includes the owners and handlers of the animals and interested fairgoers. The judge must deliver a cogent verbal explanation for his or her placement of the entries. Closed judging—appraisals that require lengthy tasting, minute inspection of details, and the like—often provides competitors with brief, written explanations of the strengths and weaknesses of their entries.

SCORECARD. Usually published in the premium book, the scorecard describes the standards by which entries will be judged. Scorecards for livestock are not published; because the pertinent criteria are well established and universally accepted, it is assumed that exhibitors and judges alike understand them. Scorecards in other departments range from the detailed to the very simple. The one for candy used at the 91st Kanabec County Fair in 1987 exemplifies the simple variety:

General
appearance . . . . . . . . . .25%
Consistency or
creamy quality . . . . . . .25%
Flavor . . . . . . . . . . . . . 50%

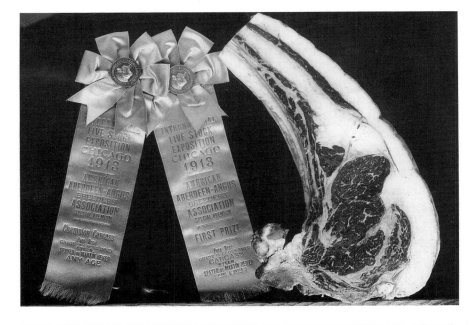

*At the annual livestock show in Chicago, animals were judged on the hoof and kitchen ready; a dressed carcass could teach the farmer what genetic traits promised the greatest profit. A Minnesota steer took two ribbons in Chicago in 1913.*

*The herd that won the 1890 sweep-stakes. The Agricultural Society published this illustration to show what selective breeding could accomplish.*

shorthorns owned by Hill, N. P. Clark of St. Cloud, and others at the state fair: "Minnesota in these days was a Shorthorn state," he remembered, with public-spirited fanciers like Bill King taking the lead in importing and publicizing purebred stock. In 1887 the managers of the Isanti County Fair matter-of-factly reported "blooded Polled Angus and Short Horn cattle and Lincoln sheep" on view in their pens. The Minnesota Butter, Cheese and Dairy Stock Association, at its fifth annual meeting in 1885, praised Hill's new giveaway program. But delegates also discussed with easy familiarity the finer points of the Polled Angus, the Hereford, and the "noble" short-horn. They toasted the future of Minnesota bread, butter, and cheese production—"the Staff, the Luxury, and the Relish of Life." "Wherever the cow goes," the membership declared, "plenty follows in her train. . . . We find, as a rule, more attention paid to the cultivation of home life and of those graces which make the American home the hope and pride of our country." An interest in fine cattle, in other words, was a sure sign of advancing civilization.

Although dairying was the coming thing in the 1890s when Fred C. Pillsbury, president of the Agricultural Society, exhibited his thoroughbred Guernseys at the state fair (but withheld them from competition in order to encourage the efforts of local breeders), the average farmer was more interested in milk than in the milker. Full-blooded Herefords, shorthorns, and the like were still the playthings of the gentlemen farmers who regularly won prizes for their pampered and petted herds. After ten years of systematic breeding, complained Oren Gregg, the acknowledged father of the Minnesota dairy industry and superintendent of the state fair's Farmers' Institute, "we make our butter from beef cattle and our beef from dairy cattle, and under this condition of things it is wonderful that we get as good results as we do."

In the last decade of the nineteenth century, educating the backward farmer in the advantages of "breeding up" his herd amounted to a crusade among the officers of cattle shows, agricultural clubs and associations, and fairs. The Farmers' Institute held in conjunction with the state fair of 1890 was given over to the issue of "how to pick the milker from the beefer," for instance. With Pillsbury playing the part of the unenlightened laggard, Gregg showed two hundred dairymen and farmers just how the ribs should be spread and the udder veined in the ideal milk cow. Using a Hereford from the herd of noted breeder C. N. Cosgrove as his living example of the ideal type, Gregg then repeated his analysis with a beef breed, pointing out "the round, fat quarters" and plump sides that had no value in a dairy animal but yielded the butcher's choicest cuts. In effect, Gregg had also shown the practical value of the judging and the competition that were the central activities of the fair.

Advocates of fairs always noted that, despite the sideshows and the pink lemonade, the institution had a serious educational mission. New implements and products were to be seen there. Ideas could be exchanged. The modern show-ring was another arena for learning and self-improvement. Throughout most of the nineteenth century, farmers went to the expense of sending exhibits to county and state fairs in hopes of recouping their costs—and more—in attractive cash premiums. Competition also gave rural people a rare opportunity for public esteem and recognition. Emotions naturally ran high, then, when the time came for judges to make the awards; finding knowledgeable people willing to serve in that capacity was often difficult. A casual visitor to the Owatonna State Fair of 1884 was pressed into ser-

vice to judge Clydesdale horses, for instance, but promptly quit when threatened by a disgruntled owner. Until cattle fanciers entered the lists with their breeding books and scientific references to Charles Darwin, judging was apt to be a hit-or-miss affair, with the largest specimen in a given class generally passing for the best.

The situation changed markedly as gentlemen farmers began to dominate open-class competition. For one thing, supporters of the new, fancy breeds saw their animals in terms of the ideal Ayrshire or Guernsey — a Platonic notion of perfection which each member of the species reflected to a greater or lesser degree. Thus owners demanded an unaccustomed precision in judging and a verbal fluency on the part of the adjudicator, who was called upon to explain just how and where one's lordly bull deviated from the type. In an age of machinery, science, and faith in progress, breeders also came to believe that animal anatomy was just as malleable to human will as the mountains leveled for railroad tracks or the native populations exploited for the benefit of imperialistic powers.

Because the ideal animal was an abstract concept, aesthetic preferences and mercurial changes in fashion influenced judging too. Animals took on geometric shapes. The pig was regarded as a simple machine for converting hard-to-ship corn into pork on the hoof; hence, portraits of prize pigs printed in the Minnesota State Agricultural Society's annual reports during the 1890s show living pork barrels, cylinders of meat with vestigial snouts at one end and tails at the other. Sheep were blocked and carded into rectangles. And the prize bull, his coat curled for texture, his tail trimmed to a decisive finish, resembled a squat, powerful square — the preferred configuration used for depicting the powerful men of the day, from the bellicose Teddy Roosevelt to the daring tycoon.

Despite the use of some esoteric criteria at the highest levels of show judging, state fair scorecards for livestock generally reflected standards of practical use to the producer of milk and meat. Randall, whose term of office as secretary of the fair witnessed a marked increase in the attention paid to livestock competition, waxed eloquent on the subject of the lessons to be learned by the attentive stockman: "No man can see and study the best types of all breeds of horses, cattle, sheep and swine shown at the fair and again look with complacency upon a lot of scrub stock at home. Initial steps toward improvement are sure to be taken and the aggregate influence of the fair in the upbuilding of the livestock of the State is beyond comprehension."

Many of the exotic animals entered in state fair competition were also for sale to farmers who saw the light as their scrub cattle went down to defeat in the ring. Livestock auctions under Agricultural Society auspices began at the 1888 fair; only animals properly enrolled for judging were eligible. Beginning in 1899 (when the Farmers' Alliance complained bitterly that the "entire management of the state fair seems to be confined to gentlemen who are not wholly identical with agricultural interests"), national livestock exhibitions and sales at the fair were held in conjunction with the American Hereford Breeders' Association and the American Shorthorn Breeders' Association. The "only state fair" capable of attracting stock of such caliber, Minnesota's held an auction of prize animals in a vast tent after each round of judging. The *Breeders' Gazette*, the nation's leading stock paper, pronounced the Minnesota State Fair's 1904 display of blooded cattle "the best ever seen in one collection at any time in the history of the country."

That encomium is also a fair assessment of the standing of the Minnesota State Fair in breeding circles from 1890 through 1910, when C. N. Cosgrove

## ON PREMIUM CLASSIFICATION AND OTHER ISSUES

"One of the most essential things, and one that determines largely how much of lasting value is to be derived from the fair, is the judging. Employ only men of known ability and integrity. By all means have your judges explain the merits and demerits of the entries as they pass upon them. If you have never tried this plan, you will be surprised to see how people crowd around the judge and try to catch every word he says. Well I remember an incident that occurred the first year that we tried this out. An exhibitor, who won first on a Holstein calf, did not think that his calf had a chance to win. After the judge got through explaining his reasons for placing the smaller and younger calf first, the owner of the winner said, 'Judge, the explanation that you have just given us is worth more to me than the five dollar premium that you have awarded me.' Without this explanation the exhibitor would have gone home dissatisfied with his winnings and thinking that the judge did not know his business. . . .

"In the stock department there are two important things to be kept well in mind: First, fields large enough so that there is keen competition and the judge has plenty of material to select the winners from. The spectators can learn but little from the judging otherwise; second, that the premiums are large enough and that they are divided into enough moneys so that most of the exhibitors win at least their expenses. There is nothing that kills the enthusiasm of the exhibitor as quickly as having to dig down into his pocket for expense money."

— E. E. Miller, addressing the annual meeting of the Minnesota Federation of County Fairs, 1913 □

stepped down as secretary of the Agricultural Society. Under the leadership of William Liggett, a past secretary and superintendent of the cattle department, the premium list had been revised late in the 1890s and the breeds carefully separated into classes to promote better judging. Breed associations augmented the customary premiums for blooded animals and added much-coveted "specials"—trophies and prizes for the winners of ribbons. Short courses in judging techniques were held and graduates admonished to remember their duty to educate participants and spectators alike in the finer points of superior stock.

But the clearest proof of the fair's newfound commitment to breeding is the building program undertaken during the period. In 1898, citing important educational considerations, the Agricultural Society began to agitate for a special state appropriation in aid of constructing a suitable "livestock amphitheatre." "It is necessary now to show animals in the open air, subject to weather conditions, where few people can see them and where the judges can do no more than make the awards without the explanation as to quality, type and distinguishing characteristics which would be of great value to farmers and other visitors," noted the annual report for that year. In 1903 the newspapers, impressed by the numbers of animals brought from every part of the country for the state fair cattle show, lamented the fact that several prominent exhibitors were "obliged to content themselves with outside stalls for their stock." Cosgrove, then serving a term as the society's chief executive, used his presidential address to lobby for a special livestock facility on economic grounds. A new, fireproof building would only increase the size of the annual auction, which had, over the past several years, disposed of some six hundred head of registered cattle. "If each of the 600 animals sold . . . produced fifty calves each year and increased the value per head five dollars," he reasoned, "this would mean $150,000 a year added to the wealth of Minnesota, and as the average breeding life of an animal is at least seven years, it would mean one million dollars added to the wealth of our state."

A livestock "coliseum" or Hippodrome of brick and tile in the Mission style was completed in 1906. The Hippodrome joined the new Sheep Barn and an Agriculture Building devoted to "blooded" apples and new strains of corn, scientifically chosen to resist the chill of a Minnesota spring; it anticipated construction, in 1907, of a Poultry Building exclusively for "blue-blooded birds."

The state fair could not please everyone, of course. A 1903 editorial in the *Anoka Press* berated the fair for charging farmers good money to see their own cattle and the purebred "'chestnuts' that have been hawked about from fair to fair and from show to show until the sight of them has grown positively wearisome." But the *Wabasha Herald* that same year awarded the fair a blue ribbon for the vigorous promotion of breeding that had become one of its most significant features:

> The state fair is over and it has proved a splendid educator to the masses of farmers from all sections of the state who visited it. No farmer could spend a day there and look over the cattle and swine and sheep . . . and agricultural products and machinery without bringing back with him a new enthusiasm for a more intelligent effort in his farming methods. It looks like a good deal of money to pay $150 or more for a bull . . . but if better cattle are to be had and more money made in this line it can only be at such prices that desirable animals can be secured. What is true of cattle is equally true of sheep and swine. . . . It costs just as much to mature the scrub as it does the full blood

animal and when you put the two on the market there is a vast difference in the price and this difference often constitutes the only profit there is. The farmer who went to the fair and put in much of his time in the stock barns gathering what information he could regarding the various breeds and their adaptability to his purposes and who follows this up by purchasing . . . a blooded animal to head his herd . . . will receive a many fold interest on his investment. For such the visit has been a profitable one. □

## LADY PRIDE PONTIAC LIEUWKJE

The interest in blooded stock among Minnesota's elite was by no means confined to James J. Hill and his family. Frederick E. Murphy, publisher of the *Minneapolis Tribune*, was the owner of Femco Farms near Breckenridge, home of a show herd that included Lady Pride, the "wonder cow" of the 1920s and 30s. By aggressive breeding, Murphy aimed to engineer a strain of dairy cattle capable of unheard-of yields. But he also maintained that, except for the bit of extra care given the prize specimens, anything he did at Femco Farms could be duplicated by the average, practical farmer. His operation was the proving grounds for working out sound new methods of agriculture and breeding.

Lady Pride, who was housed in a special dairy industry exhibit on the mezzanine floor of the cattle barn at the 1932 state fair, was Murphy's greatest success story and a living tribute to virtues of breeding. Among her claims to fame:

- produced more butter than any cow then living
- the highest milk yield ever made east of the Rocky Mountains

- holder of the new world record for combined milk and butter production
- in 365 days, according to tests "supervised by the Minnesota Agricultural College," gave 35,626 pounds of milk and 1,483 pounds of butter (whereas the average production per cow in the United States was 4,000 pounds of milk and 170 pounds of butterfat).

Lady Pride was also expected to compete in the state fair show-ring in the "aged cow class." Her appearance, it was claimed, would demonstrate the results of "good breeding, careful feeding, the kind of care that every dairy matron should receive to insure high yields." She was also a reminder of the "sensational dairy animals that have made Minnesota famous the world over as a seed stock center."

Lady Pride was an example "to thousands of dairymen and a challenge for them to strive for higher production of dairy stock. Lady Pride is a living proof of the value to humanity of institutions and systems for advancement of scientific agriculture and all agriculture." □

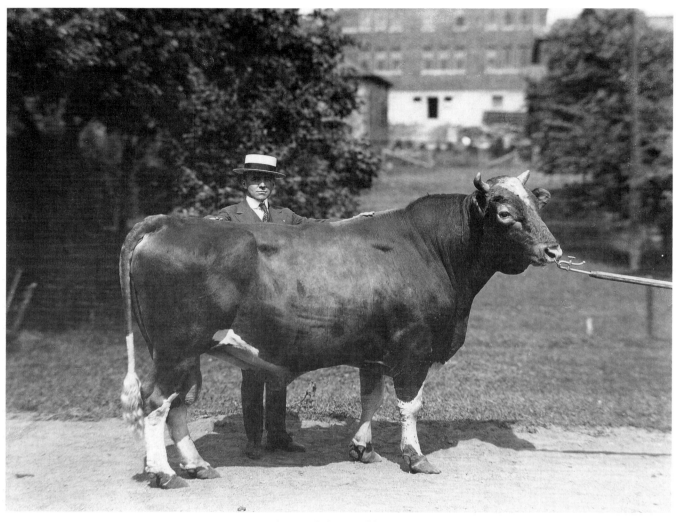

*An exhibitor of the World War I era, using his hands to emphasize the straight back of a distinctly rectangular bull, the period's ideal shape*

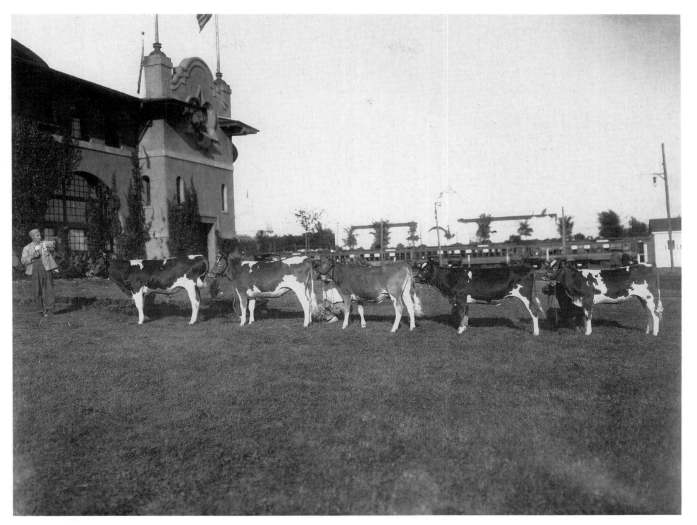

*Handlers posing a dairy herd outside the Hippodrome, about 1915*

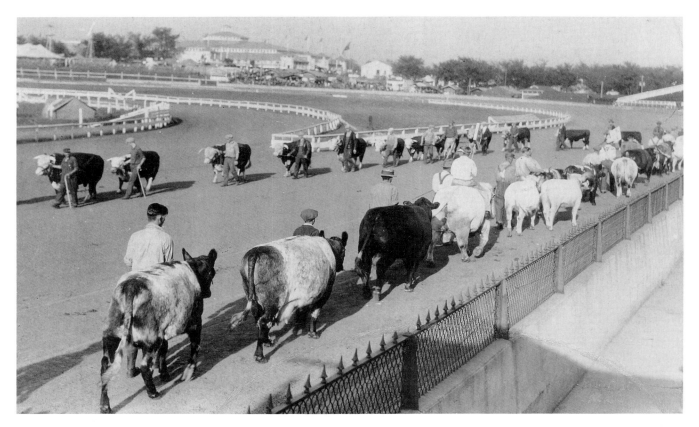

*The livestock parade, about 1910; traditionally a major attraction, it was held in the Grandstand before masses of spectators.*

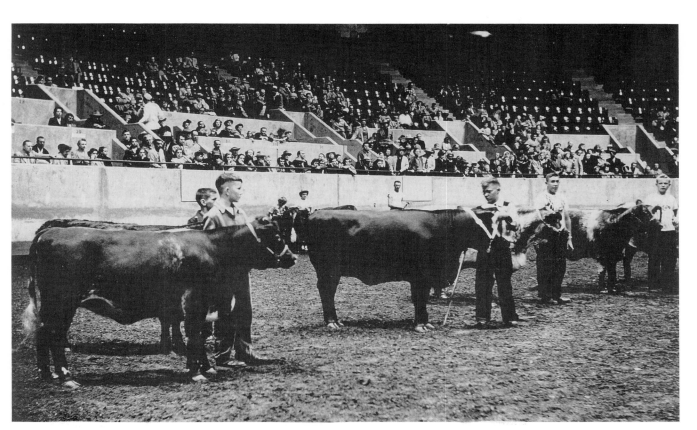

*The first year of cattle judging in the new Coliseum, 1951*

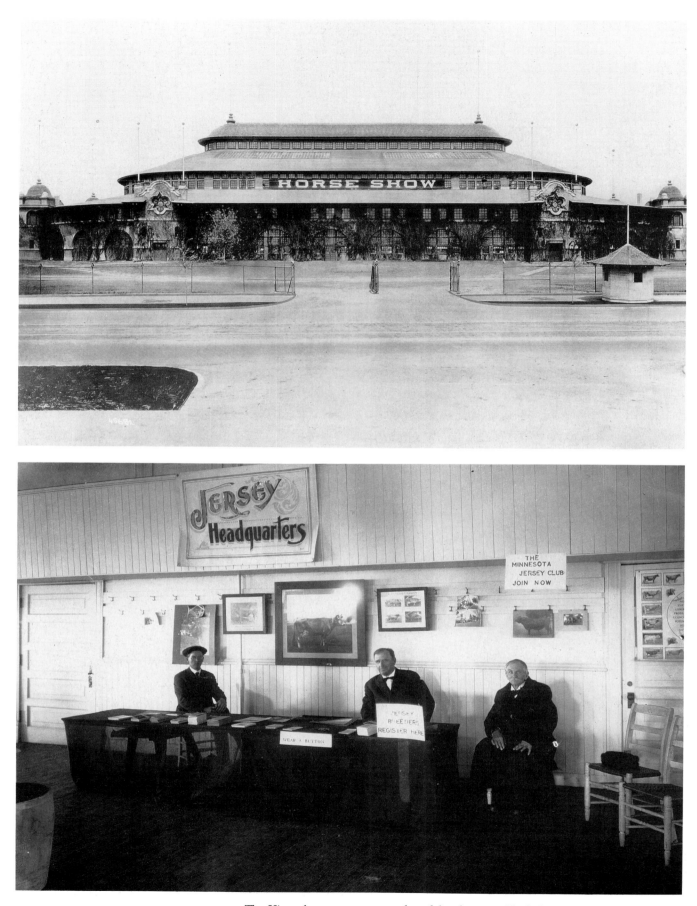

*The Hippodrome, once a wonder of the show world: dedicated, 1906; razed, 1946.*

*Jersey promoters of the 1910s, inviting fairgoers to wear a button supporting the cause*

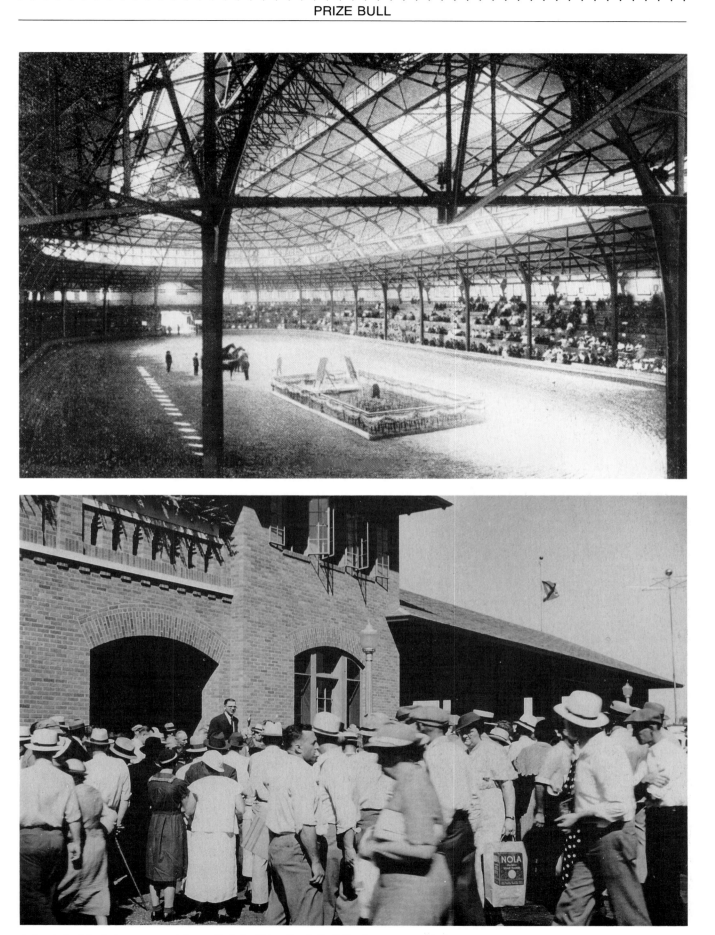

*Animals inside their quarters (also called the "Live Stock Building"), a scene worthy of postcard treatment in 1908*

*Dedicating the new Swine Barn, September 7, 1936*

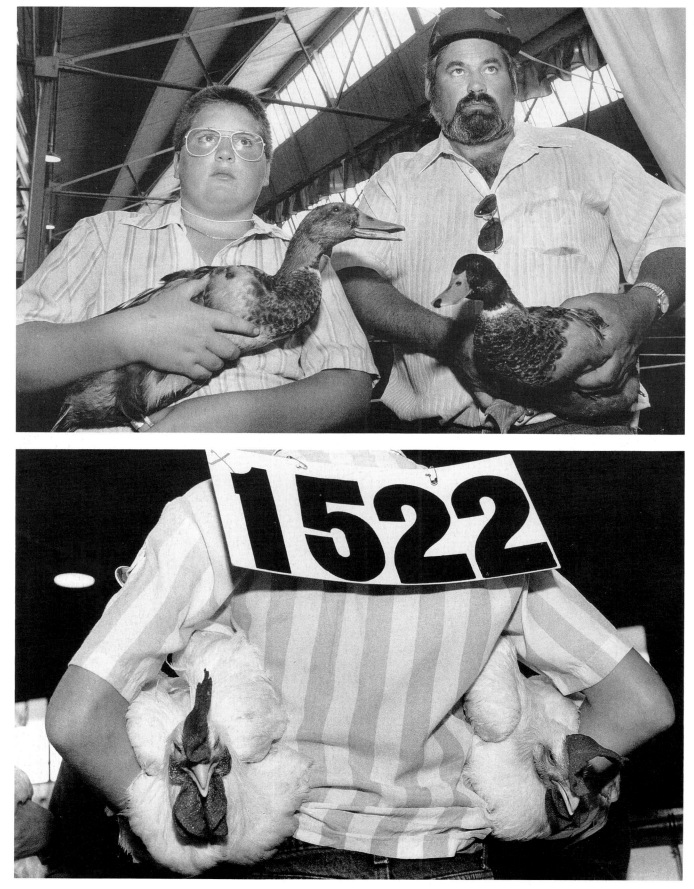

*Father-and-son team from Howard Lake, exuding anxiety as the judges approach, 1980s*

*Roosters unimpressed by their imminent stardom, 1980s*

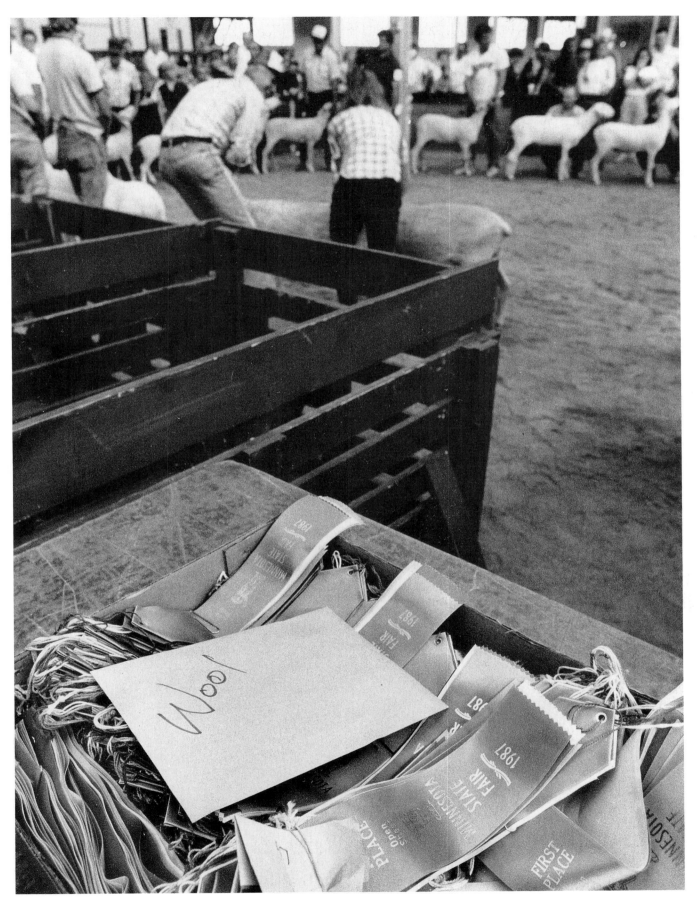

*Sheep ribbons: bundles of blues, reds, greens, and whites, 1987.*

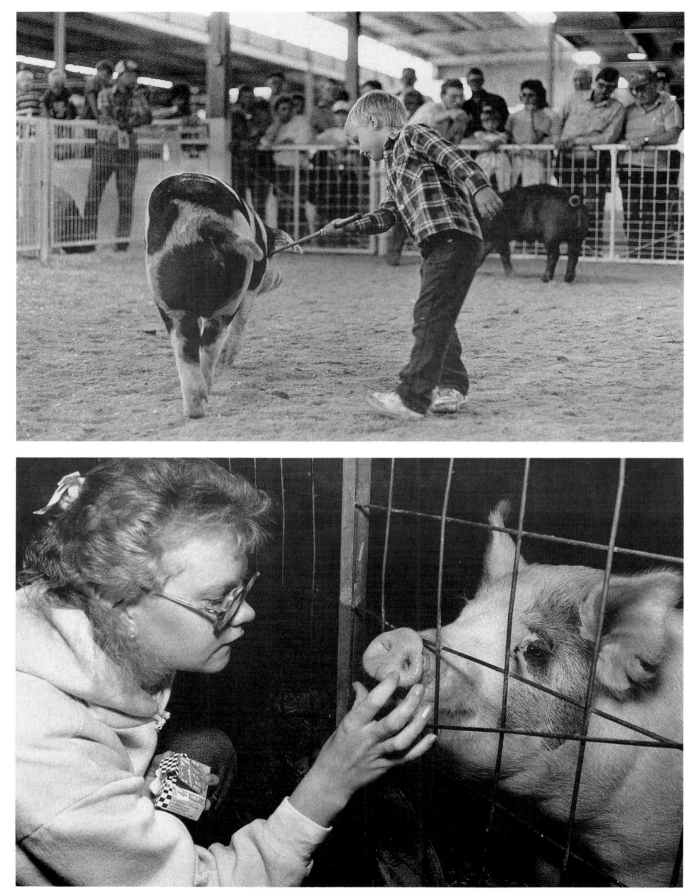

*Pigs seldom behave in the show ring, 1987.*

*More docile are pets like Peaches, sharing a treat with her owner, a 4-H'er from Houston County, 1980s. Peaches, alas, was bound for the slaughterhouse the next morning.*

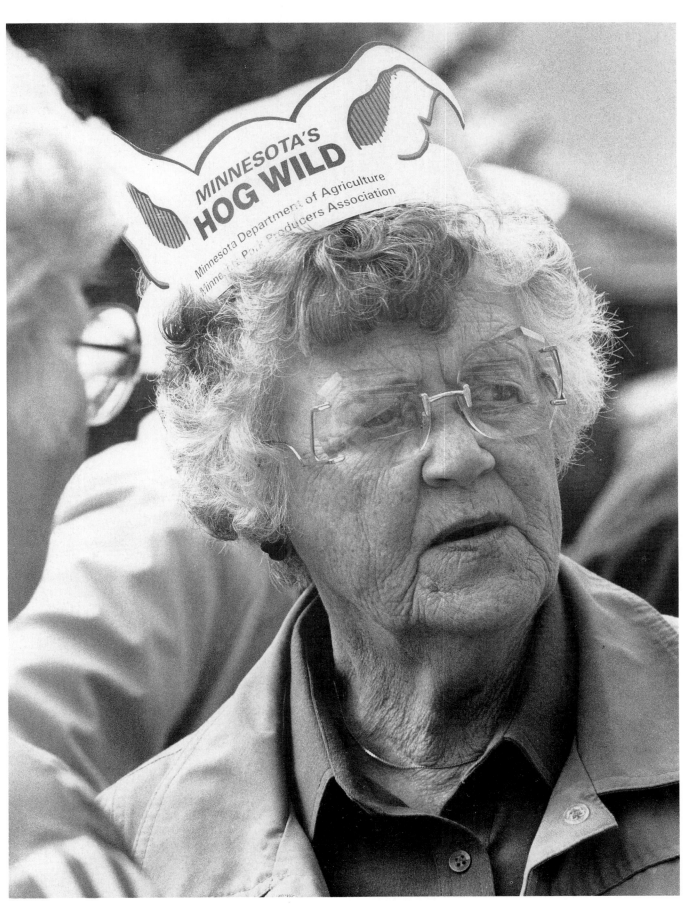

*Sally Johnson of Forest Lake, "hog wild" about the 1987 fair*

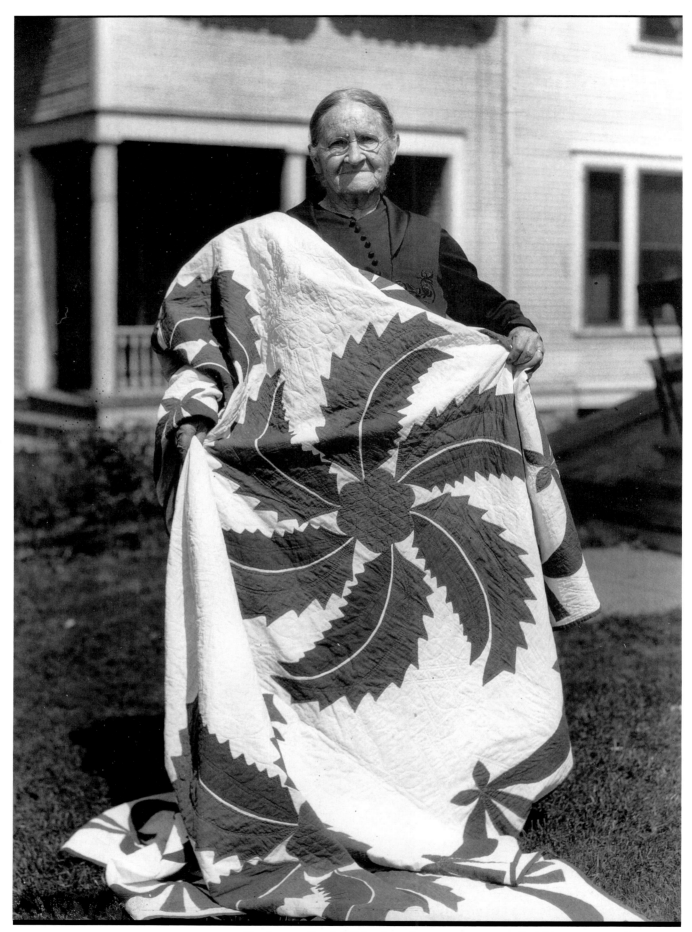

*The best quilt of 1926, when the category was called "Domestic Arts"*

# WOMEN'S WORK

BECAUSE FAIRS were significant social events in a frontier society composed largely of men, early organizers took pains to encourage attendance by "the ladies" of Minnesota. Flyers announcing the first Hennepin County Fair in 1854, for example, particularly requested women to send "specimens of their industrial work." Newspaper accounts of the next year's gathering noted with satisfaction the presence of large numbers of ladies who displayed butter, hand-woven carpets, houseplants, flowers, and "many specimens of needlework and fancy articles." The printed circular announcing the 1863 state fair at Fort Snelling also made it clear that women were considered crucial to the success of that larger enterprise:

> Ladies, if last, by no means least! You have always contributed largely and generously from the fruits of your labor to the success of our exhibitions, and we feel full confidence in your assistance this year. Your handiwork in all branches of industry bears a wide reputation; we are sure of your ability to sustain it. Therefore, having exhorted the sterner sex, we have only to say we wish to make this THE FAIR!

Descriptions of women's entries in Minnesota's pioneer fairs provide insight into daily life in the nineteenth century. Before factory-made goods were readily available, for example, hand-woven carpets were a household necessity in a cold climate. Far from being a leisure-time hobby, the ability to make rugs, quilts, coverlets, stockings, and even yard goods was a skill fundamental to the well-being of the family. Hence many classes on the premium lists elevated the routine work of women—weaving, sewing, baking, knitting, putting up preserves for the winter—to a position of high honor. And just as the judging of animals established a community standard for the breeder, so inspections of intricate stitches and the flake of a piecrust helped to define the accomplishments expected of the superior housewife.

There were decided fashions in the category of "fancy work," however. In the 1880s premium lists at even the smallest county fair included wreaths and bouquets-under-glass made from human hair, wax, grains, or mosses, but in 1892 a Twin Cities columnist discussing women's entries at the state fair dismissed such articles as "monstrosities." Nonetheless, "paintings on funghi" and the like remained viable entries in the Amateur Fine Arts class until the turn of the century. Compelling evidence, in fact, suggests that the managers and superintendents of the state fair used the premium list to keep alive certain "nearly extinct" arts practiced by women in order to counter the emergence of a new, undomesticated Minnesota female. That the skills once exercised by Minnesota mothers and grandmothers were being lost on a rising generation of women bent on "entering all the professions and many of the trades" was an article of faith among fair watchers in the

1890s, and quilt making became a kind of litmus test of traditional femininity.

Quilts awarded ribbons at the Fort Snelling fairs had been demonstrations of thrift: pieced together from the contents of the scrap bag, the patchwork quilt also symbolized the lavish expenditure of time required to fill one's needs in a society woefully short on cash. Over the next twenty years, however, the quilt took on a different character. Embroidered crazy quilts of satins and velvets still required intensive labor, but the object now was to create a thing of beauty, a testament to its maker's good taste and knowledge of ornamental stitchery. Occasionally, too, the scraps that made up the crazy quilt came from the dresses of illustrious ladies of history, the castoffs of royalty, or the garments of colonial worthies; when so labeled, they conferred a certain social prestige upon the seamstress. And whatever the lineage of its component parts, a crazy quilt made a statement of sorts about the economic status of the household that could free its womenfolk for such superfluous endeavors.

The album quilt, a collaborative effort among groups of friends, church- or clubwomen, was popular, too. Each square was the work of a different seamstress, whose autograph constituted the chief decorative motif. A linen album quilt submitted to the 1892 state fair by the members of a charitable society gave the formula an ingenious, commercial twist: embroidered in red on each square was the "name of different firms in the Twin Cities" that had paid handsomely for the privilege.

*The first-prize state fair quilt of 1859*

Despite such ongoing proofs of the survival of the quilt in novel forms (including the "photo-electric" one adorned with scenic views printed on sensitized cloth), the redoubtable Sibyl Wilbur and the sisterhood of lady columnists who were beginning to make their mark in the Twin Cities newspapers vacillated between predicting its imminent demise and asserting that the showcases full of rising-sun and log-cabin designs were a "protest against the new woman who has forgotten this charming handicraft." "Anyone who is still tormented with the fear that the appearance of the new woman will mean the disappearance of the . . . handiwork of the old-time woman will be reassured by a half hour's visit to the woman's exhibit of the state fair," wrote the domestic affairs editor of the *St. Paul Globe* in 1897, just as the *Minneapolis Journal* was lauding "a decided revival of these articles."

But anxious discussions of the annual quilt display could not reverse the tides of change. The patchwork quilts still to be found at the state fair came, increasingly, from the country districts alone and from "old ladies" with the time and the patience to collect scraps, like the 7,012 pieces that made up seventy-three-year-old Mrs. Eliza Brown's log-cabin quilt, shown at the 1906 fair. After 1900 the real contest in that "rural domestic industry" raged almost exclusively between matriarchs of seventy-three, eighty-five, ninety, and ninety-eight years, who had moved into town from the farm and spent their retirement years recreating the beloved quilt patterns of girlhood. Among younger women and city women, who visited the state fair's distaff department to inspect elegant, hand-painted china and fashionable Battenberg lace, interest in quilts had "about died out." The complete absence of the crazy quilt "of our grandmother's day" from the 1904 state fair was cited as "evidence that this is a faster age" than that in which Minnesota's foremothers had lived:

> They had time to make crazy quilts; their daughters and granddaughters
> haven't. They spent hours and days and weeks fitting the pieces
> together; their descendants are too busy with club work, with golf and

automobiling to patch quilts. Perhaps it is just as well; perhaps making bedclothing is a better way to employ the machinery of the factory than to employ the wife and daughters of the family.

Despite the pleas for women's work, the close scrutiny of their efforts and mounting dismay in some quarters over their failure to excel at the genteel arts preserved in the premium books, the ladies were not treated with much solicitude by state fair officialdom. Their quilts, burnt wood, tidies, and cakes were apt to be tucked away in a spare corner surrounded by vendors of questionable "vegetable cutters, sewing machine needles, 25-cent diamonds and kindred lines," for example. And although a woman was usually in charge of arranging the display of homemade articles, the general supervisor of the division—and the person who allocated the prime spaces to manufacturers and merchants—was always a man. In 1890, when county fairs from one end of the state to the other had already built their Pomona and Floral and Fine Art halls for the purpose, the "ladies department" at the Minnesota State Fair was still all but lost within the cavernous expanses of Main Building. In 1897 it was given temporary use of a new brick building, only to be banished in 1903 to the old carriage house. In 1907 the stately Manufacturers' Building was vacated abruptly, and in 1908 the entity variously called the Women's (or Woman's) Department, Women's Activities Division, or simply the Women's Division (which then comprised one-fifth of all the entries) finally found a permanent home by default.

The growing social and professional clout of the infamous new woman also played a role in securing the building. Although the Agricultural Society would not admit its first female delegate until 1912 (she was Miss Jessie Walkup, secretary of the Pipestone County Fair), that body acknowledged a changed reality in 1903, when it invited public addresses from practicing home economists on such subjects as "The Relation of Live Stock Farming to the Home" and "The Selection of Textile Fabrics for Household Use." At the same time, the wives, daughters, and in-laws of the fair's directors rose to prominence in the leadership of a special state fair committee of the Federation of Minnesota Women's Clubs. Anna B. Underwood, Matilda R. Liggett, and Mrs. John R. S. Cosgrove were among those to insist that homemaking was a rational science—they called it "domestic science"—that could be inculcated through demonstrations and lectures, much as the breeding of cattle and the selection of seed were currently taught to the men. The homemaker who dealt with her household tasks in a businesslike fashion gained the time to pursue an independent life of learning, service, and artistic accomplishment—increasingly the feminine activities for which women wished to be recognized at the fair.

Because the fair's bureaucratic mechanisms were as resistant to change as the premium book, the aspirations of the new woman first found expression not in the designated Woman's Building but in the quasi-official clubhouse of the Federation of Women's Clubs. All kinds of groups, societies, and fraternal organizations had headquarters on the fairgrounds at the turn of the century: newspaper editors, veterans, Masons, Knights of Columbus, Moose, Elks, Territorial Pioneers, and the Woman's Christian Temperance Union (WCTU) were among the many who occupied cabins and cottages in which visiting supporters were entertained during fair week. Citing that precedent, Anna Underwood and her committee secured a commodious three-story house for the use of the federation in the summer of 1899.

Since the nineteenth-century lady was regarded as the moral superior of her mate—and bearer of "the highest culture of Minnesota"—it was only

## ANTI-SUFFRAGETTES

In 1915 the Minnesota State Fair allocated two spacious booths—E and F, by name—in the old Dairy Building to Mrs. E. Pennington to serve as an "anti-suffragette headquarters." The usual rental charge was waived.

In preparing the annual report to the Agricultural Society that year, the superintendent of the fair's new Public Welfare Department quoted with evident relish a newspaper article about "the woman of today," claiming a change for the good. "Preeminent in interest in the Woman's Building at the Fair is the infant welfare exhibit," the story argued, "whereas a few years ago, one would have thought babies were the last objects women were interested in, if they judged by the character of exhibits in the Woman's Building."

The display in question was a baby contest, held in a large, glassed-in, show-ring cage placed in the center of the exhibition hall. The sign above the welter of nurses, pediatricians, anxious mothers, and squalling infants read: "Will you help us improve the MOST IMPORTANT CROP raised in the State of Minnesota?"

Like the antisuffrage booth, the baby contest (and the rhetoric surrounding it) mirrored a deep-seated anxiety over the changing role of Minnesota's women. □

fitting that the building was the former resort of the Minnesota Jockey Club. Built under the terms of the questionable deal that was believed in some quarters to have turned the state fair into a den of vice, the sumptuous clubhouse alongside the racetrack, with its turrets and verandas, embodied the high-living ways of the gambler. Asked to trace the modest history of feminine involvement with the fair for the Agricultural Society in 1908, Matilda Liggett remembered "the gambling days" when "it was considered hardly the proper thing for women" of breeding to attend the fair at all. By giving the horsemen's lair over into the purifying custody of Minnesota's womenfolk, the state fair signaled the beginning of the reform movement. By accepting it, the ladies of the federation stepped outside the domestic sphere and took up the cause of social reform.

Federation officers and reporters alike described the interior of the Women's Headquarters as "homelike." Newspaper stories written during the first summer of operation also waxed lyrical over the warm hospitality tendered to touring clubwomen. But the crowded program of lectures, discussions, and exhibitions ranged far beyond the rituals of the cozy parlor. In 1900 special days were devoted to discussions of village and county improvements, "delinquent fathers," the creation of traveling libraries, and "a course of demonstrations in home economics." In 1902, in addition to practical lessons in "correct" methods of cooking and sewing by a professional teacher of domestic science, the clubhouse featured a "model sickroom, with a (female) physician and a trained nurse on hand" to treat ailments or to discuss proper, hygienic methods of care. The Women's Auxiliary of the State Horticultural Society, "leaving to their brethren in horticultural hall the more practical displays," took up the dreadful aesthetic condition of Minnesota's streets and roads. In 1903 flames from a gasoline stove burned the headquarters to the ground, including an extensive series of exhibits showing the results of scientific teaching methods and curricular reform in Minnesota's public schools. The disaster interrupted plans for a series of lectures entitled "Can Housekeeping Be Made Easy?" After the fire the Federation of Women's Clubs relocated in the old Farmers' Institute building but quit the fair in 1911 after a series of public disputes with the board.

The managers of the Women's Headquarters were certainly not radicals, but their programs reveal a fresh understanding of the role of women within the home and beyond its confines. In their eyes, housekeeping was a science rather than the art honored by the old premium lists. Female experts — career women, who worked for a living — could be consulted to learn the principles of efficient management. Whenever possible federation members showed women that other women could practice medicine, take part in important civic affairs, master the complexities of science, manage schedules and accounts, and speak in public. Outside the usual mechanisms of state fair premiums and hoopla, the federation sought to effect social change by holding up modern role models for the women of Minnesota to emulate.

Invited to offer a male perspective on the progress of women at the fair, an anonymous member of the Agricultural Society noted that the time had passed when representatives of "the fairer sex" were only expected "to bring us their prize sponge cakes [and] some fussy little tidies . . . to give the women's department a homelike appearance." But, when pressed to elaborate on what had really changed in recent years, he cited the records of women who had taken first prizes in the horticultural and dairy departments, the traditional bailiwicks of the jelly maker and the farm wife in need of pin money. Nor was the gentleman patronizing the ladies. Except for the lady

## THE MODEL FARMHOUSE

Early-twentieth-century reformers decried the spiritual poverty, the narrowness, and the unremitting toil that marked the lives of rural Americans, like the Minnesota farmer's wife who wrote to the United States Department of Agriculture in 1915, pleading for a chance to take a course in some useful subject. "A two weeks' school . . . would break up the isolation and loneliness and give [women] something to think about in an educational way," she reasoned, "and if there is need of education any place, it is on the farm."

The state fair aimed to meet many of the educational needs of the farm family through "object lessons"—demonstrations, side-by-side comparisons of good stock and bad, and working displays of the newest labor-saving products. The latter were often arranged to catch the eye of the "overworked woman" from rural Minnesota. The weekly laundry—with washboard, boiler, clothesline, and pins—was among the most arduous tasks consigned to the farm woman, and washing machines, accordingly, bulked large in the commercial exhibits at the fair. The Neostyle machine, produced in St. Paul, was introduced in 1905 with a one-hundred-dollar reward offered to anyone who could make a better model. A "new-fangled clothes drying device" manufactured by the same company attracted a crowd of two thousand in 1909 when it blew up and set fire to several neighboring booths.

There were those, however, who cautioned rural visitors not to be too impressed by modern conveniences. Although such items lightened toil and added to human comfort, they were no cure-all for domestic discontent, "drudgery, care, [and] mismated misery." Machines alone, without a more generous outlook on life, could never improve the lot of the farmer's family. But others argued that catching a glimpse of a better life in the showrooms and exhibition halls of the state fair *did* tend to break down the despairing sense of isolation so marked in the womenfolk—"the meagre, middle-aged wives of small farmers, who bake and cook and churn the year round, rising before dawn and stitching into the night, to save the spare pennies of the small income."

Such women were overworked, but they were also starved for beauty. Pinched farm women abroad at the fair for a few hours often seemed almost as interested in the "cut of the new sleeves in . . . winter coats" shown in the glass cases of the Manufacturers' Building as in the nearby milk separators, washing machines, and crankless churns. The displays that drew them back time after time, however, featured the appointments of the ideal farm home.

Daniel Buck of Mankato, who spoke on Farmers' Day at the 1891 state fair, blamed rural misery and depopulation on the persistence of bad habits among country husbands and fathers. The days of pioneer hardship were over, he said, yet some farmers still used the kitchen stove or the parlor floor as a spittoon and left their muddy boots on the hearth rug to dry. If the family farm were to survive, declared Mr. Buck, the beauty and gentility of "the farmer's home" was the key.

The state fair became the laboratory for improvements in the rural home. In the Progressive era, many organizations bent on social reform used object lessons to illustrate the benefits of change. Advocates of better housing for urban workers in the crowded cities of the East built "model tenements." Educational theorists set up model schools. The model kitchen introduced at the 1898 Minnesota State Fair followed the same pattern. Coordinated by the Federation of Minnesota Women's Clubs, designed by Mary B. James, a pioneer in the teaching of domestic science, and funded by the companies that sold the goods included, the room contained modern plumbing, an icebox, a range hood, and a variety of useful small appliances. But most of the other items were within the reach of persons of modest means, and many of the ideas—step-saving traffic patterns, a counter placed beneath a sparkling window—could be adopted by anyone with the gumption to rearrange her existing fixtures. The changes might or might not save significant amounts of a woman's time, but they were almost certain to make her kitchen a more pleasant place in which to work and her family, as a result, a happier and more civilized tribe.

In 1911 rural newspapers began to discuss with interest plans for an actual, full-scale "model farm home," a permanent state fair exhibit to be sponsored by the Minnesota State Art Commission. A contest (open to Minnesota architects only) was held under the auspices of the commission in 1913. The Minneapolis firm of Hewitt and Brown took first place with a vaguely colonial design for a six-bedroom wooden house estimated to cost $3,500 to construct. A durable aluminum model of the house was shown in the new State Fair Art Gallery in 1913; copies of the plan and schematic drawings were sold nearby. That plan, along with a number of other meritorious entries, was also published in a 1914 issue of the *Minnesota Farmers' Library*, the extension bulletin of the University of Minnesota. The model, meanwhile, toured the state.

In July 1915, Maurice Flagg of the art commission and a trio of women representing the Federation of Minnesota Women's Clubs, the Housewives' League, and an embryonic Minnesota Farm Women's Congress appeared before the state fair board seeking a lot upon which to build the model. They were given permission to situate it on Machinery Hill (it still stands, in an altered state, on the east side of Cooper Street, between Murphy and Lee avenues). And that summer, thousands of farm women streamed through the house, drinking in every detail of its layout, decor, and simple amenities.

Beginning around 1918, the Agricultural Society leased the house to a succession of employees on condition that they vacate the premises during the month of the fair. In 1928, however, the annual tour of the model farmhouse was suspended, and it became a year-round residence, first for the groundskeeper and later for the assistant secretary. Although the active life of the exhibit was relatively short, it was extremely popular in its heyday. Its effects upon the disposition of rural homes in Minnesota in the days before movies and picture magazines helped to close the gap between town and country are impossible to overestimate. □

riders, the daring bicyclists of the 1890s in their bloomer skirts, and the thirteen-year-old tomboy once hired by a machine company to run a traction engine, examples of the independent woman were few and far between at the fairgrounds until the presiding male head of the division entrusted the superintendency of the Women's Department and the disposition of its quarters to a Mrs. Martin L. Luther of Minneapolis in 1902.

A longtime exhibitor of painted china at the fair, Mrs. Luther was a recent graduate of Hamline University in medicine. Although she did not maintain an office, she attended to several regular patients among her friends, did charity work, and planned to resume her professional education when her small son was grown. In the meantime, she kept house, dabbled in oil painting and tapestry weaving, ran her department at the fair, and followed the medical journals so that "in case she should ever find it necessary to adopt the profession as a means of livelihood she [would] be fully prepared." Mrs. Luther, in other words, did it all. A wife, a mother, a homemaker, a doctor, an artist, and a working administrator, she went beyond the theoretical diversity of interest suggested by the programs of the Federation of Women's Clubs. Mrs. Luther practiced what her clubwomen-sisters mainly preached.

Naturally, she had little patience with the premium list and the conservative attitudes toward women's work inherent in it. The new superintendent's first order of business was a thorough revision of the classes. "We want to recognize all the new lines of work and not show only the old hackneyed list," Mrs. Luther told the press. After 1892 contestants in the bread and cake classes had been required to submit their "formulae" as well as the finished product, giving cookery a more scientific basis and allowing interested spectators to duplicate the winning entries at home. Amateur and professional china painters were distinguished from each other for purposes of judging in 1898. But by and large, the lists had changed very little over the same thirty years in which a single prize for the largest bull was superseded by a bevy of awards for an infinite variety of exotic new breeds.

Ribbons were still offered for log-cabin quilts, the darning and repair of napkins, and old-fashioned pound cakes, whereas basketry, wood burning, and the up-to-date arts and crafts associated with picturesque bungalows and courses in the fine arts were hardly represented. By skewing the balance away from the arts of the countryside, the farm, and generations past, Mrs. Luther gave the Women's Department a more urban orientation. Under her leadership, the bulk of the prizes went to hobbyists, who wove pretty baskets instead of homespun to clothe the family, who decorated cakes or put up jam in their spare time just for the pleasure of it, and who aspired, if they painted china, to move over the line that separated the gifted amateur from the working professional. Increasingly, judges and contestants alike relied on the aesthetic standards prevailing in art schools, in magazines, and in shop windows to determine excellence. Local and regional preferences yielded to more sophisticated criteria; suddenly, the distaff arts became "artistic."

Farm women were not entirely happy with this turn of events. Their skills and interests differed from those of the bright young city girls now in control of the Women's Department and Women's Headquarters, even though many of the federation officers hailed from outside of the Twin Cities. The militant modernity, the decorous afternoon teas, and the published lists of socially prominent hostesses slated to pass the lemon slices at the clubhouse proved offputting to farm wives in search of a quiet place to sit down and nurse the baby while "the mister" inspected the livestock barns. In search

A. THE STATE FAIR.
Johnnie and His Mother Become Separated.

St. Paul Pioneer Press, *date unknown*

of simple aid and comfort, they found refuge in the cottage of the WCTU.

As early as 1898, temperance advocates meeting in Minneapolis were discussing the possibility of erecting a permanent structure on Newspaper Row at the fairgrounds for the accommodation of the weary. Lacking the necessary capital, the organization settled for a pair of tents; in the larger, "purity meetings" were held and literature dispensed, while the smaller was fitted out as a "Ladies' Rest." The following summer, Rest Cottage — named after the home of temperance advocate Frances Willard — was opened. On the front porch stood a water barrel with a dipper, for the convenience of the public. Inside, one of the three principal rooms was equipped with easy chairs and a bed for the use of tired ladies toting shopping bags full of literature and free samples.

In his great Minnesota novel *Main Street*, Sinclair Lewis mocks the charitable activities of the Gopher Prairie clubwomen, whose town rest room for farmers' wives "resembled a second hand store." His heroine, Carol Kennicott, understands that the rest room is in the best interests of the merchants, whose spouses constitute the membership of the Thanatopsis Club. In fact, although businessmen and ladies' clubs did create such facilities at the turn of the century, the WCTU took the lead in making provision for the needs of rural women in unfamiliar surroundings. At the beautiful Garden City Fairgrounds in Blue Earth County, for example, the WCTU building constructed early in the century was long remembered for its rest rooms, its rocking chairs, and its omnipresent barrel of ice water: "To a mother with four little squawkers, that was a nice place to rest and have a cool drink."

By answering the real, commonplace needs of farm women, the organization reached out to those whose values supported the cause of temperance and moral reform more readily, perhaps, than any newfangled notions of domestic science and female careerism. Such ideas were firmly identified with the preoccupations of "the club women of the city" by 1911, when the state fair management was deluged with complaints charging that appropriations for the benefit of women at the fair were going exclusively to an urban coterie. Letters from farm women pleaded for more rest rooms adjacent to exhibits of interest to women, for a day nursery to look after infants and toddlers, and for a program of "talks by experts on subjects of home interest to farmers' wives." Although the women's federation denied the charges, maintaining that the demonstrations at the clubhouse could "aid farm women in domestic life," the fair's managers took the protest to heart. Two years later they voted to make the St. Louis Building into a permanent haven — the Rest Cottage and Day Nursery.

If rest-room advocates occupied the conservative wing of the women's movement, then Minnesota suffragists camped out on its liberal fringes. In 1903 members of the Women's Equality Club met in a little, out-of-the-way room in the clubhouse into which several angry legislators were reported to have ventured to remonstrate with their wives. Most fairgoers were unaware of their presence, however, and after a period of dormancy, "votes for women" advocates installed themselves in a tent aflutter with yellow and black streamers and set about proselytizing in earnest.

In 1909 the featured speaker was Essie Williams, president of the St. Paul Sacajawea Suffrage Club (and a "lady lawyer" as well as an instructor at Mechanic Arts High School). In 1911 the Minneapolis and St. Paul chapters joined forces to operate a cafeteria on Machinery Hill, which aimed to make converts to the cause by showing that women who voted were not

## FEMALE PROGRESS: AN EDITORIAL

"With the Minnesota state fair still a week away, it is too early, of course, to measure the latest step in progress which the woman's department of the 1903 fair will represent. But that it has been a substantial step upward no one who has watched woman's work in connection with previous state fairs will doubt. Beginning on the very lowest plane, with a can of superior jelly in one hand and a crocheted tidy in the other, she has climbed — and not by easy stages either — to such a height that male officials no longer tolerate her but are anxious to listen to her ideas. And it is to her credit that during her climb she has retained the can of jelly though she has left behind her the crocheted tidy . . . .

"A club house in which are held demonstrations in every line of work that can interest the housewife — and the fact is taken into consideration that the housewife's interests are no longer limited by the four walls of her home — is by no means the completed evolution of the secluded corner in a building devoted to vegetables, where formerly reposed the can of superior jelly and the crocheted tidy. Neither does the woman's building, with its display of fine, hand-made lace, its loaves of crisp and well browned bread, its examples of fine sewing, represent the last step in the matter of exhibits. The hopeful woman, indeed, dreams of a millennium in which there will be no separate exhibit hall for women, even at the state fair."

— *St. Paul Globe*,
August 23, 1903 □

unnatural creatures: they could also cook dishes called Susan B. Anthony Pie and Legislative Pudding. Another novelty was the appearance of a noted New York suffragist who stumped the fairgrounds, trading quips with male hecklers from the back seat of an automobile. The auto, it seems, suggested that women who could drive should also be entitled to the other rights of citizenship. The campaign for the vote in 1912 involved a parade of thirty cars from downtown Minneapolis to the suffrage tent at the state fair. Or perhaps, despite their short-lived interest in baking pies, anything truly modern caught the fancy of Minnesota's forward-looking suffragists. Their auto parades continued, but in 1914, when motion pictures were still a novelty, they created a real sensation by showing "suff" movies on the Midway.

World War I dampened enthusiasm for causes. It also disrupted fairs all along the circuit; employees enlisted, the military threatened to commandeer the railroads, gas was in short supply, and at the Minnesota State Fair, pies, cakes, cookies, and candy were stricken from the premium book because of sugar rationing. The Nineteenth Amendment gave women the vote in 1920, and the former members of the Minnesota Woman Suffrage Association (newly renamed the League of Women Voters) crusaded for world peace from old booths adorned with new banners and slogans — or showed their sisters how to mark a ballot properly. But the most popular women's feature of the postwar period proved to be the State Fair Style Show, at which a consortium of area department stores presented the latest fall fashions. Other attractions included the Betty Crocker Cooking School and ladies' driving competitions in which the contestants were attired in the last word in auto apparel. Somehow, by the middle of the 1920s Minnesota women seemed to be right back where they had started in the 1890s when Jennie K. Rush of Kentucky challenged Villa Poole to a ten-mile race on horseback, when Pillsbury offered a five-dollar gold piece for the "best loaf of bread made by a girl under 12 years of age" using their "Best" brand of flour, when prizes were awarded to the lady bicyclist who balanced her vehicle with supreme grace while wearing "the most attractive costume." □

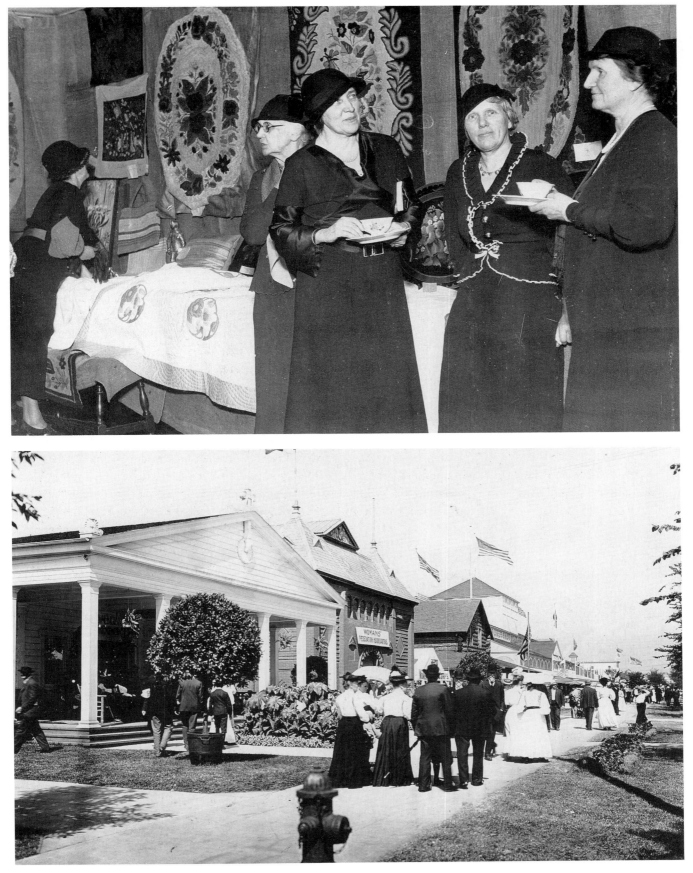

*Rugs and quilts at an afternoon tea held by the Women's Division, about 1935*

*What might be called the women's promenade, about 1904: from left, the New England Company building, which catered to homemakers; Womans' [sic] Federation Headquarters; Women's Relief Corps; Pioneer Hall, staffed by females as well as males; Horticulture Hall, soon to be the Woman's Building.*

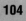

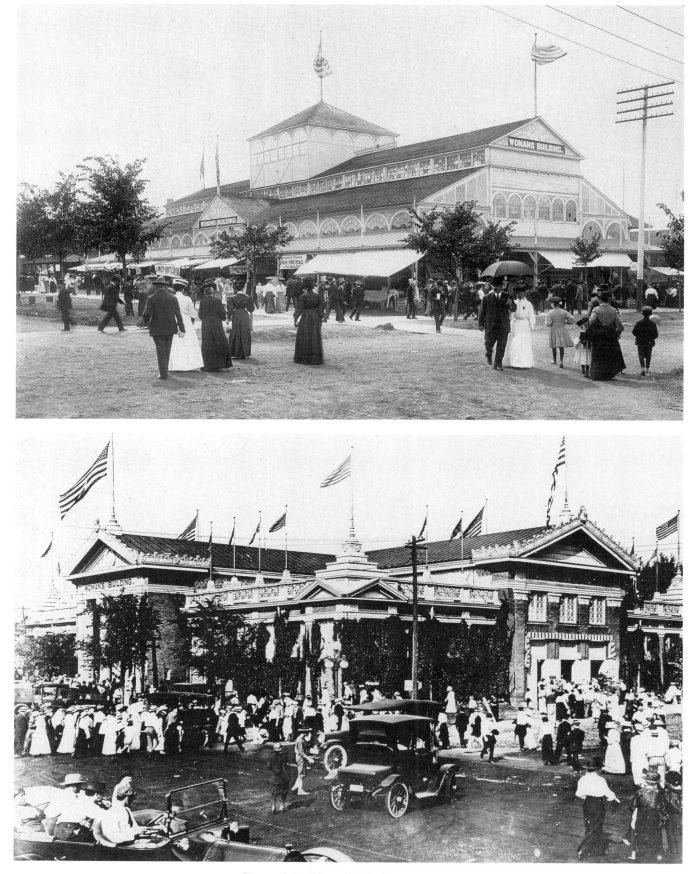

*Woman's Building, 1905. Some complained that they had to fight their way through the mob of salesmen who set up shop under its portico.*

*Woman's Building, originally a showcase for manufacturers, which housed the creative efforts of women (and later men) for more than five decades*

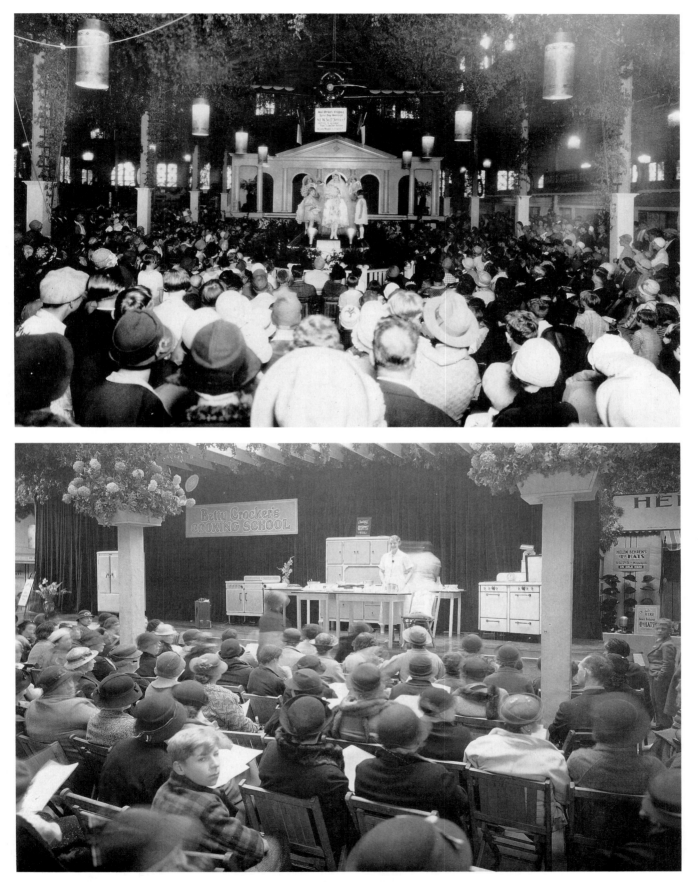

*Bridal finale to the Montgomery Ward Style Show of 1928, held on the balcony of the Hippodrome.*

*Lessons at the fair, 1935, when girls no longer learned to cook at home as a matter of course*

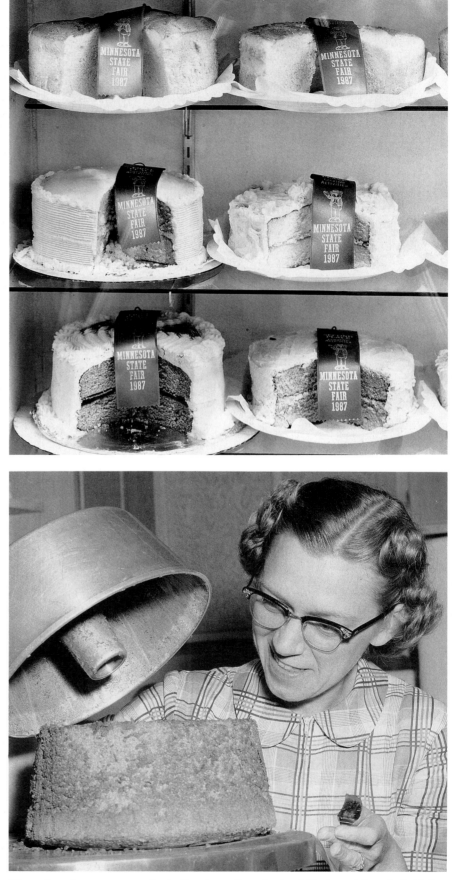

*The cake often serves as the bellwether of aesthetic shifts in cuisine. Is it higher and lighter this year? Or denser and richer?*

*In 1957 the "blooded cake," especially the airy angel's food, was the aristocrat of state fair cookery competitions.*

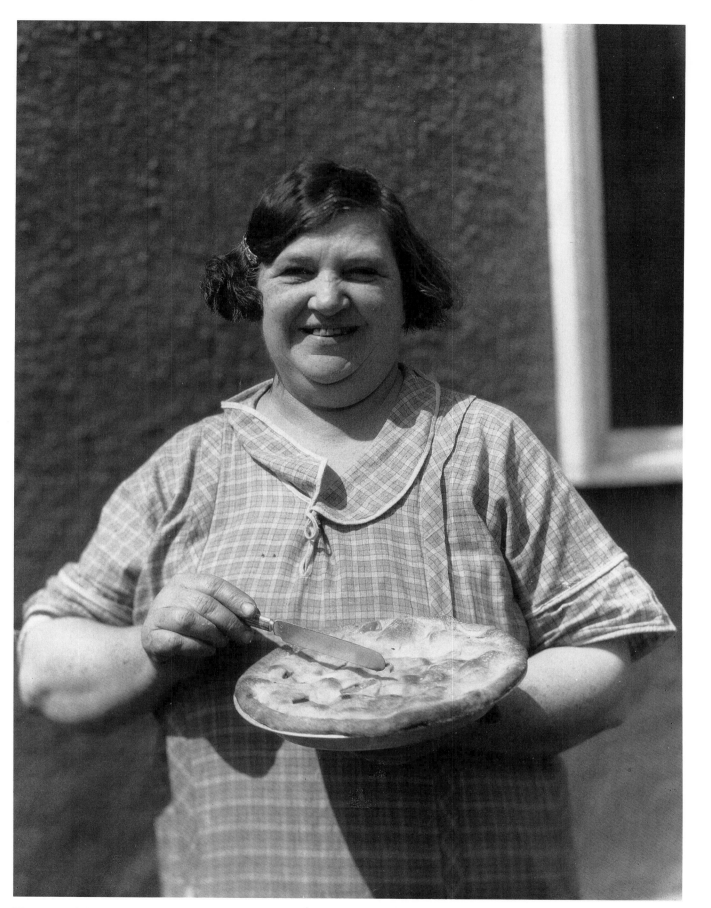

*Woman with her prize pie, 1926, when flaky, "digestible" crust — the destina-
tion of much Minnesota lard — was the country cook's crowning achievement.*

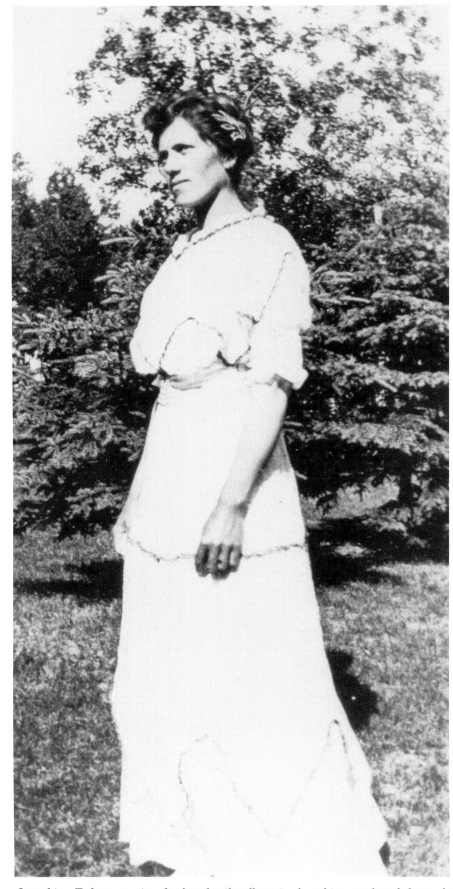

*Josephine Toftner, posing for her family album in the white crocheted dress she was about to send to the 1917 fair. The lovely gown took a third premium.*

*Judging the canned goods, 1933: Gunnar Ahlquist of Minneapolis, and Mrs. J. B. Graham of Duluth.*

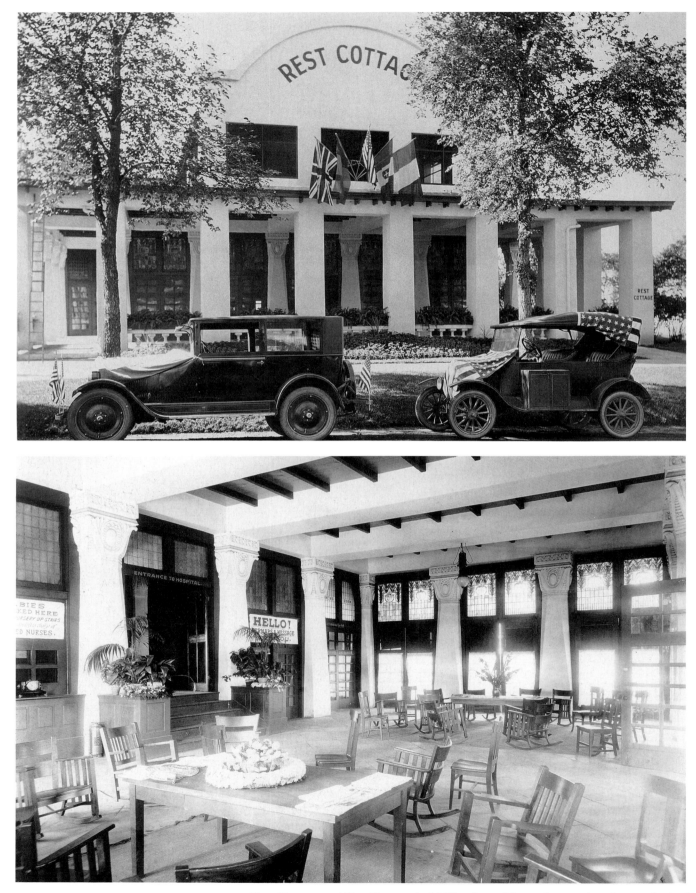

*Rest Cottage and Day Nursery in 1919, adorned for an international peace festival and the starting point for a women's driving contest*

*Signs inside the Rest Cottage hint at some of the amenities.*

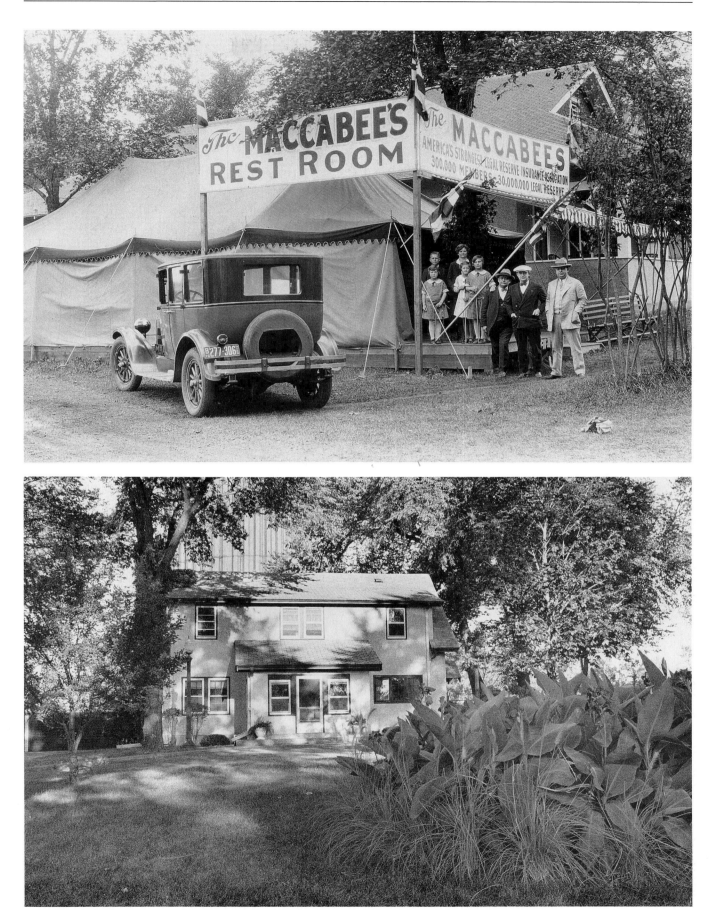

The Maccabees Rest Room, one of several such facilities at the 1926 state fair

Model farmhouse, as it looked in the 1980s. Planned according to the latest theories of health and household science, it was built with the support of women's groups in 1915.

*A future farmer checking out the possibilities, a favorite fair pastime, 1987*

# MACHINERY HILL

BY 1909 THE GENTLE RISE OF LAND on the northern border of the fairgrounds was being called Machinery Hill. There, a steel-and-concrete structure had recently been completed to accommodate "one of the most interesting departments of the fair." But Machinery Hall was only the center-piece for more than seventy-five acres of sheds, tents, and enclosures occu-pied by those who manufactured and sold farm implements: Deere & Webber, International Harvester, Minneapolis Steel and Machinery, and the Minnesota Moline Plow Company were among the more prominent firms that erected permanent buildings atop "the Hill." From their corporate head-quarters, salesmen offered hospitality to farmers along with the opportunity to watch demonstrations of the new gasoline-powered apparatus that prom-ised to revolutionize American agriculture. In 1907, noted *Twentieth Cen-tury Farmer*, "the Machinery Show was as large as the combined shows of the Iowa, Illinois, and Wisconsin Fairs."

With the steam engine in eclipse and the horse consigned to the track or the show-ring, the modern age had arrived. Demand for space on the part of the "power plow manufacturers" was so strong that many concerns were forced to hold trials in rented fields adjacent to the fairgrounds. In 1912 the value of the self-propelled equipment displayed on Machinery Hill reached $1 million for the first time. Gasoline threshers and traction engines attracted the most attention, but there were also devices for fabricating cement farm buildings and a working prototype for the silo—visible proof of the hegemony of the cow on the Minnesota farm.

These wondrous machines all simplified work and eased the farmer's toil. More than that, however, they were seen as instruments of scientific progress and harbingers of a distinctly modern culture. "Whoever masters a new machine has made an intellectual advance as well as added to his money-making power," one editorial writer argued. "Processes and machines unite in uplifting the farmer. He is no longer a 'Rube,' a 'hayseed' or a 'rustic.' He is a practitioner of a profession."

The keen interest in modern machinery evidenced by the displays at the state fair during the 1910s contrasts with the prevailing opinion of the American farmer's social backwardness and resistance to change. Encouraged by the patronage of visitors to Machinery Hill, the fair assumed a position of national leadership in espousing the new technologies of the day. Officials claimed that the annual State Fair Automobile Show, held for the first time on the ground floor of the brand-new Grandstand in 1909, set the standard for similar displays at the nation's other major agricultural expositions. It was, even in its inaugural year, the largest automotive show west of New York City. Like the demonstrations of patented truss bridges and macadam paving that always drew a crowd on Machinery Hill, the auto show reflected

*Big boys like to fiddle with farm machin-ery, too, 1979*

farmers' concerns for free access to markets and supplies over the vast distances of the Northwest. And the show stressed the agricultural applications of the horseless carriage: trophies were offered to sturdy cars that concluded long-distance road "tours" from Fargo and Duluth at the gates of the state fair; vehicles were modified for use as farm wagons; enterprising dealers showed how a pump or a corn grinder could be operated off a car engine by raising the rear axle and attaching a belt to a tire.

Although city people came to see the latest models, too, the Minnesota farmer's unique and abiding interest in technology went back to the days when wheat was still harvested with a sickle and threshed with a flail. The refinement and manufacture of equipment particularly useful in the cultivation of wheat on the prairie coincided with the settlement of Minnesota Territory. (The John Deere steel plow dates from 1837 and the McCormick reaper was patented in 1834.) The 1860 fair at Fort Snelling hosted Minnesota's first recorded exhibit of farm machinery — in addition to the combined reaper and mower from Illinois, a binder was tried out, in the absence of standing crops, on the hazel brush that grew along the racetrack. Thereafter, such trials became a regular feature of Minnesota fairs; when Horace Greeley predicted the general use of steam plows at the 1865 fair, he was catering to a boundless local optimism about the prospects of technological advances, announced annually at the Minnesota fair.

The 1869 gathering at Rochester was noteworthy for a preponderance of Minnesota-made equipment in the trials. The Valley Chief self-raking reaper and mower, manufactured by the W. W. Eastman Company of Minneapolis, aroused considerable interest. The Gopher State plow from Faribault and other models from Fillmore, Winona, Rochester, and Minneapolis encouraged the addition of plowing matches to the usual exhibits.

But throughout the 1870s, when wheat was king and self-binders temperamental, harvesting machinery remained Minnesota's leading import. Farmers contemplating large cash outlays on such devices were avid observers of the field trials of reapers and mowers organized by the Agricultural Society outside of fair season. In 1871, for example, "agents of the various machines" were invited to sanctioned contests near Owatonna, where spectators could judge the efficiency and simplicity of operation for themselves under actual working conditions. During a period of recurrent hostility between farm consumers and the large equipment manufacturers, the society avoided open confrontation by creating a forum in which buyer and seller could meet to mutual advantage. Although the field demonstrations incorporated into the Great Grangers' Picnic Exhibition, begun in Williams Grove, Pennsylvania, in 1873, are often cited as models for a more amicable relationship between farm and industry, it is clear that Minnesota's Owatonna trials set the pattern the Grangers followed.

Thanks in large measure to such trials, agricultural technology improved markedly in the 1870s and 80s. The steam plow Horace Greeley had so confidently predicted was at work on Machinery Hill in 1891. By 1895 twenty company buildings, a forest of windmills, samples of wire fencing, and the open-air displays of "a hundred manufacturers of implements and vehicles" were scattered across the site. Minneapolis, where the trade journal called *Farm Implements* was published, "is the great distributing depot of machinery of this class and all of the firms located in that city . . . will have exhibits," bragged a local daily. "Even at the expense of possible display of ignorance it may repay the visitor from the city not familiar with our modern farming . . . to ask questions about the different appliances that will be shown."

## MACHINERY AND MANUFACTURING

From the outset, the definition of machinery at the fair was not confined to agricultural hardware. Indeed, the category included a wide variety of products made or sold in Minnesota. Fire engines, Red Wing steel safes, commercial coffee grinders, and the apparatus for making binder twine in the state prison at Stillwater all counted in the 1860s and 70s.

In 1888 the secretary's annual report stated that 843 working machines (connected by 1⅜ miles of power shafting) had been exposed to public scrutiny that year. Electricity was introduced in 1892 in the form of a 220-volt generator situated in the Machinery Division; run by steam power, it illuminated a bank of multi-colored bulbs and charged a fifty-cell battery designed to cure rheumatism. Even the mammoth refrigerators installed in a jerry-rigged Machinery Hall in 1900 to hold butter statuary and wheels of cheese were themselves considered industrial exhibits.

Although the large size of agricultural equipment and the need for outdoor trials had often resulted in the dispersal of the varied exhibits of the Machinery Division, around 1900 a movement to draw a symbolic distinction between farm machines and "manufactures" gained ground. Essentially, this was a split between agriculturalists (and their suppliers) and Twin Cities industrialists who demanded equal representation for the products of their factories. The "factory men" took their cause to the state legislature in 1902, lobbying for a building in which the processes used in the fabrication of their goods could be shown along with the finished wares. City people were routinely told that

the state fair could teach them new respect for the contributions of their country cousins. Why shouldn't rural folks see the city at work when they came to Hamline? "The state fair is primarily an advertising spectacle which gives prominence to the resources of the state," the industrialists continued, "and for this reason . . . the manufacturing industries should have equal prominence with the agricultural products."

Thus, in 1904, thanks to a thirty-thousand-dollar appropriation from the state, an imposing Manufacturers' Building was erected at the main Snelling Avenue gate. (It forms the nucleus of the present Creative Activities Building.) Faced in brick and adorned with classical columns, the structure stood at the foot of Machinery Hill, strategically removed from the site and its succession of Machinery Halls devoted exclusively to agricultural implements. As early as 1907, however, the interest of Twin Cities firms in mounting exhibits had apparently flagged; the fair's board of managers adopted a new policy whereby the building would be reserved for the products of a different Minnesota community each year. Civic pride alone, it was hoped, would guarantee a superior show.

The city of Red Wing—the "Desirable City"—took over the "old Manufacturers' Building" in 1907. Cheered on by a delegation of local residents wearing big Red Wing badges, twenty-four companies set up working displays in the cavernous interior. Three fellows made jugs by hand and two others rolled cigars. Nearby, another crew made leggings with the help of "a machine . . . capable of cutting twenty pieces at a time." A boat with a "two horse-power

jump spark engine" chugged away in a tank of water, a power press printed cards for onlookers, and devices operated by electricity were used to finish shoes.

The Red Wing display (duplicated thereafter at several locations within the fairgrounds and last held in the Electric Building in 1923) was highly praised for its intrinsic interest and for the energy of its boosters. It set no precedent, however. After 1907, most operating machinery seen beyond the slopes of Machinery Hill took the form of cars or airplanes. The Manufacturers' Building came too late in the process of Minnesota's economic development to live up to the promises of its backers. Local shoemakers and cigarmakers were fast losing ground to regional and national concerns. Improved transportation, advertising, mail-order firms, and all the other appurtenances of mass culture conspired to give successful Minnesota companies a more cosmopolitan outlook. Schooled by the competitive displays at the world's fairs of the period, Pillsbury-Washburn, Kingsland Smith & Co., and many of the prominent early exhibitors at the state fair came to realize that their best markets lay beyond the borders of Minnesota. At home, they were preaching to the converted; their promotional dollars were, perhaps, better spent elsewhere. □

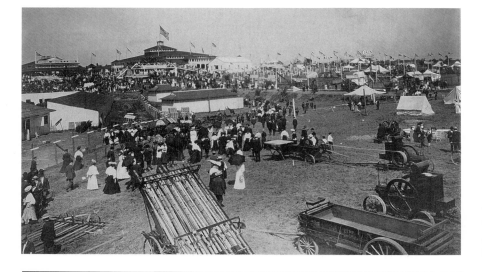

*Machinery Hill in 1906, with equipment run by belts attached to a stationary engine. The new Machinery Hall is in the background, flying the American flag.*

## "A SHOCKING ACCIDENT"

Like the Eiffel Tower, which was also built for a world's fair, the Ferris wheel at the 1893 Columbian Exposition in Chicago looked mechanical and futuristic, with its fretwork of slender metal struts and braces. Like the spindly bicycle, which it somewhat resembled, the Ferris wheel was an ambiguous sort of machine: it was great fun but, somehow, it managed to suggest the possibility of more serious applications of its principles of dynamic motion. Accordingly, the great wheels caused enormous excitement wherever they were set up.

Twin Cities newspapers gave advance notice of the arrival of a sixty-foot wheel on the fairgrounds in 1896, in case readers wanted to watch its assembly. The 1904 model was slightly smaller but far more elegantly appointed: the cars were upholstered in red plush, finished in brass, and illuminated by twinkling electric lights. The powerful engine was so finely tuned, it was said, that the sensation of motion was all but imperceptible. In 1906 there were three Ferris wheels at the state fair; the largest one, with wicker cars, was owned by a Minneapolis showman who had operated it successfully at Lake Phalen during the warm-weather months.

On the afternoon of Wednesday, September 6, an Eau Claire, Wisconsin, couple strolled toward the biggest of the Ferris wheels. He was a hardware dealer and a Prohibition leader.

Interested parties sometimes toiled up Machinery Hill only to find it deserted, however. In 1897, despite the fact that the Agricultural Society had provided sheds for those unwilling to invest in buildings of their own (in contrast to the "bare ground" approach customary at other fairs), the superintendent of the Machinery Department remained apprehensive about the success of his show until the very last application for space had been tallied. He was nervous because the makers of threshing machines had combined in 1896 to prevent the exhibition of their merchandise at any agricultural or trade fair, citing the expense of shipping and the lack of appreciation on the part of farmers as reasons for the sudden boycott. Hit hard by cyclical depression in the farm economy, firms dealing in harvesters had signed a similar agreement with devastating results. The boom-or-bust skirmishing between fairs and reluctant exhibitors continued off and on for years. In 1904 fair trials were tabooed by a consortium that included "all of the leading threshing machine manufacturers, the largest makers of plows, the country's leading makers of harvesting machinery and numerous vehicle concerns." In Minnesota, the Hill stood empty and quiet that year. But suddenly, with no word of explanation from the harvester trust, Minnesota was exempted from the ban in 1905, and 350 manufacturers appeared with carloads of wares. The implement display exceeded all previous efforts "by at least 40 per cent" and was compared favorably with those at "the so-called world's exhibitions." A relieved superintendent was happy to announce "there is positively room for no more."

The 1905 show was a remarkable event in other ways too. Streets had been graded across Machinery Hill and sidewalks saved the fastidious pedestrian from the usual hazards of ankle-deep dust or mud. Businessmen, bankers, and city editors followed the crowds to what had once been the almost exclusive domain of the farmer. There they discovered that the best of the new equipment was powered by the same internal combustion engine that ran the race car Barney Oldfield had recently brought to the fairgrounds for a five-thousand-dollar purse (during the off-season; the first sanctioned state fair auto race was held in 1907). They saw things like a steam plow that could cut sixteen furrows at once — older types of machinery enlarged in order to compete with the new products. They saw automatic seeders, weeders, cultivators, huskers, shellers, and potato diggers, all of which suggested "to what a science modern agriculture has been brought."

It was places like Machinery Hill, where the object lesson met free enterprise, that stimulated the development of automation on the farm, visitors concluded. "What agency has introduced into practical use the manure spreader, the hay loader, the silo, and a hundred other inventions that save labor and make for better farming?" asked a proud official of the Minnesota fair. And the answer, of course:

> The state fair. Books can be written, lectures given and sermons preached but the country implement dealer won't carry a new line until there is a demand, and the practical farmer won't demand a new thing until he has seen it in operation. He wants an optical demonstration. He gets this at the state fair, buys the machine, takes it home, demonstrates it to his neighbors, who in turn buy, and farming conditions in that community are improved.

Up on Machinery Hill — where International Harvester was running a newfangled moving-picture show entitled *The Romance of the Reaper* — prosperity reigned in the 1910s as Minnesotans embraced the technology of the new century with the fervor of true believers. Cars, silos, cement, and concrete were big sellers; the tractor made its first appearance in force.

World War I only accelerated the drive to modernize and mechanize the farm.

In 1917 there were widespread rumors that the War Department would close down state fairs to avert a shortage of freight and passenger space on the railroads. But Ray Speer, the Agricultural Society's resourceful publicist, turned the crisis to advantage when he marketed the state fair as a "Food Training Camp." For the duration, the usual competitions and exhibitions were given a special twist by using them to preach the "gospel of efficiency" of federal Food Administrator Herbert Hoover. Efficiency meant baking "liberty bread" with cornmeal instead of flour, cutting a dress pattern so as to avoid wasting fabric, canning and preserving garden produce (such as "flag pickles"), breeding stock that yielded a higher ratio of meat and fat to live weight. But, above all, it meant learning to produce larger crop yields from the same land by using farm machinery.

In the name of patriotism, management launched a successful campaign to fill the available berths on Machinery Hill with all the latest working models. (Outside space was free until 1920; indoor slots cost ten cents a square foot.) The massive display was intended to suggest alternatives to the continued use of horse- and manpower. Thanks to the draft and the demand of the military for horses, both were in short supply. But they were also unequal to the anticipated task of feeding Europeans, whose richest agricultural regions had been devastated by war. If enough food were to be produced to fill the international demand, Speer hypothesized, "the small farm tractor must be introduced as a supplement."

Much improved in type and performance over the last several years, the tractor was one ready solution to the labor shortage on the farm. But it also answered the farmer's need to be regarded as efficient, businesslike, and modern — a manager rather than a drudge. "It is . . . necessary for more farm machinery to be used in doing farm work so that man may become a supervisor of machinery rather than a manual laborer himself," Speer concluded. The first postwar state fair machinery show, in 1919, billed by the ebullient publicist as "the largest ever held in the world," included more than one hundred tractors and was advertised by a staged photograph of a pretty girl in high heels and a coverall behind the wheel of a new model. The picture reflected the changing social realities of the period; in 1915, for the first time in the history of the Minnesota fair, a woman had entered livestock in the show. But the sweet young thing at the wheel of the Fordson also suggested that *anybody* could operate today's efficient machinery. The farmer, meanwhile, was free to roam Machinery Hill, planning new and better ways to streamline his operation.

The Ford Motor Company dominated the show during the 1920s with the Fordson tractor. Like the popular Model T, it was cheap, dependable, easy to repair, and a tinkerer's delight — with the mere flick of a wrist, it seemed, all kinds of useful gadgets for doing farmyard chores, repairing access roads, and stringing fence could be hitched up. In 1924 Ford leased a large tract of land at the north end of the fairgrounds, on the border of Machinery Hill, and built a 235-foot show-ring into which all the adjacent streets funneled. There, during the annual run of the fair, the company held regularly scheduled shows of Fordsons pulling various pieces of Ford-made tillage equipment. Fifty other manufacturers who made attachments for tractors were also invited to participate. According to the *Minnesota State Fair News*, the extravaganza proved the tractor to be "the most efficient farm machine of the age."

There were those who worried that the enthusiasm for machinery had

She was the mother of five, including a baby not yet out of diapers. As Frank Sebenthal told their story the next day, it was his wife who wanted to ride the wheel:

I never approved of such forms of amusement. I have always had a dread of such dangerous things. My wife begged me to take her on the wheel. . . . When I first sat in the carriage I was seized with fear and from the time it started I was afraid. We had got to the highest point of the machine and we were turning on the down lap when something happened.

I think the bottom fell out of the carriage. I knew nothing until I awoke under the care of the sisters in the hospital. I did not know that my wife was dead and my family left without a mother.

Inspectors found "rusted and bent bolts and ramshackle joints" throughout the mechanism, which had become dilapidated by exposure to the elements and frequent shipments around the country. Agents for the owner tried to suggest that the deceased had caused the accident herself by thrusting her parasol through the guy rods while the machine was in motion, but no parasol was ever found and eyewitnesses disputed that explanation. The coroner's jury came to the fairgrounds to examine the wreckage, and the fair's chief engineer closed down all the Ferris wheels. Meeting in emergency session, the managers barred such devices from future state fairs.

The ban was lifted in 1913 and, in various versions, the wheels remain a carnival staple today. In 1933 the Royal American Shows revived interest in the venerable ride and garnered international publicity by running four giant wheels in tandem on the Minnesota State Fair Midway, where a hint of danger still clings to the great, revolving symbol of the age of machines as it turns against the nighttime sky. □

gone too far, that the gospel of efficiency masked the underlying problems of rural depopulation and economic distress. Addressing the Minnesota State Agricultural Society in 1929, Ohio's agriculture commissioner praised American efforts to meet the shortage of farm workers with machinery. "But there is a limit to the possibilities along this line," he insisted. "Machinery can never take the place of living, breathing, intelligent, energetic, earnest men and women." With the onset of the Great Depression, however, the dilemma of mechanization was temporarily forgotten. From 1929 until 1935 — the first good harvest of the decade — there were no "moving-type" demonstrations on Machinery Hill, although the Minnesota State Fair continued to enjoy a reputation as a center for equipment displays. When the exhibitors trickled back with the gradual improvement in the business climate, several innovations were to be noted. Tractors had balloon tires for speed, just like automobiles. But the reduced acreage had also created a demand for smaller garden tractors, and hard times stimulated a revival of interest in hand tools. A whole section of the Hill housed windmills that generated homemade electricity and patented bins for storing homegrown feed.

By 1938, with recovery in full swing, such economies were all but forgotten. Allis-Chalmers brought seventy-five different pieces of state-of-the-art equipment to the Minnesota State Fair that year, including a tractor-drawn, all-crop harvester adaptable to eighty-three different grains and grasses. Deere & Webber introduced a new corn cultivator with the blades mounted in front of the tractor so the driver could watch them without twisting around in his seat. As for tractors, they came in bright colors now, instead of basic black or brown; they were streamlined to "lessen wind resistance" and increase eye appeal; they all used pneumatic tires for comfort; and most of the newest ones ran on diesel engines. The show was bigger, better, and more up-to-date than ever.

In preparation for even bigger shows to come, the display area was redesigned in time for the 1940 fair. The landscape of Machinery Hill was "leveled off and squared up" to complement the streamlined shape of the new 4-H Building nearing completion on Cosgrove Street. Paved streets and concrete sidewalks were added. Underwood Street was driven northward from Commonwealth, creating a grand concourse linking the livestock and machinery districts. Fairbanks, Morse & Co., celebrating more than four decades of participation in the fair, unveiled plans for a "modernistic" headquarters in keeping with the sleek, aerodynamic look by which Machinery Hill as a whole expressed the futuristic dreams of Minnesota agriculture on the eve of World War II.

The state fair celebrated Minnesota's Territorial Centennial on Machinery Hill in 1949 with a special show contrasting old equipment — the straw-burning steam engine, the 1910 tractor with its huge iron wheels, the venerable McCormick reaper, the gang plows with eight-horse hitches once used to break the prairie sod — with the very best that modern industry had to offer. Ostensibly, this was an occasion for looking back with reverence at the primitive beginnings of contemporary agriculture. In the prosperous postwar period, when the drive for increased production to pay off the implement bill was manifest in harvesters capable of threshing thirty-five acres a day, it was tempting to forget the feast-or-famine cycles in farming best observed by counting the numbers of exhibitors on Machinery Hill in any given year. Like those before them, the Minnesota farmers of the Centennial Fair believed the promises of the technological future as they looked forward to an ever brighter tomorrow from the top of Machinery Hill. □

*Free visors draw a crowd for a dealer in tillers, 1954*

## THE GREAT LOCOMOTIVE SMASH

Machinery Hill spotlighted a beneficent technology. The devices exhibited there contributed to improved crops, better yields, higher income. But there was a dark and dangerous side to the machine as well, revealed in the acts of popular daredevils who defied death by pushing cars and planes and cycles beyond their limits. Fairgoers who bought tickets on the Midway rides became daredevils themselves for the duration of the circular voyage of the roller coaster or the Ferris wheel. Despite the dangers, however, those who took the rides and watched the stunts believed, for the most part, that the machines would not fail them. The pleasure of tempting fate on a carnival wheel is much greater when the danger is, in fact, very slight.

Nevertheless, the relationship between modern culture and the machine has always been colored by a tinge of Luddism—the wish to see the mechanism smashed and the old, preindustrial order restored. The staged collision, which enjoyed great popularity at the beginning of the auto-mad 1920s and was revived at the height of the economic crack-up known as the Great Depression, expresses the grimmer aspects of Americans' ambiguous relationship with their motorized alter egos. Donald B. Marti, in his *Historical Directory of American Agricultural Fairs,* attributes the invention of the prearranged locomotive wreck to Clyde G. Eberhart, manager of the Big Fresno Fair in California, who lured thirty-five thousand people and the nation's newsreel cameras to his grandstand show in 1919 by advertising such a spectacle. The young William Saroyan, then peddling soda-pop in the stands, thought that it wasn't much of a crash and that "everybody

who witnessed the event felt let down." But the immediate clamor for more and noisier collisions suggests that it had succeeded in capturing the American imagination.

The Minnesota State Fair scheduled its first collision for September 4, 1920. Two eight-wheel locomotives were purchased in Des Moines at a cost of forty thousand dollars and positioned on rails laid in the infield of the racetrack. When the trains were moving at sixty miles an hour under a full head of steam, the plan called for the engineers to leap from the cabs allowing "the iron monsters" to meet head-on. Publicity for the event reminded readers of the train wrecks they had read about in the newspapers and argued that the attraction was really a "safety-first lesson," illustrating "just what happens when rail employees and the public at large grow careless and disregard the warning: 'Stop, Look, Listen!'" The better parallel, however, was to the sentimental railroad ballads of the period—"The Freight Wreck at Altoona," "The Wreck of the Old '97," "The Engineer's Child"—recorded by popular hillbilly singers like Vernon Dalhart. The songs let the audience weep tenderly over the wrecked lives of others while reminding them of their own good fortune. Despite disingenuous claims for the educational benefits of the performance, the state fair train wrecks encouraged the release of these same emotions.

In both 1920 and 1921, the wreck was the principal opening day come-on, but for the second year new wrinkles were added to bring back spectators disappointed by the 1920 version, which had been held in a drizzle on tracks that proved too short with engines too light for a satisfying smack. The roadbed was lengthened in 1921, the speed increased, and the

engineers—Texas Carrington and "Wild Bill" Hayes—given a hero's buildup in the papers for added human-interest appeal. Although the outcome seemed foreordained, zealous press agentry also aimed to create a modicum of suspense about the pseudocalamity. "Rail engineers and experts refuse to predict what will happen when the locomotives collide," read the text of one such ad. "Only one thing is certain—there will be a terrific crash. They may roll over; one may telescope the other, or both may be pulverized into so much junk. The answer will be given . . . in front of the grandstand." But the Great Train Wreck of 1921 fizzled when dynamite, buried under the tracks to simulate a collision, went off after the locomotives had all but passed.

After a suitable hiatus, the locomotive crash returned to the Minnesota State Fair in 1933 as the centerpiece of a newly established Thrill Day. (The Iowa fair held the first midwestern Thrill Day in 1932; it too was climaxed with a train wreck.) This time, the tracks were elevated slightly at their ends, permitting a truly high-speed wreck, and the engines—actually, Minnesota Transfer Railway engines No. 30 and No. 34—were rechristened NRA (the National Recovery Act was the best-known of President Franklin D. Roosevelt's popular New Deal measures) and Old Man Depression.

The crowd was delighted but the fair was threatened with a lawsuit by J. S. Connolly of Des Moines, who had managed the less-than-satisfactory wreck of 1920. As he had in 1921, when the Minnesota State Fair staged its own locomotive crash without him, Connolly charged a violation of his copyright on the title "Head-on Collision." Had the board examined the record carefully, it might have noted that back in 1898 its predecessors had taken up the possibility "that a head-on collision may be among the attractions at the state fair this fall"—a full twenty-one years before Eberhart allegedly invented the locomotive crash in Fresno! In the absence of that intelligence, members of the board did what they had done in 1921—they voted to ignore Connolly and press forward with plans for 1934's act of destruction. A delegate was sent to Mason City to inspect a staged plane crash. But in the end, they settled for one last locomotive wreck at the Minnesota State Fair. □

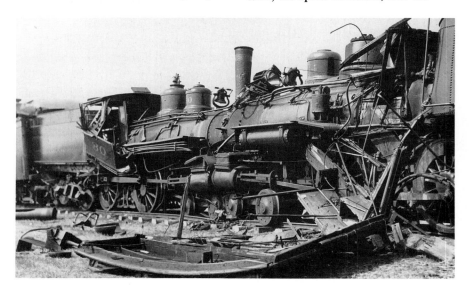

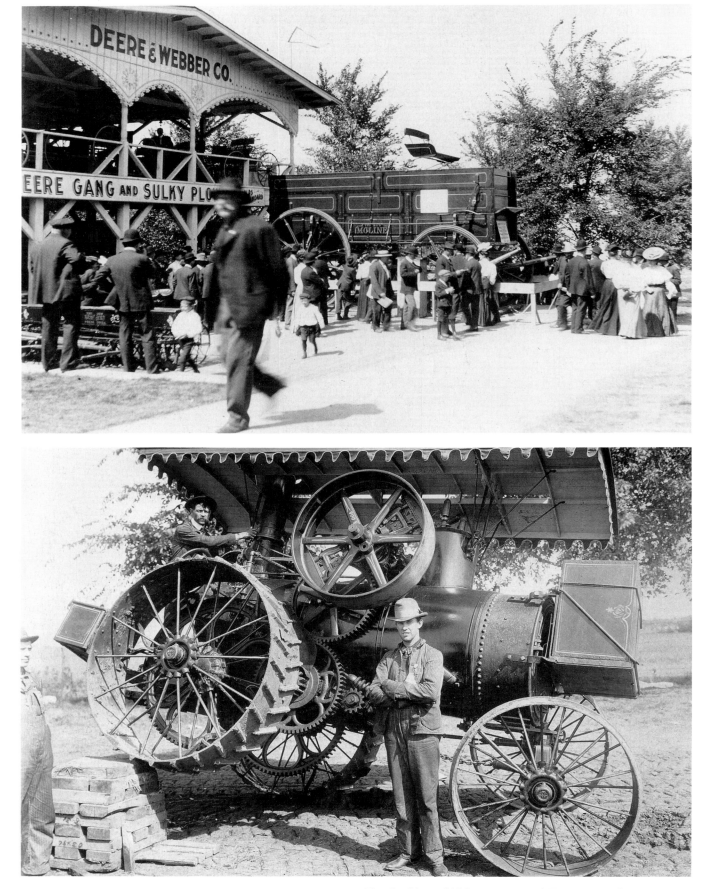

*The new Deere & Webber building, 1906; International Harvester and Minneapolis Steel and Machinery also built on the hill that summer.*

*Inspecting a tractor, 1903*

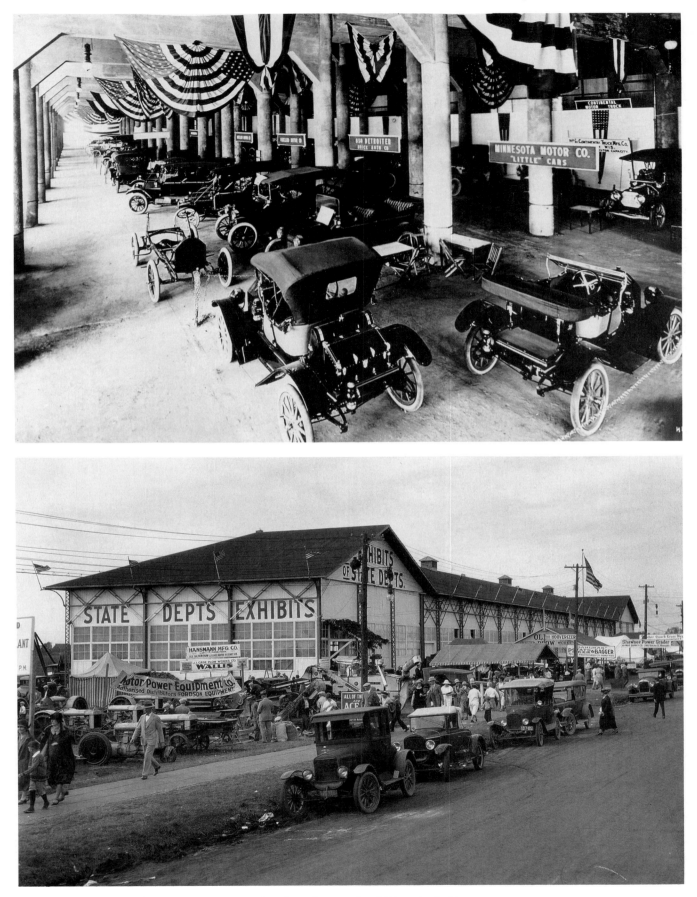

*The 1912 auto show in the Grandstand, the fourth such annual exhibit to be held at the state fair*

*State of Minnesota displays, housed on Machinery Hill in 1921*

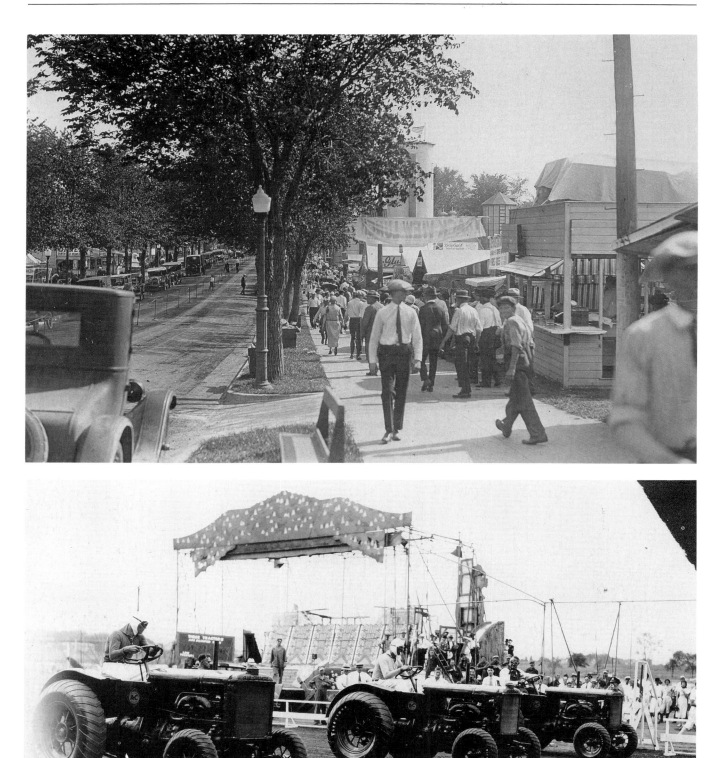

*Silos, water tanks, and "grab joints": Machinery Hill returned to normalcy after World War I.*

*Tractor race, 1933, an obvious gimmick to stir up interest in a flat market during the Great Depression.*

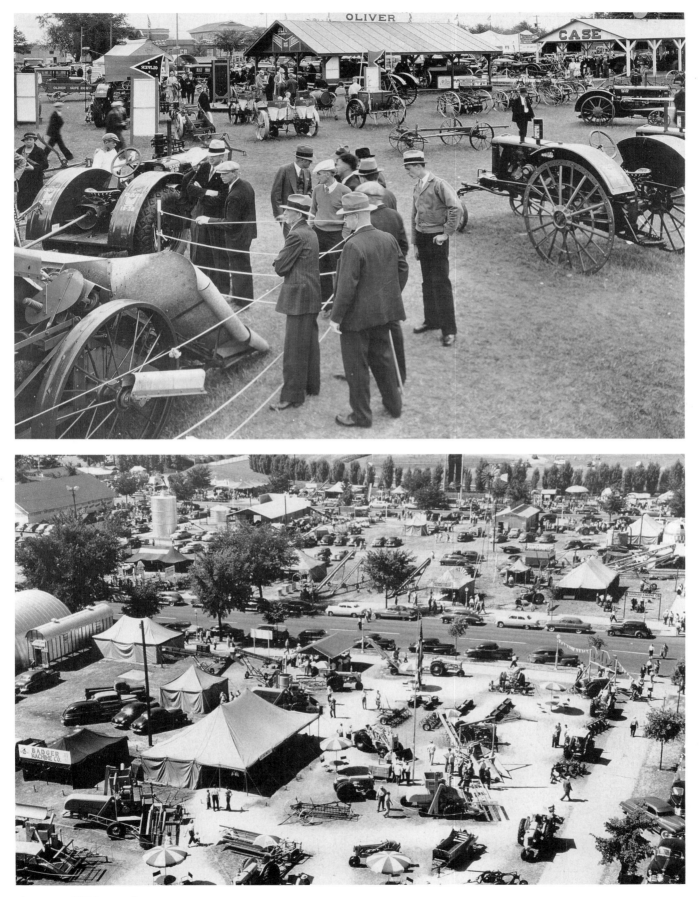

*A sparse 1934 crowd*

*The postwar boom changed all that; every inch of space on Machinery Hill was rented. Note Paul Bunyan's dungarees in the background, an expansive emblem for a period of great prosperity.*

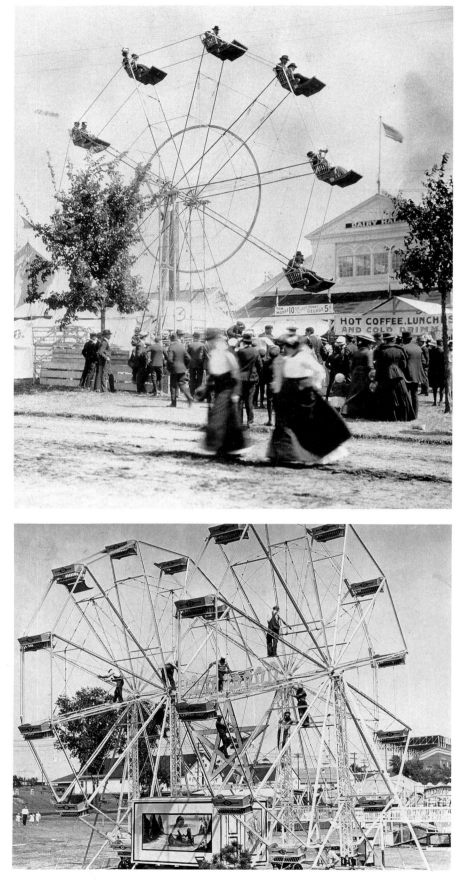

*Ferris wheel, 1902, which shared the luster of other modern technological marvels such as the Wright brothers' fragile biplane*

*Putting up tandem wheels, 1933*

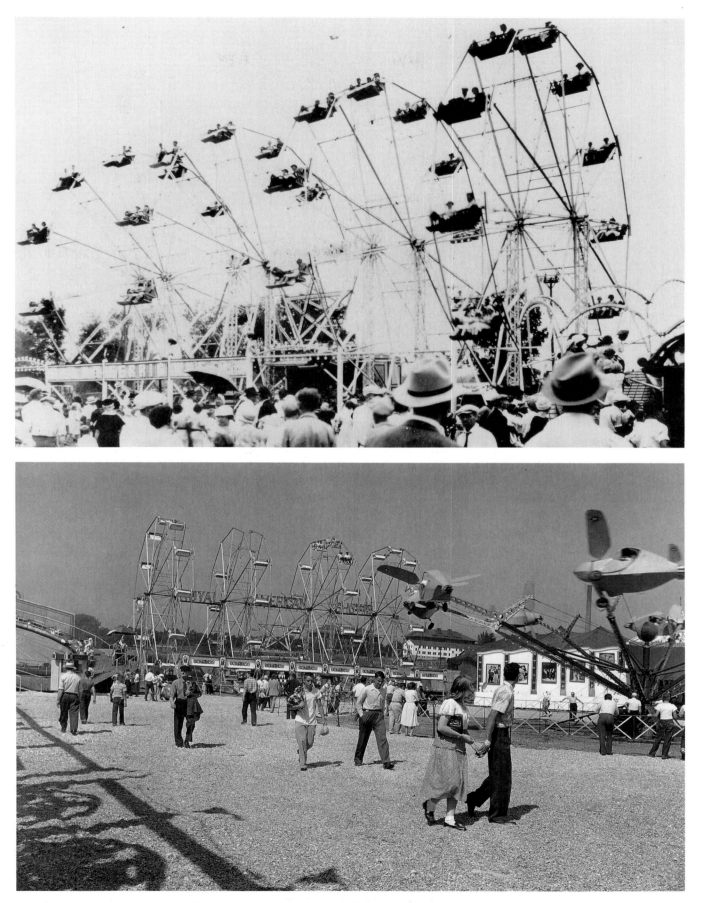

Four wheels in a row at the 1933 fair, claimed as the world record

Four wheels and make-believe military airplanes, 1948. Midway rides let the young
try on adult situations and mastery of the world of machines.

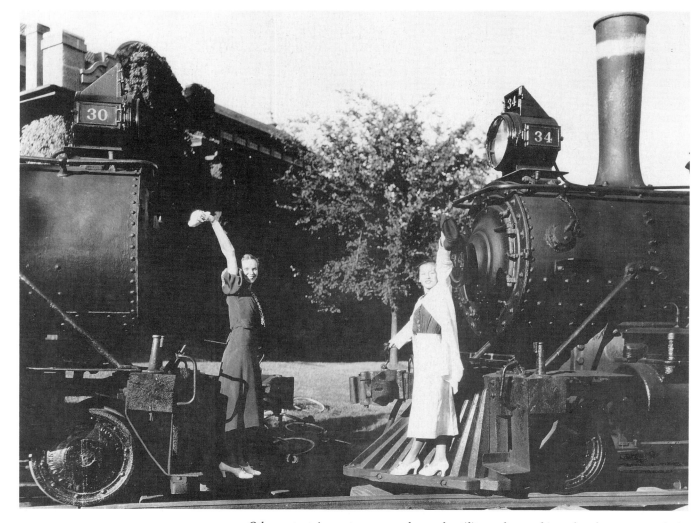

*Other entertainments expressed open hostility to the machine: the glamorous prelude to the staged train wreck, September 8, 1933.*

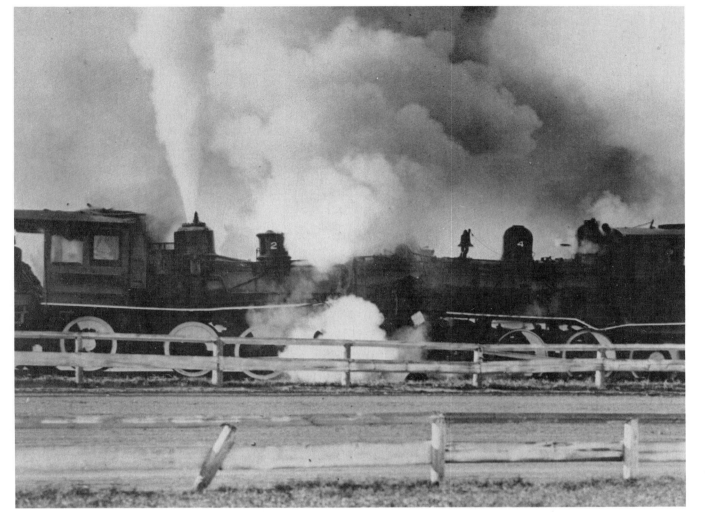

*They did it again in 1934, with even more satisfying results.*

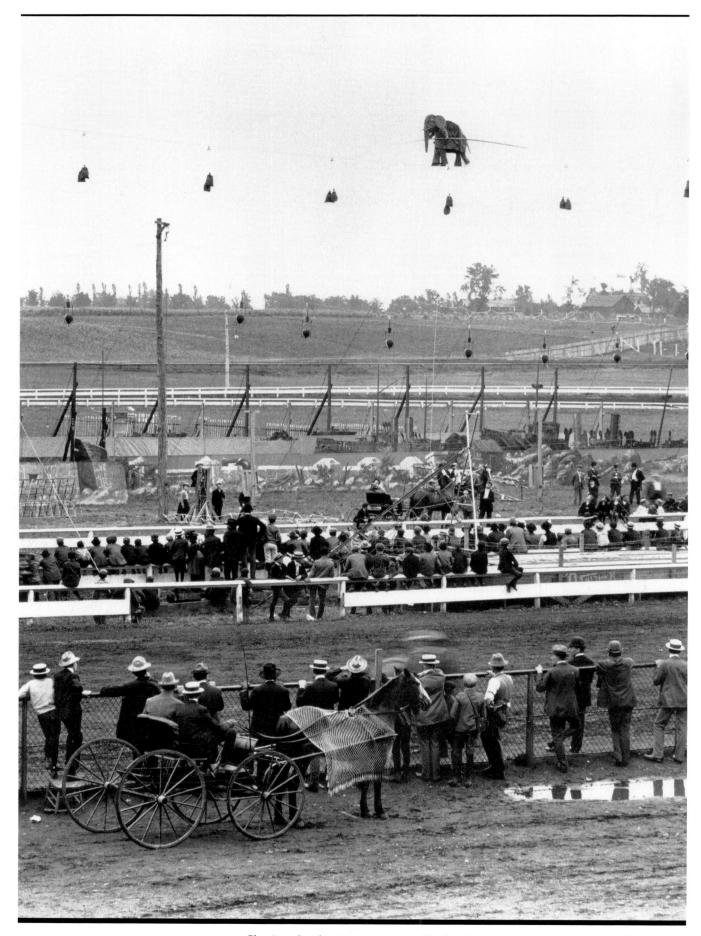

*Sharing the daytime program with the feature races, a tightrope-walking team, about 1900, compounded its difficulties by performing in an elephant suit.*

# THE WORLD'S GREATEST OUTDOOR ENTERTAINMENT SPECTACLE

FAIRS HAVE ALWAYS meant entertainment. In Minnesota, lady equestrians, a manned balloon flight, brass bands, horse races, and a stiff dose of political oratory rounded out the ideal program of diversions during the fair's early days.

As the state fair increased in scale and moved to a permanent site with ample room for grandstand spectators, entertainment features multiplied. In 1887 eighty-five thousand witnessed a Civil War battle reenactment, and the following summer, when the fair was officially opened by the push of an electric button, a second such spectacle proved only slightly less popular. Electricity was the real key to the expansion of the annual program of amusements — once artificial lighting of the grounds permitted operation after dark, organizers were pressed to fill those newly created leisure hours with spectator events of interest to urban workers who came to the fair after a full day at factory or office.

Nighttime Grandstand shows began in 1899 and consisted of an hour of harness racing followed by a massive fireworks exhibition. From 1899 and the "Burning of Manila" through the 1920s, when "1776," the "Fall of Troy," and "A Night in Baghdad" provided the themes for elaborate pageants of light and sound, these wordless dramas were the accepted form of outdoor entertainment. Shows produced by fireworks companies such as Pain, Gregory, Porter, Thearle-Duffield, and their competitors made the circuit of state fairs after being perfected at Manhattan Beach, the Canadian National Exhibition in Toronto, or a world's fair.

Certain productions became old favorites, cherished by several generations of the Minnesota families who made it a point never to miss a program. "The Burning of Rome," first mounted above a three-foot-deep Tiber in a tank in 1903, was brought back again in 1925, for example. "The Last Days of Pompeii," based on the novel by Bulwer-Lytton, was revived for the fiftieth anniversary of its New York debut in 1929 after "scores of letters and calls were received from . . . all parts of the state" (where "Pompeii" had last been seen in 1916) urging the commemoration. "The universal sentiment was that no outdoor entertainment in the last half century had made such a lasting impression on the general public, or reached such a height of spectacular and dramatic quality as this famous extravaganza."

However compelling, by 1929 the fireworks pageant was merely the climactic element in a larger schedule of nightly events. Followed by aerial fireworks in the forms of moving cartoon characters, Niagara Falls, Commander Byrd at the South Pole, or a pyrotechnical interpretation of George Gershwin's "Rhapsody in Blue," the spectacle was traditionally preceded by various daredevil, vaudeville, and circus acts. These might include a

*A Peugeot racer "aviating" above the racetrack, about 1916*

lady fire diver, who hurled herself into a tank of water in flames; a troupe of dancing ponies; the Seven Grunathos (female acrobats); Treat's Trained Seals; "Norman, the Frog Man" (a contortionist); the Navassar Ladies' Band; auto polo matches; the Flying Codonas (aerialists); "Poodles" Hanneford, the clown; various high-diving horses; and several generations of the Zacchini family, acclaimed for being shot from cannons.

After 1890, when the state fair attracted the greatest crowd in its short history by reviving the ladies' riding match, the desire to stimulate fair going with pure entertainment led to annual increases in the number and fame of the scheduled features and a corresponding expansion and replacement of the old Grandstand. At the turn of the century, agricultural purists only tolerated such adjuncts to serious business for the income they generated. By 1915, however, entertainment in general was being defended as a legitimate aspect of the recreation necessary to ward off mental exhaustion in a fast-paced modern world. Citing the Country Life Commission's criticism of the drudgery of rural existence, officials of the Minnesota fair asked if "the greatest state Fair in the world" should reject a schedule of events that brought enjoyment to so many and "turn its back upon the spirit of advancement and progress?" And if social research were not sufficient reason for believing that "entertainment is as much the purpose of the Minnesota State Fair as the exhibits of live stock or machinery," statistics showed that 57.3 percent of all the premiums awarded at the most recent fair had been paid for by profits from the Grandstand programs.

When fairs justified their amusements on the basis of a "Play Spirit" needed to ward off ennui and rekindle ambition, they were echoing the prevailing ideology of mass culture in the 1910s. According to the ads, at any rate, passive spectators at movies and sporting events came away with some borrowed measure of the youthful vigor embodied in a Douglas Fairbanks-style hero. The vicarious pleasure of watching someone perform a fairly routine task—at higher speeds than ordinary common sense dictated—did contribute to the popularity of auto racing and stunt driving during the years surrounding World War I. One former sportswriter and historian of the racing oval credits the Minnesota fair with being the first "to pay special attention to auto racing as an attraction." In fact, the transformation of the high-performance automobile from an annoyance that frightened the racehorses to the agent of their ultimate downfall was remarkably swift. In 1904 the race car was just another novelty item, of interest because the featured motorist was a pretty young French girl, but in 1909 Ralph DePalma, "the Demon Driver," piloted a Fiat Cyclone to three official world's speed records before the new state fair Grandstand. The last remaining harness race was dropped from the state fair schedule in 1950 to make room for eight full days of auto heats on the track where the immortal Dan Patch had set his record.

From the beginning, with only one or two days of racing on the card and safety questions on the lips of irate horsemen, the throngs turned out nonetheless to see Barney Oldfield, Walter Christie, Louis Chevrolet, and "Wild Bill" Endicott in his twenty-seven-thousand-dollar Lightning Benz. Enthusiasts demanded an even greater proportion of the daylight schedule, reasoning that with sales of cars on the rise, "the time has come . . . for the horse to take not more than half the attention on the annual state fair program." In the teens, the 1920s, and the early 30s—until he retired to open a garage—Sid Haugdahl, the "Norsk Speed King" from Albert Lea, dominated the state fair track. During his reign, purses reached ten thousand

dollars, crowds of fifty thousand were not unusual, and the management boasted that Minnesota had invented dirt-track racing. "The first auto race ever held by any fair in the world was put on by the Minnesota State Fair, almost fifteen years ago," read flyers promoting the 1921 meet. "Up to that time it was not thought possible to stage an auto race on a . . . circular dirt track. Today 95 per cent of all the auto racing in America is done on half-mile and mile dirt tracks."

Despite the fatal crashes of local drivers Clarence "Norske" Larson and Charles Anderson in the early 1930s, auto racing finally achieved parity with horse races in the fair's "speed program" during that decade (after three days of cars and three of horses, the seventh was given over to motorcycles), and a group of midwestern fairs, led by Minnesota's, created a new racing circuit to secure quality matches. On Labor Day in 1936, seventy-three thousand fans — the largest crowd ever to witness a race of any kind at the fair — watched Gus Schrader, American dirt-track champion, best Emory Collins by less than three feet in the ten-mile U.S. championship.

Auto racing was banned during World War II as part of the effort to conserve gas and rubber, and throughout the 1950s the sport was plagued by problems: charges of monopolistic practices directed against the fair by operators of rival speedways, a rash of gory accidents, a slow decline in spectator interest. The appearance of well-known drivers from the Indianapolis 500 — A. J. Foyt, Mario Andretti, and Johnny Rutherford all competed at the fair in 1965 — kept the tradition alive, and a weekend of sanctioned races could still attract twenty thousand paid admissions in 1982, but the heroic days of state fair auto racing ended with the Great Depression.

The makeshift oval before the Grandstand was no longer the place where records were set, headlines written, auto design changed, and local heroes born; racing had become a brisk, impersonal affair with superstars hustled into town for the day and gone again at nightfall with their cars and crews. For excitement, noise, machinery in the raw, and the passion somehow missing from orthodox racing, some fans preferred the periodic appearances of the Joie Chitwood Auto Daredevils, the "human battering ram" who crashed through a flaming wooden wall strapped to the hood of her husband's stunt car at the 1952 fair, or the "powderpuff" entry in the first State Fair Demolition Derby, held in 1971. Performed on the same track where the races were run, auto stunt shows were components of various Thrill Day or Thrillcade programs designed, as the name suggests, to exercise the emotions at some primary level.

In 1899 *Billboard*, the trade journal of the itinerant showman, suggested that fairgoers demanded stunts in hopes of seeing someone killed and sarcastically noted that "the balloon part of an agricultural fair has become too free from casualties to be attractive." But if newspaper accounts of various aerial disasters at the state fair are to be believed, most Minnesotans were properly appalled, for example, by the accident that befell balloonist Joseph Hoffman at the Grandstand in 1902 when his parachute failed to open and he plummeted four hundred feet straight down into a pile of lumber. The real purpose behind the feats enacted in fast cars and in a succession of airborne craft was to allow the spectator to rehearse those unfamiliar feelings of terror and exhilaration associated with modern vehicular technology. Thus the fair acted as a potent agent of modernization, acclimating Minnesotans to the presence of cars and planes in the twentieth-century world and to the feelings elicited by the prospect of taking a flight or driving a car of one's own.

## F. SCOTT FITZGERALD SURVEYS THE PLEASURES OF THE FAIR: SEPTEMBER 1911

"The two cities were separated only by a thin well-bridged river; their tails curling over the banks met and mingled, and at the juncture, under the jealous eye of each, lay, every fall, the State Fair. Because of this advantageous position, and because of the agricultural eminence of the state, the fair was one of the most magnificent in America. There were immense exhibits of grain, livestock and farming machinery; there were horse races and automobile races and, lately, aeroplanes that really left the ground; there was a tumultuous Midway with Coney Island thrillers to whirl you through space, and a whining, tinkling hoochie-coochie show. As a compromise between the serious and the trivial, a grand exhibition of fireworks, culminating in a representation of the Battle of Gettysburg, took place in the Grand Concourse every night."

— "A Night At the Fair" (1928) □

The most dramatic stunts involved the very latest modes of conveyance or odd combinations thereof. The latter category included bicyclists riding wires strung atop moving automobiles, races between planes and cars, and tricks in which drivers clambered up rope ladders into moving aircraft. The former included speed trials involving balloons, dirigibles, an Orville Wright-made biplane, the sister ship of Charles Lindbergh, Jr.'s *Spirit of St. Louis*, zeppelins, and hovering autogiros, each novelty giving way to the next in short order. And from the very beginnings of powered flight, the state fair assumed a position of leadership in promoting civil aviation, often against stiff opposition.

In 1909 a flurry of editorials in newspapers across Minnesota took Secretary Cosgrove to task for turning the fair into a circus by offering a twenty-five-thousand-dollar purse for an air race between French pilot Louis Bleriot (who had just flown the English Channel) and the Wright brothers. Cosgrove not only maintained that "demonstrations by a practical aviator would be the greatest drawing card the state fair has ever had" but also justified the expense on the grounds that the management was duty bound to prepare Minnesotans for the inevitable. "The whole community used to be aroused when some local spendthrift came out with an $800 one-lunger," he recalled. "Now we glance carelessly up . . . and murmur: 'There's Bill Jones' new $10,000 250 horsepower touring car' and then go on trying to figure out what this season's wheat crop is going to be. Five years from now most of the young bloods . . . will go soaring through the air and shooting from the country club to the roof garden regardless of speed limits or grade crossings." Undeterred by his critics, Cosgrove pledged to meet the offer of any competing fair or exposition. "If we can't get Bleriot," he concluded (and he didn't), "I am satisfied we can get Latham or Glenn Curtiss. The Minnesota state fair was the first western fair to exhibit a dirigible balloon and will be the first western fair to exhibit a practical aeroplane in flight."

Cosgrove's prediction came true almost immediately. The first flight in Minnesota history, although sponsored by private promoters, took place on the fairgrounds on June 20, 1910, and the state fair contracted with the Wright Company for a series of exhibitions later in the summer. The Labor Day flight failed to become airborne and the pilot was injured, but on two subsequent days his partner succeeded. And Fred Parker, a youth from Hamline, also gave demonstrations in a monoplane under a crowd-pleasing agreement that paid his salary only when his aircraft achieved a height of forty feet above the racetrack. In 1911 the Wright team was back again with a contract that illustrated the strides made by the industry during the past year: it called for flights of at least ten minutes each at heights of at least two hundred feet.

By 1912, when the National Aeroplane Company brought two biplanes and a Nieuport monoplane to Hamline under a similar arrangement, level flight had ceased to be of much interest to Minnesota fairgoers. The era of stunt flying began. Lincoln Beachy looped the loop in 1914. In 1915 DeLloyd Thompson flew upside down and Art Smith made a night flight, setting off the Grandstand fireworks as he went. Ormer Locklear, the first of the wing walkers, appeared in 1919. The beautiful Ruth Law, an early "aviatrix" and proprietor of her own Flying Circus, dangled fetchingly from the fuselage in 1920 and 1921. In 1922 Lillian Boyer became the first woman to perform the risky auto-to-airplane transfer. Gladys Roy, a Minneapolis native who learned her trade at the Robbinsdale Airport, did aerial acrobatics

while blindfolded, before being injured in a routine parachute jump at the 1926 fair. And in 1935 Captain F. F. Frakes, a former mail pilot, added a new wrinkle to thrill flying by deliberately crashing his plane into a flimsy "house" erected in front of the Grandstand.

In 1923 the state fair received (and promptly tabled) several protests against attractions which "depend for their popularity on the hazard of human life." One petition acknowledged that auto racing would probably continue and merely recommended structural alterations in the Grandstand oval to prevent future accidents. A second, more vehement document demanded an end to stunt flying, calling it a detriment to "public confidence" in the safety of commercial aviation. But it was only in 1951 — after a biplane failed to come out of a dive and drilled itself into the ground near the intersection of Snelling and Larpenteur, killing the pilot and his seventeen-year-old stunt girl as thirty-two thousand spectators watched in horror — that aerial thrill shows were banned from the fair.

Before World War II put a more businesslike face on American aviation, stunt flying was one of the most popular forms of daytime entertainment at the state fair. Fireworks and a potpourri of vaudeville and circus acts sufficed for the evenings. But the entertainment business as a whole showed signs of a major upheaval, manifest as early as 1927 with the coming of John Philip Sousa, the first real "name act" at the Minnesota State Fair. "The World's Greatest Bandmaster" had been on the road with his ensemble for thirty-five years but had never played a fair or a circus. Sousa made an exception for several choice fairs that summer, however, and arrived in Minnesota from the Iowa fair in Des Moines wreathed in advance publicity and bearing a newly composed "Minnesota March" for presentation to the university. Declining to lend the institution's name to any music-for-profit scheme, university officials refused to appear at the fair to accept the gift, but Sousa's engagement was a rousing success despite the snub. Thanks to the music-publishing industry, records, and the radio, Sousa was one of the nation's most famous popular musicians, and fairgoers, like other devotees of America's burgeoning mass culture, had learned to prize a celebrity. It was one thing to have a band at the state fair; it was quite another to have John Philip Sousa in the flesh.

*John Philip Sousa*

Significant changes in the time-honored fireworks show during the 1930s and 40s also reflected Minnesotans' demands for innovative forms of entertainment and for genuine stars, well known from their appearances in the media. By way of sprucing up the old nighttime pageant, for instance, the superintendent of amusements (after inspecting a similar show in Des Moines) added ballet numbers, dialogue, music, and a stronger story line to the 1930 fireworks show. Called "The Awakening," the production traced the history of the world from Adam and Eve, Nero, and the American Revolution to the present day, which was symbolized by the traditional burst of rockets at the end of the program. Subsequent evening spectacles depicted the great cities of the world and even episodes in Minnesota history. Although the shows were standardized affairs, appreciated precisely because the same routines had already thrilled customers at the Iowa State Fair or the Century of Progress Exposition in Chicago, producer Frank Duffield could tailor any given performance to the special needs of his clients.

By 1935 the old fireworks thriller had become a snappy State Fair Revue, with dancers "direct from Radio City's Music Hall," minor Hollywood starlets, a series of musical numbers with titles like "The Opera" and "The Follies" — and, of course, a "smashing fireworks finale." The 1936 revue

spotlighted the "Stair-O-Tone," a musical staircase "played" by a quartet that tapped out tunes with their toes as they danced up and down in a style associated with choreographer Busby Berkeley and the popular Warner Brothers movie musicals of the period. The 1939 version, with its futuristic sets and squads of chorus girls swinging giant hoops in synchronized patterns, further suggested Billy Rose's distinctive water ballet at the New York World's Fair of that year. Their tastes sharpened and refined by the pictorial spreads in magazines and nights at the local movie houses, Minnesota fairgoers turned out for shows that brought the glamour of Hollywood and Radio City to the Grandstand.

All the fair lacked now was a star of the first magnitude. In 1941 the State Fair Revue indeed promised no fewer than "57 headline acts," but the real attention-getters were Edgar Bergen, the radio ventriloquist, and his wooden-headed sidekick, Charlie McCarthy, whose one-night stand all but overshadowed the nine-day run of the variety show. Although the revue was still being staged in the 1960s, it had become little more than a showcase for name acts imported from television and the Top 40. Ricky Nelson of the popular comedy "The Adventures of Ozzie and Harriet" starred in a special, free Grandstand show on Children's Day in 1957, just after his first rock-and-roll record, "I'm Walking," had made him America's prime teenage heartthrob. His appearance set the precedent for a series of nighttime shows built around the hit records or TV routines of current favorites like Al Hirt, Anita Bryant, Rosemary Clooney, the Smothers Brothers, Patti Page, Bob Newhart, and the Supremes.

In 1969 ads for a Johnny Cash concert at the Grandstand drew twenty-six thousand fans, many of them willing to settle for standing room only. The police had to be called after a ticket seller's cage "was nearly destroyed by the surging crowd." Introduced by warm-up acts that traveled with his show—the Statler Brothers and the Carter Family—Cash did a full program of nineteen songs and two tumultuous encores. His solo triumph confirmed the concert format as the new standard for state fair shows. The Grandstand became the domain of the superstar.

The daredevil acts are free at today's fairs and are apt to be found at any convenient spot on the grounds—in 1986 and 1987, wire walker Jay Cochran performed on a cable strung between the turret on the 4-H Building and the top of the Space Tower, and the trick divers did their number in a tank set up beside the Dairy Building. The bandshell and smaller stages in Baldwin Park, Heritage Square, and the International Bazaar presented gifted amateurs, local talent, acts whose fortunes were on the rise, acts whose fortunes had probably reached their peak. In venues scattered from Machinery Hill to the fringes of the Midway, the entertainment never stops. The orators and racehorses of old are in short supply. But some things haven't changed. When the last show is over, old-fashioned fireworks still light up the sky above the Grandstand, and everybody still gasps in wonder at the glorious nighttime spectacle. ☐

## "I SAW RICKY NELSON"

"I remember the trip I made to the State Fair on my own, hitching a ride from Isanti County with a neighbor, and spending the entire day there taking in all the sights by myself at the age of 13.

"The year was 1957 and Ricky Nelson was scheduled to appear at the Grandstand on the first Monday of the Fair—Children's Day. That also happened to be the day when Ayrshires were one of the featured cattle breeds. Our neighbor Martin was an Ayrshire fan who always spent that day at the Fair, leaving his wife at home to take care of his Ayrshires. My mother apparently had no fears about my spending the entire day at the fair alone. Even though the State Fair was in 'the Cities,' it was different from 'downtown.' Just two years earlier my girl friend and I, sans parental accompaniment, were allowed to spend the day 'downtown' but were limited to the confines of Woolworth's for six hours until her father picked us up.

"At any rate, Martin and I arrived at the fair early in the morning so he could get a good parking place near the livestock barns. The free Grandstand performance featuring Ricky Nelson (with Brenda Lee as the opener) was jam-packed with pre-teens and teenagers. I sat so far away from the stage that I could hardly see either performer but it was quite a thrill.

"However, I discovered in my wanderings around the Fair that Ricky Nelson was also appearing that night at the Horse Show at the Hippodrome. I checked ticket prices and decided to splurge on a ticket for $2.50, which meant that I had barely enough money left for food and certainly not any for souvenirs, rides or trinkets.

"I cannot remember what I did all day, and my diary records only the following: 'I went to the State Fair today with Martin. It was cold out. I saw *Ricky Nelson* and Brenda Lee at the Grandstand. I went to the Horse Show tonight at the Hippodrome and saw *Ricky Nelson* again.' It is probably significant that the entry is written in pencil but 'Ricky Nelson' is underlined with a ball point pen!

"I do remember that I found the horse show rather boring. But I pretended to enjoy myself and was well rewarded because when Ricky Nelson performed during the intermission, he faced the end of the Hippodrome where I was sitting! And he was much closer than at the Grandstand that morning. I still remember the green sweater with the two white stripes on the left sleeve. It was almost more than a midwestern 13-year-old could bear!

"I had to leave the horse show shortly after the intermission so that I could meet Martin for the ride home. I was sure that his day of hobnobbing with fellow Ayrshire fans had been far less eventful.

"However, my diary entry for the next day indicated that I had a fever and a cold. You pay for your thrills!"
— Marilyn Anderson McGriff, Braham □

*Marilyn Anderson at the fair in 1960, when she entered the 4-H Dress Revue*

## PRINCESS KAY AND HER SISTERS

For many years, the traditional kick-off to the entertainment program of the Minnesota State Fair was the coronation of a new Princess Kay of the Milky Way at the Grandstand. During her year-long reign, the lucky winner travels the state promoting the dairy industry, but her most onerous duties begin the morning after the pageant. She is the first of the eleven-member court of regional dairy princesses to be sculpted in butter in the revolving cooler in the Dairy Building; thereafter, she rides in the evening parades and generally presides over any fair-time event that demands a regal presence. She is a lovely symbol of the Minnesota State Fair.

Princess Kay was the brainchild of Lew Conlon, manager of the Minnesota Dairy Industry Committee. Inspired, perhaps, by Wisconsin's Alice in Dairyland promotion, Conlon developed the notion of a beauty pageant to involve "4-H and FFA (Future Farmers of America) girls who had no dairy projects" at a time when dairy farmers were switching to beef in great numbers because of adverse publicity about nuclear fallout and high cholesterol in milk products. A regional pageant with contestants from eleven northwestern counties was held during a "Dairy Day" meeting in Thief River Falls in June 1950. In 1953 the contest became a statewide affair, and Eleanor

Maley of Grand Meadow was named Princess Kay I.

Although organizers have always asserted that "no girl has ever won the Princess Kay crown on the strength of looks alone," eligibility requirements and the orientation of the contest have varied over the years. During the 1950s and 60s, for example, despite claims to the contrary, publicity surrounding the competition gave it all the trappings of a homegrown Miss America contest. By 1970, reflecting a shift in attitudes about beauty contests in general, scaled-down festivities had been moved to the Dairy Building, and by the late 1980s the coronation was held on Preparation Day (the evening before the fair officially opens) at the bandshell on Cosgrove Street. The young women competing must hail from a farm; their parents have to be "actively engaged in the production of milk for sale to a licensed plant." Deglamorized somewhat, then, Princess Kay has become a comfortable, down-home tradition of the Minnesota State Fair, and the selection process emphasizes each candidate's ability to serve as a knowledgeable and articulate ambassador for the Minnesota dairy industry.

These changes in the character of the pageant and its role within the program of the fair correspond closely to the ups and downs in the history of the American beauty contest. A product of the 1920s and the freedom of

the "new woman" to wear a revealing bathing suit if she so chose, such contests reached their peak of popularity in the 1950s and 60s when pageants served to endorse a domesticated and subservient image of the ideal woman. In 1968 and 1969, activists in the women's movement picketed the Miss America Pageant in Atlantic City, protesting its role in perpetuating sexual stereotypes. Others charged organizers with excluding women of color. When beauty contests made a modest comeback in the 1980s, officials were quick to deemphasize or at least disguise the "cheesecake" aspects of the events with a new stress on talent and the ability of the contestant to serve as a spokeswoman for the products of the commercial sponsors.

The first beauty contest at the Minnesota State Fair was a competition for the title of Miss Minneapolis conducted by written ballot under the auspices of the Minneapolis Trades and Labor Assembly in 1923. Two years later, a young woman "discovered safe from sheiks and movie directors on a farm near Rochester" was named Miss Minnesota by the state agencies mounting exhibits on Machinery Hill. There she was stationed during the fair, chaperoned by the governor's wife, to meet the people. Bernice Pennington's selection was also a critique of beauty pageants elsewhere; her wholesome beauty and awards for cake- and breadmaking were said to show "that

*Foot inspection, 1934, part of the contest for the title of 4-H Health Queen*

*The 4-H Style Queen, 1937, flanked by the other candidates. All contestants made and modeled their own clothes.*

bathing suits are not the standards of measurements in Minnesota farmlands."

But Minnesotans were by no means immune to the power of a pretty girl to garner attention for a product or industry. In 1929 commercial air carriers based in Chicago sponsored a Carnival of the Sky at the Minnesota fair. To promote aviation, the plan called for trimotor planes to swoop down on thirteen Minnesota towns and pick up the winners of "popularity contests" held in local movie houses. These "sky princesses" would be flown to the state fairgrounds to compete for the crown of Miss Minnesota; she would face young women from fifty-nine major American cities in a pageant to select "Hera, Goddess of the Sky." Publicity pictures showed the leggy local queens wearing the fashionable short skirts and cloche hats of the day and all but obscuring the aircraft behind them.

The appeal of a pretty queen was undeniable, although Minnesotans frequently insisted that state fair royalty possess other attributes as well. The annual 4-H Style Revue, begun in 1933, selected a Miss 4-H Minnesota (with a cardboard crown and three ladies-in-waiting) on the basis of the appearance and workmanship of a homemade outfit. Although the state 4-H leader asserted that "pulchritude has no place in this contest," it is clear from the publicity surrounding selection of the annual style and health queens that attractive young people

who also embodied the values of thrift, cleanliness, and hard work were the natural monarchs of the 4-H competitions. Her practical accomplishments always carefully enumerated, the Style Queen fell into an entirely different category, for instance, than the various unofficial Miss Minnesotas chosen from among the more winsome female performers in the night shows at the Grandstand during the 1930s.

With the end of World War II and the rise of highly formalized beauty pageants, reporters lost interest in industrious 4-H queens. Dressmaking contests became genuine club events, attended chiefly by those who made it a point to visit the new 4-H Building on Machinery Hill. The big-time beauty pageants, meanwhile, moved to the Grandstand. An elaborate contest was held in 1949 to select a Centennial Queen and court to preside over Grandstand events. In the 1950s and 60s, Miss America contestants routinely stopped at the fair to drum up publicity for their own pageant and to lend prestige to the new Princess Kay ritual. But the most interesting beauty contest of the period was the Mrs. America Pageant, headquartered at the state fair in 1968.

Staged on the eve of the Miss America protests, the 1968 Mrs. America Pageant was perhaps fated to be a troubled event. For most of its thirty-year existence, the competition had been held in Florida; it moved to Minnesota in the midst of a transition

in sponsorship punctuated by rumors that the outgoing titlist had not received the prizes owing her. Refusing to host the event for a second year, the state fair management later charged Mrs. America officials with gross incompetence, citing bungled judging procedures and a history of failures to secure network TV coverage. But in many ways the contest was blighted by its own ferocious domesticity. In addition to the usual displays of physique, the program included pancake making, parallel parking, "child communications," preparation of a canned ham, and a variety of other so-called contests that attempted to turn the most undemanding household tasks into occasions for serious competition.

Coming at a time when the role of the homemaker was being reexamined by author Betty Friedan and her feminist colleagues and younger women were beginning to assert their personal and political rights, the cloying combination of sex appeal and domestic trivia would probably have proven fatal to the Mrs. America enterprise in Minnesota even without its administrative shortcomings. By the 1980s state fair beauty queens— Princess Kay, the Honey Princess, the Lamb Princess, and their numerous sisters—were pretty young women who were most noteworthy for the brisk competence with which they dispensed ribbons, greeted fairgoers, and discussed the merits of their respective products. It has always been a function of the agricultural fair to determine and articulate local standards of excellence through competition. Princess Kay and the other royalty of the Minnesota State Fair are the best in their class: they typify the intelligence, self-assurance, and poise expected of modern young Minnesotans. □

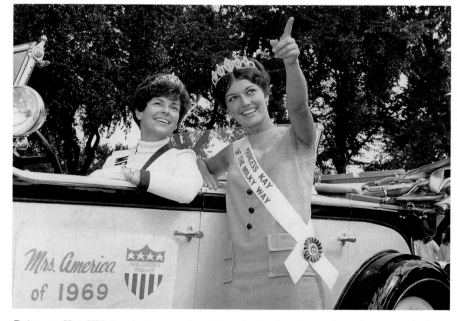

*Princess Kay XV, Linda Louwagie of Marshall, showing points of interest to Joan Fisher, Mrs. America, 1969*

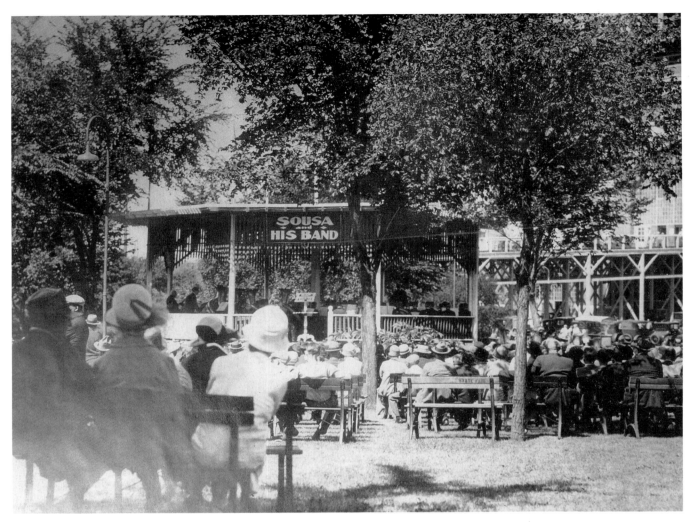

*Crowds gathered to see and hear the famous Sousa and his band, 1927*

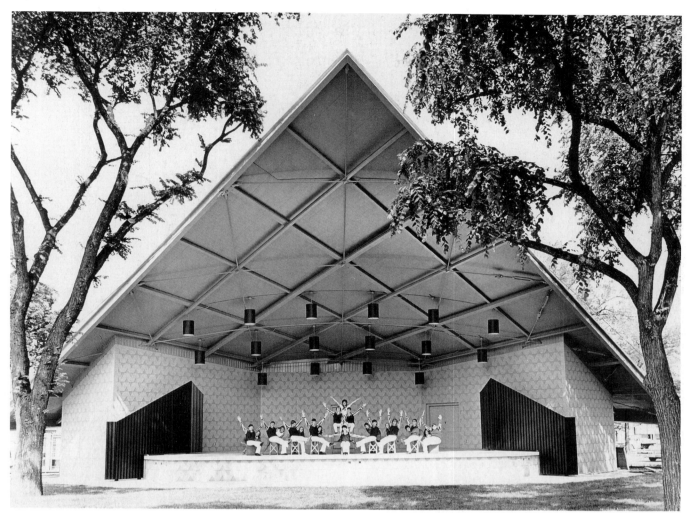

*Fair Tyme Singers at the brand-new bandshell in Administration Park, 1971. Free shows are still a major feature of the fair.*

*The daring high-wire walker can be seen by anyone on the Snelling Avenue side of the fairgrounds, 1987.*

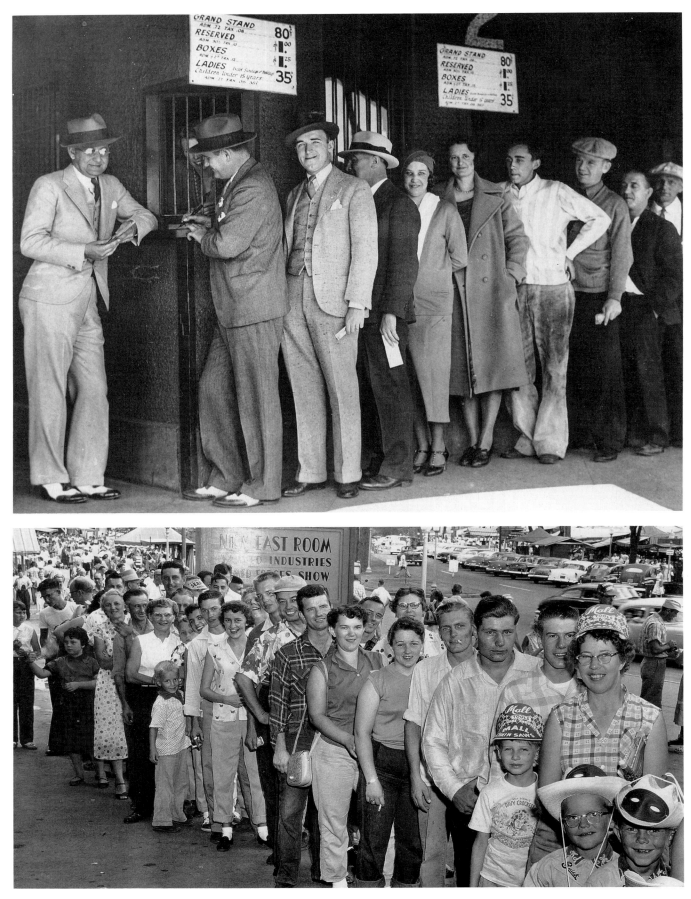

*Long lines at the Grandstand box office, 1935, when fancy dress was the order of the day*

*And in 1955, a more casual era*

*Waiting for the afternoon program to begin, 1909*

*Advertising the nighttime fireworks spectacle, 1911*

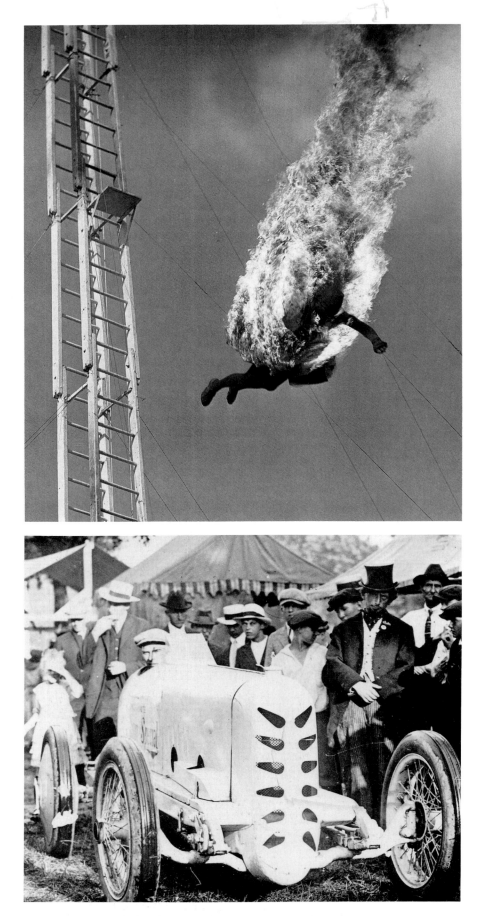

*Male fire diver, Thrill Day, 1937*

*Sig Haugdahl of Albert Lea, the leading driver of his day, began racing at the Minnesota State Fair in 1915.*

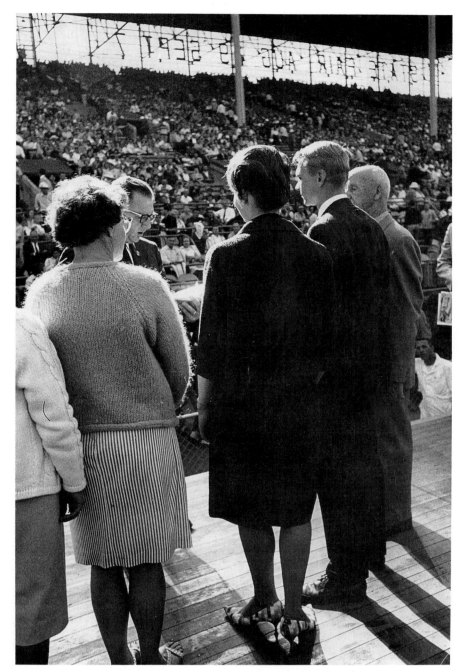

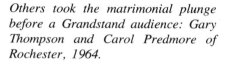

*Others took the matrimonial plunge before a Grandstand audience: Gary Thompson and Carol Predmore of Rochester, 1964.*

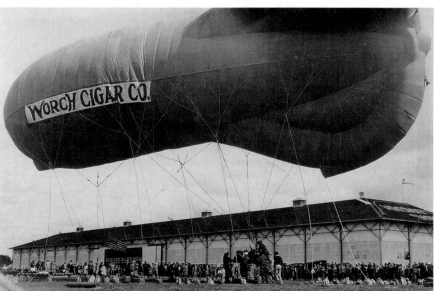

*A sausage balloon, available for rides at the fair, 1928*

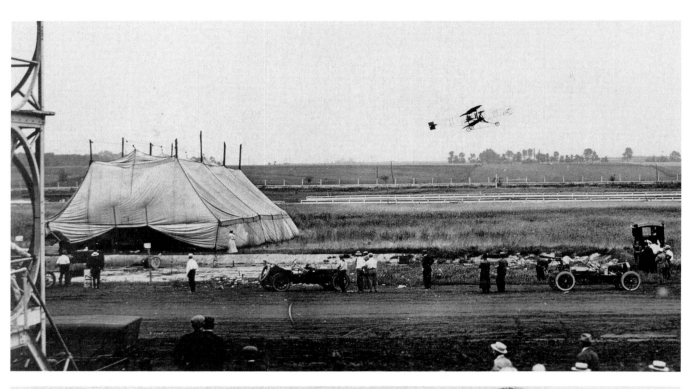

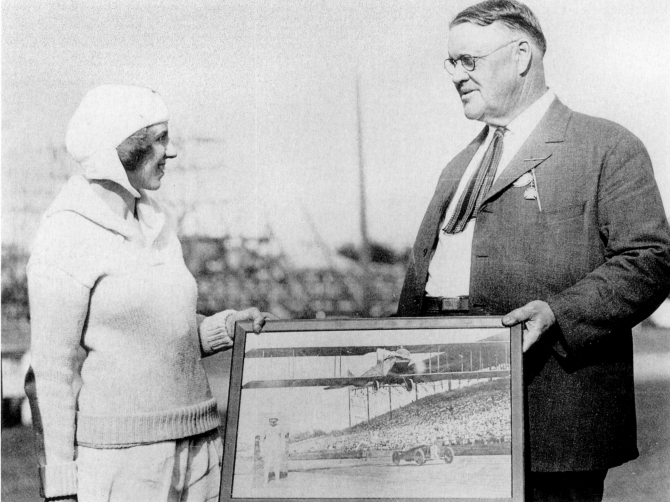

*Early stunt flier, about 1910, performing in a Curtiss biplane*

*Lillian Boyer, whose wing walking and acrobatic flying both terrified and delighted her fans, brought her air circus to the Grandstand in 1922 and 1923.*

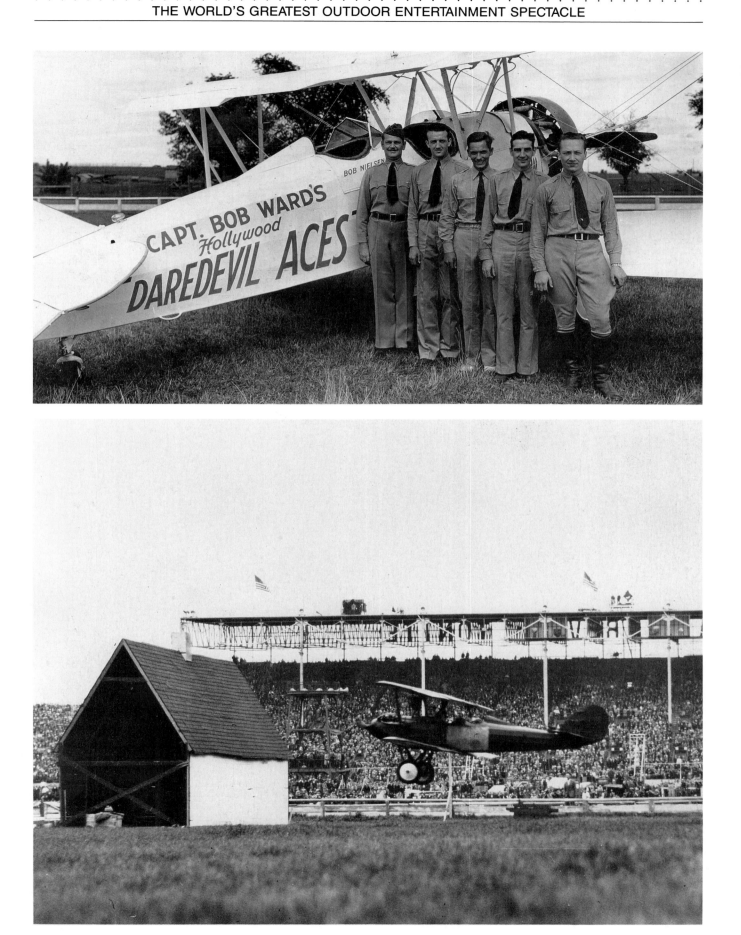

*Air stars of the 1930s*

*F. F. Frakes, about to pilot his plane through a house on the third annual Thrill Day, 1935*

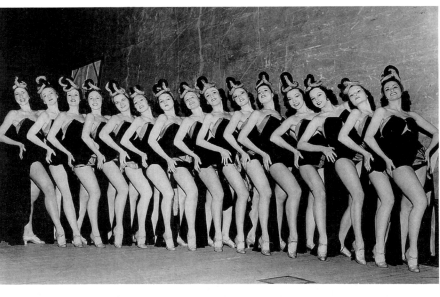

*Calmer Grandstand attractions: the Ronald Melvin Dancers, 1941*

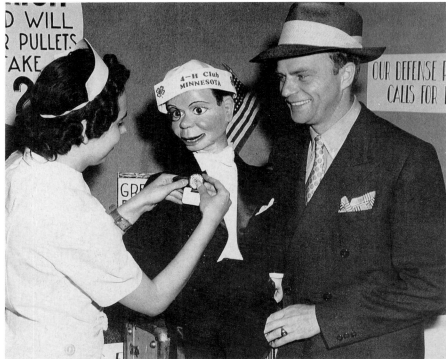

*Edgar Bergen and Charlie McCarthy opened the night show in 1941. By day, they dropped in on the 4-H Club.*

*Country singer Johnny Cash, the Grandstand's superstar of the 1960s and 70s, posing with state fair royalty between shows*

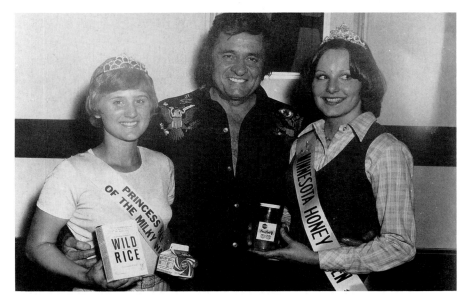

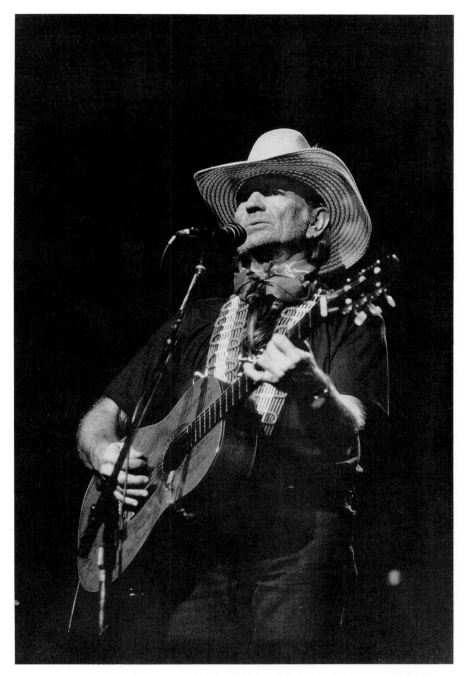

*Willie Nelson, Minnesota's favorite state fair headliner, in concert, 1987*

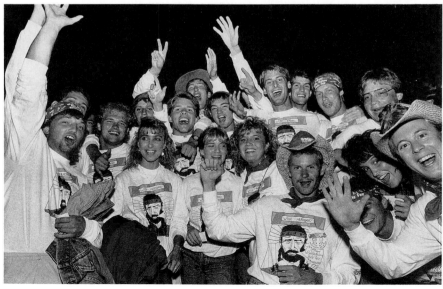

*Diehard Willie Nelson fans from Detroit Lakes, 1987*

*Seventeen-year-old Bernice Pennington of Olmsted County, the unofficial Miss Minnesota of the 1925 state fair; a devoted "farmerette," she also belonged to a canning club.*

*Princess Kay of the Milky Way, crowned in the rain in 1958*

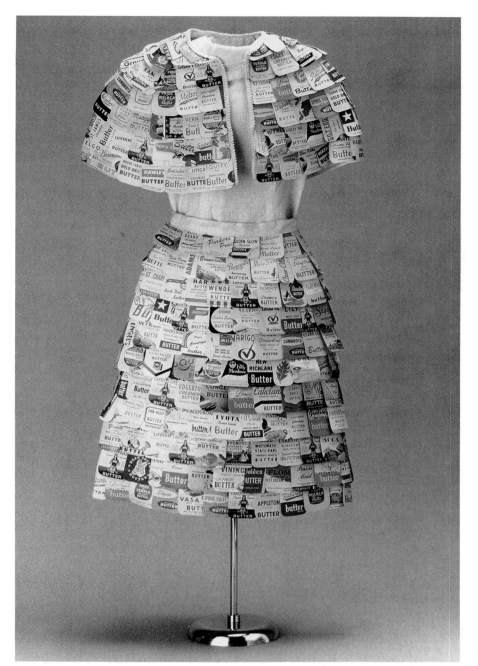

*Princess Kay's robes of office, made of butter labels. Mary Ann Titrud of Clarissa, Princess Kay XII, was the first to don the royal garb in 1966.*

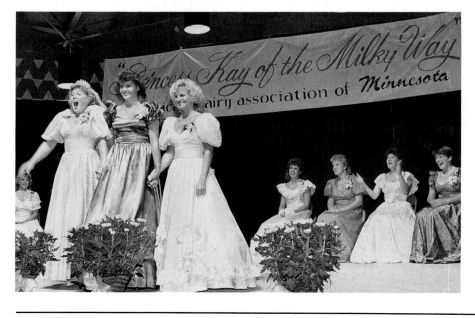

*Amy Polikowsky, chosen Princess Kay, 1987*

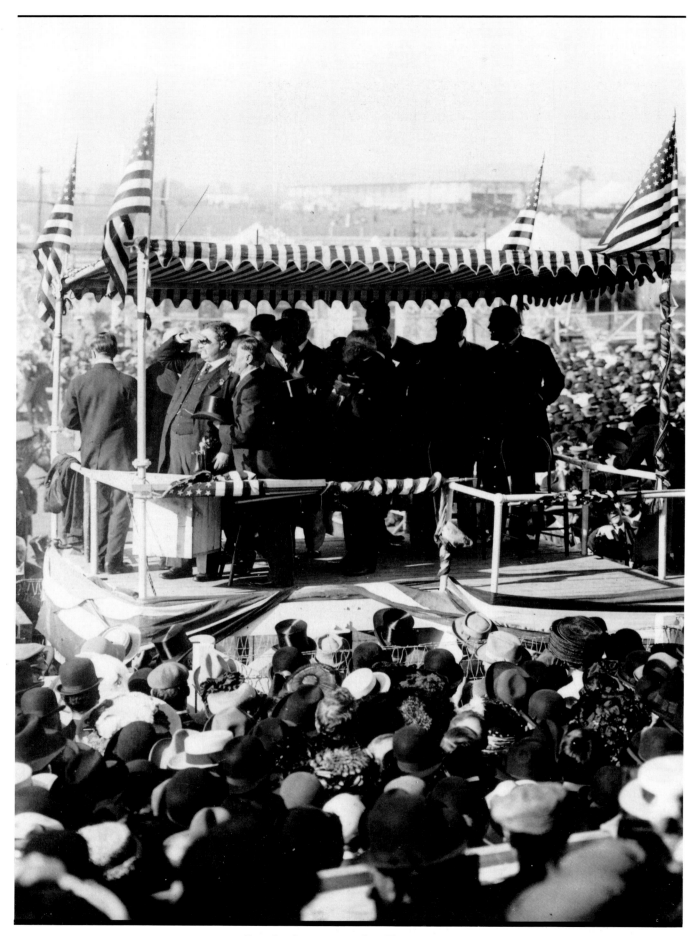

*Popular former president Theodore Roosevelt, the "Bull Moose," preparing to address a crowd at the 1910 fair, 11:00 A.M.*

# ORATING AND SPEECHIFYING

ON SEPTEMBER 6, 1922, at a few minutes before three o'clock, the temperature in the bleacher seats stood at a broiling ninety-eight degrees. The crowd was large; by some estimates, twenty thousand people had filed into the Grandstand before noon to get good seats for the advertised program. Sound was no problem. Technicians had hooked up a new "loud talking device," and the words were clear enough. Bipartisan praise for Senators Frank B. Kellogg and Knute Nelson. Fifteen minutes of fulsome tribute to the farmer. A history of American agriculture. Another quarter-hour's worth of reasons why government assistance to farmers quite properly, in the estimation of the speaker, had "well-defined limitations."

Out of deference to the orator of the day, noisy soft-drink vendors had been forbidden to hawk their wares until the dignitaries had left the Grandstand and Sig Haughdahl drove his "Wisconsin Special" onto the track to signal the beginning of the auto races. Most of the spectators had come to see the Minnesota-born Speed King and were prepared to tolerate the remarks of Vice-President Calvin Coolidge so long as they did not impinge upon the racing card. But some forty-six minutes into those remarks, with a formidable pile of manuscript pages still remaining, a burst of hand clapping started among the small boys in the back rows. Mistaking it for spontaneous applause, Coolidge paused and signaled for silence. The ruckus went on for several minutes, however, and when the vice-president recovered himself sufficiently to press on with the speech, he was drowned out again by cheers and catcalls and the sound of feet pounding on the floor.

"Let's get on with the races," boomed a voice from the crowd. The din grew, and as Governor J. A. O. Preus mopped his brow and the official party looked "anxiously at the vociferous thousands in the stands," Coolidge skipped to the last page of his text, read the final paragraph, and sat down, to a thunderous and heartfelt ovation. A member of the state fair board rushed forward to give the vice-president a souvenir of his visit—an oil painting by Minnesota artist Cameron Booth, chosen from among the entries in the annual art show. The brevity of that presentation also won the approval of the sweltering audience, as the politicians beat a hasty retreat and Haughdahl's racing car pulled into view.

Embarrassed functionaries blamed the debacle on the weather, not the quality and duration of the address. "Mr. Coolidge made the best speech I ever heard on the Fair grounds," declared the president of the fair board. "It was indeed unfortunate that the weather was so hot," said another member. "The crowd that comes to a fair is different than that which goes to a theater or to a lecture, and with the temperature the highest it has been for some time, and a scorching hot sun, some of those in the audience were disposed

to be impatient." "I don't blame them," Coolidge reflected the next morning. "I was getting rather nervous about having it over with myself so I could see those automobile races start."

In some quarters, Coolidge's raucous reception was taken more seriously. The head of the state's women's clubs thought the heckling "reflect[ed] the general wave of lawlessness — the utter disregard for law and for public officials." Others cited labor unrest and the assaults on public order that had brought Coolidge into prominence when he suppressed the Boston police strike of 1919. A professor from the University of Minnesota pronounced the incident a textbook case of "mob psychology." But whatever the root causes of the hooting and hollering on that hot afternoon in 1922, Coolidge's abbreviated speech marked the end of a long and vigorous tradition of state fair oratory.

Students of the subject later attributed the waning interest in speeches to the radio, which made the sound of the human voice available on demand. But the Coolidge address preceded the advent of network radio and the "talkies" by several years. The reasons why fair-time oratory went out of fashion in the 1920s are more complex than that explanation would suggest. To the fairgoer of 1922, for instance, a speech by the vice-president was a mere grace note in an entertainment program that included Sig Haughdahl, four days of horse races, Lillian Boyer's death-defying transfer from a car to a speeding plane, a diving horse, several vaudeville acts, a "singing" band, and a fireworks finale entitled "Mystic China" — along with the usual reunions, exhibits, displays, and festive foodstuffs. And a decade later, in the depths of the Great Depression, when Governor Elmer Benson revived the Labor Day oration in order to plead for greater unity between farmers and city workers, newspaper photographs undercut the significance of his address by showing an equally attentive crowd gathered at the feet of a Midway barker. By contrast, back in 1865 when Horace Greeley first appeared at the Minnesota State Fair, his speeches on the second and third days were among the chief inducements to attend.

Clearly, audiences that tolerated Sunday sermons of stupefying length were also capable of finding diversion in wholly secular harangues. The legendary two-hour address delivered by Cassius Clay at the 1860 fair was criticized for its highfalutin language and inaudible delivery but not for its duration. Perhaps Clay's pledge to avoid "talking politics" deprived his remarks of a certain anticipated bite, too. In the nineteenth century, political debate was engrossing for the passion with which positions were held or assailed, for the fiercely competitive nature of party rivalries. A good, stem-winding stump speech combined the emotional intensity of grand opera with the neck-and-neck excitement of a close horse race.

Since politicians were well represented in the ranks of the founders of Minnesota fairs, oratory stood high on the list of sanctioned amusements. In 1854 the first fair in the territory included speeches by former Governor Alexander Ramsey, Governor Willis A. Gorman, and former Judge Bradley B. Meeker. The great Joint Fair of 1855 was structured around an address by the Honorable Martin McLeod. In 1857 Henry Sibley did the honors, followed by Judge Moses Sherburne in 1859. With the coming of statehood and a larger role in national affairs, demand for orators renowned beyond the borders of Minnesota brought the likes of Clay and Greeley and President Rutherford B. Hayes to the state fair.

The "President Hayes Fair" of 1878 marked the culmination of the drive to measure the standing of Minnesota by the prestige of the invited state

fair orator. At the height of the struggle between Minneapolis and St. Paul for custody of the fair, St. Paul had secured Hayes and Minneapolis countered by engaging presidential hopeful James G. Blaine. Both speakers appeared in both venues, each time boring the audience with a dry recitation of statistics. Thereafter, enthusiasm for prominent speakers waned a little.

The Minnesota State Fair was not the only institution of its kind to witness a decline in the relative importance of the annual oration toward the end of the century. During the Iowa State Fair of 1874, for example, the traditional address was delivered by the president of the state college at Ames, but it was sandwiched in between what were clearly the more engrossing attractions — the heats of the speed trials. Although things had not yet come to such a pass in his own state, John A. Johnson of St. Peter addressed the subject of suitable amusements for fairs at the 1898 meeting of the Minnesota State Agricultural Society. The future governor conceded that "the 'neighsal' twang which issues from the stall nearby too frequently overcomes the logic of the man who essays to talk agriculture or politics. This form of amusement seems to thrive better in a public hall."

The drawbacks of outdoor discourse notwithstanding, in 1887 sentiment among board members favored inviting President Grover Cleveland to appear at the fair, and the offer was tendered again in 1891, as the general election approached, to former President Cleveland, his successor and rival, Benjamin Harrison, and to the Kansas Populist, Representative "Sockless Jerry" Simpson. Presenting sparring candidates would maintain the aura of impartiality expected of a public institution while still serving up a political contest that amounted to a dramatic duel to the death. When the national standard-bearers failed to appear, however, the state fair made do with the local politicians foregathered at the Farmers' Institute. The state fair's answer to charges that agriculturalists were deriving no benefit from the annual shows, the Farmers' Institute had recently become a hotbed of agrarian agitation.

In 1867 Oliver H. Kelley founded the Order of the Patrons of Husbandry — the Grange — which quickly evolved into an organization that fought monopoly capitalism. After the Panic of 1873, however, many of the so-called Granger Laws regulating railroads and forbidding monopolies were repealed, and the organization declined from twenty thousand chapters in 1874 to a mere four thousand nationwide in 1880. But farmers who had learned to advance their own interests by organizational means supported the Farmers' Alliance, founded in Chicago in 1881. Ignatius Donnelly of Minnesota (an active member for many years, he was vice-president of the Agricultural Society in 1887) rapidly became the prime orator of the Alliance and a national figure in the Populist movement that succeeded it. A critic of railroads and grain dealers, a supporter of state-owned terminal elevators, Donnelly was preparing to run for governor on the Populist ticket in 1891 when he and his rivals turned up to woo the farm vote at the Minnesota State Fair under the guise of discussing "the great economic questions of the day" without regard to politics.

Handshaking their separate ways up Machinery Hill from the Farmers' Institute summer after summer, political heroes like Donnelly and his great rival Knute Nelson became state fair fixtures. But, while Minnesota statesmen at the fair could be waspish about their opposition, they came to serve a different function from the imported politicos who were counted upon to supply verbal fireworks and rhetorical fisticuffs. Local candidates, along with their retinue of beloved ex-governors and ingratiating would-be senators,

## THE RAILROAD BARON'S CORN

Ignatius Donnelly spoke for those skeptical of the motives and methods of big business, but the state fair was also eager to present representatives of the opposing view. Because of his personal interest in agriculture, his prominence on the country fair circuit, his corporate support of the fair, and his standing as a leading citizen of Minnesota, James J. Hill was the logical choice to be the principal speaker on opening day in 1906, when the new Hippodrome (razed in 1946) was dedicated. Attendance on September 3 reached a record ninety-three thousand, helped along, no doubt, by the appearance of Dan Patch.

Hill's dedicatory speech has been forgotten. His colorful, freewheeling addresses at the annual meetings of the Minnesota State Agricultural Society are worth recalling, however. Deeply concerned with the erosion of rural life, he deplored the prospect of boys and girls from the farm "soaking down their hair" and moving to town for work. "Better men and women live in the country," he told the society in 1903. At the root of the farm crisis, Hill believed, was ignorance. And invariably he excoriated Minnesota farmers for their backwardness, their stubborn resistance to modern methods.

At the 1914 annual meeting, Hill repeated his claim that "you could increase output 20 percent by discarding antiquated methods and becoming thoroughly acquainted with scientific farming," citing his perennial example of a fourteen-inch ear of corn which, he insisted, "could not be produced in Minnesota" under current conditions of cultivation. He had also bet one thousand dollars that he was right about the corn.

As the speaker launched into his peroration, the Agricultural Society's president, John J. Furlong, quietly approached the podium brandishing a 14⅛-inch ear of Minnesota corn and claimed his reward on the spot, to the vast amusement of Hill and his audience. □

*Internal politics, 1987: the board of the Agricultural Society always meets on the premises during the fair.*

gave visible form to the history of Minnesota's progress as a state. Less entertaining than reassuring, they also reminded their audience of how rapidly the tides of political fortune could change and how little, in the end, the passions of the moment really mattered.

The countervailing aspect of politics-as-entertainment found its champion in the colorful figure of Theodore Roosevelt, who agreed to open the 1901 state fair. "In his strenuous life 'Teddy' has many engagements and many things to do," reported a management still overwhelmed by the vice-president's assent to their proposition, "but [he] never fails to find the time to carry out his plans." A Roosevelt Marching Band drilled in St. Paul to serve as his escort. Rough Rider clubs planned excursions to the fairgrounds. Certain editorial writers, taking note of Roosevelt's undisguised presidential ambitions, condemned his slated appearance as underhanded electioneering. "The fair is the grandest in the history of the state and is one for which no Minnesotan need feel called upon to apologize," argued the *Wabasha Herald*. "We always doubted and always will doubt the propriety of mingling politics with the exhibits of the state fair. Theodore Roosevelt is a grand good citizen but Minnesota did not need him to open her state fair."

Teddy nonetheless appeared as promised, teeth gleaming and spectacles flashing with the sheer, irrepressible energy of the man. Connoisseurs of speechmaking — they had turned out in force at the 1891 fair to hear former Governor R. B. Hubbard of Texas repeat his celebrated address from the 1876 Philadelphia Centennial on a daily basis — thought Roosevelt no orator: his gestures were too choppy and his voice too high. But even his critics were impressed by his forcefulness and evident sincerity. And Roosevelt partisans went away confirmed in the belief that they had heard "not the mouthings of a vacillating weakling but the burning convictions of a mental and physical giant."

Filled with references to trust-busting and reminders that the speaker believed in "big stick" diplomacy in future dealings with Latin America, the address soon became known as the Minnesota Speech. Political pundits saw it as a prophetic blueprint for Roosevelt's own presidency. In any case, just four days later President William McKinley was shot at the Pan-American Exposition in Buffalo, New York, and Teddy was sworn into office. The stroke of fate that sent Roosevelt from Hamline to the White House made speaking at the Minnesota State Fair a good-luck charm for other hopefuls.

Senator Charles W. Fairbanks of Indiana, engaged in preliminary skirmishing to become Roosevelt's running mate, thought it wise to open the fair in 1903 with a supposedly apolitical talk on agricultural conditions, which competed successfully with the debut of Dan Patch. The next year, when Senator Knute Nelson was chosen to do precisely the same thing (Nancy Hanks was his equine adversary), his speech had to be moved from a tent to the Grandstand to make room for throngs of eager listeners. But he was widely faulted for a text in which Republican ideology was only "partially submerged" in a general discussion of farming. "There is no reason whatever in the nature of things why a man prominent in public life . . . should be called upon to deliver the address proper at such functions," the *St. Paul Globe* declared warmly. "A state fair, especially when it attains the proportions reached by that of Minnesota, is an enterprise belonging to all the people. It knows no Democrats and no Republicans, no party, no political preferences. . . . It is supported by the contributions of all the taxpayers of the state. They have a right to require that it should be kept perfectly

## STATE FAIR POLITICS

By its very nature as a public institution, the state fair is subject to the political process. Devices like Legislators' Day were designed to curry favor with lawmakers, whose displeasure could spell trouble for the ongoing health of the Agricultural Society's annual show. In the main, however, the fair has more often been the target of political action than the instigator of it.

Trade unions have been among the fair's most persistent critics. Beginning with objections raised by the St. Paul Musicians' Union in 1892 to the engagement of a military band "not dependent for subsistence upon engagements outside their calling," organized labor consistently protested hiring practices that differed from standards prevailing in local industry. Before World War II, when the labor movement still carried strong radical overtones, few of the angry communiqués from brotherhoods of stagehands and plasterers were given much consideration. (The fair brooked no interference from businessmen's trade councils, either.) The construction of the AFL-CIO Building opposite DFL headquarters at the corner of Cooper Street and Commonwealth Avenue in 1959 signaled a truce in the long war of words between labor and the fair.

The most significant and damaging criticism has come from the Minnesota legislature, which has the power to regulate activities on the fairgrounds (chapter 18 of the laws of 1895, barring gambling at the fair, is a case in point); to award or withhold special appropriations for improvements; and to audit the books. Although the Agricultural Society goes on while politicians come and go, these prerogatives have given lawmakers a measure of control over the state fair.

Rejection of a proposal to put $1 million into an expansion and renovation of existing facilities in order to mount a semicentennial exposition in 1908 was seen, in some quarters, as a judgment on the urban character of the fair. According to the *St. Paul Pioneer Press*, "the argument was freely used that the Twin Cities got all the benefit and should therefore stand the greater part of the bill." But as the debate continued, other grievances found their way into the record. "Isn't it true that the state fair has practically ruined the county fairs?" an outstate representative asked. Others accused the management of sharp practices "which

continued themselves in office as long as they wished," and the lone Populist, Senator Ole O. Sageng of Otter Tail County, charged that under whatever fancy name it cared to call itself, the fair was still nothing but a scam "for the benefit of the saloonkeepers and hotel men."

That debate may have inspired the first full-blown investigation of the fair, undertaken behind locked doors by a special House committee in 1909. To the disappointment of some critics, no criminal wrongdoing was uncovered, but bookkeeping practices were faulted and members of the board of managers criticized for unseemly extravagance— free dinners and auto rides, all-expense-paid trips to other fairs, and reimbursements based on the honor system. Dubious transactions between management and its seasonal employees were also uncovered, most notably the case of B. E. Gregory, manager of the annual fireworks finale, who purchased the fireworks from a Chicago firm bearing his own name and billed them to the fair. When the dust had settled, Governor John Johnson (former manager of the Nicollet County Fair Association) exonerated the board and it, in turn, blamed the whole brouhaha on rumors circulated by a spiteful amusement promoter denied the use of the grounds "for his own pecuniary benefit."

More serious was a 1966 investigation of Secretary-General Manager, John E. Libby, and his father James, a forty-seven-year employee of the fair. The probe detected a pattern of irregularities that suggested misuse of official positions for private gain. The senior Libby was charged with selling hay cut on the grounds and pocketing the proceeds. His son was accused of buying new cars from an auto-thrill-show concessionaire at bargain prices. His grandson was said to have broken a rule against employees of the fair holding concessions by operating a swing purchased from the Royal American Shows, holder of the Midway privilege. Public interest petered out when the Ramsey County attorney (a Republican) decided not to file charges, much to the chagrin of the state attorney general (a DFLer), who left office still demanding restitution of disputed sums.

In 1967, as the attorney general's successor was pondering fresh action against the Libbys, the roof of the brand-new Education Building collapsed under the weight of a February snow, touching off fresh allegations of corruption in the award of contracts.

Again, after much testimony and many inspections, results were inconclusive. Examiners found it inappropriate for the state fair's architect to have acted as agent for the outside firm that designed the building. It was also discovered that during construction cheaper materials had been substituted for those specified in the plans. Damages of two hundred thousand dollars were sought from the builders, but a proposal calling for another in-depth study—a move toward making the Minnesota State Fair an official state agency—was criticized as an attempt to politicize a fundamentally apolitical institution. Other observers felt that further action was unwarranted because the Agricultural Society had not asked for public appropriations since 1949.

It was nonetheless apparent that the management was troubled. New legislative hearings called by State Representative Bruce Vento found that, despite safeguards against such monopolies, one person ran eighteen of the fair's ice-cream stands and another owned thirteen Pronto Pup stands, the Beer Garden, and shares in the Space Tower and the Skyride. After a searching auditor's report that documented his practice of leasing cars at highly favorable terms from a firm that held contracts to manage racing programs at the fair, John Libby resigned from office on October 1, 1976, citing ill health.

His successor, Michael Heffron, has come in for his share of troubles, too. A federal indictment for tax evasion, against Carl Sedlmayr, Jr., owner of Royal American Shows, disclosed irregular practices among concessionaires, including records of gifts to Minnesota policemen and fair officials. Heffron was listed as the recipient of thirty gratuities during the period from 1968 to 1974. Although the press had a field day with the Sedlmayr case, Heffron was able to show that the numerous "gifts" were really a few inexpensive promotional items stamped with the Royal American crest.

Public scrutiny has strengthened the fair. Bookkeeping and purchasing practices have improved. Special care is taken to allow all applicants for concessions to compete on an equal basis; appeal procedures have been established. "Politics" has helped to create a more responsive and responsible leadership of the Minnesota State Fair. □

free from all political entanglements or alliances."

When the chance came to snare a political celebrity of the first magnitude, however, all thoughts of reform dissipated. Since 1896 the fair had been angling for William Jennings Bryan, the "Peerless Leader," the "Great Commoner," three-time presidential candidate of the Democratic party, and the most electrifying orator of his age. In 1907, with negotiations close to success, Bryan backed off, stating that during a campaign he made it a policy not to speak where an admission fee was charged. So in 1908 fair officials countered with plans for a "Roman Forum of Later Days" to be held in a fenced enclosure at the corner of Snelling and Langford avenues at absolutely no cost to those wishing to attend. Scheduled to coincide with the state fair, the forum scheme called for inviting both Bryan and William Howard Taft to speak on a neutral topic of general interest. Taft ignored the invitation, thereby denting the illusion of lofty statesmanship, but Bryan's eloquent address was regarded as one of the high points in the history of state fair speechifying. The mesmerized crowd of twenty thousand surged toward the podium at the end of his remarks, upsetting the press bench and trampling an Annandale reporter in its enthusiasm.

Bryan returned to the fairgrounds several times. In 1915 he appeared on behalf of woman suffrage, and in 1922, the year of Coolidge's rude treatment, he attacked the theory of evolution at a meeting of the Northwestern Bible Conference held in the Hippodrome several weeks after the fair had closed. Teddy Roosevelt was another repeat visitor. In 1910, when attendance at the Minnesota fair was double that of any other state fair in the country, the total of 318,264 admissions included President William Taft who spoke on Monday, and former President Roosevelt (then reentering politics after a brief hiatus as a volatile elder statesman and big-game hunter) on Tuesday.

In honor of his return, a local dairy created a life-size butter sculpture of Roosevelt in a pith helmet and jungle garb with his foot on the neck of a prostrate lion. It was the stellar attraction at the Dairy Building, and in 1912 Teddy himself was the Minnesota fair's biggest draw, when he came back to the Grandstand to launch his Bull Moose campaign to regain the White House. The crowd was so large that he was forced to stand on one side of the rostrum for a few moments and then turn in the other direction and repeat what he had just said. And although Roosevelt carried on in this fashion for an hour and twenty-five minutes in ninety-degree sunshine, not a sound was heard except for cheers that made the speaker bare his famous teeth in smiles of pleasure.

Bryan, Taft, and Roosevelt: the campaign trail seemed for a time to run straight down Como Avenue. Warren G. Harding, Republican candidate for the presidency, followed James M. Cox, the Democratic contender, to the Grandstand in 1920. And Calvin Coolidge came twice: in 1922 as a vice-president with expectations and in 1925 (he keynoted the Norse-American Centennial celebration held on the fairgrounds in June) as a president with aspirations of reelection.

Although General Dwight D. Eisenhower's prospects for the Republican presidential nomination were a topic of open discussion in 1947, he came to the state fair in uniform as a war hero — a celebrity whose principal function was to be seen touring the grounds in an open car, greeting the Army Recruiting Queen, eating a Minnesota apple, grinning at 4-H'ers, chatting with enlisted men in charge of the numerous defense exhibits massed in the old Horticulture Building, and accepting a clock presented to com-

*In honor of TR's 1910 visit, a larger-than-life butter sculpture; photographs of this remarkable creation were given away as souvenirs.*

## THE RIGHT TO FREE SPEECH

Over the decades, the state fair has been responsible for some of the most fervid oratory ever heard in Minnesota, but on several occasions it has also been accused of denying the right of free speech to fairgoers. In 1944 the Reverend Henry J. Soltau, a Minneapolis vice crusader and head of the Minnesota Good Government League, was arrested at the fairgrounds on a charge of libel brought by Raymond A. Lee, secretary of the fair board. For the second time in as many years, Soltau had complained to the attorney general and the newspapers that the fair had been turned into a "den of thieves" where "minors by the hundreds play gambling devices, look at partly nude women and pictures in penny arcades and sideshows where they get their first lessons in crime and immorality."

In rebuttal, furious fair officials issued a statement citing their obligation to protect the good name of "an institution that has provided the people of this state for more than three-quarters of a century with annual programs of education and entertainment. We are going to find out in court," the text concluded, "whether this man can continue his irresponsible accusations from year to year."

The Soltau case disappeared from the headlines after Midway owner Carl Sedlmayr—whose wheels of fortune and ballyhoo shows were under attack—visited Cell No. 1 at the state fair lockup and offered to post the minister's one-hundred-dollar bail so that Soltau could avoid further confinement with the eighteen criminals arrested at his own insistence for gambling and indecent exposure. That gesture, and Soltau's sour refusal to accept the bond, won the day for Royal American Shows. The case was dropped, and Minnesota's own Savonarola was heard from no more.

In 1980 two would-be concessionaires whose applications for space were denied sued the fair for violations of the constitutional right to free expression under the first and fourteenth amendments. The first suit was brought by David Yurkew, a tattoo artist; his request to set up a booth had just been turned down for the third time. Yurkew had already gone through the fair's appeal process, too, but the verdict was firm: "The board of managers has determined that tattooing should not be permitted on the Fairgrounds."

The fair contended that tattooing could constitute a health hazard. Listing John F. Kennedy, Barry Goldwater, Sean Connery, and Lady Churchill among the satisfied bearers of body decor, Yurkew countered with a lawsuit charging that the rental policy was an "arbitrary and capricious" curb on his rights of artistic expression. In a fifteen-page opinion, U.S. District Court Judge Harry MacLaughlin ruled in favor of the fair that tattooing was potentially dangerous and was not "sufficiently communicative" to rise to the level of activity protected by the First Amendment. The disgruntled artist vowed to seek an injunction from a higher court, but he was not among the concessionaires of record when the state fair opened for business on August 21.

The second free-speech case of 1980 involved members of the International Society for Krishna Consciousness, who, in 1977, had been forbidden to solicit for donations in the public areas of the fairgrounds. In a split decision, the Minnesota Supreme Court allowed management some latitude in limiting the number of persons asking fairgoers for money and affirmed the fair's right "to prohibit conduct that creates disorder." But the Court would not support the rule confining the Krishnas to their booth. "It is fundamental that First Amendment rights may be restricted only for weighty reasons," wrote Justice C. Donald Peterson for the majority.

The U.S. Supreme Court agreed to hear the Krishna case on appeal in 1981. In a landmark decision that changed the pattern of "wandering solicitation" in airports and other public places across America, the High Court sided with the Minnesota State Fair. Yet the implications of the Hare Krishna suit continue to be debated. Five union members detained by state fair police in 1982 after picketing a pizza stand being wired by a nonunion contractor, for example, noted that the Minnesota Supreme Court, in its Krishna decision, "ruled that the fairgrounds is state property and persons do not forfeit their constitutional rights under the First Amendment when at the Fair."

Trying to account for the vehemence of the fair's resistance to the notion of a tattoo parlor, David Yurkew speculated that the managers probably associated his craft "with drunken sailors and undesirables." All three of the cases cited here originated from transitory episodes of public displeasure and mistrust. Soltau's crusade was a local manifestation of a nationwide attack on carnival "girlie" shows; comparable peep-show pinups that young American GIs were painting on the noses of their bombers represented to some alarmed observers the wartime breakdown of the nation's moral fiber. Lewd pictures were apparently sanctioned by the military; women (wearing pants!) were doing men's jobs. Suddenly, nothing was quite as it should be. In such an atmosphere of uncertainty and change, censorship of all kinds flourished.

Yurkew was probably correct in thinking that tattooing had unsavory overtones in some quarters, evoking memories of shore-leave excesses during World War II, 1960s hippies, and worse. And the Krishnas had the misfortune to come to the fair at the height of public hysteria over cults and their mysterious influence on the young. Insofar as the fair reflects the temper of the state, it serves as a fever chart of the prejudices and fears of the moment. □

memorate his visit. His duties as Labor Day orator included sitting on the platform before the Grandstand where he could be more readily observed by fairgoers, showing interest in the program for the upcoming auto races, and giving a brief talk without the aid of a weighty written text. "It is the first state fair I've ever attended," the genial soldier noted, "and I hope I have made a good beginning by visiting the greatest first." Fifty thousand onlookers roared in approval and, for the moment, forgot that all the hoopla was sure to delay the start of the races.

At the time of his state fair appearance, Ike professed uncertainty as to whether he was a Republican or a Democrat. Genuine or not, the ploy set him apart from other politicians and confirmed his special, heroic identity. And because of his temporary detachment from partisan conflict, Eisenhower was probably the last great public figure who could give a speech of general interest on the fairgrounds without touching off allegations of favoritism. Throughout the 1930s and 40s, political activity at the state fair had taken on a combative edge. Straw polls using Minnesota's new voting machines asked fairgoers to choose between Franklin D. Roosevelt and Herbert C. Hoover in 1932. The majority of those questioned by a roving reporter in 1940 favored debates between Roosevelt and Wendell Willkie. When Republican spokesman Walter Judd was booked for a special Sunday Grandstand program (minus cars) in 1943, the Democrats demanded equal time for Clifford Townsend of Indiana.

By 1953 the Democratic-Farmer-Labor party had ensconced itself in a prefabricated metal garage across the street from the Administration Building (the futuristic building in use in the 1980s was constructed in 1956 by union workers in their spare time); the Republicans had set up shop not far from the popular St. Olaf Church Dining Hall. A new pattern had been established: thereafter, party workers would man the barricades while the political stars sallied forth to greet the voters on nearby sidewalks. On certain designated occasions — a Legislative-Editorial-Radio-TV Day was the focus of activity in the 1950s — politicking rose to a crescendo, but it was of the person-to-person variety, for the most part, punctuated by spates of cow milking or wearing silly hats for the cameras. Formal speeches played a minor role in appeals to the state fair constituency — even the ebullient Senator Hubert H. Humphrey limited himself to ten-minute talks delivered twice a day at the public drinking fountain in front of DFL headquarters.

DFL annals record a gigantic State Fair Bean Feed at which President John F. Kennedy spoke to sixteen thousand of the faithful gathered in the Hippodrome (and four thousand others with standing-room-only passes in the Cattle Barn). That rally was held in the autumn of 1962, however, after the fair had closed, as was the comparable oratorical feast laid on in aid of Hubert Humphrey's vice-presidential candidacy in 1964. The appearance of political dignitaries at the fair proper was handled in a more gingerly manner. Humphrey Day in 1965, held to honor a native son made good, included a motorcade, a horse show, an honorary membership bestowed by the Future Farmers of America, a glass of milk from Princess Kay, a cup of coffee at the St. Olaf Dining Hall, lots of handshakes, and a ceremonial cake cutting at the new Education Building. But the only oratory was the vice-president's off-the-cuff reflections on the value of a good education, observations that went all but unnoticed by fairgoers intent upon the demolition of that sixty-pound Lady Baltimore cake, frosted to resemble the new building. □

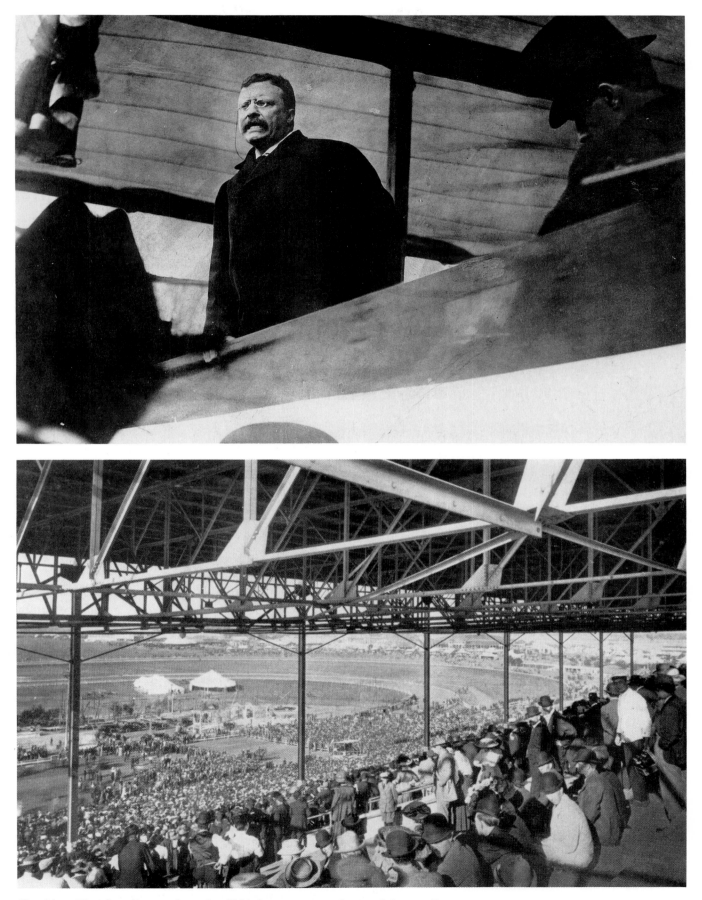

*President Theodore Roosevelt at the 1908 fair, stumping for candidate William Howard Taft, his hand-picked successor; Minnesota Governor John A. Johnson is at right.*

*Grandstand crowd on Roosevelt Day, 1910*

*Vice-president and Mrs. Calvin Coolidge, greeted by the ladies of the Minnesota State Fair, September 6, 1922*

*Ike, the supreme war hero, arriving at the Grandstand on Labor Day, 1947*

*The young Hubert H. Humphrey of the Democratic-Farmer-Labor party, mayor
of Minneapolis when he visited the 1947 fair*

*GOP headquarters at the fair, opened in 1959*

*Slow business during the Ford campaign of 1976, when favorite son Walter Mondale was running for vice-president on the other ticket*

*A deep-fried cheese curd and a little help from Minnesota Senator Rudy Boschwitz for Republican Senator Bob Dole of Kansas during primary season, 1987*

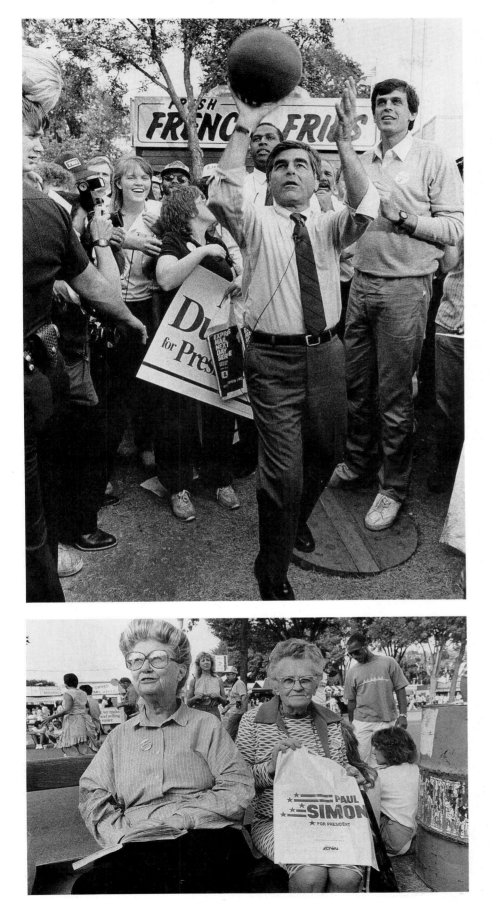

*Democratic Governor Michael Dukakis of Massachusetts, getting some help of his own from iron range native Kevin McHale, a star of the Boston Celtics, 1987*

*More signs of the 1987 presidential season*

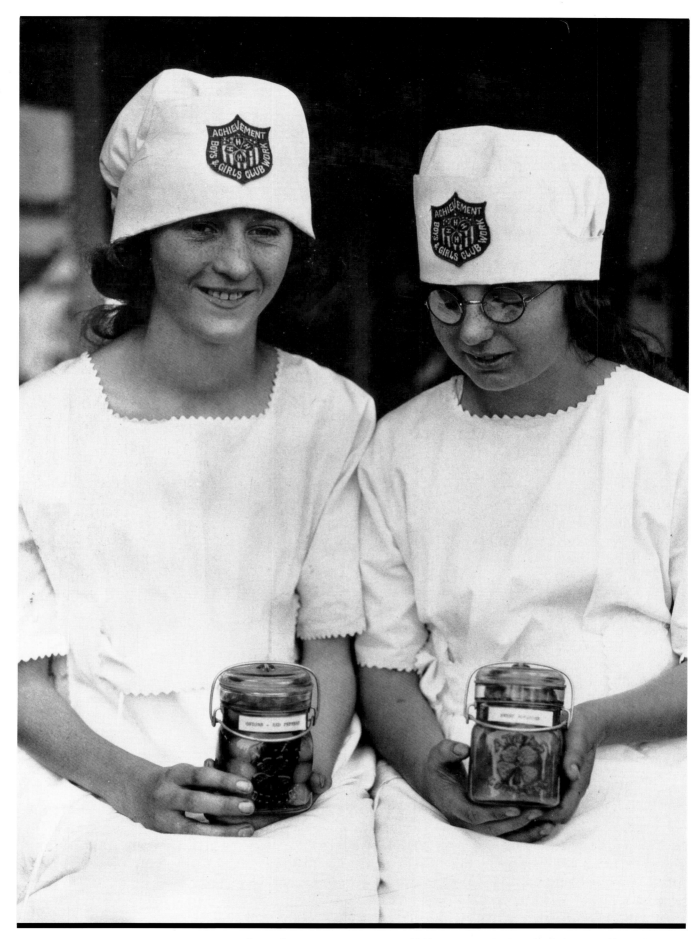

*State champion canning team, 1918, sporting the four-leaf-clover emblem, the symbol of the 4-H clubs, on caps as well as jars*

# A "4-H'Y" KIND OF FAIR

MINNESOTA'S CHILDREN, mainstays of the trade in cotton candy and poisonously pink lemonade, have always attended the fair in force; concessionaires protest loudly whenever educators attempt to open the public schools before the state fair closes. Despite the impact of their nickels and dimes, however, few youngsters appear in the annals of the state fair before the turn of the century, and those who did were portrayed either as troublesome impediments to their parents' progress or as would-be adults in miniature. In early accounts, small boys whine for balloons, popcorn, peanuts, souvenirs, rides, and a glimpse of the fat lady as they are dragged firmly by the hand past such delights; they sulk when their mothers linger too long over the glass cases of fancywork. More was expected of young ladies, of course. Girls were encouraged to eschew fair-time frivolity and compete for bread-baking premiums in a special category for contestants under the age of twelve established by C. A. Pillsbury & Company of Minneapolis. And the real-life counterparts of Almanzo Wilder, hero of Laura Ingalls Wilder's juvenile novel *Farmer Boy*, followed their fathers solemnly through the stock sheds and capped off a mature consideration of Minnesota agriculture by entering the open-class competition for the largest, tastiest pumpkin.

Babies — or their safe disposal during Mother's visit to the fair — commanded more attention. Inspired by the nursery facilities available at the great international expositions of the age, the Minnesota State Fair licensed a kind of checkroom for infants and toddlers in 1903 in a tent attached to the women's club building. There, a trained nurse and a squad of uniformed helpers fed, entertained, and put the little ones down for naps while their parents toured the grounds. The enterprise was pronounced a success when, on its first day of operation, eighteen babies were enrolled. There were hazards in running such a business, however. In 1905, for instance, several babies chewed up their identification tags and were returned to the wrong mothers, precipitating momentary hysterics.

Baby checking was another manifestation of women's legitimate claims to independence, but a mounting interest in the plight of abandoned infants discloses a countervailing fear that the "new woman" might some day elect to leave the family and never return. In addition to the nursery, the Federation of Women's Clubs in 1906 began to sponsor what it hoped would be an annual exhibit of foundlings available for adoption, including a newborn left in a paper parcel on the fair-bound train from Duluth. A reporter for the *Minneapolis Tribune* took heart from the numbers of women who came to coo and smile at the little visitor. "To an observer this corner of the Federation Building is intensely interesting," he wrote, "for it offers flat contradiction to the theory that the maternal instinct is lacking in the modern woman."

*Proud owner of the 1923 Calf Club champion*

But one baby died of heatstroke and the others took sick. Although the day nursery continued to operate (at fees that ranged from ten cents to fifteen cents per hour), the state fair orphanage hastily went out of business.

Yet babies continued to draw crowds to a money-making concession, begun in 1909, that put premature infants on display in glass incubators. In 1913 a whopping total of 16,803 fairgoers — considerably more than those who bought tickets to the flea circus or the motordrome — paid twenty-five cents each to file past the little enclosures and hear a young woman in nurse's attire discuss the feeding of the tiny youngsters. The incubator display was justified on the basis of its supposed educational and scientific value. Indeed, just as home economists of the day insisted that the common tasks of housewifery were best accomplished using modern time-saving techniques perfected in the laboratory, other experts declared that "baby-raising" was an exact science, the postulates of which could be demonstrated at the state fair. And so, after 1912, the new Rest Cottage and Day Nursery became the scene of an annual baby contest, designed to find the healthiest and brightest infant in Minnesota and to teach fairgoers precisely what factors of environment and breeding made for a superior class of babies.

The state fair baby contest had all the competitive trappings of a horse race. City babies were pitted against country babies. Minneapolis babies were matched against those from St. Paul. The *Minneapolis Daily News* reported that a mosquito bit the local favorite, Wilbur Frank Hurrle, squarely on the forehead; would the judges deduct marks for that minor imperfection? (They did!) The so-called world's record of 98.8 points, set a week before at the Iowa State Fair (where Mary Watts of Audubon, a farmer's wife, was credited with inventing the modern baby contest) was said to be the mark to beat.

Like the "pretty baby" judgings of an earlier day, this contest was great fun and drew such enormous crowds that in 1915 the examinations had to be moved to a glass cage in the center of the Woman's Building. But the hoopla did not wholly obscure the serious purpose behind the competition. Eugenic theory was bandied about. The panel of doctors and educators who inspected the babies lost no opportunity to attribute the fine qualities of the prize specimens to "rich, fresh cow's milk," fresh air, sunshine, exercise, and a little meat from home-raised chickens. But above all, the sponsors of the baby contest wanted fairgoers to recognize "the importance of childhood, especially the physical and mental welfare of the child" and "the laws of child development."

This new emphasis on childhood as a period of significance in the cycle of life contrasts sharply with the attitudes of the eighteenth century, when portraitists depicted infants as little grown-ups, lacking personalities and capabilities of their own. During the later nineteenth century, children were often portrayed as cherubic innocents or sweet creatures of nature, more animated than colonial boys and girls but hardly more consequential. Under the pressure of rapid industrialization and massive immigration, however, turn-of-the-century educators were among the first to understand childhood in a radically different way. John Dewey and William James saw the schools as agencies of social betterment and change; the rising generation, trained in new patterns of perception and behavior, would graduate better able than their parents to cope with the demands of the modern world. Thus schools and their curricula suddenly became the focus of intense scrutiny.

At the Minnesota fair, curiosity about public schooling resulted in large-scale displays of the penmanship, sewing, and manual-training exercises

produced by the scholars of Minneapolis and St. Paul. In 1897 the educational exhibits in the Main Building ran the gamut from kindergarteners' cutting and pasting to a working steam engine and a copy of the Venus de Milo by the older students at Mechanic Arts High School in St. Paul. The State Training School, which aimed to turn delinquents into "useful members of the industrial society of the future" and customarily sent work to the world's fairs to illustrate Minnesota's progressive approach to penology, also turned heads with impressive demonstrations of cabinetry, tailoring, printing, blacksmithery, and *sloyd,* a novel Swedish system of manual training in the use of tools.

What constituted a proper education for children of the modern century was by no means a settled matter. In 1902, when some school boards proposed to open early, denying students the opportunity to visit the state fair, officials struck back with a publicity campaign that argued "Children who attend can learn more of the state of Minnesota in a short time at the fair than in a year in the school room." Whether in business or in agriculture, the "strenuous life" demanded of twentieth-century Americans seemed to call for an active, practical education by doing. Liberty Hyde Bailey of Cornell University, an important rural-life theorist of the day, summed up the case for reform in this pithy aphorism: "There is as much culture in the study of beet roots as in the study of Greek roots." He found strong local support in Minnesota. An irate delegate from a rural part of the state, speaking from the floor at the annual meeting of the Agricultural Society in 1903, demanded more down-to-earth courses in farming in the public schools. The system, he said, was geared to breeding doctors and lawyers and businessmen but did nothing to foster the skills needed by future farmers. "Our children are learning Greek and Latin in the common schools, and I would like to see agriculture substituted for the Greek and Latin."

The drive for experiential education in general and for vocational agriculture courses in the rural schools in particular had begun in a small way in the 1870s, with the rise of the farmers' movement. In 1878 the Grange went on record as favoring practical education in country districts. Because it permitted young people to become active members at a time when the children of farmers were often no better than unpaid hands, the organization is sometimes credited, too, with providing the inspiration for the first boys' and girls' clubs devoted to allowing youngsters some autonomy in the study of new agricultural methods. Supported, in the main, by energetic school administrators, such clubs sprang into existence all across the Midwest in the years between 1903 and 1906. Corn clubs attracted boys. Membership in calf and pig clubs was evenly split between the sexes. Girls enrolled in canning clubs, which disseminated safe techniques and encouraged rural families to enhance their diets with tomatoes and other seasonal produce rich in nutrition. So, in addition to raising the self-esteem and interest of rural children who might otherwise have joined the migration to the city, the clubs were the means whereby the agricultural experiment stations of land-grant universities attempted to bring word of scientific discoveries to country people notorious for their skepticism about newfangled notions. As the yearbook of the United States Department of Agriculture noted with evident satisfaction in 1903, "the problem of arousing an interest in farmer's institutes and the questions discussed at them has been solved. The farmers were reached through their children, and the interest thus aroused will be handed down to their children's children."

Although 4-H leadership dates the beginning of an organized youth pro-

gram in Minnesota to 1903, the actual time and place of its genesis are difficult to fix. In 1902 Nelson, in Douglas County, held the state's first school fair, at which children exhibited homegrown produce and a variety of items they had made. In 1904 Olmsted County mounted an "industrial contest" for youngsters, featuring examples of sewing, baking, canning, and manual training as well as farm products. In 1905 the McLeod County Fair Association gave cash prizes to members of corn and flower clubs who had won ribbons in a special school competition for boys and girls.

But the most significant first step toward the creation of a permanent program was taken in Douglas County in 1904 when Theodore A. Erickson, a progressive educator, spent twenty dollars of his own salary on a load of Minnesota Number 13 field corn seed, developed by the university farm in St. Paul to withstand the rigors of the local climate. Public-school pupils interested in becoming members of Superintendent Erickson's corn club had to write him a letter asking for a pound of seed, much as modern-day 4-H'ers sign contract cards pledging to complete a given project. Receipt of the seed obligated the member to exhibit ten ears of corn at the local school fair. The response was so enthusiastic that Erickson soon added a potato contest. (He got twenty-five dollars for a grand prize from James J. Hill, who supported reforms in rural education and regularly addressed Minnesota school fairs.) New club projects in bread, tomatoes, and poultry soon followed. As a result of his pioneering efforts, the university farm hired Erickson in 1912 to organize club work across the state, and when the Smith-Lever Act of 1914 established the present system of county agents, he became "state leader of boys' and girls' club work," responsible for nurturing the network of clubs and county projects that would shortly become 4-H. The father of Minnesota 4-H, "Dad" Erickson held this position until retirement some thirty years later.

The advent of county agents marked the decline of the influence of the teachers in the children's movement. But Erickson's autobiography, *My Sixty Years With Rural Youth*, makes it clear that the initial impulse behind club work was educational in the broadest sense. He knew that giving boys and girls a supply of seed was the first step toward persuading their parents to attend farmers' institutes and read extension bulletins. But rural educators were also convinced that their pupils needed a sense of accomplishment, often lacking in the joyless toil of the family farm; like the members of Theodore Roosevelt's Country Life Commission, early club leaders sought to make the child's picture of the rural experience "more attractive, and fuller of opportunities, pleasures, and rewards."

The official report of the Country Life Commission, issued in 1909, praised youth clubs as instruments of the new educational philosophy sweeping rural districts. Minnesota's Putnam Law of 1909 appropriated twenty-five thousand dollars for use in the ten high schools presenting the best plans to promote agriculture, home economics, and manual training; by 1915, more than one hundred schools had initiated "vo-ag" courses. But Erickson's clubs increased in membership despite competition from the revised course of study. From the outset, part of the appeal of corn and bread clubs was their extracurricular character, the absence of the subtle coercion and regimentation often involved in classroom projects. When the county agent and, later, the community volunteer assumed control of organized activities for rural youth, enrollments skyrocketed. The country school now taught agriculture, but 4-H taught independent thinking and the ability to master self-chosen tasks.

## CAMPING OUT AT THE STATE FAIR

The youth camp established at the state fair in 1912 was one of those ideas whose time had come. Boy cadets, sponsored and drilled by the *Minneapolis Journal,* had held a paramilitary encampment during the 1906 fair; Boy Scout troops from Minnesota and western Wisconsin took their place in 1911. Both endeavors were part of the growing youth consciousness of the period that also produced such groups as the Order of Farm Boy Cavaliers, founded by the principal of the State School of Agriculture at St. Anthony Park in 1916.

The order was a rural alternative to scouting. Achievement badges could be earned in butter making, bee culture, and blacksmithing as well as bird study. Boys aspiring to move upward through the ranks of page, esquire, and knight were required to invest their own money in a farm project. Rewards were geared to the interests of children for whom hiking across fields was a part of the daily routine—not an exotic form of recreation. Like the Order of Farm Boy Cavaliers, the state fair camp was an effort to find appropriate and inspirational extracurricular activities for boys from the country.

In the beginning, candidates for the Farm Boys' Camp were chosen, one to a county, on the basis of a six-hundred-word essay about "Our Farm Home" and "why I desire to remain there." The New York and Illinois fairs had tried camps in 1911, and certain aspects of those pilot programs were adopted in Minnesota. The boys, sixteen to nineteen years of age, had to solicit references of good character, for example, and the selection committee demanded assurances that those chosen would "be willing to co-operate with the fair management to make their visit of value to all concerned." The eighty-six winners received a trip to the state fair, a uniform—the khaki-and-blue outfits, with a tie and a ranger's hat, cost the fair $3.27 apiece—sleeping quarters, all the food they could eat, and a chance to study the exhibits at close range. They were expected to act as ushers at the Grandstand and the livestock shows and to produce a second essay, for which animals and implements were offered as prizes, outlining the lessons they had learned as campers.

In keeping with the scientific preoccupations of the day, careful statistics were compiled on the "prize boys." To no one's surprise, the Class of 1912 was found to be uncommonly large and healthy. The average boy had a 32⅔-inch waist and wore a size 7½ shoe, but one lad needed a size 11. All proved themselves to be champion eaters. Data collected from new arrivals in 1920 disclosed that "four of the members of the Camp had never been on a train until they started for the fair. Nine had never been out of their home counties. Thirty-two had never seen a street car. Fifty-four had never been in the Twin Cities. Thirty boys traveled over 300 miles each." Camp was, the superintendent reported, "a great education and inspiration and a wholesome, broadening influence." Wrote one early camper: "I saw sights that were worth seeing and gained much useful knowledge. I persuaded my father to buy a manure spreader when I got home. I saw machinery that would make work a pleasure instead of a drudgery."

Serious parts of the program included addresses by ag professors and other dignitaries. But farm camp was fun, too. The boys organized themselves into squads—the Aces, Crackerjacks, TNTs, Yippers, and Gophers—to vie for annual awards given to the neatest, the most courteous, the boy with the best table manners. Beginning in the 1930s, the last Saturday morning of the encampment was given over to balloting for a Hall of Fame, in which were enshrined the names of the loudest snorer, the boy with the biggest feet, the answer to a maiden's prayer, the best usher, and the biggest eater. That last award recognized true achievement, since all of the campers were said to have prodigious appetites. A major crisis in the history of the Farm Boys' Camp came during World War II, when rationing temporarily cut off the supply of butter. "They all said they would go home appreciating more the blessings of farming," noted a counselor.

Given the rising expectations of Minnesota women during the camp's formative years, it is understandable that the enterprise did not long survive as a boys-only club. Farm girls were chosen by the same methods used to select their male counterparts and were assigned duties in the kitchen, as helpers and waitresses. During World War I, when the fair described itself as a Food Training Camp showing the rural contribution to the defense effort, the presence of young women working side by side with young men in the cause was taken as a sign of Minnesota's commitment to victory. After the war, however, the Girls' Camp Department was regularly voted out of existence, merged with 4-H, and otherwise altered beyond recognition only to gain a new lease on life in periods of national crisis or agitation for equal rights. The girls were banished from camp in 1922, but the auxiliary was back on the job in the kitchens during the World War II labor shortage.

In 1976 the powers that be finally changed the name of the Farm Boys' Camp to the Minnesota State Fair Youth Camp in order to acknowledge the shift from a contingent of male ushers from rural areas to a mixture of youngsters including boys and girls from both country and city. At the time of the change, about ninety boys and twenty-four girls (chosen by 4-H, Future Farmers of America, or school groups in their home districts) attended the camp, but true parity between the sexes under Title 9 of the new federal equal rights requirements mandated a thorough remodeling of the old wooden barracks at the northeast corner of the fairgrounds to provide separate but identical facilities for the female ushers. In 1982 there was talk of closing the operation down because of the cost of the necessary physical changes. Former campers rallied to save the program.

Carolyn Vegors of Bloomington, who had spent thirteen years at the state fair as a camper and staff member, came back to reminisce that summer, when the threat of closing hung over the site like a thundercloud. Like many of the estimated ten thousand who had participated in the program since its creation, she had been followed to camp by her brother and her cousin; after seventy years, farm camp had become a family tradition in some Minnesota households. Vegors, who came from a small town in southwestern Minnesota, described the experience as "a great opportunity for farm kids to get to the Cities."

John Brush was another graduate who rallied to the support of the farm camp that August. An alumnus of the first session in 1912, "when Barney Oldfield was the main man on the racetrack," he was visibly relieved by word that state fair camping would continue. Like the other alumni who dropped in to offer their help, he thought that "the good we're doing our farm kids by bringing them up here can't be replaced." □

The origin of the term 4-H, which was used to describe Minnesota club work as early as 1910, is veiled in mystery. The letters originally stood for head, heart, hands, and home (later health). The phrase "head, heart, and hand," as it applied to the training of children for useful lives, may have originated with educator Booker T. Washington or in a poem by Rudyard Kipling; it was, in any case, in common use among public speakers by 1905 and seems to have become associated first with the club movement in Iowa. O. H. Benson, school supervisor of Wright County, Iowa, is said to have distributed three-leafed pins (purchased for fifteen cents each) to reward excellence in practical work and added a fourth leaf in 1909 to represent a second year of achievement. In 1911 Benson took the symbol to Washington where he was employed by a national program for farm demonstration work, thus spreading the use of the green clover more widely. In the South it served as the trademark for club-canned vegetables. In the West it identified a type of Yellow Dent corn. But after 1920, when 4-H came into general use to describe the boys' and girls' clubs in farm communities everywhere, the term also stood for a new spirit of comradeship and association among isolated farm families, a new hope for the future of country children, and a new commitment "To make the best better" (the club motto). The club pledge, adopted in 1927, sets forth the credo of the 4-H'er:

I pledge

My Head to clearer thinking,

My Heart to greater loyalty,

My Hands to larger service, and

My Health to better living

For my Home, my Club,

My Community, and My Country.

"Club work," as the youth programs of the 1910s and 20s were known, constituted the greatest single change in the character of the Minnesota State Fair to date. Overnight, it seemed, the fair became a showcase for the talents and ambitions of the young. In 1912 the management began the practice of selecting representative boys (and later girls) to live in a Farm Boys' Camp for the duration of the fair. Those chosen for the honor served as ushers at the Grandstand shows and, in exchange, earned a trip to the Cities, broadened horizons, and a lesson in responsible behavior. A fair-sponsored State Spelling Bee, a judging contest for boys (in livestock, wheat, and corn), and public-school exhibits that eventually evolved into fierce competitions in building Mission-style furniture, hemstitching fine linen, writing business letters, raising vegetables, and baking bread were all in place by the time the first campers trundled up Machinery Hill toward their dormitories. But the decisive moment in the history of the fair's involvement with the children of Minnesota came in 1913 when the board answered "Dad" Erickson's appeal for official recognition of club activities by allocating special exhibition space among the school displays and two hundred dollars in prize money for the winners of an acre-yield corn contest.

Reviewing the contest in his report to the Agricultural Society, Erickson recalled that "a few years ago a visitor at the State Fair would see very little that would remind them of the boys and girls." Their situation had improved dramatically, he continued, but some adults still confused club work with school work or recreation. "What do we get out of the boys' and girls' contest?" he asked:

It is not for the sake of getting them to grow a little corn or work for a

prize. We have a larger purpose in view. . . . We think we make a mistake sometimes in trying to teach agriculture. Sometimes the high schools go at it in the wrong way — in too technical a way. I think you can do more good just to get them interested in the work about the farm and the things that are done in the kitchen. . . . That is why we present the plan of having a contest. The second thing we want to do is make it as attractive as we can. . . . The third object we are looking for is to get the boys and girls to see the possibilities of farm life. After we have gotten them interested, the whole thing is then presented, and they see there is more than just the taking care of the corn.

The Agriculture Department at the fair, however, revealed a general dissatisfaction with the methods of corn judging in the open class just as Erickson's corn clubbers were drawing public attention to quality seed, improved yields, and a marketable product. Exhibitors were admonished to refrain from bringing only the largest specimens and urged to "carefully select those true to type, smooth and of uniform size." If youngsters absorbed lessons in agricultural advances from their club work, adults also had much to learn from their junior counterparts; 4-H events at the fair were an important means of educating the parents who came to cheer for their offspring. In contests of all sorts, the judges' explanations of why one entry was superior to another were deemed especially important as lessons. The 4-H'ers, in turn, passed along what they knew about the best way to judge corn, fold a fancy napkin, bake a perfect cake, or can green beans through step-by-step demonstrations in which they explained what they were doing as they actually performed the task.

By 1922, when 4-H took over the former Bee Building, the club department had become the fastest-growing division of the Minnesota State Fair. (In 1933 the program moved into the immense space under the Grandstand, which it outgrew five years later.) More than one thousand 4-H'ers (of the twenty-thousand-plus statewide) were expected to come to the fairgrounds for a week of judging in categories that rivaled the grown-up classes in numbers, variety, and purses. Prize money totaling $22,652.50 — six times the amount allocated for women's work and more than twenty times the premiums in the Fine Arts Division — was offered in 1924, and publicists boasted that the fair's youth program was the largest in the United States. The fair board made such activities a cornerstone of its revised mission for modern times.

Like airplanes and tractors, youngsters demonstrating the latest methods of making farm life more productive and more satisfying stood for the future, for the progressive attitudes espoused by the Minnesota State Fair. "It is one of the mightiest Children's Crusades in the history of the world," proclaimed a copywriter dazzled by the sheer energy of the 4-H kids in green and white who, with their much-feted style queens and good-health royalty, came to dominate the fair in the 1930s and 40s. "The hope of our agriculture today lies in the farm boy and the farm girl," wrote another observer as the Great Depression began. "Anything which can be done to demonstrate conclusively to them that the farm offers them a healthier, happier, a more prosperous life than they may attain in the cities, makes a distinct and significant contribution to American agriculture. That, in substance, is another compelling reason why the fair exists today."

4-H burst upon the scene at an auspicious moment in Minnesota fair history. County fairs had never really recovered from the depression of the 1890s. After the wartime production boom, some agricultural districts experienced hard times again in the 1920s. Cars, movies, and the like robbed

## A CAKE SPEAKS

4-H demonstrators have sometimes resorted to shock tactics in order to get their points across in the noise and bustle of the fair-time crowds. Seventeen-year-old Doris Belange of Thief River Falls gave a new twist to a demonstration of lefse making by rolling the finished product around a foot-long hot dog and creating a new Norwegian-American delicacy. Bob Lintelman, age sixteen, from Fairmont, showed how to French fry grasshoppers. But perhaps the most ingenious culinary demonstration was the brainchild of Dorothy Clow of Humboldt, who took the platform in 1922 to recount her cake's opinion of itself.

"I am a plain butter cake.

"My mistress is very good to me and tries to make me carefully so I will be pleasing to the appetite of the hungry family.

"First she gets all her utensils and ingredients together on the table. She is very careful to measure the ingredients accurately because if she didn't I wouldn't turn out well.

"She creams the sugar and butter together very carefully so I will have a fine texture. . . .

"Then she puts in one-half teaspoon of vanilla which gives me better flavor. The batter is now ready for the egg whites. She is always very careful not to beat them into the cake because the air cells would fall and I would not rise so well.

"After this is added to the cake she puts me in the oven. When I am baked properly I become a beautiful golden brown. Many times, however, I am left in the oven too long by some careless persons and part of me becomes burned. It is a terrible sensation when this happens because of course cakes have feelings as well as human beings. . . .

"I have a very dear friend, the sponge cake. Once in a while we quarrel, but not very often. Sometimes she becomes angry with me if I seem to be more popular than she is. However, she soon quiets down and we are friends once more.

"I can be made into many different kinds of cakes by adding other ingredients or putting a filling between my layers and an icing on top.

"On the whole, I have a very enjoyable life and would not be anything else for the world." □

## A PLAGUE OF TEENAGERS

In the early 1960s a strange and dangerous species of youngster appeared on the Minnesota State Fair scene: the dreaded teenager! In 1962 teens with distinctive clothes and a cheeky manner crashed the gates in numbers, slipping over the fences and avoiding the ticket takers with no signs of bad conscience. The following year, when planners tried to mollify this new constituency with a free morning "rock 'n roll" concert (Bobby Vinton replaced James Darren at the last minute), a policeman was assaulted by a pair of teenagers as he tried to break up a gang fight across the street. Twin Cities newspapers played down the violence but were unable to resist pictures of frenzied kids doing the twist at the Teen Danceland Ballroom, a new concession that drew more than twenty thousand gyrating customers. Asked if there were enough "teenager activities" at the fair, a panel of young trend setters thought that the ballroom was sorely needed. For members of the teen subculture, the usual old state fair attractions had become something of a bore.

And so, in 1964, management created the Teen-Age Fair. Soon rechristened Young America Center, it featured souped-up versions of many old state fair standbys. In addition to shows by rock bands and folk singers, there were displays of products of special interest to a youthful clientele: sports cars, records, motorcycles, and the latest fashions (courtesy of Dayton's and Donaldson's department stores). There was even an art show centered on a replica of Mount Rushmore with the heads of the Beatles—Paul, Ringo, George, and John—substituted for Washington, Jefferson, Lincoln, and Teddy Roosevelt.

Young America Center was always an attention grabber. In 1965 the British rock duo of Chad and Jeremy, unprepared for the atmosphere of a midwestern fair, walked out on the first day of their engagement there. The publicity office took its revenge by announcing that the pair had disappeared, and the phone lines were tied up for days by overseas calls from worried fans. As fads for bell-bottom blue jeans, mini- and maxiskirts, hot pants, face painting, tie-dyed T-shirts, paisley prints, karate, and astrology (a booth called "Mind Odyssey" did a turn-away business in 1972) came and went, each one was reflected in the merchandise on display in the compound.

Little by little, however, the notion of treating teenagers as a separate order of humanity lost favor, and the kids themselves ceased to think it "groovy" to segregate themselves in their own enclave. Admissions to what was then called Youth Expo declined radically in the early 1970s, and in 1975 the lot to the west of the Grandstand, adjacent to the Midway, began its slow transformation into Heritage Square. It is ironic that the one-time lair of rebellion and the new consciousness became the state fair's tribute to the traditional values that have sustained Minnesota families since the days of the pioneers. □

*Karen Hanson and Mary Jo Madsen, both fourteen, posing with one version of the Beatles, 1964*

smaller fairs of their audience, even in areas of relative prosperity. Thus, in the 1920s and 30s, many Minnesota fairs became 4-H affairs, to which the sparse remnants of the old open class were appended.

The situation was much the same in many parts of the state during the 1980s in the wake of another farm crisis. Although their own pleasure in competition may have been dimmed by straitened circumstances and their reliance on fair-derived information lessened by newer means of communication, Minnesota's parents revived and sustained the county fair for the sake of their children. It is at the county level that 4-H'ers are nurtured, groomed, and chosen to "go on to State," where the kinds of projects undertaken directly reflect the changing face of Minnesota. In the sixty-odd years since the program found a home at the state fair, youngsters have come to compete in aerospace, photography, computer science, and consumer skills as well as calf raising, dressmaking, and cooking. The new categories interest rural children, but they also suggest the urbanization and suburbanization of 4-H that gained momentum after World War II.

In 1982 the 4-H state fair budget exceeded two hundred thousand dollars; about a quarter of that sum went for premiums, ribbons, and kids' travel allowances. A similar amount covered the expenses of the adults who cooked the meals, patrolled the dormitories, and supervised the two five-day "encampments" — one for livestock, one for other activities — that made up the membership's own fair-within-a-fair. During each encampment, groups of 1,200 to 1,800 competitors come to stay in the upper reaches of the futuristic 4-H Building begun by the WPA in the late 1930s. The building sleeps 1,500, and the overflow spills into nooks and crannies elsewhere. The kitchen serves thirty-five thousand meals in ten days. Complaints are sometimes heard about the lack of Pronto Pups on the balanced menu, the seventy-five steep steps up which 4-H'ers must drag their suitcases, the three-tier bunks that creak and sway. But among the thousands upon thousands of 4-H alumni, fair time will always bring bittersweet memories of the bunks up above Erickson Hall, the first time away from home, a doomed flirtation with the handsome boy or pretty girl from some impossibly distant county, the thrill of winning a ribbon, the knowledge that one's best is sometimes just not good enough. To the former 4-H'er, the fair is a big part of what it meant to grow up in Minnesota. □

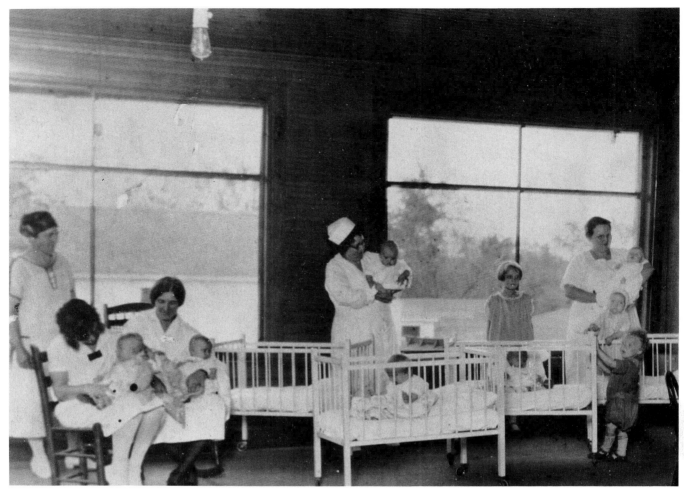

*The day nursery, 1925, established, in part, to promote infant welfare*

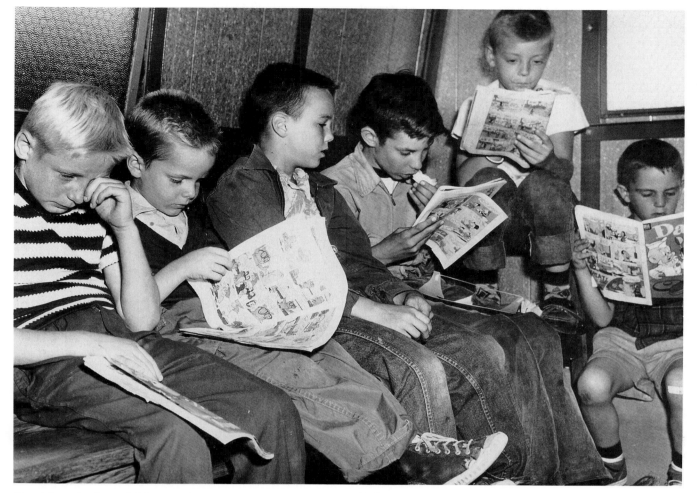

*Provisions for lost children at the fair's police station, about 1962*

178

*A ribbon for dramatic declamation, 1935*

*Minnesota Quiz for school children, held in the Electrical Building in 1950; WCCO radio personality Maynard Speece awarded ribbons and portable radios.*

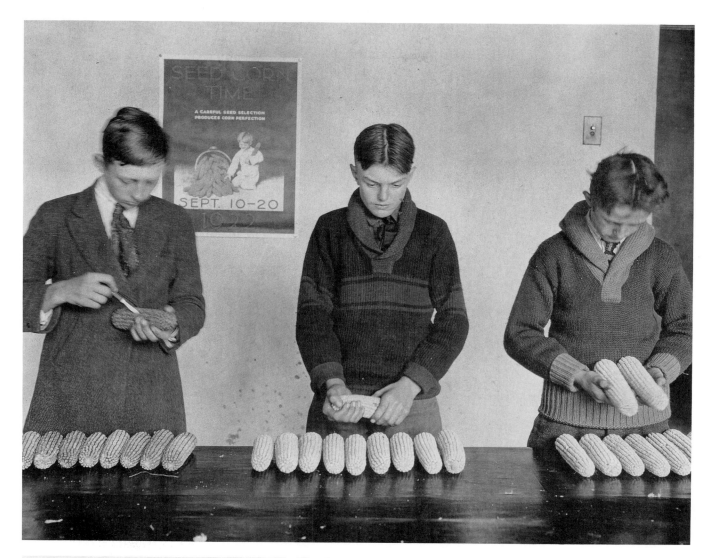

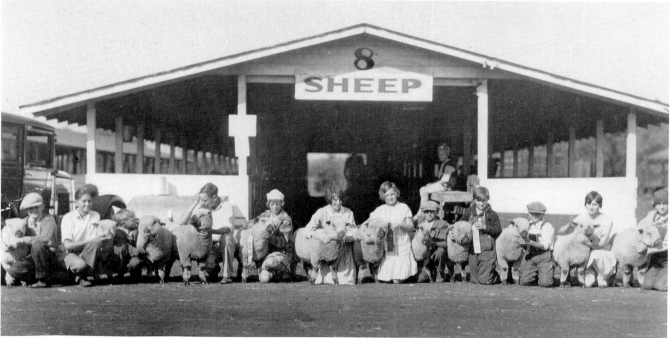

4-H club members demonstrating how to test corn, 1922

Sheep Club, 1928; like other such educational groups, it encouraged equal participation of the sexes.

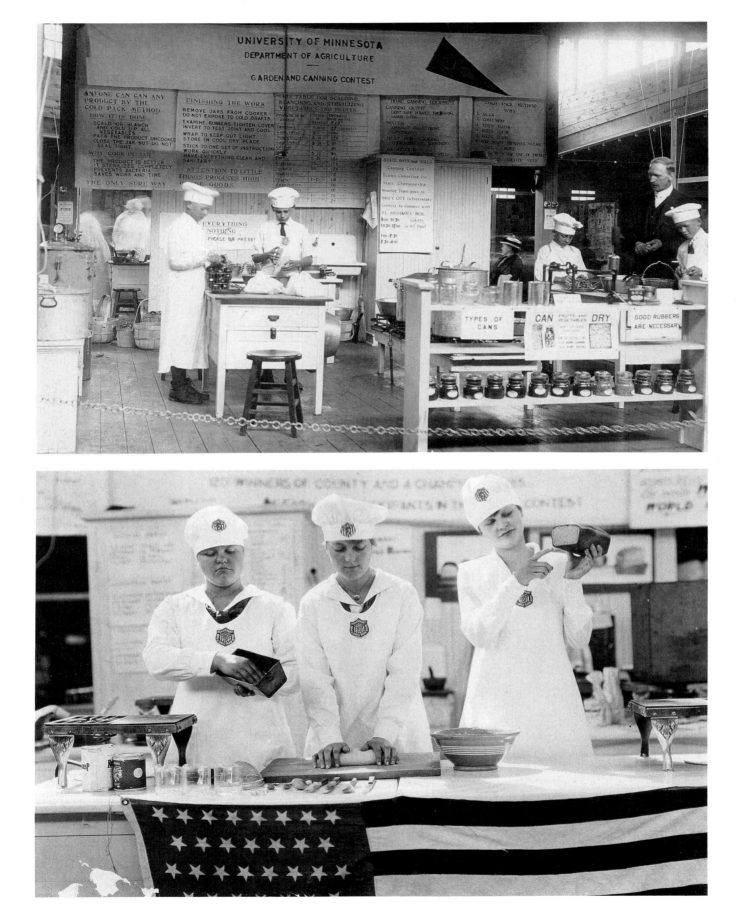

*Competitive canning of garden vegetables, open to boys and girls, 1917*

*Silent demonstration of bread baking, 1918*

*Inspection at the Farm Boys' Camp quarters, 1923*

*Grant County 4-H'ers in the dorm, 1987: Julie Frarck, Tonya Herman, and Diane Shervey, all sweet 16.*

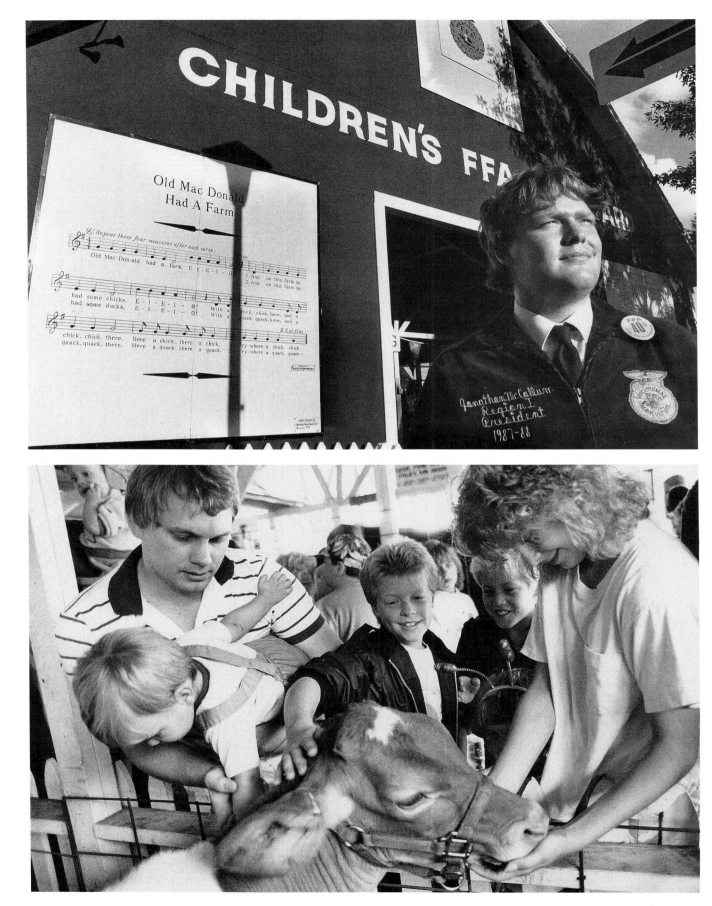

*Representative of the Future Farmers of America, another youth organization with a strong presence at the fair, outside the FFA Children's Barnyard, 1987*

*Inside the FFA petting barn, 1987*

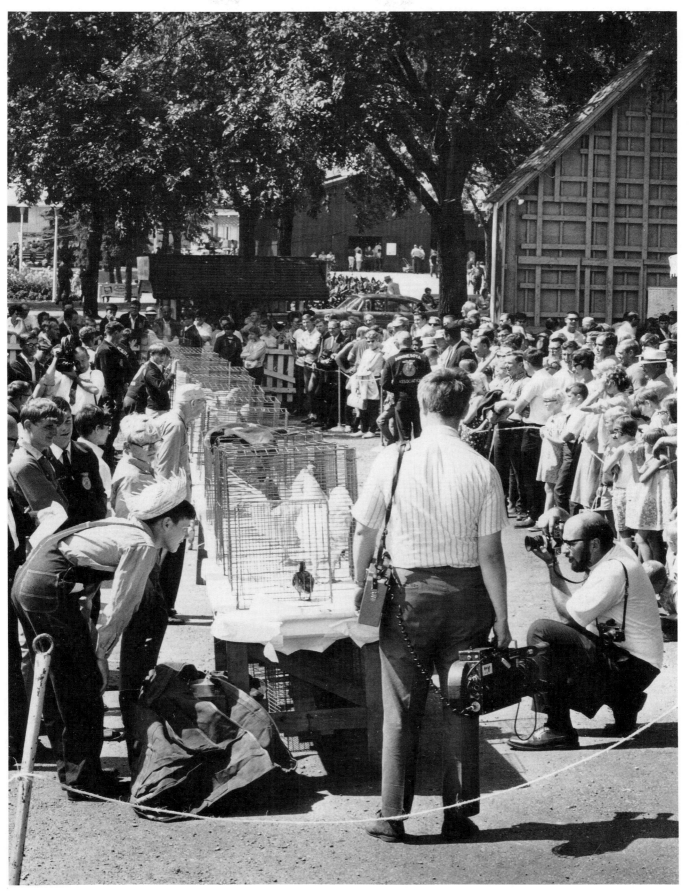

*FFA rooster-crowing contest, which attracted media attention in 1968*

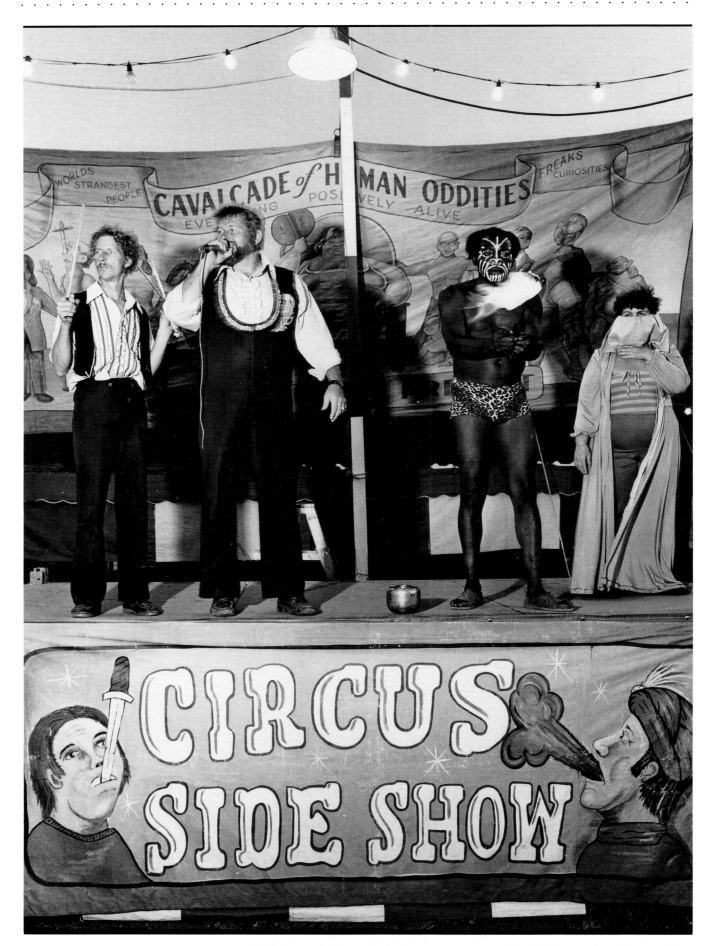

*Ballyhoo to help the barker lure customers inside, 1987: sword swallower; Mandingo, the fire eater; and a veiled beauty, a staple of carnival sideshows.*

# ON THE MIDWAY

DESPITE WORLD WAR II and the lingering effects of the Great Depression, the gleaming new 4-H Building gave the Minnesota State Fair of the 1940s an aura of fresh, apple-cheeked innocence as it sent forth platoons of industrious youngsters in white to forge a better future. But the same children who were learning how to become model citizens of tomorrow in the environs of the 4-H Building were being exposed to quite a different object lesson on the honky-tonk boulevard of shows and rides between the barns and the Grandstand known as the state fair Midway.

Since 1943 the general operation of that amusement zone had been the topic of adverse comment in the newspapers, and a 1944 crusade against indecent shows and bingo or "corn games" won a sympathetic following. Although the legislature legalized bingo in 1945, pressure forced the fair to ban all thinly disguised games of chance in 1947 after a Minnesota Poll taken by the *Minneapolis Star* revealed that only 7 percent of adults in attendance chose the Midway as a point of interest. "Those returns suggest that maybe the great annual exposition could get along without the cheap carnival which is dignified by the name of 'midway,'" the pollsters concluded. "This year, as usual, it is full of gyp stands where you pay a quarter for six rings which almost never go over the big blocks of wood. Rides which are worth a dime cost 30 cents. Fifty cents is the price of a ticket to a sideshow of a few freaks."

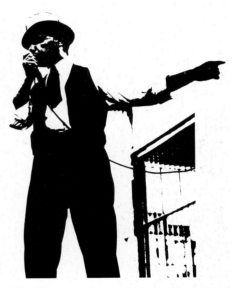

*Sideshow barker putting it over, 1937*

The fair's own books revealed that for every dollar spent at the gates, another seventy-seven cents were left behind on the Midway—considerably more folks than the candid 7 percent who owned up to a fondness for girlie shows, freaks, and a spin on the Tilt-a-Whirl were finding their way to the spot. As the *Minneapolis Tribune* noted in answer to the figures, "the Fair must have its roots in better farming, 4-H'ers, the farm boys and girls, the livestock, the quilts, the jams and the breads." But a great fair needed something else besides: "It must keep young and remain a little foolish at heart. It must have tinsel and silly exhibits and a Penny (and nickel) Arcade. Ask Grandpa about the World's Columbian Exposition. What does he remember? Little Egypt. . . . Here's to the Fair, plus the Midway. And here's to your 93% who said they weren't interested in that Midway. Because I bumped into them—in the Fun House."

In 1893 and thereafter, the exotic hoochy-koochy dancers were more likely to have come from Cedar Rapids than from Port Said. Some students of the subject claim that lewd "cooch" dancing was confined to a few dirty little tents clustered outside the gates of the great Chicago fair, that there never was a girl who called herself Little Egypt, and that the one documented Fatima on the premises was actually the father of five. The legend has proved

astonishingly durable, however, and midwestern girls in diaphanous costumes began wiggling their way along the state fair circuit as soon as the exposition closed, in company with the operators of Ferris wheels, "villages" of natives from colorful corners of the globe, fortune-telling booths, and purveyors of cheap souvenirs.

The Gaskill Carnival Company, which put together the first traveling midway specifically to play the Minnesota State Fair in 1904, carried a girlie act as well as the other celebrated Chicago and St. Louis attractions that had made the amusement area an indispensable feature of local festivals of all sorts. In Minnesota the Gaskill Midway replaced an informal agglomerate of tents, booths, and sideshows loosely attached to the enterprise since its earliest days. After 1893 it was called the Midway; after the St. Louis Fair of 1904, the Merry Pike; after the Jamestown, Virginia, Exposition of 1907, the Warpath; in the 1920s and early 30s, the Whoopee Way. By whatever up-to-the-minute title it was known, however, the Midway was as old as outdoor get-togethers.

The first "Wild Beast" shows, with two-headed calves and the like, affixed themselves to British fairs in the 1660s; around 1770 a journalist anticipated morality drives of a much later date when he condemned an English fair as "a mere Carnival, a season of the utmost Disorder and Debauchery, by reason of the Booths for Drinking, Music, Dancing, Stage-plays, Drolls, Lotteries, Gaming, Raffles and what not." In the tolerant atmosphere of post-Civil War America, games of chance, drinking, and carnival features of a questionable character gained a toehold on the fringes of the fairgrounds as amusements were commercialized and profits became a major issue in selling space to vendors. The financial failure of the 1874 Minnesota State Fair was blamed on a fit of puritanism that denied patrons both racing and beer; the 1877 fair at Minneapolis was accounted a success because races, beer stands, and what were called "side-shows" were all plentiful.

Sideshows were attractions that once lurked off to the side at respectable public gatherings; their position along the fence, or outside the main gate, testified to their marginal status. But they crept inside in the 1870s and 80s, began to pay rent in cold cash, and acquired some measure of grudging permanence even before the Columbian Exposition made a formal midway a necessity for agricultural fairs. The shows and booths that were counted among the high points of the 1886 state fair, however, were roundly condemned in 1895 when another outbreak of puritanism barred liquor, all forms of gambling, and the fast-talking "fakirs" who could separate a farmer from his premium money almost before he left the stock pens. And a lively debate on the merits of the carnival at the Agricultural Society's annual meeting for 1898 disclosed that the managers of the smallest county fairs were not unfamiliar with the temporary thoroughfare of banners and canvas that housed the weight guessers, the high-strike machines, "the museum of natural curiosities, the merry-go-round with its worn-out tunes and noisome engine, the fortune-teller, the festive doll rack, [and] the burly negro who allows you to throw eggs at him."

The 1887 tally of privileges, or licenses to operate on the grounds, shows that many of the familiar features of the late-twentieth-century midway were already in place before the Chicago fair was dreamt of. A man paid the Minnesota State Fair thirty-two dollars for the right to exhibit a cage of bears. Another entrepreneur operated a "strength tester" for a forty-dollar fee. Madam Feitsworth, the fortune-teller, was charged fifty dollars to pitch her striped tent. And comparable sums were extracted from those who ran

the so-called games of skill: two baby racks (knock over a stuffed doll with a ball and win a prize), a cane rack ("The cane you ring is the cane you win!"), and a cigar-and-jewelry wheel. The police closed down one of the baby racks for unspecified skullduggery after a single day of operation and the proprietor's deposit was forfeited, but the roster of those seeking to join the nascent Midway continued to grow, regardless.

An itinerant photographer set up shop in 1890, a two-headed woman was shown in 1891, the first merry-go-round (operated by Lindberg & Stoneburg) appeared in 1892, and 1894 brought a pony ride, a "razzle-dazzle" slide, and an Indian village. Although country delegates in particular continued to chide management for admitting "snides and swindlers" and for allowing "gambling games in an educational institution," those who believed that "freaks and fakirs have no legitimate place on a fairground" were clearly in the minority among the crowds of urbanites without the faintest interest in agricultural matters who came to the state fair to be diverted and delighted on the Midway.

Already, it seems, a curious symbiosis was at work whereby the agricultural half of the fair, weighed down by the ancient customs and conservatism of those who till the soil, found its natural complement in the trickery, bright lights, and illusion of the entertainment district. Analysts of the Chicago fair sometimes contrast the highly civilized ambiance of the White City — the portion of the exposition given over to neoclassical buildings full of edifying displays — with the savagery of the Midway Plaisance. Yet history also teaches that without the receipts from the Ferris wheel, Little Egypt, and the rest of the gaudy attractions, the Columbian Exposition would have finished its run in debt and disgrace. It is small wonder, then, that even before the Gaskill Carnival Company systematized the assembly of suitable games and rides in 1904, the Midway had become a necessary component of the Minnesota State Fair.

Before the advent of touring midways, the state fair booked the various attractions directly, charging some a flat fee and others a percentage of the gate. In 1903, for instance, Madam Moynihan (a palmist), the fat lady managed by Kelly and Pink, the fortune-teller, the Gypsy camp, and owners of the merry-go-round and Ferris wheel all paid rental fees according to their positions on the grounds, whereas the tent shows — a snake show and what seems to have been a wild-man act starring "Zulu" Sampson — were taxed according to their earnings. By following the latter practice, the fair assumed part of the exhibitor's risk, and returns were sometimes meager; nevertheless, the system was gradually extended to rides and other kinds of paid-admission features. In 1913, when the Herbert A. Kline Shows organized the Midway at Hamline, receipts from the Ferris wheel, two merry-go-rounds, a water circus, a flea circus, a motordrome, and a baby incubator show were carefully tallied to determine the fair's take.

In 1915 the World at Home Shows Midway, which carried such standard attractions as Fat and Lean, Minstrel Maids, and Diving Girls, found itself in competition with the Old Mill, a roller coaster, and several other permanent amusements newly erected on the fairgrounds under long-term leases. One method of increasing carnival revenue under such competitive circumstances was to make sure each customer spent more than he or she anticipated, and the accounting that the carnival company submitted to the fair that year lists an ascending scale of multiple fees for several of its popular acts. Having mesmerized the tip watching the free ballyhoo on the platform outside the tent show, the talker (or barker) collected one fee when

he shepherded all takers inside his "ten-in-one" (a freak show, with an assortment of natural and self-created oddities); a second fee for the "blow-off" or special, added entertainment sometimes staged in a secluded inner chamber (in the case of girlie shows, this act often involved the removal of whatever scraps of costuming remained); and a third charge for the "after-catch," or sale of items ranging from autographed pictures of the performers to naughty French postcards. By no means uncommon, this surefire technique for "fleecing the marks" added to the unsavory reputation of traveling carnies.

During the 1920s operators were torn between running a "strong" midway, with rigged games, lewd blow-offs, and bootleg liquor dispensed in lemonade glasses, and the so-called Sunday-school show, limited to wholesome entertainment and group games or hanky-panks in which somebody won a prize every time. Looser postwar morals, widespread scorn for Prohibition, and stiff competition from new amusement parks built for free-spending motorists on weekend jaunts all tempted carnival owners to play strong on the state fair circuit; a disappointing 3.5 percent drop in revenues reported by the Morris & Castle Shows in 1925, for example, was attributed to the presence of similar rides in the vicinity, and neither a midget circus nor a tentful of "art models" sufficed to make up the deficit. By the end of the decade, with sixteen shows and nine rides running day and night, Morris & Castle was still struggling to keep its Minnesota date in the black, and the fair had moved to increase its own concession revenues by reducing the space allocated to the Midway.

If not precisely a model of Sunday-school propriety, the Minnesota State Fair Midway of the 1920s was virtuous enough to escape the excesses of 1922, the summer of infamy, during which "crooked carnivals . . . with their fakers, grifters, sure-thing gamblers, pickpockets, bootleggers, cooch dancers, sheet writers, gypsy camps, thieves, smut shows and 'stealumstores' had run wild . . . bringing to rural communities everywhere the worst men and women and the worst vices of the city slums, and leaving behind them trails of disease and filth." There were two specific stimuli for the national reform movement of 1923. The first was a series of confessional articles by a reformed "faker," revealing the dirty secrets of his former profession in fascinating detail. Although the basket toss and the various count-up games had never deceived most grownups, the extent of the chicanery and outright immorality revealed by *Country Gentleman*'s informant shocked even veteran Midway skeptics. The second cause for public outrage was a "Scrapbook of Fakery" assembled by Don V. Moore, secretary of the fair at Sioux City, Iowa, who hired a clipping service to collect every news item dealing with a midway problem. Moore brought a volume of his chronicle of shame to a national meeting of fair managers in the autumn of 1922, and on the basis of his evidence secured a resolution calling for "clean fairs."

Realizing that the business had to clean its own house before more radical forms of regulation were imposed by others, the outdoor showmen's annual convention promptly set up a legislative committee and appointed a "dictator" to root out vice in the 123 carnivals that were preparing to take to the road in 1923. Likened to Will Hays, czar and censor of spicy Hollywood films, Midway moralist Thomas J. Johnson had little real power to act on the complaints that poured into his Chicago office. But he was cheered, at first, by the public's enthusiasm for purging midways of the criminal element.

Thus Johnson and his associates made much of correspondence from Minnesota that told of women uniting to secure legislation prohibiting car-

## THE OLD MILL

Scattered here and there across the fairgrounds over the years have been a whole series of rides constructed by private enterprise and operated independently of the touring midways. Originally some of these attractions stood on or near the Midway site: the wooden "Cannon Ball" roller coaster built by Austin McFadden at the Commonwealth Avenue entrance to the racetrack infield in 1914 (torn down in 1935 when the bleachers were extended) was once in the thick of the Midway district, a 150-foot-wide strip now occupied by the ramp leading to the Grandstand. McFadden's merry-go-round, erected on a leased plot nearby during the same season, remained close to its original location until its removal to downtown St. Paul in 1990.

The 1960s brought the Giant Slide, the Sky Ride—a cable car system modeled on similar overlook rides at the Seattle World's Fair and Disneyland—and a 330-foot-tall Space Tower affording a panoramic view of the Twin Cities. In the 1970s the Haunted House opened, and in the 80s a White Water Raft Ride was laid out near the main Como Avenue gate. But none of these entertainment concessions has earned the place of honor in the affections of Minnesota fairgoers reserved for Ye Old (or Olde) Mill.

The owners call it "the oldest concession on the fairgrounds" and cite 1913 or 1914 as its date of origin, thereby nosing out the McFadden carousel. State fair minutes, however, record approval of the petition of Messrs. Mahon and Keenan from Oklahoma City to "erect a permanent amusement device called the Old Mill" on January 2, 1915. Permitted to operate their ride on Sunday that year, a rare privilege also extended to

McFadden's roller coaster, the partners packed 24,071 customers into their ten wooden boats at ten cents a head, despite one day of intermittent operation caused by equipment failure.

The mechanism that drives the Old Mill is not complicated. A forty-horsepower engine turns the mill wheel which, in turn, keeps the water flowing through a 17-inch-deep, 1,300-foot-long channel. The boats drift along with the current in a deep gloom punctuated by several lighted recesses containing statuary. A mechanical mule, triggered by the passing of the boats, once raised its heels and kicked a sheet of tin, but it was eliminated at an early date because it scared patrons and made them rock the boats. (The ride was sued for the "humiliation and disgrace" suffered by the occupants when a craft sank.) The Keenan family once tried to get rid of the paddle wheel, too, in another Old Mill they owned in Shreveport, Louisiana. "That paddle isn't the most efficient way of raising the water," commented the son of the founder of this dynasty of promoters, "but it's the ballyhoo of the mill." Without the noise of the splashing water, the Shreveport ride flopped.

The Old Mill belongs to a species of tunnel rides with "scenic" grottoes that dates back to the 1880s. The first roller coaster opened at New York's Coney Island in 1886 and, with the addition of a roof and a series of "historical tableaux" on the side walls, became a scenic railroad. The quieter, gentler water rides emerged during the following decade. The Canals of Venice, invented by Arthur Pickard of London in 1891, consisted of a channel through which boats drifted on a current created by a motorized propeller. In 1902 George W. Schofield of New York improved the concept by replac-

ing the prop with a paddle wheel powered by a motor hidden behind the scenery. The giant wheel, he discovered, was an attraction in its own right. The dark tunnels were added in due course and the Old Mill—the original "tunnel of love"—was installed at several major resorts by Schofield's Aquarium Company.

Jimmy Keenan, who inherited the Minnesota State Fair concession from his father in 1923, believed that there were once about a hundred mills in operation around the country, including the Keenan mill in Shreveport and another at the Iowa State Fair that opened a day earlier than its Minnesota twin. The big red structure (red is the unofficial carnie color) at the corner of Carnes Avenue and Underwood Street was rebuilt three times before 1956. It is a Minnesota State Fair landmark. According to the several generations of Keenans who come back to St. Paul every August before the fair opens to patch the boats and get the water running once again, the Old Mill is also a place of fond memories for the many customers who return with their children and grandchildren in tow.

"Married folks come to me every year and it's always the same story," said Jimmy Keenan. "They met in the mill or maybe he tried to get fresh and she slapped him." The testimonials are convincing. Mr. and Mrs. David D. Gilham of Minneapolis took their daughter Glenda for a ride in 1958 and remembered how, as high-school sweethearts, they had argued outside the Old Mill. A reporter who observed the spat gave them tickets; when they emerged from the tunnel six minutes later, the quarrel had been patched up, David had proposed, and all was suddenly right with the world. "Boys who wouldn't want to be seen holding hands with girl friends find enough courage to do so there," remarked the beaming cupid who took the tickets.

Teenagers without dates found the Old Mill attractive for other reasons. For several years in the early 1960s, saboteurs managed to pour detergent into the pool beneath the paddle wheel. The resulting mountains of suds brought the fire department to the fair to hose down the corner and sent the owners to the University of Minnesota for a chemical defoaming agent. The pranksters struck back with packets of the water dye that downed fliers use around life rafts, but the management had the last laugh that time. "It's the prettiest green you ever saw," declared the owner. □

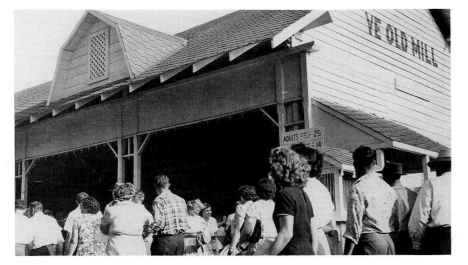

*Ye Old Mill, a classic "tunnel of love," 1958*

nivals altogether. A representative of the Woman's Cooperative Alliance, quoted in the pages of the *Minneapolis Journal*, stated that such low forms of amusement "exploit and plunder the public, and social workers and physicians have heavier burdens because of them." Other letters from Minnesota told of the Federated Women's Clubs of St. Paul extracting a promise from the mayor that no carnival would play within the city limits during his term of office, a decision by the Itasca County Fair in Grand Rapids to "can" its midway, and a poll conducted by the Minnesota State Board of Health in which doctors urged a statewide ban on sideshows "carrying dancing women."

On the national level, the campaign fizzled out in 1926. *Country Gentleman* conceded that willing marks would probably forever continue to be gulled by iron disks that couldn't cover a painted spot, stuffed cats that popped back up after being hit by softballs, wheels of chance that stopped at the behest of the operator, ersatz mermaids, "pickled punks" (deformed fetuses in bottles) made of rubber, and shiny "slum" (jewelry prizes) that actually cost a couple of dollars a bushel. In Minnesota, where the outcry was directed primarily at county fairs and street carnivals, the Midway problem had reached an uneasy resolution a decade before, at the climax of a generation's worth of raids on disguised saloons, annual indignation over "powdered ladies with bleached hair . . . and abbreviated costumes," complaints about worthless prizes and shortchanging, and false assurances from the management that acts like the Fat Girl and Nicolai, the Midget Russian Prince, were legitimate instruments of a greater educational mission. The state fair took a good, hard look at the sideshows it had, from time to time, removed from the axial approach to the Grandstand and penned up in a furtive enclosure to the west of the livestock barns.

The freaks and the crude shows along the Midway came under special scrutiny because they seemed so unrelated to the agricultural focus of the fair and the dignified presentation of Minnesota products envisioned by certain business interests. And so, in 1911, the various superintendents pledged themselves to a purge of "undesirable" attractions and the "undesirable class" of persons who induced the unwary to view them. Barkers were summarily silenced. The ten-in-one was closed down. And Minnesota's reformers went to the convention of midwestern fair managers determined to spread the gospel of purity.

They succeeded in stimulating a debate on the future of freak shows, but the resolution that emerged from the meeting restored the fat lady to her place of honor on the Midway in 1912. She was not a freak, they decided; that term would henceforth apply only to "monstrosities and abnormal persons," like the geeks who bit the heads off live animals for a fee. Squads of censors spread out across the fairgrounds to watch for other offenses to decency, too, and immediately snared a "professor" who advertised illustrated lectures on white slavery and a sweet little twelve-year-old girl with ringlets who sang highly "improper" songs. In 1913, a self-appointed committee of women, trailed by fair officials, went from show to show, prepared to point out any "objectionable features" to male functionaries whose ability to detect vice was open to question on the grounds of gender alone. As a result of their gimlet-eyed scrutiny, Oriental dancing temporarily disappeared from the Midway, although the barkers and the diving girls were permitted to remain.

In 1914, in an excess of fervor, the fair board announced that "'the Midway' and 'the Pike' of the Minnesota State Fair will never be seen there

## FREAK SHOW

The ten-in-one or freak show has always found a place among Minnesota Midway attractions. Throughout the nineteenth and the early twentieth centuries, freaks of nature—the fat lady, the India rubber man, the armless wonder, the dog-faced boy, pairs of Siamese twins, troupes of midgets, and assorted oddities of the animal kingdom—were the principal items of interest. Midgets, often posed with giants or willowy showgirls for publicity pictures, enjoyed a particular vogue in the 1920s and 30s, climaxed by the appearance of the famous Singer Midgets as the munchkins in the 1939 movie, *The Wizard of Oz*. The film was, in many ways, a commentary on the features of the traditional midwestern fair. The wizard, in the end, departs from Oz in the gondola of a fancy balloon emblazoned with the words "State Fair-Omaha." And the companions of Kansas farm girl Dorothy Gale on her dream-time adventure are the kinds of characters who might be found in a traveling carnival: the poor fellow with the hair and the whiskers of a lion, the mechanical man, the baggy-pants comedian (the scarecrow), the beautiful chorus girl (the good witch), and 124 dancing midgets.

In the postwar era, the balance on the Midway tilted sharply toward self-created freaks: sword swallowers, fire eaters, contortionists, folks with tattoos. Ralph Best, owner of the largest freak show on tour in the 1950s, attributed the change to advances in medicine and improvements in prenatal care. "When I first started in this business in the 1920s," he at-

tested, "we would hear of a new freak every two or three weeks but I haven't heard of one now for five years." A more compassionate attitude toward human misfortune also helped to change the lineup in the typical ten-in-one and increase the popularity of the all-animal freak show, the 1983 edition of which headlined a midget goat and the stuffed remains of a two-headed cow.

Freaks of all sorts remained popular at the Minnesota State Fair long after the receipts had begun to slip elsewhere. Showmen were at a loss to explain the phenomenon. In the 1950s, for example, the Minnesota State Fair gave the freak show (complete with a quarter-girl, a three-legged woman, and a giant) its best attendance of the entire seven-month tour. The Cortes brothers, who managed the show for Royal American, could only speculate on reasons why Minnesotans seemed so ready to part with their cash to see strange sights. "Maybe the people of Minnesota are clean livers," said the eldest Cortes. "It's a cinch they've got strong stomachs." His brother didn't think Minnesotans were sadistic but did allow as how they were inordinately curious about anything different. "They're isolationists out here," he declared. "What appears extremely unusual to them wouldn't raise an eyebrow in the east."

The statistics hadn't changed much in 1964 when Paul Wunder, barker and manager of the Dick Best Freak Show, also noted that the Minnesota State Fair brought in the biggest gate on the circuit. People were lined up by the hundreds before the lurid "front" or "valentine," the canvas banner hinting at the disconcerting attractions

within. "Why this is so great a freak show town nobody can tell you," he remarked, "but it has been ever since we first came here in 1933. We've got a lot of friends here. Every year we have people walk up and say, 'Hello, what have you got new this year?' You have a lot of country folks here. I think they are more interested in freaks because they don't ordinarily see anything like them." In 1971 the new Royal American computer again confirmed the inexplicable interest of Minnesotans in the dying ten-in-one.

Whatever the reasons for the interest, it was, for the most part, benign. The fifteen-month-old Seifert quadruplets of Sleepy Eye, Minnesota—Monica Mae, Martha, Marie, and Michael—went on exhibit in a special glassed-in room in the old Administration Building during the 1951 fair. An independent concession run by their parents, the Quad Show cost viewers twenty-five cents, with the fair entitled to half the receipts. The kids were back again in 1952 and 1953 in the Agriculture-Horticulture Building, playing happily under the delighted gaze of thousands, occasionally talking to a spectator, and flatly refusing to dine under mass scrutiny. □

*"Little people": the Midget City group, 1936.*

again." Strictly speaking, the press release was half accurate — management that summer dropped "Pike" from the repertory of euphemisms used to alert fairgoers to the availability of all the familiar games and scams, and, for a while, called the place an educational carnival. But the Midway didn't vanish, although it did put on Sunday-school manners for the duration and acquired a measure of stability with the advent of Carl Sedlmayr and his Royal American Shows.

When he took his first shows on the road in the early 1920s, not only was the industry under attack for sharp practices, but it also suffered from a proliferation of the same old rides, attractions, and concessions. Sedlmayr seems to have been the first entrepreneur to realize that for a midway to stand out from all the rest it must be squeaky clean and committed to treating customers as patrons — not suckers or marks. That philosophy earned Sedlmayr the loyalty of the Minnesota State Fair. Royal American Shows first contracted to operate the Minnesota Midway in 1933 and, through several changes in name and ownership (for a time in the 1940s, Sedlmayr operated the Rubin & Cherry Shows), the relationship has persisted, although talk of recreating the old, independent Midway surfaces from time to time. The fair gets a percentage of the proceeds that rises sharply from a base level of 32.5 percent as the take increases. In other words, the fair profits in direct proportion to the vitality of the Midway, which has done a roaring business since its first Minnesota stand. In 1939 the Royal American road show was widely considered superior to the Amusement Zone at the New York World's Fair in quality and value, and in 1942 the Minnesota State Fair Midway, under Carl Sedlmayr's direct supervision, set the record for the highest gross in the history of the outdoor amusement business, when $120,000 in nickels and dimes were collected during fair week. Talk of huge earnings at the Minnesota fair was widely pooh-poohed in financial circles, but the criminal element believed the figures published in *Billboard*, the Bible of the carnival world. In 1940 the tabloid reported a record box office at the Minnesota State Fair; the following summer, as a direct consequence, three newly hired roustabouts torched their way into the ticket wagon as the show train left St. Paul and made off with more than $100,000. It was the carnival heist of the century!

The state fair Midway usually separated people from their money in a less dramatic fashion. Rides that grew wilder and woollier by the year and games that held out the promise of a "piece o' plush" for your sweetheart appealed, by and large, to teenagers. The shows aimed at a wider audience. At various times in its long history, the Midway has given Minnesotans the chance to see live Philippine tribesmen in loincloths (1908), a pair of wild men from Borneo by way of Coney Island (1910), a preserved corpse alleged to be that of assassin John Wilkes Booth (1920), the six-member, 2,467-pound Karn family (1923 and 1927), an embalmed whale (1930), John Dillinger's ex-girlfriend (1939), fan dancer Sally Rand (1948), famous stripper Gypsy Rose Lee (1949), and cowboy star Lash LaRue (1957). Even football great Red Grange played the Midway in his final years, recounting gridiron memories between the acts of a saucy review.

Carl Sedlmayr, for one, saw no contradiction between cleaning up the seamier features of the Midway and the appearance of Sally Rand, whose act had proven remarkably durable because, with wit and charm galore and the full knowledge of her admirers, the lady promised a great deal more than she was prepared to deliver. Arriving at the fair on a ninety-degree day, Miss Rand lent her famous fans to two perspiring interviewers and

# GOING NATIVE: THE ETHNOLOGICAL VILLAGE

The international character of the great nineteenth- and early-twentieth-century world's fairs was enhanced by displays of artifacts and, in some cases, actual persons from the faraway branches of the family of man. In Philadelphia, Chicago, Buffalo, St. Louis, and San Francisco, serious ethnographic displays using mannequins and wax figures posed in characteristic postures recreated the lives of Laplanders, American Indians, South Sea potentates, and Oriental nobles. Cashing in on the prevailing curiosity about such peoples, various commercial displays also purported to show picturesque folk as they really were; the Streets of Cairo attraction from whence the notorious Little Egypt came was only the most cynical and profitable manifestation of the same interest.

The craze for exotica had its serious side: anthropology was in its infancy, and the sheer numbers of costumes and household objects turned up for exhibitions provided study materials for generations to come. But there was a kind of debased Darwinism at work, too — the smug feeling, on the part of the white, middle-class visitors who gaped at the canoes and kayaks, that mankind had evolved beyond these primitive beginnings, that the industrialized present represented the lofty pinnacle of human progress. Like freaks in the Midway ten-in-one, the tribal peoples gathered in mock villages for the edification of fairgoers had a certain curiosity value. But the sense of learning new scientific truths mingled with a pleasurable awareness of the onlooker's clear superiority to the specimen on display.

The first native village at the Minnesota State Fair was set up in 1896 with full knowledge of the Chicago example. The decision to bring a band of Ojibway to live on the grounds and compete at lacrosse with a group of Winnebago was based on the fact that the American Indian village had been "one of the best drawing cards on [the] Midway during the world's fair." And published descriptions of the Minnesota tepee village were couched in the pseudoscientific jargon of the world's fairs, too. The residents were "specimens of the noble red men with their squaws and papooses." The secretary of the fair was said to have tried his best "to secure representative examples of the several tribes" and "a collection of Indians including . . . the best specimens . . . obtainable." The management promised "real blanket reds — the simon pure article."

This approach dehumanized the Indians, treating them as so many carefully classified bugs on pins. Nineteenth-century illustrations of crowds at the Minnesota State Fair included Indians as a matter of course — a segment of the population — and an article in *Forest and Stream* for 1878 describing that year's fair makes it clear that furs and hides dressed by native Americans were an important part of the exposition. Displaying the first Minnesotans in ethnographic villages effectively read them out of the affairs of the present and consigned them to a romantic past. Newspaper articles about the proposed state fair village of 1896 frequently described it as a tourist mecca, sure to interest visitors from the East and the South, whose only experience with "wild" Indians came from romantic novels. At the same time, however, fair officials had romantic ideas of their own. What was wanted, one organizer admitted, was something approximating "in savage picturesqueness the idea conveyed by Remington's drawings in the illustrated periodicals that find the Indian a topic of never-failing interest to their cultured readers."

In 1904 one of the main drawing cards for the state fair Pike was Chief Flatmouth of Cass Lake, whose reactions to a live elephant, the House of Mirrors, and the freak show were thought sure to be amusing. The comic potential of exposing a newcomer to various features of American life was never far from the surface when native villages were concerned, however earnest the talk of better understanding the human condition through observing the customs of others. Cultural imperialism was also a factor in the popularity of ersatz villages from subject nations in the aftermath of the Spanish-American War.

A case in point was the Igorrote village of "Filipino head-hunters" that made the first of two appearances at the Minnesota State Fair in 1908 as a part of the Herbert A. Kline Shows. It mattered little to most of those who paid the admission fee that the display had won a gold medal for science at the 1905 Portland Exposition or that a University of Minnesota professor had recently written a book on this ancient tribe. Instead, the "barbaric" nudity of the men, their marriage customs, and their understandable puzzlement over certain aspects of the fair — the baby checkroom in particular — were greeted with gales of laughter. St. Paul residents and a visiting Indian troupe encamped nearby were advised to lock up their dogs, lest they be barbecued by the frustrated hunters. A "little savage" baby fell victim to indigestion when the crowds fed him peanuts and popcorn as though he were a caged animal in a zoo.

Villages of wild men from Borneo, "dirty and shiftless" Indians, Swedes, Hawaiians, Congolese pygmies, and Eskimos were standard Midway fare until 1949, when an Alaskan family displayed in a papier-mache igloo continued to "smile for the crowds" even when the thermometer soared past 90. The fact that television made the world a global village rapidly deprived such sorry encampments of their novelty, although the Mexican Village flourished at the fair into the 1980s. Yet the notion of internationalizing resorts and amusement parks with displays of the products and life-styles of others survives in places such as Epcot Center at Florida's Walt Disney World, a kind of permanent world's fair. There, students from the countries represented live and work for various periods of time to add a touch of authenticity to the pavilions of their native lands. □

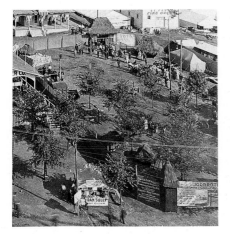

*Grass rooftops of the Igorrote village, in its second season, 1909*

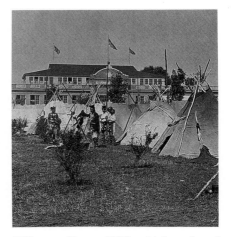

*Ojibway village, 1909, which replaced the Dakota camp of 1908*

noted that her troupe of showgirls did "not overdress in warm or any other kind of weather." And she was proud to disclose that the chorines in the Sally Rand Revue made one hundred dollars a week, top dollar in the profession. Having established that fact, the star departed for downtown St. Paul, where she was scheduled to address the Rotary on "The Importance of 4-H Clubs."

The same mixture of wholesomeness, class, and good-humored naughtiness was evident in her show, to which the *Minneapolis Tribune* exposed five self-confessed old maids. Arguing among themselves as to whether the lady was wearing some kind of "artificial support," the panel emerged unfazed by a brief glimpse of the real Sally between her parted fans.

As for the infamous Gypsy Rose Lee, she introduced herself to Minnesota as a housewife who cooked on an electric stove in her cozy trailer home; a mother, who read her four-year-old son to sleep each night while her husband smoked his pipe. Gypsy repaired her own costumes. And she also confided to the *Tribune* reporter that, like many ordinary American women, most of her thirty-seven-member company wore sponge-rubber "falsies" to work.

Historian Noel Perrin views the history of fair entertainment as a four-part progression beginning with agricultural displays and moving through horses and politics to monster midways and, finally, to the name acts that play the grandstands. In a sense, then, Sedlmayr's decision to book well-known public figures and entertainers during the 1940s and 50s gives the Royal American Shows a pivotal position in the gradual shift away from forms of amusement inherited from the nineteenth century to the more passive, star-oriented format of later years. But as Sedlmayr (and sociologists like Marcello Truzzi) realized, the enduring appeal of the Midway is rooted in the ability of the patron to participate vigorously in his or her own entertainment.

The pleasure derived from rides and games comes from screaming and winning and egging one's friends on to do the same. Half the fun of a tent show is the engaging battle of wits with the talker outside: Will the tip consent to suspend disbelief? Will the mark agree to be gullible? And once inside the tent, the interaction between spectator and performer — whether the star is a once-upon-a-time Hollywood idol or a swallower of lighted neon tubes — is far more intimate than that between a giant crowd and a distant singer under a grandstand spotlight. Although television almost killed the movies in the 1950s, when Lash LaRue brought his act to a bally platform at the Minnesota State Fair, business on America's sawdust circuit continued to grow. It is still on the rise precisely because the Midway answers a need for hands-on amusement in a way that no other form of diversion has managed to duplicate. □

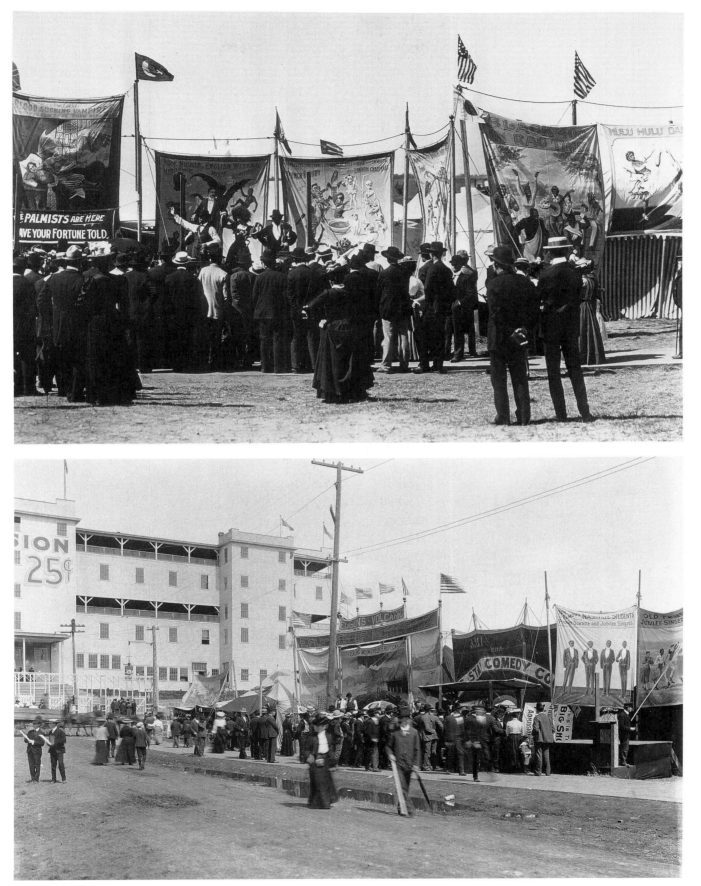

*Midway staples of the early 1900s: a vampire, palm reader, magician, minstrel show, and a slightly risqué hula number.*

*Sideshows involving film and projection techniques, such as "Edison's Volcano," 1903, amazed audiences before motion-picture theaters were commonplace.*

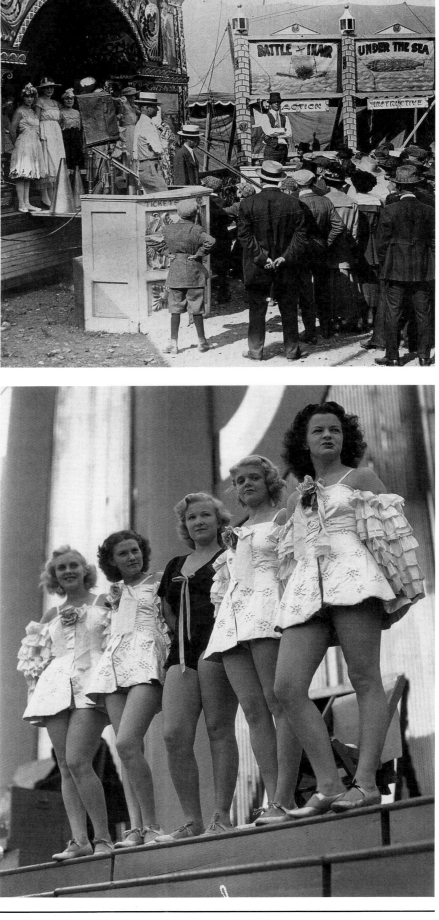

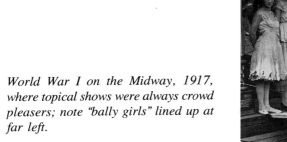

*World War I on the Midway, 1917, where topical shows were always crowd pleasers; note "bally girls" lined up at far left.*

*Ballyhoo, 1937*

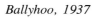

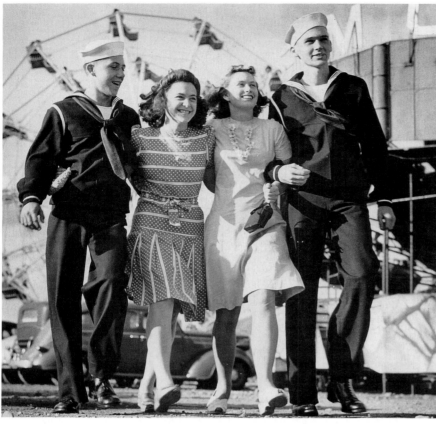

*Sailors and Minneapolis women out for a good time four months before Pearl Harbor, 1941*

*Exotic glamour, about 1950*

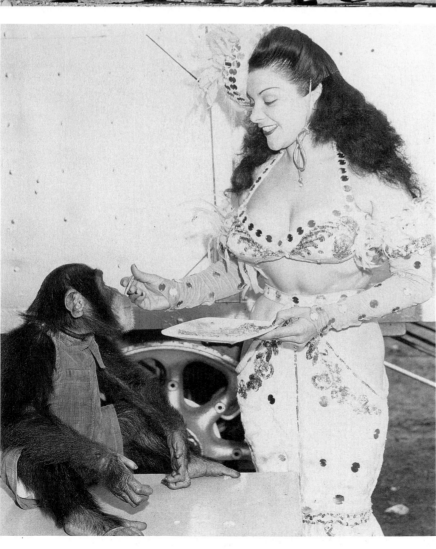

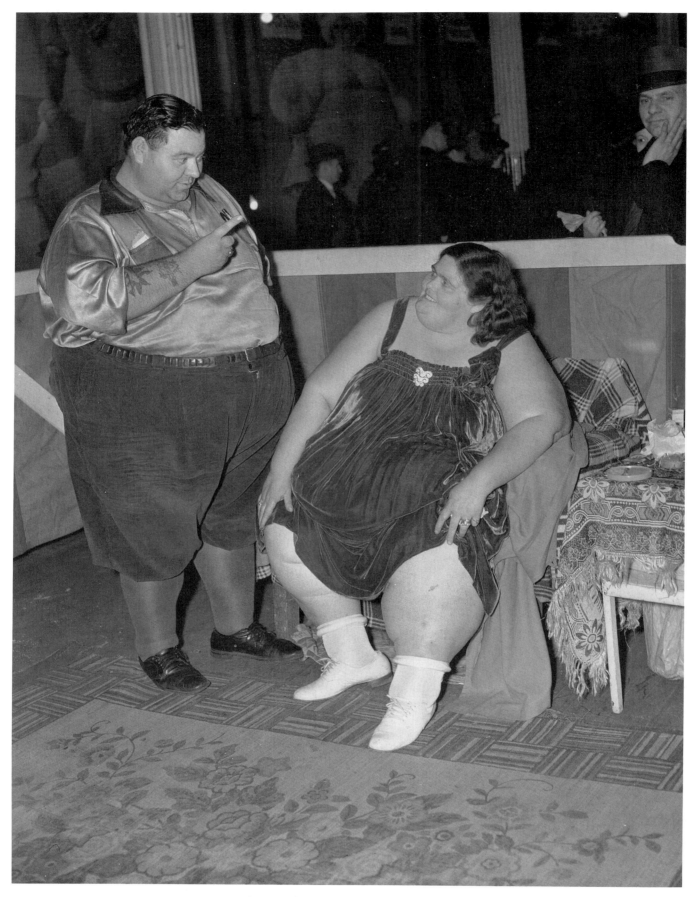

*Next to dancing girls, freak shows were the biggest draws, at least in Minnesota.
A family sideshow troupe, 1935.*

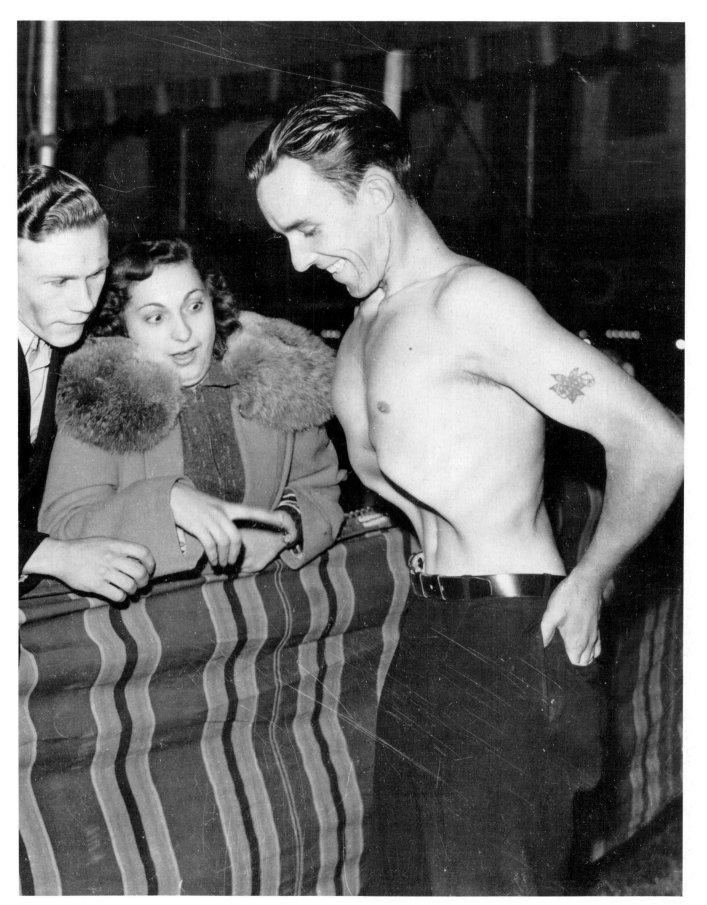

*Carl Lapayne, "the man who swallows his own stomach," one of the stars of the*
*Rubin & Cherry Midway, about 1943*

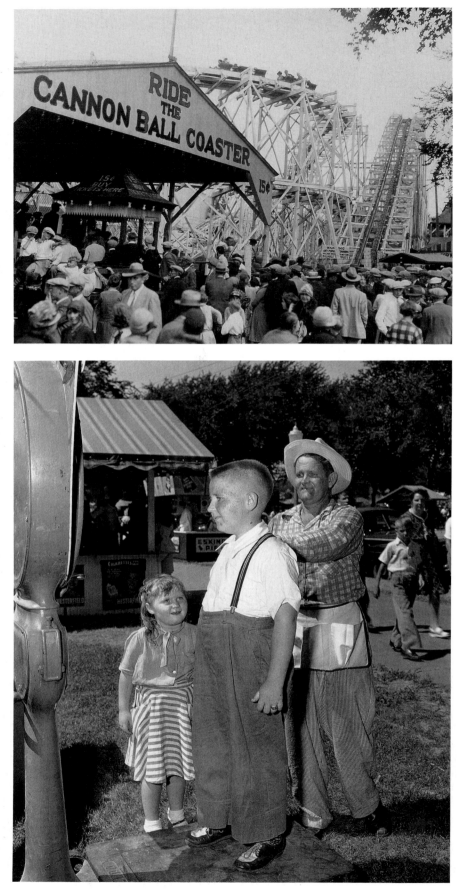

*The Cannon Ball roller coaster, built in 1914 and demolished in 1934–35*

*The weight game takes a practiced hand, 1947.*

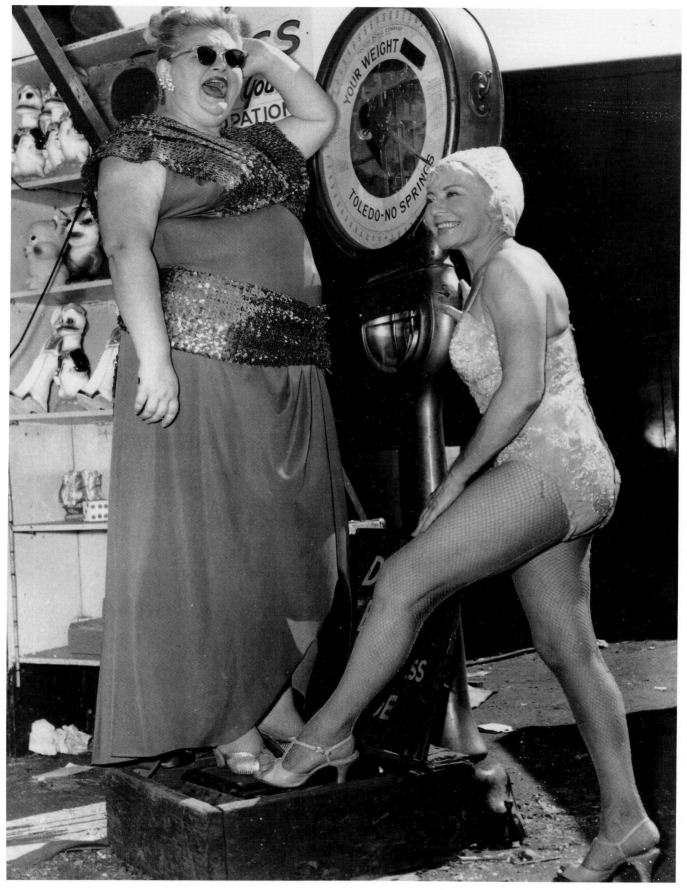

*Midwayites "Baby Dumpling" and friend, trying the weight-guesser's scale, 1960*

*Typical Minnesota family about to try its luck at the milk-can toss, 1959.*

*Ida Broda of Chicago, a twenty-year veteran when she set up shop at the
1987 fair. Her most popular prize: a poster of the rock group Bon Jovi.*

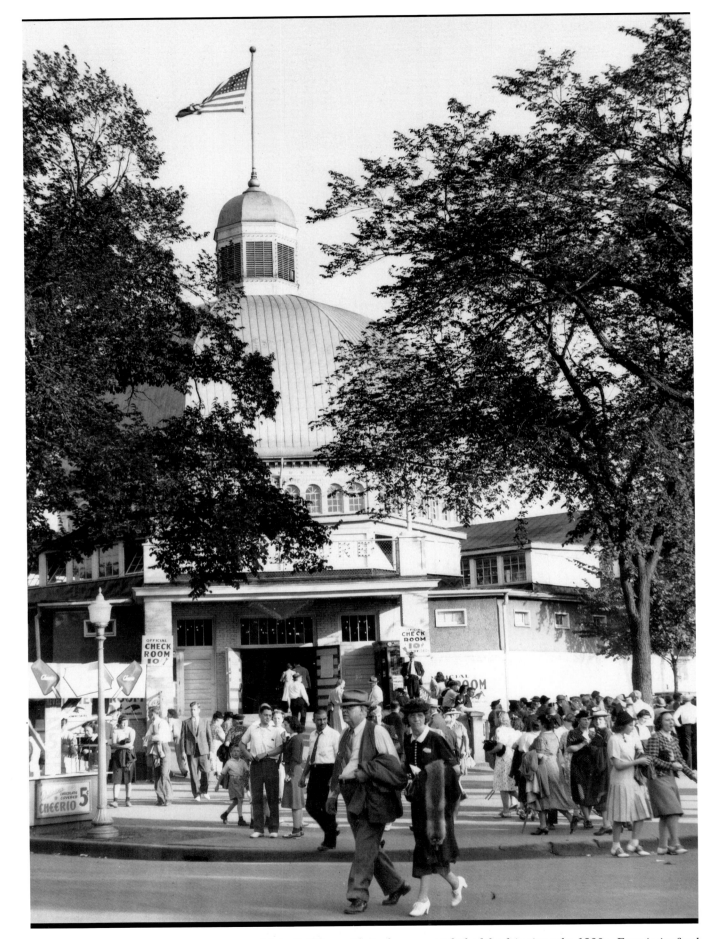

*Main Building with its dome, a symbol of the fair since the 1890s. Even in its final years, the early 1940s, relegated to checkroom duty and partially shrouded in plywood, Main retained something of its original dignity.*

CHAPTER FOURTEEN

# FAIR ARCHITECTURE: RECREATING THE PAST AND BUILDING THE FUTURE

THE MOST SIGNIFICANT ALTERATIONS in how the state fair looked came about during the 1930s and 40s, a period of rapid and often unsettling social change. Thanks to federal programs of work relief, the Great Depression afforded management the chance to replace key portions of the fair's aging stock of turn-of-the-century buildings at a nominal cost. The new horse barn and the Sheep and Poultry Building, the swoop of concrete ramp leading to the Grandstand, and the 4-H Building, all boldly moderne in style, were built with WPA assistance.

But these remained isolated statements until several fortuitous accidents necessitated a program of rebuilding. The fire that destroyed the old Main Building in 1944 created an opportunity for planners to project a brand-new image for the fair as a whole by bringing the principal structures into formal harmony with the WPA ensemble. The new Agriculture-Horticulture Building, which replaced its aged predecessor in 1947 atop a rise on the fair's central intersection, was a reprise of the nearby 4-H Building, with the same lighted tower, the same dynamic vertical thrust, and the same clean, streamlined shapes.

During World War II, a number of structures on the west end of the fairgrounds had been seized by the government and turned over to the A. O. Smith Corporation for use as a propeller plant. When the factory closed down in 1945 and buildings were slowly emptied and deeded back to the fair, it was discovered that the old Hippodrome had become unsafe for use. The new Coliseum, finished in time for the 1951 season, was the last of the white, art deco-style showpieces that give the Minnesota State Fair its characteristic appearance today. Curvilinear and flowing in shape, the Coliseum — like the Food Building, which opened in 1949 — represents a later stage of modernistic design than the angled and faceted buildings of the WPA phase. But regardless of nuances of style, the buildings completed in the postwar years bespoke a desire to look to the future, to soar upward into that technological tomorrow toward which each gleaming tower and spire and vault gestured broadly against the nighttime sky.

A distinctive shape against the Minnesota sky has always been the hallmark of the fair; for several generations, the wooden dome of the old Main Building was the chief graphic symbol of fair going. Cartoonists and designers of ads invariably pictured the state fair as a sprawling welter of tents and sheds and Ferris wheels huddled about its soaring majesty. When the building was constructed, back in 1884, domes were the most efficient means of bridging the great horizontal spans called for in exposition halls of brick and wood. But the dome also said something quite specific about the nature and intent of a given building. Public edifices like capitols and

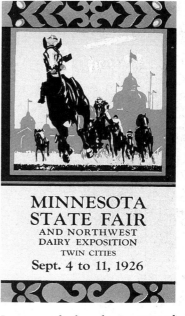

*Images of the dome graced posters as late as 1926.*

cathedrals had domes, for instance, whereas private ones did not. In an architectural language familiar to all, the sheltering circle of the dome stood for great communal undertakings.

Thus the use of segmented domes and other lofty appendages on the pavilions at world's fairs not only called attention to their presence in preskyscraper days but also lent the enterprise the dignity that once adhered to church and state alone. The modern goods and machinery on display within basked in the borrowed luster of the ages. That transference was nowhere more apparent than at the 1893 Columbian Exposition in Chicago, where dynamos, cheap souvenirs, railroad trains, prize pigs, and oil paintings alike were elevated to the status of wonders of the modern world by an imperial White City of columns, pediments, and domes. And the Illinois State Fair demonstrated how readily that notion translated to more bucolic surroundings when it moved its huge Dome Building (said to be taller and wider than any existing dome in the world, except that of Petrograd Cathedral) directly from Chicago to the Springfield fairgrounds in 1894.

In Minnesota, the dome of the Main Building inspired the domelets of many country fairs determined to capture a little of the magic of the Hamline extravaganza. The lovely, listing dome that still pokes its head above the old trees on the Dakota County fairgrounds in Farmington recalls a time when an architecture of pomp and pretense lent fresh distinction to the farmer's old-fashioned calling, so often belittled in a modern era of world's fair technology. But domes were not the only lesson the international fairs had to teach. Emmanuel Masqueray, who came straight from the 1904 Louisiana Purchase Exposition in St. Louis to design the massive dome of the cathedral in St. Paul, helped to introduce ornate classicism to Minnesota and the state fairgrounds.

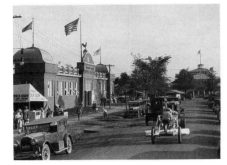

*Some other domed pavilions at Hamline, 1921: the Poultry Building and Machinery Hall at the end of street, a stripped-down version of the same style.*

In the years following the St. Louis fair, a wave of exuberant Greco-Romanism swept across the Hamline landscape. The dome and supporting drum of the newish Agriculture Building, loosely based on the details of St. Peter's Basilica in Rome (Old Main harked back to the Duomo of Pisa), seemed meager by comparison to the lush classicism of the Manufacturers' Building, encrusted with the tall stone pillars, imposing pediments, and deeply carved cornices of an ancient temple. The Dairy Building bristled with pilasters and molded balustrades. The overdecorated Poultry Building was topped off with no fewer than four corner domes, each one surmounted by a flagpole. In 1909, when Secretary Cosgrove confided to a journalist from the *Minneapolis News* that he expected a world's fair to be held in Minnesota in the very near future, there was no reason for anyone who visited the state fair regularly to doubt that his dream would come true. In Cosgrove's day, the Minnesota State Fair looked like an architectural compendium of all the best features of all the best world's fairs to date.

The practice of importing designs for new buildings from the latest world's fair continued unabated; the art deco additions of the 1930s and 40s pay tribute to the cubical towers and colored lights of the 1933 Century of Progress Exposition in Chicago and to the sinuous flow of taut white surfaces at the New York World's Fair of 1939. As in the case of the classical buildings of the early 1900s, however, these structures signify something more than an awareness of recent trends in festive architecture. By looking like a Columbian or a Century of Progress Exposition, the Minnesota State Fair cast off its former status as an agricultural display of mainly local significance and asserted its claim to be a universal showplace of agriculture, manufactures, and industry. And it is probably no coincidence that the two periods

## THE LANDSCAPE SETTING

An important ingredient in Secretary Cosgrove's plan to design a potential world's fair site on the grounds at Hamline was the creation of attractive parkland that would set off the impressive new buildings to best advantage. To that end, he oversaw the layout of a number of elaborate beds of blooming annuals, beginning in 1908. Crescent Park occupied "a rather unsightly depression" between the new Manufacturers' Building and the Dairy Building. Circle Park, cleared to house a village of three hundred Dakota Indians engaged to play parts in the Grandstand spectacle that year, was measured and leveled for later restoration. Acres of phlox filled the empty spaces adjacent to the street railroad station, the St. Louis Building, and the livestock barns. Twenty-three thousand plants were set out on the broad corridor that led to the Grandstand, the embryonic Midway district "formerly devoted to hucksters' stands and waste and ruin."

In 1909, emulating the serpentine lagoons and connecting waterways that added to the charm of the St. Louis fair, Cosgrove began an extensive program of drainage and excavation with the object of opening an all-water route from the new Raymond Avenue gate of the fairgrounds to the Grandstand. This adaptation of the canals of Venice was to have been traversed by a fleet of gasoline-powered gondolas, making it a pleasure ride as well as a source of beauty. At the terminus, management hoped to group scattered rides and shows and a year-round zoo on the shores of a man-made lake. The

scheme would have created a diversified but spatially coherent amusement zone, similar to those at world's fairs.

Although two boats of shallow draught managed to carry passengers during the summer of 1909, by the following year it had become clear that water pumped into the canals seeped into the soil almost as quickly as the six-foot trenches could be refilled. In 1910 the gondolas were able to move through only a small portion of their route. The project was given up and the waterway was left to dry out, much to the amusement of the local press, which puzzled over the inability of the channel to retain water even during the torrential downpours that ruined the 1911 fair. In time the lake became the Midway — muddy until the area was paved in the 1950s.

In the meantime, Cosgrove and his associates treated the public to a series of eye-popping formal gardens. Seen for the first time in 1909, these new arrangements took several forms. The most impressive of the lot was the sunken garden on the Grandstand approach, outlined with "Grecian borders" of foliage and completed with a huge geometric pattern of square and circular beds. Crescent Park was brightened by a stand of cannas. The lawn in front of the Agriculture-Horticulture Building featured geranium and phlox planted to form the shapes of a giant star and a crescent. This pictorial approach to landscaping, derived from contemporary exhibition techniques as well as topiary gardening, would dominate state fair floral display for the next half-century.

At the 1905 fair, Minnesota apple growers had been lauded for gigantic,

three-dimensional replicas of the Liberty Bell and an overflowing horn of plenty made of fresh fruit inserted in a hidden framework of wire and lath. This popular method of massing produce, minerals, or manufactured goods to form attention-grabbing statues was transferred to living plants in 1921 by William Vasatka, head gardener of the Minnesota fair. His first effort was a fifteen-thousand-plant reproduction of the Liberty Bell, accurate down to the crack composed of pale green sedum and the supporting arch of hen and chickens. His masterpiece of 1934, a kind of tribute to the star and crescent flower beds of 1909, was a floral staircase leading to a massive pair of open gates adorned with the moon-and-star motif. A mecca for amateur photographers, " 'The Gates Ajar,' (more pictures of which repose in family snapshot albums probably than any other feature of the fair)," was constructed over an armature of wire mesh coated in black earth.

Vasatka's final triumph was staged during World War II on Floral Hill, a sloping plot set aside for decorative plantings opposite the east bleachers of the Grandstand. There, in 1941, he installed a "living flag" made up of 4,800 bleached hen-and-chickens plants (the stars), silver maples (the white stripes), and thousands of "aschranthus" (aeschynanthus[?] — the red stripes). "Believed to be the largest of its kind in the country," the 51-by-86-foot flag was itself overshadowed in 1944 by a 30-foot-tall floral version of the historic Minute Man statue used in advertising the sale of war bonds.

Vasatka, whose son was doing military service in the Pacific as he completed his war memorial, died just before the opening of the 1944 fair. Ralph Zimmerman, his successor, maintained the patriotic motif of the plantings with a 1948 depiction of the Great Seal of the United States. Although the size of the crowds makes the maintenance of grass a feat of gardening magic, the old Liberty Bell and the other colorful plantings on the hillside surrounding the Agriculture-Horticulture Building remain, carefully tended and still featured in the backgrounds of photos for the family album. They recall the floral marvels of times past, when planners thought the fairgrounds would someday be counted among the most beautiful parks in the land. □

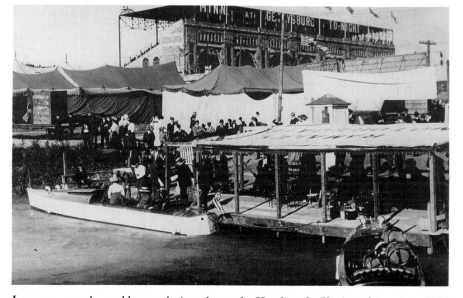

*Lagoons, canals, and boats, designed to make Hamline the Venice of America, 1909*

of intense world's fair-derived construction at Hamline — the decade before World War I and the years framing World War II — also marked the times when the publicists' noisy claims for the national preeminence of the fair in terms of attendance, numbers of exhibitors, and diversity of interest were most nearly justified by the figures.

Every new building added to the fairgrounds did not have a lineage going back to some dazzling White City or another, to be sure. But more often than not successful designs were noteworthy for their modernity and novelty. The 1906 Hippodrome, dedicated with a speech by James J. Hill extolling scientific agriculture, is a case in point. Finished off in the "modified Mission style of architecture" with a red tile roof, deep recesses and overhangs, and a generally domestic feeling at variance with the grandeur prevailing at world's fairs, the amphitheater found its closest affinities in the homey St. Louis Building transported back from the Louisiana Purchase Exposition. While bungalows and larger buildings with bungalowlike details were seen occasionally at world's fairs, the style did not have any strong connection with such places. But it was new and different in the early 1900s and, as such, stood for the generally progressive and forward-looking image the fair took pains to cultivate. When Hill made his pitch for science and up-to-date methods in a modern building whose piquant details were just beginning to appear in the smartest homes in Minnesota, architecture reinforced his vision of a bright agricultural future. The key buildings of the state fair traced out the shape of things to come.

Scattered in among these self-confident bastions of modernity, however, were pockets of nostalgia housed in a variety of log cabins which stood for Minnesota's heritage, old-fashioned values, and the charm of the good old days. The Minnesota Territorial Pioneers, who organized in 1897 with the express purpose of holding reunions of old-timers at the state fair, ensconced themselves in a cabin next to Institute Hall in 1900. Surrounded by uncabinlike verandas for rocking and swapping stories in the heat of the day, the Pioneers' headquarters became the repository for all manner of "relics of older days," solicited from Minnesota trailblazers and their descendants, and for an extensive collection of portraits of old settlers which had spilled over into Institute Hall (renamed Portrait Hall) by 1908. Surviving records muddle the issue of whether the Territorial Pioneers refurbished an existing structure (the "new" cabin was in need of extensive repairs as early as 1903) or built their clubhouse from scratch, but its emblematic significance was clear from the outset. Fair-bound Pioneers wore badges emblazoned with the slogan "Pleased to meet you at the log cabin during the State Fair!" and handed out tags bearing this legend:

Reunion Log Cabin, all week
Pioneer Day, always Thursday
Is your family group in Portrait Hall?
Have we your Mother, Father and Grand Parents Photo or Old Relics?
Send them NOW.

So strongly was the identity of the Territorial Pioneers shaped by their cabin that when the place was locked up in 1915 because its disrepair posed a serious threat to life and limb, a mob of feisty graybeards broke down the door and took possession in a fit of righteous indignation.

Like the "colonial kitchen" that dispensed the simple hospitality of yesteryear at numerous world's fairs after 1876, the cabin embodied the rude vigor of the American past. It was adopted whenever an organization wished to underscore its patriotic aims or old-style virtues. Hence in 1917

## LOOKING BACKWARD

Until the end of the 1920s the state fair had, by and large, looked forward. The management prided itself on espousing progressive agriculture, new machinery, and the very latest architectural styles. The business of retrospection was left to the Territorial Pioneers. All that changed in 1926, however, when the Twin Cities chapter of the Daughters of the American Revolution took a booth and mounted a large exhibition that included "an old-fashioned colonial kitchen furnished with authentic relics dating back from colonial days," attendants in colonial costume, collections of family heirlooms, and hourly performances of the minuet. The following summer, members from all across the state collaborated on a complete suite of model rooms representing "an early American home . . . furnished authentically in birch, pine, walnut and mahogany." For the next decade, the DAR's heritage rooms—a "colonial cottage" comprised of a four-room suite centered on a prominent hearth—were among the most-visited attractions at the Minnesota State Fair.

There are several reasons for the sudden rise to prominence of the DAR in the 1920s. The organization supported the isolationism that took hold in the Middle West after World War I. Suspicious of growing foreign influence as well as the rapid and far-reaching social changes wrought by flivvers, movies, jazz, and the other elements of the era, hereditary societies countered alien ideas and newfangled notions with a storybook version of the American colonial past, recreated in such a way as to highlight its order and changeless charm. The colonial hearth, tended by women whose freedom to engage in public affairs derived from the very change they

decried, became a symbol that pointed to what was wrong with chaotic, modern-day America.

Ideological considerations notwithstanding, the hearth and its neocolonial accessories also exerted a powerful draw on fashion-conscious Minnesotans. One of the ironies of the militant modernism of the 1920s was that cocktail tables often came in the shape of cobblers' benches, radios were disguised as Bible boxes, spinning wheels were prized by women who no longer sewed, and the latest living-room suites in the Sears catalog were apt to include a maple-finished copy of a seventeenth-century fireside settle. While the committee charged with finding artifacts "of the primitive sort" and setting up a house "of the kind inhabited by the simple farmer of the early day" hoped that the exhibit would teach the younger generation to "have some appreciation for old American traditions," the DAR cottage was equally important as a source for home decorating tips. Indeed, the Daughters' interest in Americana soon spilled over into the competitive departments of the fair. Girls in 4-H used family treasures as the basis for demonstrations of "antiquing." The department of women's activities added prizes for collections of antiques to the premium list and, in 1929, decorated its quarters with a display of "ancient" wedding gowns, including a colonial dress of rose-pink satin lent by the former state regent of the DAR.

Displays of eighteenth-century finery gave a certain social distinction to Minnesota women whose ancestors had stayed behind when the Territorial Pioneers made the trek west. There are indications that, had the Great Depression not curtailed grandiose plans of all sorts, the DAR's interior tableaux might have developed into a full-blown historical village under the auspices of the Women's Division of the fair. In 1930, for example, the superintendent of the Woman's Building returned from a trip to the Eastern States Exposition full of enthusiasm for "the displays . . . arranged in stores or houses grouped around a village green," which she likened to the popular colonial interiors at the Minnesota fair. But, although the settings became more elaborate affairs, with a changing annual theme and loan exhibits of special historical treasures, the roofless room remained the preferred format.

Sometimes it represented a "primitive Puritan home," sometimes, a "high-class early American home" with

the ladies attired as elegant "Colonial Dames." Once, the bedroom of a Rhode Island governor, circa 1750, was recreated. Another year, the replica of George Washington's desk once owned by President James A. Garfield was borrowed from a St. Paul woman. In 1932, as the DAR was preparing to celebrate the George Washington Bicentennial with a display drawn from his era, the Minnesota Historical Society entered the lists with a Minnesota home of the 1860s, furnished with pieces from "prominent Minnesota families" and showing a quilting bee in progress. In 1934 thirty-eight women's clubs cooperated to produce a third display illustrating "home life in the '50s and '60s, when Minnesota and its fair were young." In 1937 the fair organized a show of farm equipment going back to the implements of ancient Egypt to illustrate "The Story of the Plow." History was suddenly big business at the Minnesota State Fair.

As special displays held at the fair in honor of the territorial and statehood centennials demonstrated, looking backward could stand for something more than nostalgia, family pride, or disgust with modern life. The "quaint" 1858 kitchen set up for the 1958 anniversary of Minnesota's statehood reminded fairgoers that, for all the charm of the past, the present was clearly superior. Hearths were beautiful, but a modern furnace was more reliable and a gas stove a lot safer. Quilts were beautiful, too, but who had the time or the patience for that kind of thing nowadays, when you could buy a nice, warm, electric blanket for next to nothing? Sometimes it took a good, hard look at the stuff of history to remind a person that living in the here and now wasn't so bad after all. □

*Model colonial home furnished with reproductions, 1931*

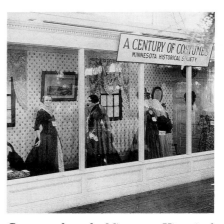

*Costumes from the Minnesota Historical Society, shown in the Woman's Building, 1931*

*Chinese arch in situ on Nicollet Mall, Minneapolis, 1970*

## A CHINESE ARCH?

One of the oddest bits of architecture on the Minnesota fairgrounds is the ornate Chinese Welcome Arch that forms the ceremonial entry to Baldwin Park. Built by the Chinese-American Association of Minnesota for the 1970 Minneapolis Aquatennial parade, the arch was presented to the state fair when no other suitable site could be found for the colorful construction, adorned with symbols of brotherhood and peace. Yet the arch is right at home on Machinery Hill. Its cheerful tones and exotic forms suit the festive atmosphere of the fair, where a Chinese gate seems no stranger to the eye than a Space Tower, a log cabin, or a giant green pepper dispensing French-fried pepper rings. □

a second log cabin on the state fairgrounds, an "old" one described as "long vacant," was taken over by the St. Paul branch of the National Association of Patriotic Instructors to be a center where the foreign born could receive instruction in citizenship. The Grand Army of the Republic built a third cabin — a Lincoln Memorial Log Cabin — in 1934 to advertise the good works of its Women's Relief Corps.

Standing as it did for Minnesota antiquity, the cabin also made an ideal museum. The WPA put one up for the Forestry Division of the Minnesota Conservation Department in 1936. Used briefly as a logging museum in recognition of the heritage of northern Minnesota, it later served as the office for the Tourist Camp before migrating to Underwood Street in 1958 to replace the original relic room of the Territorial Pioneers. Meanwhile, several smaller cabins with indoor displays reminded overheated visitors of the pleasures of "going up North" in the summer. In 1935 the Brainerd Chamber of Commerce fitted up one such cabin as a museum full of the giant, make-believe artifacts of Paul Bunyan in an effort to divert tourists northward. That same year, the *St. Paul Pioneer Press* and radio station WTCN joined forces to build a log house on the fairgrounds that gave "the appearance of a north woods summer cabin." By the use of the cabin symbol, the editors and newscasters within were packaged as just plain folks — honest, outdoorsy Minnesotans made of the stuff of the hardy pioneers.

The largest state fair cabin by far was the new Conservation Building, constructed in 1934 by the Emergency Relief Administration, forerunner of the WPA (which did build conservation cabins for several county fairs during the period; the log house on the Itasca County fairgrounds in Grand Rapids is a particularly nice specimen). The rustic materials, the low, earth-hugging lines, and the dark color all made for a startling contrast with the tall, white, elegant forms of the art deco complex that took shape all around the cabin as the decade wore on. But that split between the past and the future was also characteristic of depression culture as a whole. In the 1930s the National Archives and the Jefferson Memorial were built to honor the past, but the glitzy Trylon and Perisphere at the 1939 New York World's Fair predicted the look of the future; as lawmakers struggled to prevent future economic and social ills by utopian planning, moviegoers everywhere lost themselves in the story of Scarlett O'Hara and the antebellum South.

Some analysts of the American scene have called the kind of historical iconography popular during the New Deal era the "usable past," a pragmatic means for a stricken nation to regain its bearings, to find some firm ground to stand on as the Great Depression shook the foundations of society. That solid, historical base became the bedrock of confidence from which soaring visions of a better tomorrow arose. The Conservation Building played a similar role at the state fair, reminding Minnesotans of their roots and traditional values in a time of stress. The log cabin stood for the pioneer past, the days of struggle and hardship from which modern Minnesota emerged, but it also represented nature in the raw — the fields and forests as they were before the plow and the saw and the pickax changed the face of Minnesota forever. The cabin promoted the recreational use of the outdoors that promised to take hunters, fishermen, campers, and hikers back to that simpler era to refresh their troubled spirits. The squat log building was Minnesota's usable past, without which the futuristic art deco towers all around it would have seemed both precarious and presumptuous.

In the 1980s Mike Heffron, general manager of the state fair, called it an "enigma . . . which mixes new with old, tradition with innovation." That

Janus-faced aspect of the fair is nowhere more apparent than in its postwar architecture. The Mink Show Building (1956; later used for dogs), the Merchandise Mart and Home Improvements Building (both opened in 1973), the Education and Creative Activities buildings (ground for the former was broken in 1964 at the same time the latter was being extensively remodeled and given a new facade and an annex), and many smaller structures went up quickly in combinations of prestressed concrete and metal paneling. The boxy shapes and reticent ornamentation of these additions are distant echoes of the International Style, filtered through the vernacular adaptations of corporate America. Recalling the pragmatic architecture of the commercial strip or the prefabricated farm sheds along the highways of rural Minnesota, the fair's latest crop of buildings tends to recede into the background. They enclose exhibits and keep out any passing showers but do nothing to claim undue attention on the basis of appearance. Instead, they form the neutral background against which the historical make-believe of the state centennial and American bicentennial building campaigns stands out in vivid relief.

It was the hundredth anniversary of Minnesota statehood in 1958 that prompted creation of a major historical complex on the site once occupied by the cabin of the Territorial Pioneers. Condemned by the fire marshal, that landmark had been torn down after the 1957 fair and replaced by the WPA-built log house. And to the new cabin grounds were added a thirty-six-foot statue of a pioneer woman, first erected near the Administration Building entrance on Snelling Avenue in honor of the centenary year, and a new portrait gallery (now the Senior Citizens' Center). This simple, almost unadorned box of a building made a perfect backdrop for the sculpture representing Minnesota's own Eve, a nineteenth-century earth mother in a sunbonnet.

The Minnesota State Fair was not unique in its sponsorship of facilities devoted to the region's past. The Iowa fair had its Pioneer Hall, too; Michigan's Pioneer Society was holding programs at the Hillsdale County Fair as early as 1871; and in 1958, the Marshall County Fair in Warren, Minnesota, acquired the log cabin, church, and one-room school that would make up the nucleus of an impressive Street of Yesteryear. Although the Street of Yesteryear was another offshoot of the Minnesota Statehood Centennial celebration, the inclusion of "historic villages" in fairs goes back to 1919 and the Eastern States Exposition, the largest fair in New England, which by the early 1920s included a replica of the Massachusetts State House, in which Bay State products and resorts were advertised. The rest of the New England states were quick to add their own pavilions to the exposition (although Maine had to appropriate funds for the replica of its capitol over the governor's veto!), and the "Avenue of States" took on the appearance of an eighteenth- or nineteenth-century thoroughfare in some impossibly prosperous community. It was only a small step to add genuine period buildings and to create the outdoor museum known as Storrowtown Village.

Period villages appeared all across America at the end of World War I. For the Plymouth Tercentenary, observed in 1920 on the site of the Pilgrim landing, for instance, a cluster of cottages and cabins with thatched roofs was recreated according to descriptions of dwellings contained in autograph documents of the 1620s. At Williamsburg during the 1930s, a sleepy country crossroads punctuated by gas stations and power lines was being transformed into John D. Rockefeller's notion of the opulent good life in colonial Virginia. At Greenfield Village, outside Detroit, auto magnate Henry Ford was busily rebuilding the America of his own boyhood years.

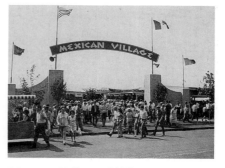

*Mexican Village, 1970*

## THE MEXICAN VILLAGE

The same interest in local history that gave rise to Heritage Square at the Minnesota fair prompted California expositions to celebrate that state's Spanish roots. The Mexican Village at the Los Angeles County Fair in Pomona, built in the 1950s and operated as a concession by a firm called Mexican Villages, Inc., was such an attraction. A reprise of this original adobe compound opened on Judson Avenue in time for the 1970 Minnesota State Fair.

The Mexican Village was an instant hit. Records for 1970 show that it was the most popular feature of the season with its unfamiliar foodstuffs, inexpensive but eye-catching souvenirs, and appealing entertainment. Timing was a factor, too, since this slice of picturesque Old Mexico came to Minnesota on the crest of a wave of national interest in Latin cuisine, decor, and music, and the advent of the fly-now-pay-later Mexican vacation. Although vendors under contract to the owners of the village complained of sharp practices, the operation prospered. In 1977, for example, the fair took in fourteen thousand dollars and a hefty percentage of the beer sales racked up in the cantina on the premises. Periodically, the board raised the possibility of enlarging the perimeter toward the west to ease crowding and increase revenues.

But in 1984, on the recommendation of his staff, General Manager Heffron announced the demise of the Mexican Village. The Latin fad had run its course. Across America, the newest of the new restaurants featured the cooking of other ethnic groups; desirable gift-shop wares came from other climes. And so the ersatz adobe was replaced by wood-grain siding and pseudo brick, and the Mexican Village became the International Village. When used as a merchandising device, exotic architecture was subject to the pressures of the marketplace. □

Fairgrounds were ideal spots for similar projects undertaken by local historical societies or study groups. The land was generally public property and commodious enough to hold a cabin or two without crowding. And the presence of the fair guaranteed an audience. Thus it came about that the Minnesota State Fair acquired the rudiments of its own village, "an 18th and early 19th century-themed exhibit area," in 1975. To the site once occupied by the rock-'n-rollers of Young America Center were brought "two real log cabins" from Marshall County, complete with a live-in family. Nearby, in the old North St. Paul depot donated by the Soo Line Railroad and several carnival train coaches from Royal American Shows, a museum of state fair artifacts took shape.

The tiny village—later supplemented by a blacksmith's shop, an old newspaper office, and a garage—stood within an enclosed compound known as Heritage Square. Around the periphery were located appropriately old-timey concessions, including vendors of antiques, buffalo burgers, homemade kites, used books, and studio photographs of fairgoers attired in Victorian costume. Expanded in 1976 "as part of the Fair's official observance of the nation's Bicentennial celebration," Heritage Square confirmed a trend that swept the county fair circuit in the 1970s, depositing country schoolhouses and pioneer cabins on fairgrounds from Anoka and Owatonna and Mora to Albert Lea, Blue Earth, and Garden City. As more and more communities passed the century mark, what was in many cases the oldest surviving institution—the fair—became a living symbol of Minnesota's proud agrarian heritage. The successive epochs of yearning and striving that led from a distant, log-cabin yesterday to a space-age tomorrow are nowhere more visible than in the architecture of the Minnesota State Fair, where every building is a telling landmark along the long, unfolding highway of history. □

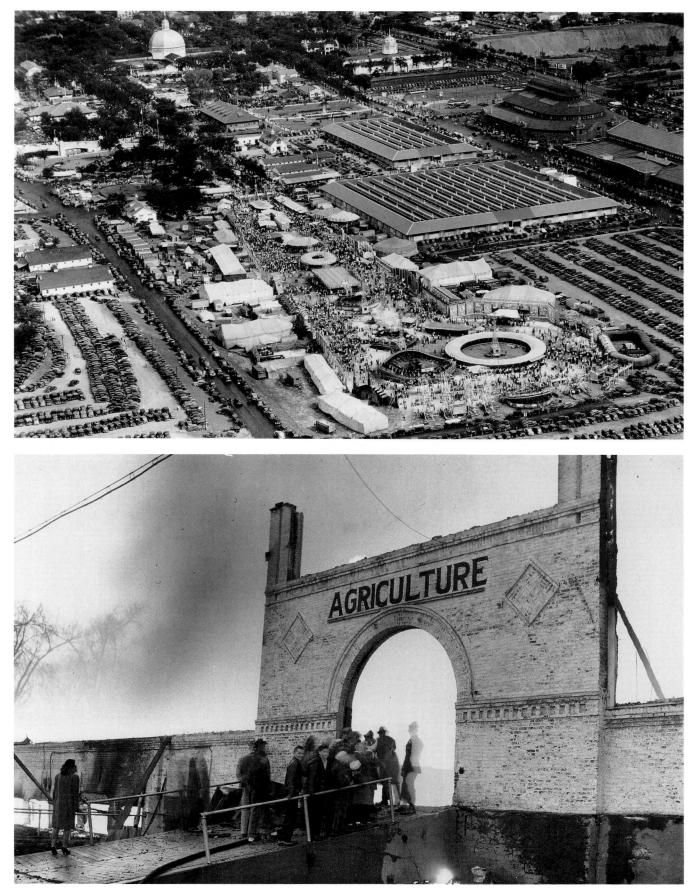

*The dome of Main Building, a dramatic skyline element, rising above other roof-tops in an aerial shot from the late 1920s*

*Old Main burned to the ground on November 10, 1944.*

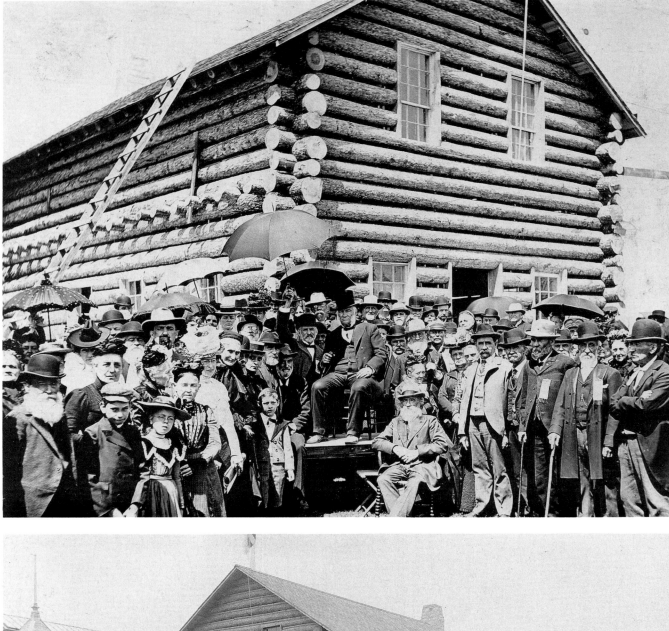

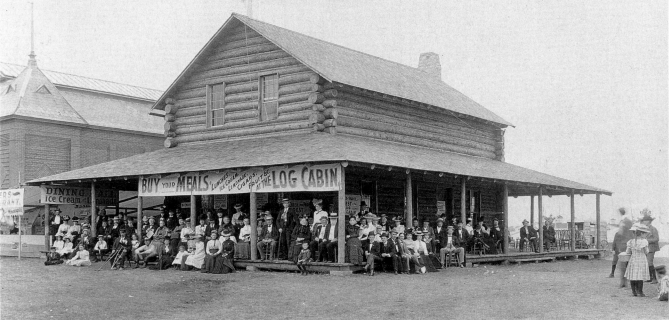

*Former Governor Alexander Ramsey (seated on platform), at the dedication of Territorial Hall, May 11, 1900*

*Useful for gatherings and sales, the porch addition, about 1905, made the cabin seem less like a historic relic.*

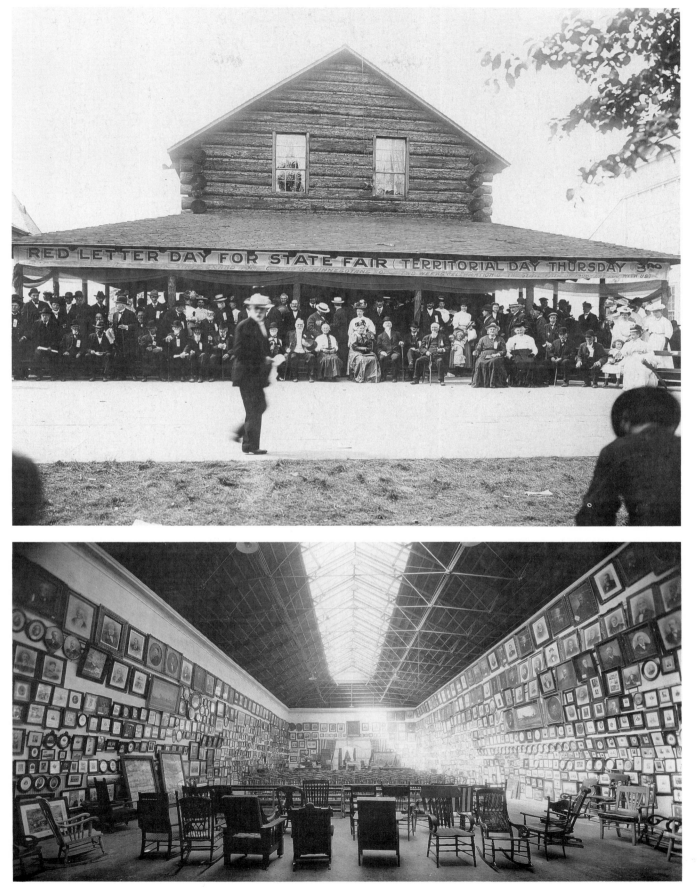

*Territorial Hall, 1908*

*Interior of the Pioneers' portrait gallery, about 1920*

*Inside the Lincoln Memorial Log Cabin, built on the fairgrounds in 1934; Nellie McCall, the Women's Relief Corps president, stands at left.*

*Conservation Building, "tamed" by trees and paint, 1948*

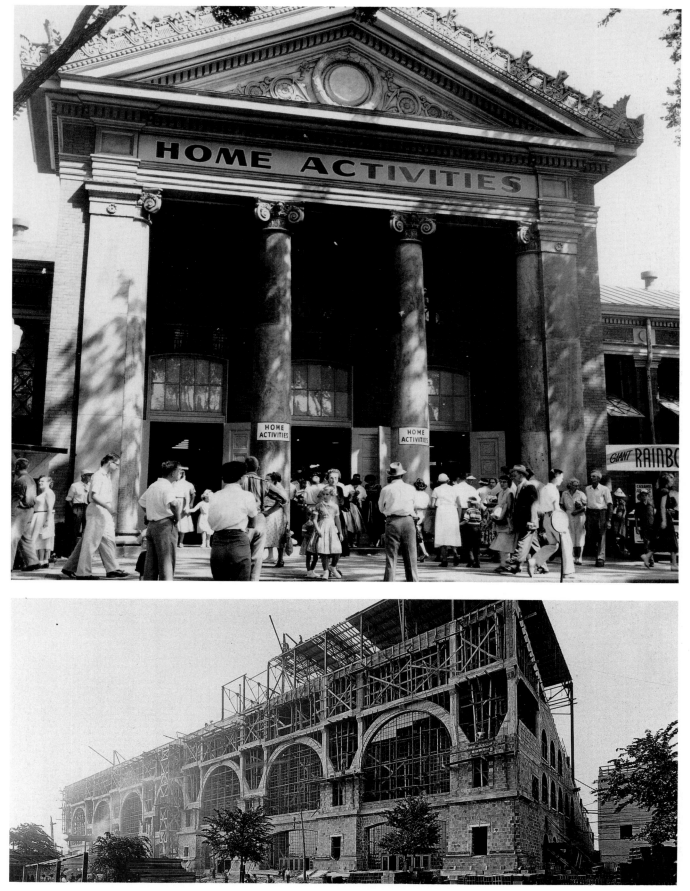

The peak of lofty state fair classicism, the Manufacturers' Building of 1904, which in 1952 had a different name and purpose

The steel-and-concrete Grandstand, under construction in 1909, masked its advanced technology with a slipcover of Roman arches and antique cornices.

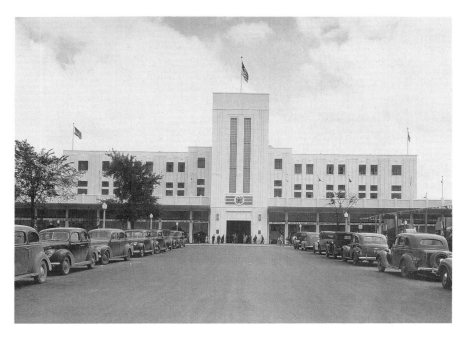

*The 4-H Building, dedicated in 1939 and opened in 1940*

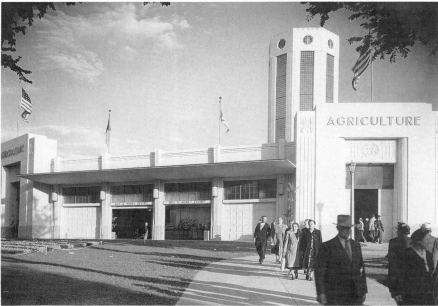

*Agriculture-Horticulture Building, built, 1946; opened, 1947.*

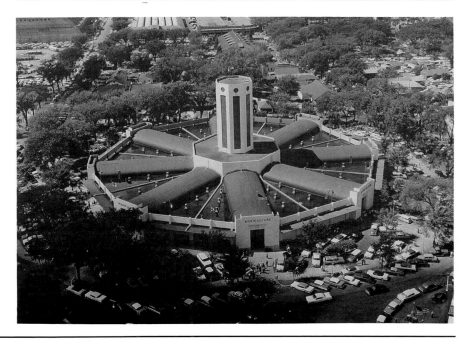

*The hub form, reinterpreting the in-gathering circle of old Main Building's dome, 1959*

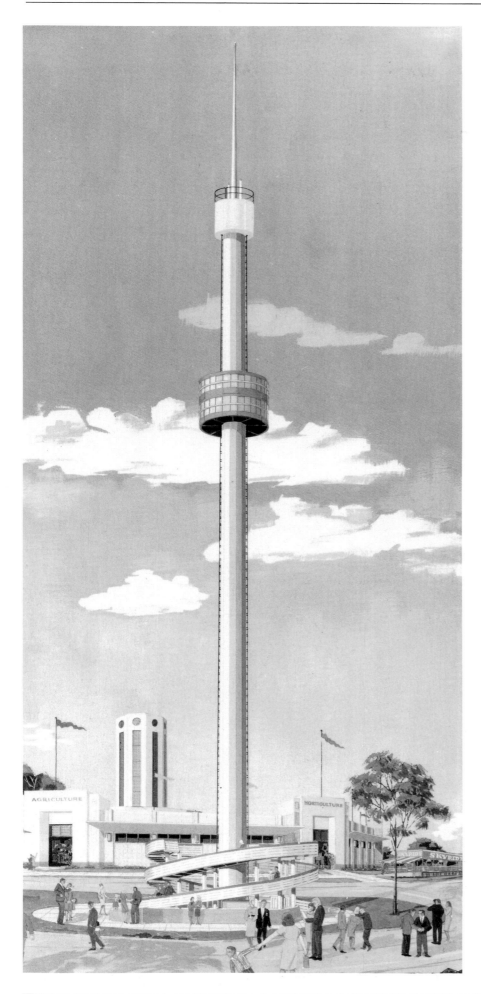

*Space Tower, 1965, modeled on the Space Needle of the Seattle World's Fair of 1962. Its ultimate origins are pure Buck Rogers.*

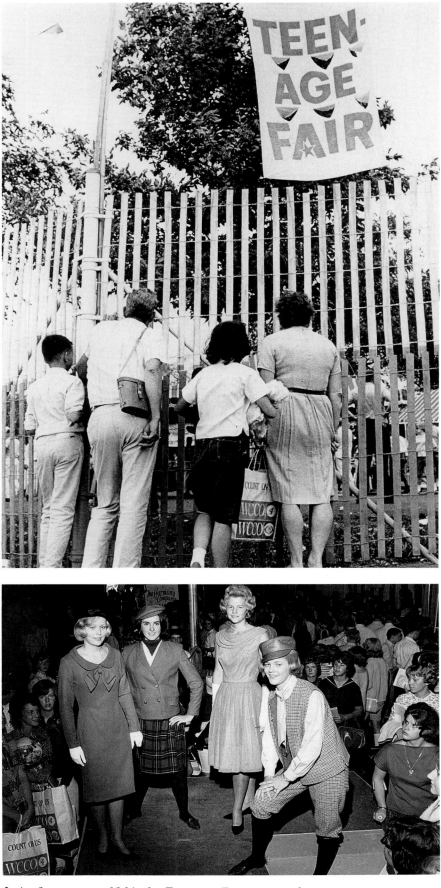

*In its first season, 1964, the Teen-Age Fair suggested a zoo.*

*Mysterious rites of back-to-school fashion, celebrated inside the buildings of the Teen-Age Fair, 1964, by members of Donaldson's Teen Board*

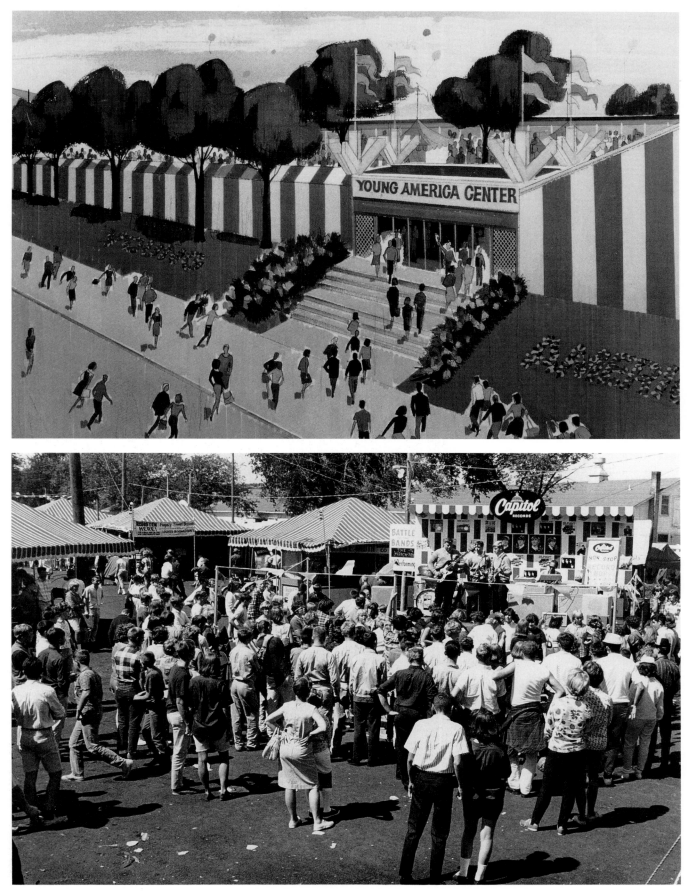

Rendering of Young America Center, a three-acre compound comparable in design and intent to the ethnic villages of the early-twentieth century.

The Henchmen, performing at the Capitol Records booth inside the Teen-Age Fair, mid-1960s

*Heritage Square, about 1985: nostalgia and a long look backward.*

*Willie Nelson and Heritage Square, providing down-home atmosphere for David Hartman of ABC TV's "Good Morning, America" show, 1985*

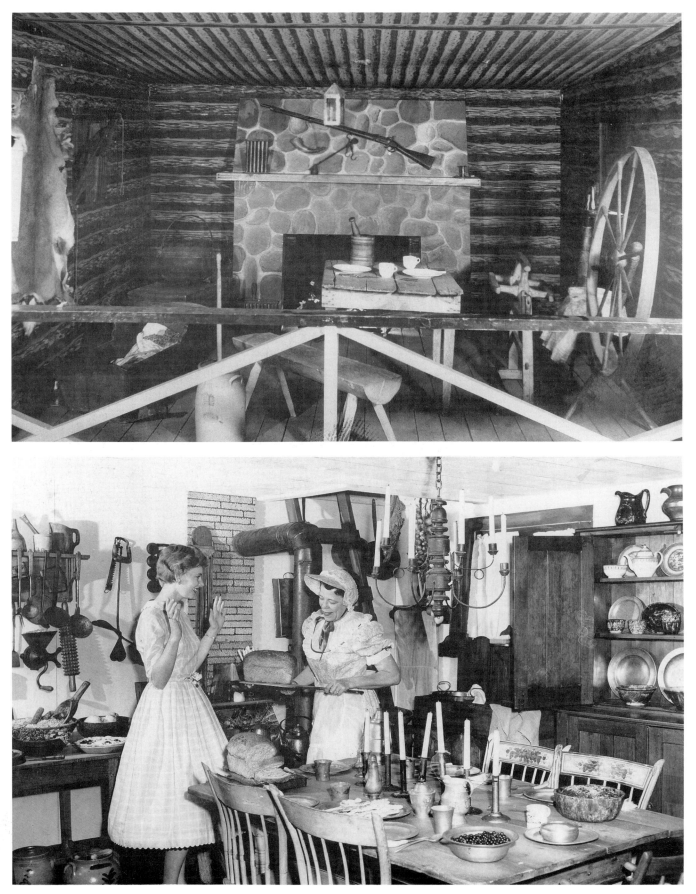

*Minnesota Historical Society booth, 1937, recreating the home of a typical settler family*

*Statehood Centennial exhibit, 1958*

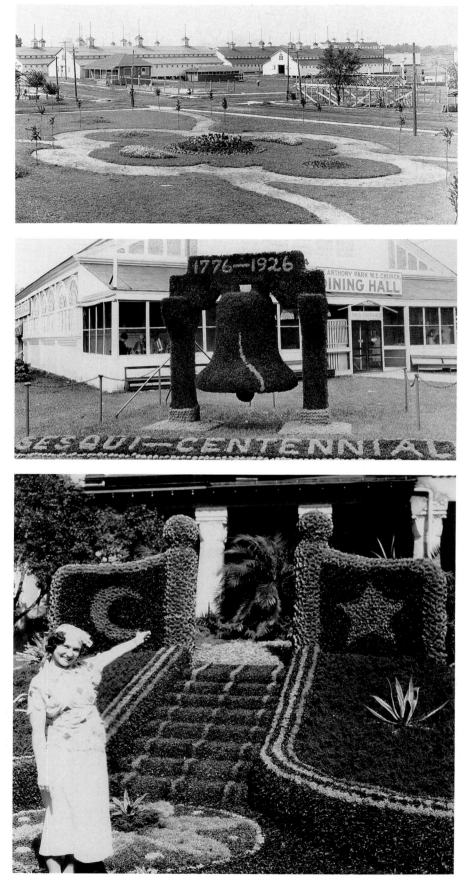

*Lucky clover flower bed, 1912*

*Plants set in an armature of wire and wood*

*Lillian Rapp at "The Gates Ajar," composed of twenty thousand plants on the lawn of the Rest Cottage, 1934*

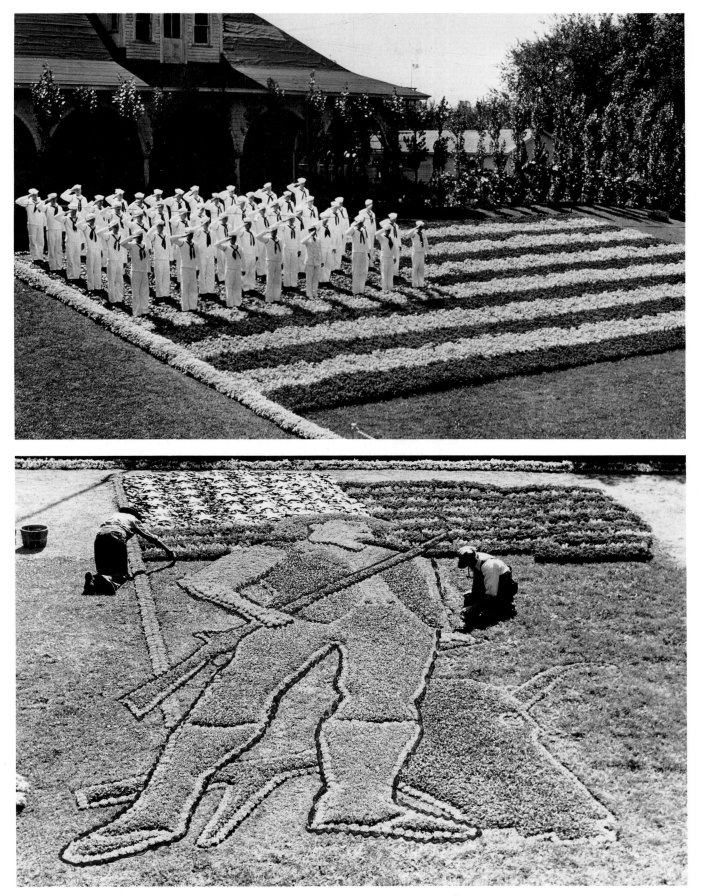

*Floral flag, 1941*

*Minute Man, 1944, composed of fifty-six thousand plants*

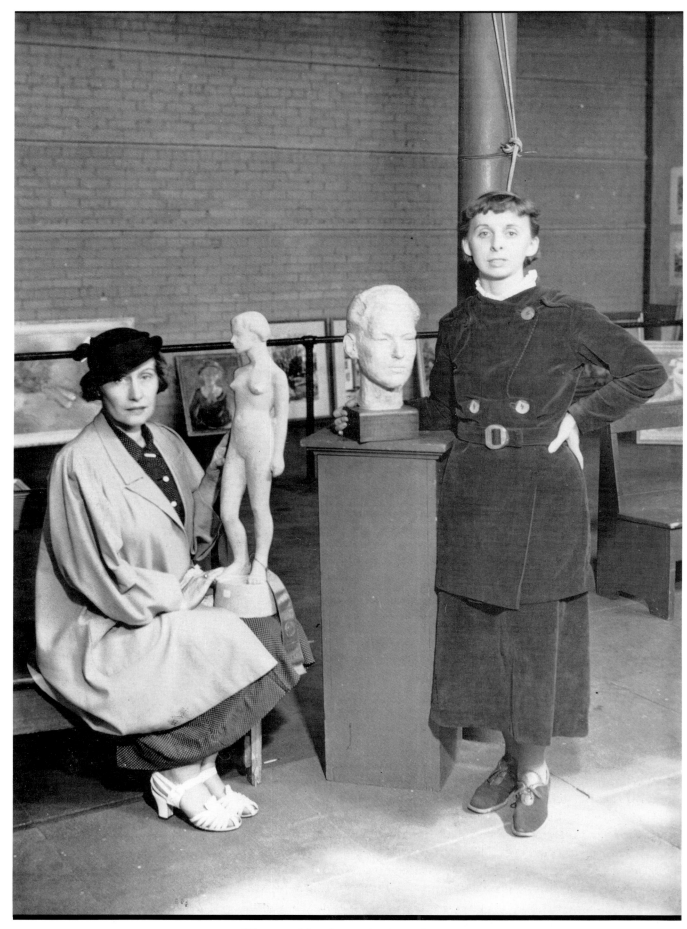

*Winners of first honors in the sculpture class, 1935; a pipe railing substitutes for the customary velvet rope around exhibits.*

# THE FINE ARTS AT THE FAIR

BECAUSE OF A GOVERNMENT BAN on nonessential use of the railroads and then a polio epidemic, the Minnesota State Fair was canceled in 1945 and again in 1946. The last time that had happened was in 1893 when operations were suspended for fear that the fair's most ardent supporters would all be off to Chicago for the World's Columbian Exposition. In 1893 the difference between success and failure often hinged on the loss of several hundred paid admissions; the decision to close down was a prudent one and occasioned little debate. But in the 1940s, with an annual attendance that hovered around the half-million mark despite serious wartime restrictions, calling off the state fair was a lot like skipping Christmas.

Its absence was keenly felt, especially by competitors. In 1945 the *Minneapolis Tribune* and Dayton's department store tried to take up the slack by holding a canning contest in downtown Minneapolis according to the standards established by the state fair premium list, but the affair lacked the zest of the real thing. In 1946, thanks to the early submissions required in those divisions, the fair-that-never-was officially awarded ribbons in two classes: butter and cheese making and the Fine Arts Division.

The presentation of the 1946 prizes for the best oil painting (won by Dewey Albinson of Minneapolis) and the best sculpture (Graham McGuire, St. Cloud) underscored the prominence of the fine arts on the agenda of the Minnesota State Fair between the wars. The fairless "million dollar" exhibition for 1946 went on as scheduled in a spacious new gallery in the Grandstand. It included one-man shows by Thomas Hart Benton, Reginald Marsh, and a dozen other painters of national reputation; an architecture display borrowed from the Museum of Modern Art in New York City; a collection of Southwest Indian relics; and documentary studies of the war commissioned by major American advertisers. There was, in short, something to suit almost every taste, according to the policy of cheerful aesthetic pluralism established by painter Clement Haupers, the recently retired superintendent of the fair's Fine Arts Division.

Under the direction of Haupers, who took up his duties in 1932, the annual state fair art show had become the best-attended cultural event in Minnesota, with its combination of touring exhibits of beloved Old Masters and controversial modern art, its previews of new works acquired by Twin Cities museums, and its competitive, juried shows of art created by Minnesotans. The state fair was the most important source of inspiration, group cohesion, and constructive criticism for many aspiring young artists; one of them, Erle Loran, sang the praises of the exhibition in a 1936 issue of the prestigious *American Magazine of Art*.

The union between art and the agricultural fair is an old one. Elkanah

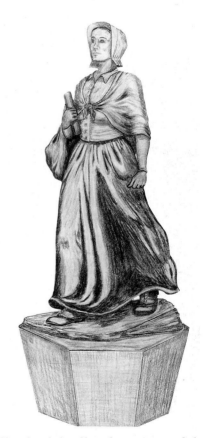

*Sketch of the fiberglass statue of the Pioneer Woman, the state's official centennial symbol*

Watson introduced prizes for the arts (albeit of the household variety) at the Berkshire Fair in 1813. Thereafter, drawing, decorative work, and similar items were almost always granted a place on premium lists and a spot on the fairgrounds, whether in a designated Art Hall or in a corner of the Woman's Building adjacent to the colorful jellies and quilts. But throughout the nineteenth century, especially at frontier fairs — and even at country fairs in the older states — the definition of art tended to be a great deal more elastic than today's cognoscente might wish. The miscellaneous class that encompassed artwork at the 1854 Iowa State Fair, for example, contained a monochromatic painting, a floral painting, a collection of snakes, a fur hat, and a "new style of artificial teeth . . . for restoring the natural contour of the face." At the infant Minnesota fair, "almost anything deemed beautiful, ornamental, skillfully executed, or merely curious was exhibited as art."

In a society lacking many of the accoutrements of gracious living, images made by mechanical means were not thought markedly inferior to those produced by artistic skill alone. Nor was either type sharply differentiated from entries that defied classification among the animal, vegetable, cooking, and farm-machinery categories. Thus, in the art section of the Balloon Fair of 1857, the daguerreotypes were grouped together with several oils and watercolors, ladies' fancy collars, and "decorative squashes." The department of fine arts at the Faribault County Fair of 1868, according to accounts of the proceedings, was graced "with a variety of useful and ornamental articles, including babies." The 1869 state fair display took in bona fide paintings, chromolithographs, samples of ornamental penmanship, slabs of multicolored slate, and native furs.

But Minnesota's catholicity of taste also ensured that any noteworthy work of art in the vicinity generally made an appearance at the state fair. Artists and patrons were often induced to show celebrated pictures without entering them in competition at all. A painting entitled *Deer Chased by Wolves,* now lost but credited to the mysterious Ben Cooley who was said to be St. Paul's only resident painter of the 1850s and 60s, was exhibited at the 1865 fair as a marvel worth seeing. By 1879 the standard state fair exhibition generally included a display of pictures in gilded frames lent by their distinguished owners as a kind of public benefaction; such can be inferred, at any rate, from the management's bitter complaint that year that "the art exhibition . . . was a dead failure" because the St. Paul business community had failed to send anything of value to fill up the galleries.

In 1886, in a blatant bid for state money, the superintendent in charge of such matters also went on record deploring the lack of a permanent, fireproof art gallery "where it was safe to exhibit a picture of value." James D. Larpenteur of St. Paul was a painter who had returned to the Twin Cities in 1883 after years of study in Paris and the first in a long line of energetic promoters of art at the fair. To him, Hamline's wooden architecture was a detriment to assembling loan shows of real quality. His argument and the prospect of a state fair without important examples of the fine arts persuaded the Agricultural Society to build a suitable facility of brick immediately. In the summer of 1887, Larpenteur garnered praises for "the completeness of his [new] art gallery and the collection of fine paintings" assembled therein. The show also gave prizes to Minnesotans who essayed the difficult task of picturemaking for themselves. For example, Miss Adelia Carr, who maintained a studio in the Syndicate Block in Minneapolis, took a handsome silver medal in the 1887 Fine Arts Division for the "2nd best painting" in the "flowers, fruit, and still life class." But the work of local

## NOTEWORTHY WORKS OF ART ON VIEW AT THE FAIR

1898. In addition to the usual "moulded figures in butter," aesthetic treats included several exhibits in the art gallery. One consisted of sculptures of twine produced by inmates at the state prison. The other was "the now famous painting by N. R. Brewer, which is a realistic portrayal of the Hinckley fire, done on a large canvas about 10 feet square."

1904. Lars Christenson of Benson, a Norwegian immigrant and Swift County pioneer, entered a magnificent hand-carved altarpiece, adorned with cherubs, evangelists, and elaborate New Testament scenes adapted from pictures in an illustrated Bible. Today the work is one of the folk treasures of Vesterheim, the Norwegian-American Museum in Decorah, Iowa.

1910. The artistic attraction was a "weird picture" by Henry Hammond Ahl, sent on tour by its owner to raise money for charity. A view of a darkened room suffused with a glow from a mysterious source, the work was called a miracle painting because the shadow of a crucifix appeared to hover among the beams of light. "Should you go in a scientific frame of mind prepared to scoff, or in a religious frame of mind prepared to worship," the *Young America Eagle* allowed, "you will find plenty to think about."

1911. *The Island of Death* by Swiss painter Arnold Boecklin came to the fair. Depicting "the leavetaking of the soul from its body which is left buried in a tomb in the rocks of a weird, mystical island shadowed by cypresses," the sixty-thousand-dollar canvas was called "one of the wonder paintings of the world" and drew crowds wherever it was exhibited. One

Minnesota woman told Superintendent Flagg that she had made a special trip to Europe six years earlier expressly to meditate before *The Island of Death*.

1922. Cameron Booth's prize-winning picture of a Minnesota lumber camp was presented to Vice-President and Mrs. Coolidge as a souvenir of their visit to the state fair.

1936. In addition to the competitive exhibition, Art Superintendent Clem Haupers also hung a one-man show of the work of controversial Chicago realist Ivan Le Lorraine Albright. Reporters never failed to note that Albright had learned his technique by drawing wounds during World War I and his anatomy from a study of x-ray plates. "He's no Van Gogh for either drawing or color," wrote a Minnesota critic. "I grant you that. But he gets meaning into things."

1937. Alongside the Albright show, the art gallery in 1936 had played host to a special exhibition of the work of sculptor Warren Mosman of Christmas Lake, another controversial artist then producing enormous ceramic pieces based on classical themes and polychromed in dazzling color. A little shocking when seen in Spartan quarters at the state fair, his big nudes, as critic James Gray observed in a *St. Paul Dispatch* review, would have seemed right at home in the foyer of Radio City Music Hall. For the centerpiece of his special show in 1936, Mosman had made an eighteen-foot plaster nude entitled *Eve* that weighed more than one thousand pounds. She had been cast in pieces to get her inside, but Mosman took no steps toward removing the lady after the fair was over. Desperate to empty the gallery in time for the 1937 show, the Fine Arts Division called in reporters to see various gigantic portions of the

figure—the toes, the dismembered head—in an effort to scare up a taker. The fate of poor *Eve* became a nine days' wonder. Just before the fair was scheduled to open, John Madden, owner of a resort on Gull Lake, agreed to take *Eve* and put her back together in "a natural pine setting" up north.

1954. In honor of the new art gallery on the top floor of the Grandstand, the Walker Art Center and the Minneapolis Institute of Arts both lent important works. Among the ten masterpieces from the institute was the vibrant portrait by Henri Matisse known as *White Plumes*.

1970. An assemblage consisting of an American flag draped over a dynamite box and a Molotov cocktail was removed from the exhibition by the fair's general manager, John Libby, even though the sculpture had been awarded an honorable mention in prefair judging. Entitled *Spirit of '76*, the piece was the work of Leland Fletcher, a twenty-three-year-old junior majoring in sculpture at the University of Minnesota. He was not a political activist, Fletcher said, but did mean *Spirit* "as a social comment on the times as they are now."

In retrospect, the reasons for the censorship seem feeble: an electrician working to install the lights had apparently complained to the management. Many board members were unaware of the controversy when reporters approached them for comment, with photographs of the offending object in hand. One official asked what the thing was and, upon learning that Fletcher's work had won a ribbon, stated that "I and the judges never agree." Another lauded Libby's action: "I'm for throwing out things like this. We're too soft on subversive attitudes anyway. It's like it can't happen here. But it can." □

*Stanley Fenelle's* Twilight, *the second-prize winner at the 1934 fair, and judges Francis Chapin of Chicago (left) and Nicolai Cikovsky of New York City*

artists and amateurs was of strictly secondary interest in the 1880s, when imported statuary and paintings of high monetary value were used by the fair and by a host of other public institutions to attest to the cultural maturity of the State of Minnesota.

In 1883 civic-minded art lovers held the first in a series of loan exhibitions that would lead to construction of the Minneapolis Institute of Arts. In 1880 businessman T. B. Walker found it necessary to add a gallery to his Hennepin Avenue mansion to hold a collection of European and American masterpieces which would one day cover half a city block. The zealous cultural apostles who labored to spread the aesthetic gospel in the Northwest were motivated by a genuine passion for art; nonetheless, it is also true that paintings and statues were widely regarded as both instruments for civilizing the rough-and-tumble frontier and proofs of its growing refinement. One of the principal selling points of the Minneapolis Industrial Exposition was a two-story, fireproof art gallery containing fourteen exhibition rooms tastefully draped in maroon cloth and a permanent collection of casts of famous ancient statues worth a staggering twelve thousand dollars. The very magnitude of the much-publicized expense, it seemed, gauged the depth of Minnesota's appreciation for the finer things of life.

According to the estimate of the superintendent of the exposition's art department, "a room or two" would have sufficed to hold the output of all the artists plying their trade in the environs in 1886. To fill the yawning spaces of the picture rooms, organizers were forced to borrow from a variety of sources, including dealers, whose wares were, of course, for sale. Among the nearly four hundred oil paintings hastily assembled (there were lots of photographs, etchings, pen sketches, and watercolors on view, too), even apologists were forced to admit a certain want of quality. But the quantity was most impressive, and works by several celebrated artists, including Albert Bierstadt, were acquired as the nucleus of a "permanent gallery . . . a step of the greatest importance to the future of art in our midst." Hanging costly pictures by famous artists was the surest guarantee that art would one day flourish in the former wilderness on the Upper Mississippi.

This, of course, was precisely the same rationale Larpenteur would use to convince the state fair to erect a new art gallery in 1887. Indeed, it is hard to avoid concluding that Larpenteur's brick building was just one more byproduct of the ongoing competition between Minneapolis and St. Paul. What the average Minnesotan thought of the great art-gallery war of the 1880s is hard to determine. No firsthand testimony survives to suggest whether the estimated 150,000 visitors who wandered through the galleries at the Minneapolis Exposition paid their dimes out of real enthusiasm or bought tickets out of a nagging sense of duty — a vague feeling that cultural interests were expected of responsible citizens, the notion that art was somehow good for a person. It is clear, however, that the vogue for pretentious exhibits of borrowed art at the state fair was short-lived. In 1890, when the Agricultural Society renounced the fripperies of the recent past in favor of a good, old-fashioned "farmer's fair," the "old art gallery" was the first such sign of unseemly luxury to go. The building became the Farmers' Institute, and whatever samples of homegrown artistry continued to make their way to Hamline under the auspices of the Fine Arts Division were dispersed to a variety of scattered locales.

In late August of 1890, for instance, the first vice-president of the Agricultural Society, who was also responsible for arranging the interior of Main Building, confessed that much of the space was still empty and

issued a call for potential exhibitors to "bestir themselves" immediately. In particular, Dan Moon wanted "a line of fine cutlery, of dental and surgical instruments, of fine furniture, of bronze or brass goods and ornaments, of ready-made clothing by representative houses, of carpets and draperies; also a larger display of photographic work and fine crayon or pastel work, both amateur and professional. In short, anything that will tend to adorn or beautify the main building will be very acceptable. It will represent home manufactures."

Moon consigned works of art to the company of other talismans of status, good taste, and refined living. In the competitive divisions, however, art was sharply distinguished from "household manufactures" on the basis of its relative uselessness. The latter consisted of quilts, stockings, shams, and pictorial embroidery that was applied to domestic linen, whereas the Fine Art Work category ("open to amateurs only") included wax- and hairwork, conventional portraiture and still life, and decorative painting on "glass, satin, velvet, shells, fungi, tile, chamois, and bolting cloth." But whichever class milady chose to enter, it was apparent that state fair art in the 1890s meant the genteel crafts pursued by women at their leisure.

The shift from the fine arts to what would later be called hobbycraft did not go entirely unnoticed. An 1892 editorial in the *Minneapolis News* bemoaned the replacement of soothing masterpieces with contentious agriculturalists:

> The art hall—once . . . regarded as indispensable—is a thing of the past and the familiar brick building has been given up to the farmers' institute, the impression being that discussions as to the proportions to be used in mixing silo and ensilage are infinitely more profitable than the cultivation of an artistic taste. Where once the sweet nudity of Psyche smiled down from the walls, the cold plaster will look down in barren desolation as plans are laid for the murder of chinch bugs. Where once an art loving people gazed entranced upon "Venus and Tannhouse," horney handed advocates of a sub-treasury scheme will argue the question: "Every Farmer His Own Rain Maker." Even Ed Langevin's horses and Larpenteur's dogs will no longer be available. Art is a good thing, but she has had her pictures turned toward the wall.

And even though the 1892 premium list offered prizes for "paintings upon canvas . . . modeling in wax . . . a Minnesota landscape painted from nature, [and] the best historic painting," other critics, who also bemoaned the removal of art to the Women's Division, predicted that any fine arts exhibit that included "everything in the fancy work line from knitted stockings to photograph cases" was bound to be a "monstrosity." That prophecy, by all accounts, was accurate. Reporters primed to write glowing accounts of the fair's wonders warned their readers that a quick "bird's-eye view" would suffice for the amateur watercolors. Among the few high points to be noted in a special exhibit mounted by the St. Paul Ladies' Art Club were several copies of well-known paintings and a temperance still life depicting a pistol, a half-empty whiskey bottle, a deck of cards, and a pile of poker chips tellingly positioned "on a plain pine table."

The change in the character of the state fair art display in the 1890s reflects the convergence of several tangled currents of opinion. Because of its association with the end of the frontier and the amelioration of physical hardship and spiritual deprivation, art attached itself readily to the image of the good life. Like soft, factory-made fabrics, store-bought furniture, and elegant glassware, pictures in carved frames were part of the domestic sphere ruled by the gracious lady who had recently evolved from the pioneer mother.

## AN ART DEMONSTRATION, CIRCA 1915

"Mr. Flagg had prepared an outdoor studio with a platform and easel, and the landscape gardener had arranged a very attractive arbor of vines over it and chairs for about two hundred. In good weather we went out there for demonstrations and when it rained we moved the platform inside. This is, briefly, the way we 'performed.' It is so simple that it could be done in sculpture and in some of the crafts. I believe these demonstrations have proved in Minnesota one of the most effective ways to remove the mystery of art and make people believe it is a part of their own expression.

"In the first place we posed the model upon the platform, showing how to get an attractive pose, and then made a large drawing of the figure in fifteen minutes. The audience loved to see the work done[;] it meant more to them than all the talking about the pictures did. We started with the young woman and then took an old man and then a little child, and varied the program each day. We would pose the young woman straight ahead with the head in this stiff position, making a very rapid sketch life size and then show how by simply loosening one side of the figure and relaxing it we could gain informality and grace.

"We had one delightful old soldier with a grizzly beard and many brass buttons, and we demonstrated that the beard and the buttons were non-essentials. Then we would show with the young lady what the photographer does today. Today the country photographers have all become art photographers, and they make the model 'look pleasant,' or agonizingly 'graceful' and we showed how silly that was. Then we would follow that

Busy husbands assigned such lovely nonessentials, along with music, poetry, manners, and the education of the young, to the women's sphere. When the state fair gave art over to the Women's Division, therefore, the directors were merely recognizing the commonly accepted fact that art was an ornament to the home, a proper leisure-time activity for a proper lady.

The prominence of amateurism — especially female amateurism — in the fine arts at the fair represented a radical departure from the earlier tradition of huge shows dominated by highly regarded professionals. The decision to abandon those shows was part of the fair's own reform program of the 1890s. Chris Rasmussen, in a preliminary study of the Iowa State Fair, noted growing tension in Des Moines around the turn of the century over the role of amusements in the conduct of fairs. Horse racing, gambling, drinking, and the whole range of more innocent forms of entertainment whereby agricultural societies attempted to lure visitors to their shows and pay for ample premiums came into question all across the Midwest during the depression of the 1890s. And those nonagricultural attractions, which had given many state fairs a more urban flavor, a more frivolous outlook, were noisily renounced in a gesture of support for the imperiled life of rural America. Thus it was in Minnesota that the art gallery became the Farmers' Institute and art returned to the premium book, where it was to be tolerated only if submitted on equal terms with pigs, catsup, fancywork, and Yellow Dent corn.

Citified connoisseurs were not alone in observing a dramatic decline in the quality of artwork displayed under the new dispensation. In 1896 the *Northwestern Agriculturalist* called upon authorities to "abolish the art department of the State Fair . . . in the name of decency and education . . . and confine the Fair to the cattle, sheep, swine and crops until our civilization becomes advanced enough" to produce something of merit. What had the farmers ever done — what had Minnesota in general done — to have "its knowledge of art, its refinement and taste so outraged as it was in the hideous caricatures and nightmares displayed in the alleged art department?" the tirade continued. "There was not a picture in this exhibit that indicated that the painter had ever the faintest conception of either drawing or color. We do not expect art-masters on all of our farms, but that does not justify a great educational institution such as our State Fair in lowering the standard so as to hold up to youth and ignorance these horrible visions!"

The sorry condition of the fine arts at the state fair was not unique to Minnesota, however. In 1896 an editorial in the *Des Moines Leader* wondered why entries in the Iowa State Fair Art Salon vacillated wildly between the acceptable and the truly deplorable: "In no other department of the fair could there be found such a medly of good and bad. Some of it was in touch with the most advanced ideas of the times and some with the extreme backwoods of a primitive civilization. It is to be regretted that the management does not discriminate and encourage only that which is in direct line with the art world."

The problem was a thorny one. In the absence of regular on-site exhibitions to establish standards, could superintendents expect entries to reflect prevailing trends in the larger "art world"? Was it fair to subject rank amateurs, semiprofessional purveyors of decorative items, and hobbyists to measures of excellence devised in the ateliers of Paris or the studios of New York? Among potential state fair competitors, a different aesthetic prevailed. In the 1880s a great "decorative rage" had swept the ranks of workers in cigar bands, feathers, and the like. Manuals offered self-

instruction in decalcomania, hairwork, and painting on china; as these fads entrenched themselves in small-town America, the products of local handiwork appeared at fairs. In 1897 the Fine Arts Division of the Minnesota State Fair was dominated by the vogue for hand-decorated china, although oil paintings, wreaths and watch fobs of hair, and other fashionable items of years past were also numerous. In addition, diplomas were offered to professionals active in what might be called the mechanical arts — photography, pen work, industrial drawing — creating, in the end, the kind of jumble the *Des Moines Leader* deplored.

Shortly after the turn of the century even the most ardent craftspersons began to worry that the state fair shows were becoming too "hackneyed." Some woodburnings (an exciting new medium in 1902), for example, were being made from prepared panels with parts of the design already blackened in! And it was generally conceded that "what the state fair needs, as much as anything else, is a toning up along artistic and educational lines." The first step in that direction came in 1904, in a 30-by-18-foot booth in the Woman's Building — the old Art Gallery turned Farmers' Institute. There, the Minnesota State Art Society (later called the Minnesota State Art Commission) revived the loan show with an exhibition of paintings from the collection of B. F. Nelson, usually on display in the gallery of the Minneapolis Public Library. The pictures shown were by no means new to the Twin Cities or unfamiliar to art lovers: James Hart's *The Dairy Farm* and *The Old Woman* by Julius Rolshoven were among several paintings the Minneapolis Exposition had acquired in 1886. But these Minnesota Old Masters were hung alongside two exhibitions of contemporary art, one organized by the students and faculty of the Minneapolis School of Fine Arts, and the other a juried show open to all Minnesota artists. "In order to insure a certain standard of excellence," declared the circular announcing this new departure, "all works intended for exhibition must be submitted to the exhibition committee for approval at the woman's building. . . . The cost of transportation of works accepted for exhibition will be refunded by the state art society."

Because the art society proved unable to sustain the effort on an annual basis, the Federation of Women's Clubs assembled a picture collection for the 1907 fair. Two years later T. B. Walker, at his own expense, showed a group of Indian portraits by H. H. Cross in the Territorial Pioneers' portrait gallery, with proceeds from the sale of the popular catalog going to "the benefit of the fair." Art was on the agenda again. The moment had come to rethink the role of the fine arts at the Minnesota State Fair. The time was ripe for the involvement of Maurice I. Flagg, new director of the Minnesota State Art Commission.

Flagg began to cast an envious eye at the built-in audience commanded by the fair around 1912, when he became involved in the early stages of a project to build a model farmhouse on the grounds. Just a year before, officials of the state fair had decided to extract the fine arts from the various women's, commercial, historical, and educational divisions in which they currently languished so that a legitimate statewide contest in painting, sculpture, and the other time-honored forms of artistic expression might be developed in addition to the usual craft show. As Flagg remembered the order of events that turned a struggling enterprise into a nationally known showplace for the arts, he was sitting in his Capitol office one day in 1913 hoping for just such an opportunity when an official of the state fair wandered in and made him a proposition. "You run an art show don't you?" asked

with a landscape. We found to our surprise that they were not really as interested in the figure as they were in landscapes. We would draw a large landscape with a red barn in the middle and a road cutting the corners of the picture and the trees planted at regular intervals and would show how awkward that was, and then we would demonstrate the proper planting of trees leading up to the house and the arrangement of buildings on the farm grounds pictorially. We would rearrange the composition, move the barn over and illustrate the general principles of composition and beauty. Occasionally we would follow that by taking one of the pictures in the exhibition and draw it, to show them the restful spaces, the unity of the composition, and it was surprising how rapidly they gleaned the sense of these terms.

"All told, during that one week we made little demonstrations of the ways and means of art to over sixty thousand people. . . . I believe the first thing is to amuse, interest, get the people to come, give them a taste of it and they will want more. If we reach the great mass of the people of this country in an interestingly intimate way, it seems to me that in a very few years there is no reason why we should not have 60,000,000 art promoters and lovers in this country. I do not believe we can do it so easily in any other way as to meet the people on their own ground at state . . . fairs. The masses can be aroused, and then the individual must be interested and made to believe he can produce. I think by next year we shall have the studio in the Wisconsin fair."

— Dudley Crafts Watson, Director
   Milwaukee Art Institute
   and Director of Art Education
   at the Minnesota State Fair □

## PUBLIC ART ON THE FAIRGROUNDS

Over the years, the fair has taken pains to adorn itself with suitable pictorial and sculptural embellishments. In 1947 Jerry Cannon, who had painted scenes in the dome of the old Agriculture Building thirty-five years before, returned to adorn its brand-new counterpart with a pair of murals (eighty-by-eight feet in size) depicting rural scenes. In 1984 members of 4-H, working with a community arts organization, affixed "the world's largest jigsaw puzzle" to the exterior wall at the east end of the Coliseum. Composed of eighty-seven giant pieces—one for each county in the state—the completed mural served to publicize the educational art programs of 4-H.

More memorable, perhaps, have been the fair's excursions into outdoor sculpture. The thirty-six-foot-tall pioneer woman of gold fiberglass, erected in 1958, was moved to the lawn in front of the Territorial Pioneers' picture gallery in 1959 to make room for a huge statue of Neptune of the same material, a tribute to the opening of the St. Lawrence Seaway. Neptune went to Duluth later that year, and in 1966 Fairchild the Gopher, a colorful, twenty-four-foot fiberglass statue, took permanent possession of the same much-used pedestal near the Administration Building on Cosgrove Street.

Dressed as an old-time midway barker, in a striped jacket and a straw skimmer, the gopher was the new mascot of the fair. His likeness graced badges, tickets, maps, and souvenirs, and a life-size version in a furry suit (nowadays accompanied by his nephew, Fairborn) delighted children and waved to spectators from a float in the daily parade.

Fairchild got his name in a state-wide contest. The name is a clever play on the title of the institution, but it is also an artful tribute to Henry S. Fairchild, the man who suggested that the Ramsey County Poor Farm become the permanent site of the Minnesota State Fair. □

the caller, referring to the art commission's annual. "We have an art show at the State Fair, and if we could work with you a little, we might furnish the people and you furnish the show." Flagg readily agreed to take charge of the massive new undertaking that would result from the merger of the state fair competition with the Annual State Art Exhibition. No more, he wrote, would art in Minnesota consist of "a few sofa pillows and a lot of painted china . . . tucked away in a corner of the Woman's Building—what men usually think of as women's work." Rather, art would be on a par with livestock or any other serious and well-managed competition at the fair:

> Anyone in Minnesota was to have the privilege of sending a picture, or piece of handiwork, or hand painted plate, or coal shovel with a picture of the old home on it. We brought from outside the state skilled men and women to judge and pass upon these subjects and reject those not meritorious, and furthermore, we gave everyone the privilege of receiving actual instruction; a written criticism from the jury if he wished it. This was a radical effort to increase and better the standard of art in Minnesota.

The first show in 1914 was a tremendous hit. During that summer, 120,000 passed through Flagg's five "spacious art galleries," jovially asking one another why the judges had chosen those particular artists as winners of the $650 in cash premiums and a pair of gold medals. The following year, more than 160,000 attended the six-day show; an estimated 75 percent of them came "from rural districts" where items such as John Daniels's carved nudes (he also sculpted fully clothed figures in butter in the Dairy Building) were rarely seen. The novelty of the program at the remodeled gallery was one reason why attendance continued to soar throughout the decade. Old, familiar items—the Old World lace made by the women of New Ulm and Sleepy Eye, for example—were examined afresh, as possible starting points for new Minnesota businesses. A chalk-talk artist gave entertaining lectures on aesthetic issues, painted whole pictures with an audience looking on, and raffled off the results every afternoon. Fairgoers gained some perspective on the merits of the juried Minnesota show by viewing subsidiary exhibitions of works by established New York and Chicago figures and avant-garde artists whose names had become synonyms for bohemian panache in the pages of mass-circulation magazines. Those who returned to the 1916 exhibition were pleased to learn that a prize-winning picture by Minnesotan Alexis Jean Fournier, displayed there the summer before, was the first work of art sold at the current San Francisco World's Fair, the Panama-Pacific Exposition. All in all, the state fair fine arts show had rapidly become one of the liveliest attractions this side of the Midway!

Flagg's reign as the art czar of the state fair was not without its troubles. Longtime competitors were shocked by the severity of a jury that rejected seven out of ten entries in the early years of the new regime. Women circulated a petition objecting to Flagg's proposed appointment as head of a division once dominated by home manufactures. But by the time the state fair became a wartime "Food Training Camp" in 1917, the art show had emerged as a leader among the more professionalized exhibitions then taking hold at state fairs in Texas, Iowa, Michigan, and Illinois, and the pattern of art activity that would be followed at the Minnesota fair for the next thirty years was fixed.

Crafts, which emphasized the recreational process of fabrication, by and large retreated to the Woman's Building and its successor, the Creative Activities Building. The galleries were left to painters and sculptors, many of them young talents seeking encouragement to pursue a career in art. And

the accompanying loan exhibitions, including a schedule of major shows circulated by the American Federation of the Arts, exposed Minnesotans to works and styles otherwise inaccessible to them. George Bellows's prints; selections by the Chicago Camera Club; sketches for WPA murals; the wood engravings of Winslow Homer; models for a monument to the Pioneer Mother to be erected near Ponca City, Oklahoma; twenty works by members of the art colony in Brown County, Indiana; scenes of Russia, China, and Arizona from the brush of Leon Gaspard; and $500,000 worth of paintings by the Basque costume artists Valentin and Ramon Zubiaurre direct from the Carnegie Institute in Pittsburgh: such were the focal points of various state fair shows advertised between the wars.

At other state fair exhibitions, the introduction of advanced styles — abstraction in the 1920s, regionalism in the 30s — was a source of conflict. The superintendent of Iowa's so-called Art Barn, a virulent opponent of abstraction who thought only academic realism qualified as "white man's art," removed popular Minneapolis portraitist Frances Cranmer Greenman from his panel of judges in 1925 on account of her reputed interest in "modernist stuff." And in 1935, when Iowa jurors were elected by a vote of participating artists, the defeat of Minnesota's Dewey Albinson was seen as a victory for antiregionalist conservatives. But back home, where Greenman and Albinson were frequent prize winners at the state fair art show, amity reigned. Until the postwar period brought increased public access to color reproductions of artwork, adult education courses and do-it-yourself kits that encouraged ordinary people to paint, and an effort on the part of museums to attract a broader audience, the state fair alone defined the nature of art for the vast majority of Minnesotans.

In 1954 the annual exhibition moved into new quarters at the top of the Grandstand; in 1980, in recognition of the regard in which fairgoers hold the show, the Fine Arts Division took over the 1907 Machinery Hall next to the 4-H Building. There it anchors an educational zone that stretches downhill to the Creative Activities Building. And there, artists give demonstrations. Distinguished jurors continue to deliberate. In recognition of the fair's democratic approach to artistic judgment, a one-hundred-dollar "People's Choice" award is made to the entry preferred by gallery goers. There is no need for the imported "great art" exhibitions of the past, although special shows-within-the-show are sometimes organized; in 1983, for example, a group of photographs of the fair attracted notice.

In 1855 the Joint Fair had featured a competition for daguerreotypes; this was the territory's first exhibition and its first public acknowledgment that art merited a place among the necessities of life. In 1877 the Union Fair in downtown Minneapolis provided the first state fair art gallery. The Art Center on Machinery Hill reaffirms the traditional importance of the fine arts at the fair. ☐

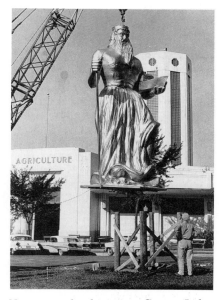

*Neptune clutching a Great Lakes steamer, honoring the completion of the St. Lawrence Seaway, 1959*

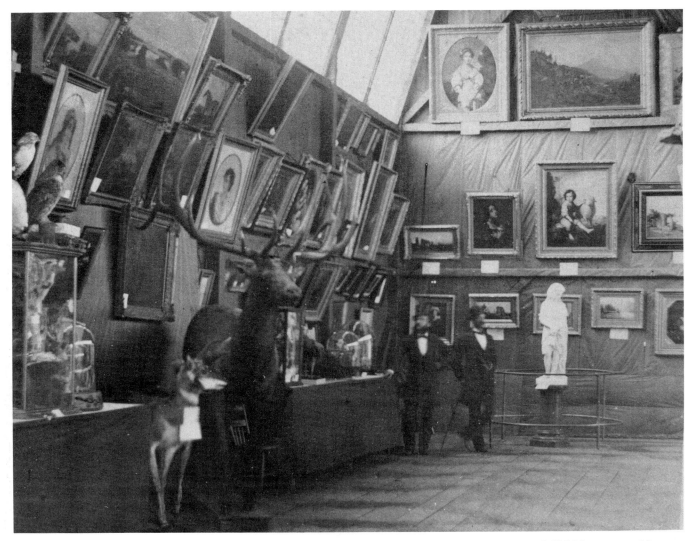

*State fair art gallery in the 1880s, containing copies of Old Masters, taxidermy, and floral arrangements (under glass) of human hair and moss*

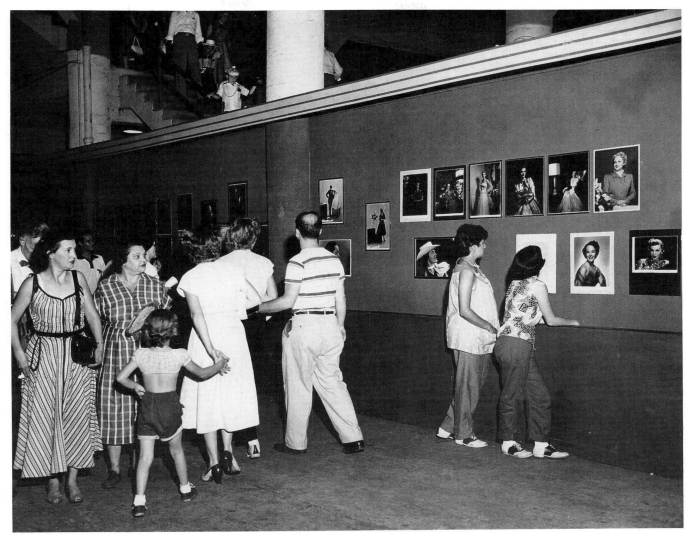

*Art gallery inside the Grandstand, 1953; lighting conditions were terrible, and the
shows were easy to miss.*

*The new Arts Center, 1980, in the airy space that once was the Dairy Building*
*On the inside: long paintings, 1980s*

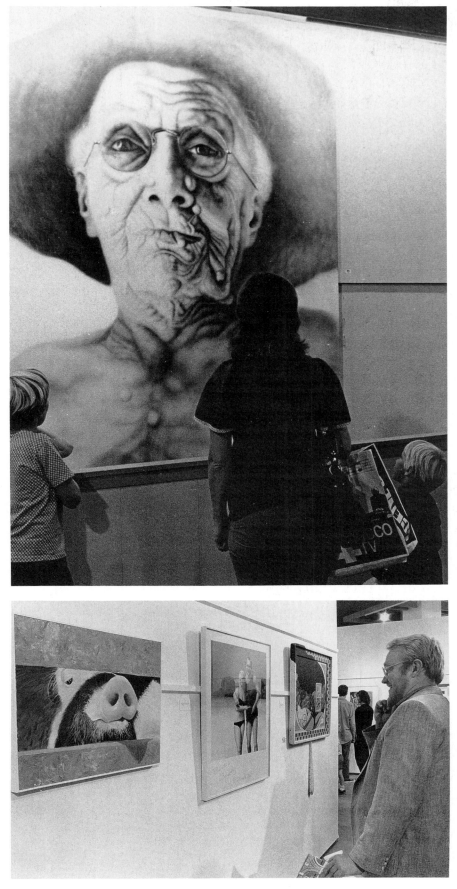

*Tall paintings, 1980s*

*And the pictures sometimes look back at the viewer.*

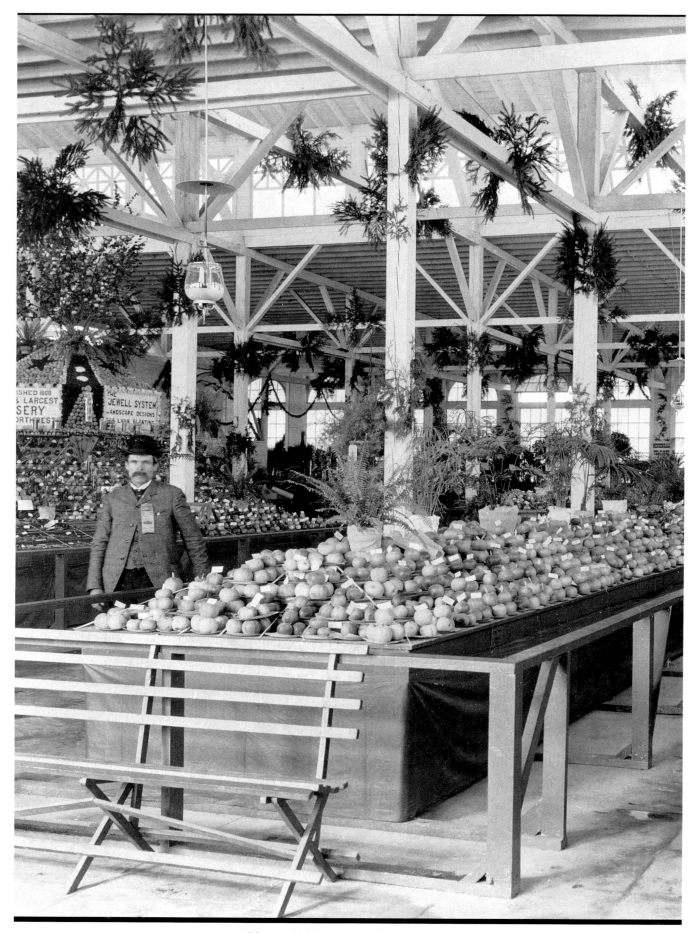

*Plates of Minnesota apples, painstakingly stacked in even rows, with sizes of the specimens precisely matched, 1903*

# THE ARTS
# OF EVERYDAY LIVING

THE BUSINESS OF EXHIBITING at the Minnesota State Fair became professionalized after the turn of the century. The competition in the fine arts gradually eliminated from consideration the kinds of homemade fancy-work and handicrafts that once dominated the premium lists. Those items to which an aesthetic component was central went to the art gallery whereas entries which — however handsome or daintily disposed — could be eaten or worn or played with or sat upon were scattered among a variety of departments reserved for women, horticulturalists, and the like. Few competitors in canning, cake baking, whittling, gardening, and the other home arts made a living by practicing their sundry crafts; nevertheless, the work they sent to the state fair every summer from the 1860s through the Great Depression represented skills still prized in the efficient housewife, the thrifty husbandman, the clever boy or girl. But by the time the fair recovered its prewar equilibrium in the 1950s, most of these endeavors had become hobbies — recreational activities in a world of frozen foods, packaged cupcakes, and do-it-yourself kits.

The definition of art was clearly a great deal more capacious in the early 1900s, when railroads, nurseries, various growers' associations, seed dealers, and ordinary citizens determined to boost the charms of their home counties all arranged their wares in elaborate pictorial tableaux designed to enhance the appeal of the product displayed. Using techniques borrowed from the Jewell Nursery Company's revolving model of Fort Snelling in apples, exhibitors at the state fair began modestly enough, with a few grain pictures and likenesses of Old Glory laid out in produce. In 1906 the movement peaked with a group of "the most elaborate and expensive exhibits of vegetables ever attempted in the United States": a massive copy of the new State Capitol made of white onions by the Growers' Association of St. Paul and a three-dimensional rendering of the "Falls of Minnehaha . . . entirely of vegetables in harmonizing colors" by the rival Market Gardeners' Association of Minneapolis. Often fabricated with professional assistance, these creations were strictly promotional in nature and were not competitive entries. But the fair did offer ribbons and cash prizes to amateurs who undertook to display their homegrown squashes and potatoes in a similarly "artistic" manner. In 1905 the first prize in crop display went to a giant cornucopia of onions that spilled forth a representative sampling of the "Products of Minnesota Gardens."

This species of state fair crop art actually began with rural people, and it was they who persisted in its development long after the commercial exhibitors had moved on to flashier means of advertising. The *St. Paul Pioneer Press* visited Agricultural Hall in 1892, for instance, and came away im-

## BLUE RIBBON WARFARE

"No other instrumentality is capable of doing what the state fair does. Its work is unique. Human nature changes slowly. People instinctively crave and respond to public recognition and commendation. It is creditably human to covet the appreciation of our fellows. We prize their corporate seal of approval which, in the case of the fair, is a silk ribbon, plus a cash reward and advertisement. Sportsmanship is innate in us. Men delight in competitive contests. The emotions and satisfactions which characterize success in running a foot race, pitching horseshoes or shooting at a target are identical with those experienced when we achieve honors as exhibitors of any of the multitudinous grown, raised, manufactured or hand-wrought objects of which a state fair display is composed. . . .

"The spirit of contest, competition and conquest is inherent in every man or youth. This spirit is the life of the fair, which provides the most inviting and appropriate opportunity for its expression. At a state fair the premium won in any department confers more credit upon the recipient than a premium awarded at a local show. Exhibitors, conscious of this fact, eventually graduate from the county or district fair class to that of freshmen at the state fair.

"War, peaceful or sanguinary, is man's endless necessity. He will extend and intensify it in proportion to his genius, skill, temperament, industry, provocation and opportunity. Victory and revenge are born of each other. Both spring from man's undying sportsmanship. His splendid lust for winning is, when wisely directed, a social force of the highest value. The state fair is an appeal and a challenge to his pride, sportsmanship and abilities."

— DeWitt C. Wing, associate editor of *Breeders' Gazette* (Chicago), from a 1914 speech to the Minnesota State Agricultural Society

□

pressed with the care with which the most ordinary fruits of the soil — the beets, the carrots, the pie plants, the ubiquitous "great yellow pumpkins, the staunch old friends of every fair" — had been arranged. "They form a very attractive display," the writer noted, "and the farmers show that they have some knowledge of the decorative art[s], even with their prosaic material. . . . Some of the exhibits are really artistic."

The individual displays were overshadowed by the exhibits of Anoka, Stevens, and Goodhue counties, however. Designed to incorporate as many distinctive forms of local produce as possible and to attract potential immigrants through the manifest tastefulness and ingenuity of the local committee in charge of artistic arrangements, these boothlike enclosures often featured symbols or pictures rendered in homegrown materials. The Stevens County exhibit for 1892, decorated by a group of women from Morris, was praised for a "banner showing an immense rooster made wholly of horticultural products. Even considering the rough and ungainly nature of the materials," opined one would-be art critic, "the great rooster is well formed and worthy of the admiration bestowed upon it." The battleship *Maine* delineated in "potatoes, squash, corn, oats, flax, barley, rye and all sorts of farm products" from Pine County was a sensation of the 1898 fair.

The annual statewide competition for the best county booth awarded substantial points for creativity and "artistic arrangement," much to the chagrin of districts that approached the contest from a strictly quantitative point of view. The supervisor of the competition, requesting an increase in the premiums in 1898, cited two reasons for augmenting the cash awards. First, he noted, with the increase in displays by big firms using fancy signs, working models, and photographs to woo the public, it was getting harder and harder to find a humble product of the soil at the state fair; were it not for the county booths, most visitors would "go home and say the fair is a failure because they could carry all the agricultural products they saw in a wheelbarrow." The second reason why he thought the awards should be enhanced was the amount of time competitors invested in the "artistic display" — the official scoresheet entry called it "Design and Taste in arrangement" — for which two hundred points out of a possible 1,500 were given.

The county competition remained keen throughout the 1920s and 30s, and the new Agriculture-Horticulture Building, dedicated in 1947, even made provision for permanent booths along the walls of several of the wings that radiate from the central tower. But, whereas 4-H'ers were still decorating club booths in their own building in the 1980s, the practice quickly waned among adults. In 1951, when seven of the twenty-one remaining displays were wholly in their charge, booth making was a spare-time hobby for women. Mrs. William G. Dokken of Atwater, who took the sweepstakes prize for her Kandiyohi County exhibit that year, was a town dweller who hunted up grain samples, attractive containers, and appropriate decorations in leisure moments stolen from cooking, sewing, canning, and flower-arranging projects also destined for the fair circuit. Her childhood friend, Mrs. Fred Main of Howard Lake, the 1944 sweepstakes winner, considered herself a part-time "professional county exhibitor." Mrs. Walter Dornfeld of Stillwater, long known for her state fair dahlias and chiffon cakes, decided to do the Washington County booth when she noticed the space standing empty — it seemed like fun.

The sheer pleasure of competing for prizes breathed new life into many forms of endeavor that persisted as pastimes long after their practical justification had disappeared. Scientific agriculture had little use for one-of-a-kind

vegetables, for example. Uniformity of size and regularity of shape meant greater profits, and so vegetable freaks gradually found their way into county booths, where they assumed a purely symbolic significance. The ten-pound radishes, the eight-inch-long pea pods, and the seventy-three-pound winter squash on view in the 1905 booths of Morrison and Blue Earth counties, like the 176-pound lake sturgeon exhibited by Becker County in 1926, were meant to emphasize the fertility and abundance of those locales. Likewise the various prize specimens of pumpkin, melon, squash, and cabbage awarded ribbons in the early 1900s solely on the basis of gigantic size served as graphic metaphors for the state fair itself, growing bigger and better by the year.

Such exhibits were also the preserve of the home gardener, the non-commercial grower prone to experiment with a strain of giant, hard-to-ship, impractical pumpkins as a form of recreation. As for-profit growers ceased to find costly state fair exhibits crucial to their businesses — the commercial potato premium was dropped in 1925 for lack of interest, and the number of prizes in grain and corn was trimmed — hobbyists gradually took over the allotted spaces in the halls devoted to the fruits of Minnesota's soil. By 1950, as it was represented at the Minnesota State Fair at any rate, agriculture had become a leisure-time art.

At one end of the aesthetic spectrum was the baroque hyperbole of the prize pumpkin; at the other, the system of laying out vegetables of all sorts in unassuming groups of matched specimens, an innovation adopted in the 1920s on the grounds that peck lots "do not make a very pleasing show," especially when delivered to the judges in a variety of spare boxes, baskets, and gunnysacks. The pictorial arrangements of produce of the county booths fell somewhere between the two extremes. And, after the booths declined in popularity (and ceased to be fabricated from agricultural products), a new form of crop art, the seed mosaic, became a major category of state fair competition among do-it-yourselfers in the mid-1960s. Never a format favored by state fair practitioners of the fine arts, crop art is nonetheless a legitimate expression of community standards of beauty and the end pro-duct of a local tradition of decoration based on Minnesota's agricultural heritage. It is also a prime example of those arts of everyday living recognized by the ribbons awarded at the Minnesota State Fair.

A new feature called "Crop Art and Arrangements," sponsored by the Farm Crops Division, was instituted in 1965 after two hobbyists from rural Minnesota in search of topics for their home agent's next extension class saw some mosaic panels incorporating natural materials on display in the Lutheran Brotherhood insurance building in Minneapolis. The women re-turned home, adapted the technique to seeds and grains glued down in pat-terns derived from crewel embroidery, and eventually began marketing kits to their neighbors. They also organized weekend workshops on their craft at several locations. County fairs were swamped with entries of an unfamiliar sort. Soon, there were enough seed fanciers working in Minnesota (which remains the one-and-only home of the medium) to justify official recogni-tion at the state level. Three years after her trip to Minneapolis, Mrs. George Antolick of De Graff (Swift County), one of the original pair of seed entre-preneurs, won the first sweepstakes prize for crop art offered by the state fair.

By 1970, when Darlene Thorud of Bloomington took the reserve grand champion ribbon with a seed-studded totem pole, the annual crop art con-test had become a popular and much-anticipated state fair event. The appear-ance of the typical seed mosaic had changed, too. The earliest winning

## A PRIZE CAKE

The scorecard used to judge chocolate cakes at county fairs, school fairs, and cookery courses in rural schools in 1911 allotted points this way:

- 10% General appearance
- 30% Lightness
- 25% Texture
- 5% Moisture
- 10% Tenderness
- 20% Baking

specimens resembled mosaic work in glass or ceramic, a popular artistic medium of the 1950s and early 60s especially suited to the flat, uncompromised surfaces of new buildings reflecting the tenets of the International Style. Like many hobby crafts, crop art translated a high-art form into the domain of popular culture and thus signaled a general acceptance of what had been an aesthetic novelty. Once liberated from its ties to the world of art, however, the style of seed mosaic rapidly developed along lines mutually determined by regular competitors and their judges. Mrs. Antolick's highly stylized work recalled both crewel embroidery and the bold, abstract patterns seen in architectural mosaics. But Mrs. Thorud's work, although marked by the strong, simple forms of her Indian prototype (also popular among designers of the day), tended toward realism. Her representation of a totem pole was constructed over a three-dimensional wooden armature. The trend toward naturalism of a precise and intricately detailed character—the style of the earlier species of crop art, with its buildings of onions and potato-bedecked battleships—was confirmed several years later by the success of Lillian Colton of Owatonna, perennial winner and the acknowledged grand master of Minnesota State Fair crop art.

In 1974, her ninth year of competition, Mrs. Colton took the Best of Show award with a portrait of Barbra Streisand dressed in a filmy hat and a lacy, high-necked gown for the starring role in *Hello, Dolly*. She chose that subject, the beautician stated, because of the challenge of doing the difficult costume in cream of wheat and pearl barley set off by hairy vetch, cornhusks, and a single pea (an earring). When told that fairgoers were gathered three deep around the display rack in the Agriculture-Horticulture Building, wondering what kind of seeds had been used for each detail and oohing in disbelief over the fineness of the work, she did allow as how the picture had taken three "quite long" evenings to complete. And Barbra's portrait was only the first in a gallery of notables that came to include Willie Nelson and Abraham Lincoln (with full beards of seeds), Joe Garagiola, Lucky Lindy, FDR, Billy Graham, Shirley Temple, and Grandma Moses, all displayed in a 1984 retrospective mounted to celebrate the twentieth anniversary of the crop art show. Asked for the secret of her success, Mrs. Colton (who had taken the Best of Show prize ten times by 1979, along with seven sweepstakes awards) professed ignorance: "I don't known why mine got picked always, because some of the others are good, too. I wish somebody else would win because they are so close. There's a Mrs. Voelkert from Randolph who does very well and gets some first places. I always think she's going to get it every year. She's a good competitor."

But what do the judges look for year after year? "Originality": no ready-made patterns bought in some craft store. "Neatness, artistic merit, composition, color, blending of textures, craftsmanship, use of materials, and framing." In short, they look for the same delicate blend of artistic values that characterizes winners in a wide variety of other state fair contests, ranging from baking and sewing to violin making and singing in the talent contest. They seek a product, a performance marked by self-evident competence and just the right dose of novelty. Whether in seed mosaics or in chocolate loaf cakes, too much originality in the handling of the formula threatens to displace the object from its proper class. Too little attention to the whys and wherefores, on the other hand, deprives the spectator of the considerable pleasure to be had from seeing a piece of work done well in every particular.

Women have had far greater opportunity over the years to watch the

*Mrs. Fred Main, Howard Lake, with corn-kernel pictures prepared for the 1944 fair*

## ON JUDGES

Leona Peterson of Mora describes state fair judges as fussy. Once during her long and distinguished career as a champion cook, she entered a contest calling for eight jars of different canned vegetables and was marked down on her scorecard for using one lid that wasn't quite as shiny bright as the rest. It takes nerve, a keen eye, and high set of standards to dock Leona Peterson for dull lids—she's the lady whose perfectly uniform carrot slices, stacked in impossibly precise configurations, take your breath away every summer in the back corner of the Creative Activities Building, where the big, lighted cases ablaze with color and dazzling pattern prove that canning should be added to the list of the lively arts.

Leona concedes, however, that their fussiness makes it hard to put anything over on the experts down in St. Paul. There was the year she didn't get around to making the dill pickles until the middle of August. That summer, she didn't get a first in dills either. Instead, her entry card came back with this assessment of the too-young pickles: "Beautiful pack. Beautiful color. Poor taste." "They *were* pretty blah, I guess," she recalls.

Mrs. Peterson saves those comment cards because they help her to improve her performance and avoid mistakes. And they're her only direct link to the experts who taste her pickles and poke at her cakes to help evaluate their fine crumb and tenderness. At the Kanabec County Fair the tasters are sometimes to be seen on Preparation Day, deep in conference over the

baked goods. At the state fair, the judges are invisible eminences, known only by words of praise or censure on scorecards—and the suspense of waiting for the verdict is all the greater. But so is the thrill of winning. Leona Peterson's most memorable victory came in 1980 when her entry, Our Favorite Devil's Food Cake—which had already won a blue ribbon at "State" in 1975, as well as firsts at the Kanabec County Fair in 1972, 1973, 1975, and 1979—took the sweepstakes and a special award from the Hershey's Chocolate folks: twenty-five dollars and a ten-pound Hershey bar!

Counting both fairs, Leona Peterson has 930 ribbons now, give or take a few, and almost five hundred of them are blue; that's more than enough for a premium quilt. She has pictures of herself holding the big chocolate bar and the purple rosette for chocolate cakes. She has personal letters of congratulation from Senators Hubert H. Humphrey and Rudy Boschwitz and the governor. And she has wonderful memories.

She remembers the first time it struck her that canning could be more than a chore, back in the late 1940s or early 50s, when she and her husband began to garden on a large scale to feed the family. "One day I went to a friend's house to visit. It was canning season and she had been canning. It was a beautiful sight. Everything was packed just so. It gave me ideas. Boy! Did it ever! So, as I canned in the weeks to follow, I tried packing jars as she had done. I did pretty well." Indeed. Leona became almost as fussy about her canning as the fussiest judge at the Minnesota State Fair. □

*Gunnar Ahlquist, wiping his tongue between samples of pears, 1946*

*Bread judge Amy Newcomb, 1960*

judges at work and to adjust their standards accordingly. Homemade objects submitted by men — classified from the 1850s onward as "pretties," "household manufactures," "fancy work," and even "women's work" — were rarities at early fairs. Those few that were forthcoming were the anomalous "male embroideries" and "gentlemen's quilts" grudgingly hung in the Woman's Building and always singled out for quizzical attention in the newspapers. Even after the turn of the century, sparse male entries and the absence of premium classes for activities other than sewing, china painting, and the arts traditionally assigned to women suggest that men did not spend their idle hours in such endeavors in numbers sufficient to warrant awards geared to their interests. The first significant change in this situation came from the ranks of firemen and other occupational groups forced to endure large stretches of leisure time. At the 1911 fair a Minneapolis fireman turned heads with a portiere — a hanging curtain — made of 1,500 intricately and "artistically" carved peach pits, the product of nine years of whittling on the job. A quilt made by a prison inmate was a curiosity worth noting at the 1914 fair; knitting by disabled soldiers was featured during World War I. And the same decade also witnessed a rise in the numbers of ship models and woodcraft projects submitted by residents of homes for oldsters.

While the contrast between the domestic interests of men who tinkered with such projects and the callous desertion of home and hearth by the suffragists was irresistible to journalists, the male handicraft craze of the 1920s and 30s actually hinged on dramatic alterations in the culture's understanding of a healthy balance between work and free time. Men who used to die in the harness were now living long enough to retire with time heavy on their hands, and up-to-date farmers and businessmen alike came to recognize the value of leisure-time pursuits that provided a refreshing break from the daily grind. Carl Jones of the *Minneapolis Journal*, who addressed the Agricultural Society in 1923 on the topic of "City Folks at the State Fair," specifically urged those in positions of authority to make provision for a diversity of hobby interests in their program on that basis. And so men carved horses and bowls and chairs, inlaid tables, turned metal, built model cars and dollhouses, tooled leather — and occasionally hooked a rug or crocheted an afghan. By 1960 such handicrafts were distinguished from the "home art crafts" (beads, ceramics, clay modeling), but the effort to revive the old practice of dividing the field of human endeavor into neat, sex-specific halves has not worn well in the years since. As early as 1950 Superintendent Mildred Harrington passed along the suggestion that the Woman's Building be rechristened the Family Interest Building in recognition of the universal appeal of homecrafted items. In 1958 the title of the department was changed to Home Activities, and when it moved in 1971, the new structure was called the Creative Activities Building. At last the everyday arts really were for everybody, men and women alike.

Yet the newfound equality of all craftspersons, regardless of gender, should not obscure the accomplishments of the several generations of legendary champs once known as the blue-ribbon royalty of the Minnesota State Fair. Unofficially, at least, every year of the 1940s and 50s brought the crowning of a new Jelly Queen, an Angel's Food and a Devil's Food Cake Queen, a Bread Queen, a Coffee Cake Queen, a Canned Chicken Queen, a Pie Crust Queen, a Queen of Preserves, Conserves, and Pickles, and lesser monarchs of the cookie, the canned green bean, the tea loaf. It was not unusual for women who made "show cooking" for the state fair their real hobby to accumulate vast quantities of ribbons. One Le Sueur grandmother

. . . . . . . . . . . . . . . . . . . . . . . . . . . . . . . . . . . . . . . . . . . . . . . . . . . .
ARTS OF EVERYDAY LIVING

247

probably set a record of sorts by making six large quilts out of her awards, but the so-called premium bedspread was by no means a novelty. Some weary contestants kept at their canning kettles specifically to complete unfinished coverlets. St. Paul's Christine Arlt, who won her first ribbons for canning at the 1919 fair and was the acknowledged Jelly Queen of the 1940s, had collected more than three thousand ribbons and the title of "Mrs. State Fair" by the time she hung up her apron in her mid-eighties. By then, too, she sometimes found herself forced to throw away many of the jars of jewel-like jelly and perfectly packed vegetables on which her reputation rested. There was nobody left at home to eat the goodies. Cooking "is just a hobby," she confessed, "just something fun."

Like spare-time activities in general, the nature, status, and popularity of the culinary competitions at the state fair in the postwar period provide insights into broader social issues. The splashy media spreads devoted to competitors invariably photographed in their own kitchens, surrounded by domestic paraphernalia and dressed in spotless ruffled aprons, seem compensatory somehow — reassuring images of women who are not at all like the independent female war workers in their Rosie the Riveter slacks and hard hats. Their fancy cooking may be a form of recreation, but it is clear enough from the annual stories about them that Mrs. Arlt and her sisters cooked everyday meals, too, and did the wash and scrubbed the floors. Just as the Mrs. America beauty pageant of the 1960s would serve to glamorize the lot of the housewife, so the hard-fought state fair cake and jelly contests of the preceding epoch affirmed the value of her customary activities in the home.

*Amateur performing artists get their chance to compete in the fair's Talent Show; dance line, 1987.*

Women were not being coerced into cooking, to be sure; Mrs. Arlt's pleasure in her accomplishments was genuine. But several powerful external forces conspired to make homemaking an attractive hobby as well as a full-time profession. Magazines bulged with ads for brand-new kitchen appliances, while the articles sandwiched in between the glossy pictures of freezers and ranges described new culinary methods and exciting changes in the American diet. The fair's Food Exposition followed suit, highlighting bamboo shoots and other exotic "chop suey" ingredients as early as 1937. But the biggest alterations in Minnesotans' eating habits were registered in the prize-winning recipes of the next several decades. Home-rendered lard disappeared from piecrust and home-canned meats became a novelty. Canning in general (along with bread baking) lost ground to the preparation of special-occasion foods, such as cakes and coffee cakes for the neighborhood coffee klatch. Thanks to the use of vegetable oil, those delicacies became lighter and "healthier." Calorie counters substituted skim-milk powder for whole milk or cream in their time-tested recipes, fondue became the "in" dish for hostesses and demonstrators, bread was kneaded in the food processor, and Weight Watchers sponsored a state fair recipe contest featuring microwave dishes. The premium list in Creative Activities has thus charted the rapid public acceptance of culinary technology and a variety of food fads ranging from Bundt cakes to an array of ethnic dishes.

Under whatever title they are classified at any given moment, the arts and crafts of the fair — the cakes, the quilts, the model airplanes, even the county booths of old — are all intended as objects of contemplation, expressions of the aesthetic sensibility of their makers. Many such items once had (and some still retain) a practical use and were fabricated in the normal course of a busy day of work. Since the dawn of the present century and, more particularly, since the beginning of the Cold War era, the home

crafts — special, leisure-time activities now — have tended to surrender their utilitarian dimensions in favor of pure display. The prize quilt is a showpiece. Prize vegetables are sometimes thrown away when the fair is over. Nobody takes a blue ribbon for baking if the cakes, however toothsome, are a little lopsided. Carefully premeditated statements about beauty, harmony, and prevailing standards of good taste, these state fair staples are the artwork of the people, the arts of everyday living. □

## MAKING APPLES NICER TO LOOK AT

Amateur and professional nurserymen alike pursued two common goals reflected in the horticultural competitions at the state fair. The first was to develop strains of apples adapted to the short growing season and cold winters of Minnesota. The second was to interest the fair-going public in their progress.

It proved easier to encourage and support grafting programs through the gentle persuasion of the premium lists than to convince Minnesotans that an apple was something worth a second look. Polished, graded, boxed, or heaped into pyramids, apples were still apples, and promoters of an artistic bent strained to give them a fresh élan.

In 1909 the apple display under the dome of the old Main Building consisted of a working Ferris wheel covered in fragrant fruit, the background against which a ladies' orchestra wooed fairgoers with beautiful music. In 1911 the board of managers contracted with Harold Simmons of Howard Lake to mount an exhibit providing visible proof "that Minnesota is an apple growing state" in which horticulture could be pursued "to commercial advantage." The previous year apples

had been shown somewhat haphazardly, in groups of three disposed on wooden plates that straggled along long, tiered tables; nobody paid much attention. Simmons aimed to overwhelm his audience by the sheer force of numbers. He brought with him from Howard Lake a whole carload (six hundred bushels, roughly ninety thousand specimens) of Minnesota apples — Wealthy, Patten's Greenings, Hibernals, Dutchess — and massed them in great, eye-popping vertical banks topped off by floral sprays. The apple show that year was the toast of the fairgrounds.

The Haralson, a new winter variety developed at the University of Minnesota's Fruit Breeding Farm in Excelsior, went on display for the first time in the Horticulture Building during the 1932 state fair, and again response was tepid. The variety didn't really catch on until 1936, when the Minnesota Fruit Growers' Association centered its exhibit on a golden-brown, one-hundred-pound apple pie, made with two bushels of Haralsons. The size, the aroma, and the flaky grandeur of the pastry launched the long-keeping Haralson on its career as Minnesota's favorite pie apple. In the eye of a state fair visitor, aesthetic appeal can sometimes outweigh logic, economics, and years of hard work. □

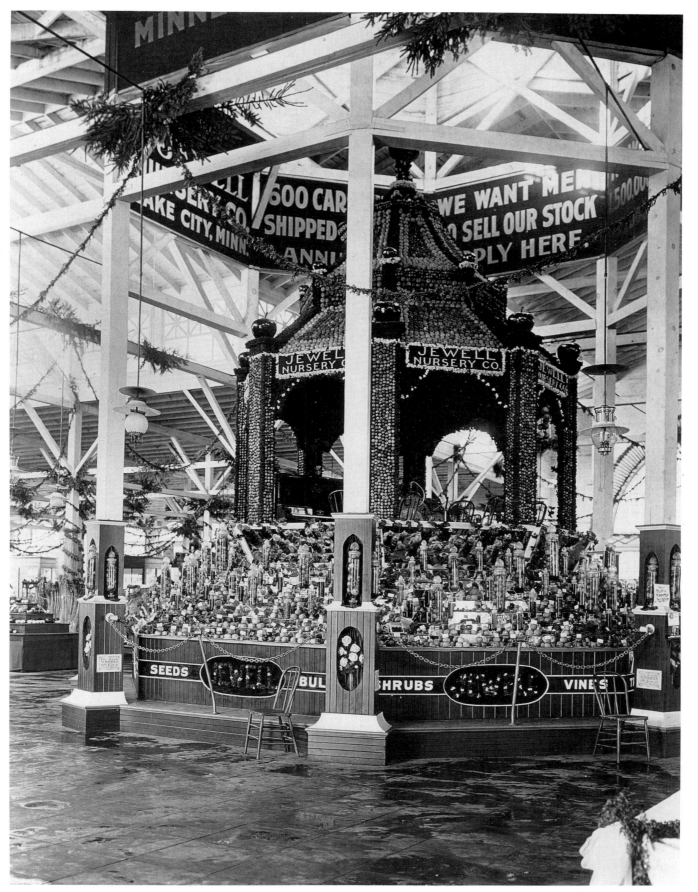

*Pagoda of fruit, 1906, meant to enhance the beauty of agricultural products*

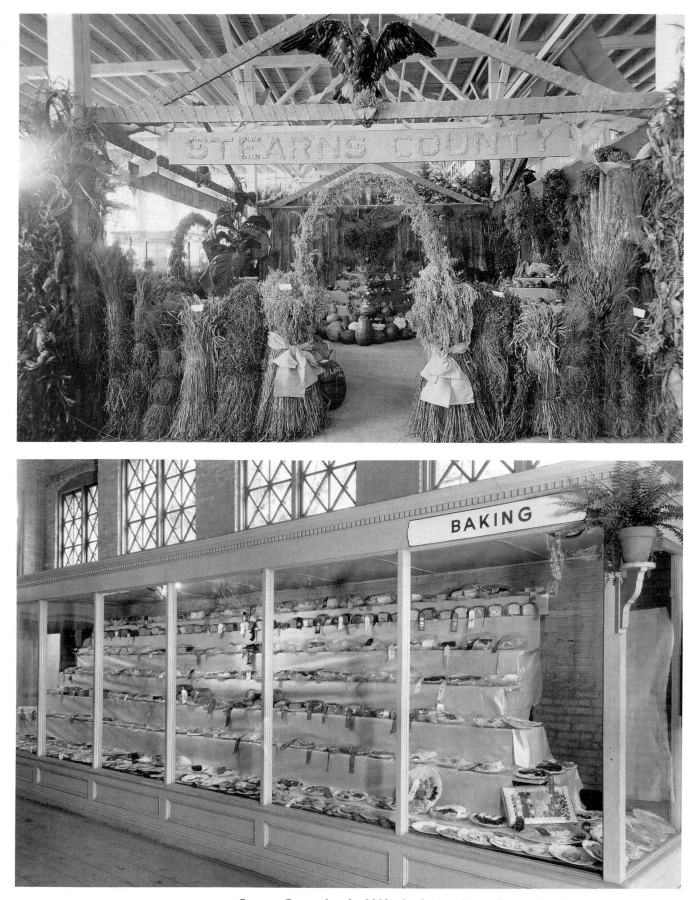

*Stearns County booth, 1902, displaying the quality and variety of produce in the most aesthetic manner possible*

*Cakes, breads, and cookies, 1947, admired for their color, texture, and shape as well as for taste*

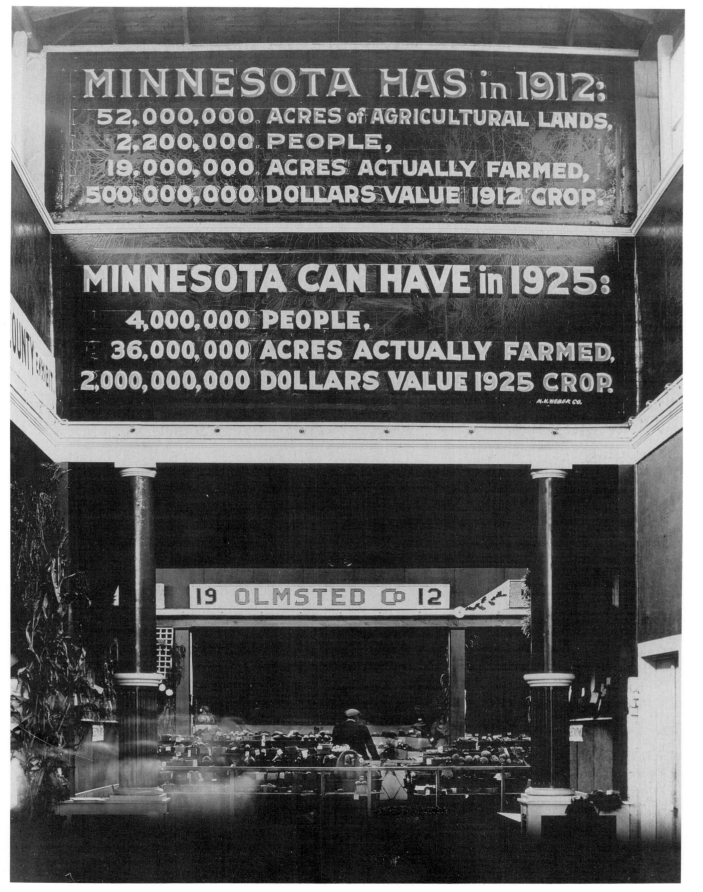

MINNESOTA HAS in 1912:
52,000,000 ACRES of AGRICULTURAL LANDS,
2,200,000 PEOPLE,
19,000,000 ACRES ACTUALLY FARMED,
500,000,000 DOLLARS VALUE 1912 CROP.

MINNESOTA CAN HAVE in 1925:
4,000,000 PEOPLE,
36,000,000 ACRES ACTUALLY FARMED,
2,000,000,000 DOLLARS VALUE 1925 CROP.

19 OLMSTED Co 12

*Like the Old Masters in the art gallery, the artistic booth was meant to prove the cultural and agricultural maturity of Minnesota, 1912.*

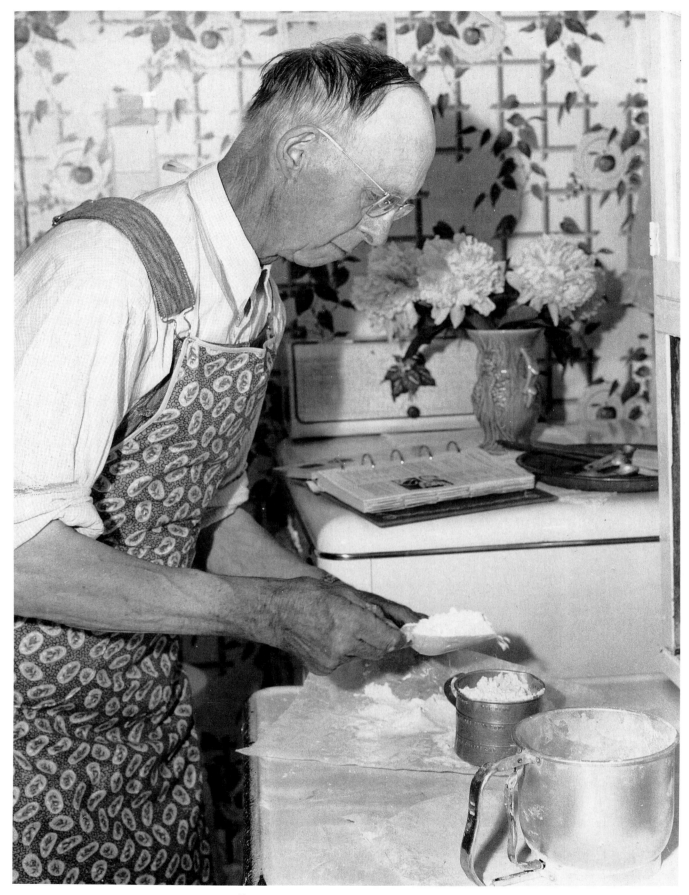

*Seventy-two-year-old Arthur Schlegel of Blakeley, a farmer, preparing to compete for the 1952 spice-cake prize*

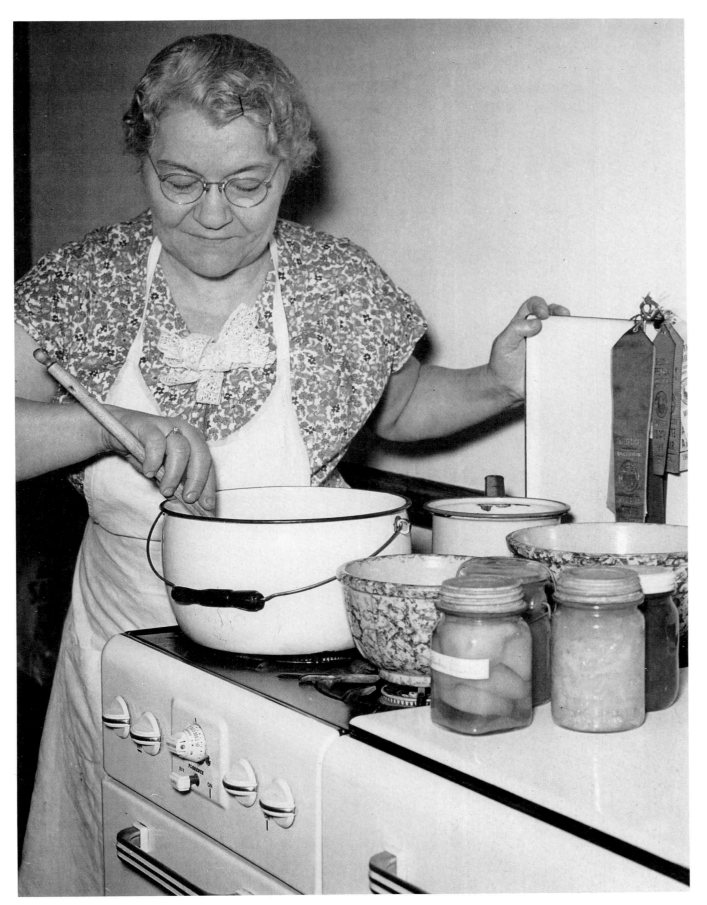

*Freda Dueholm of St. Paul, winner of the blue ribbon for peach jam in 1943, stirring her 1944 entry*

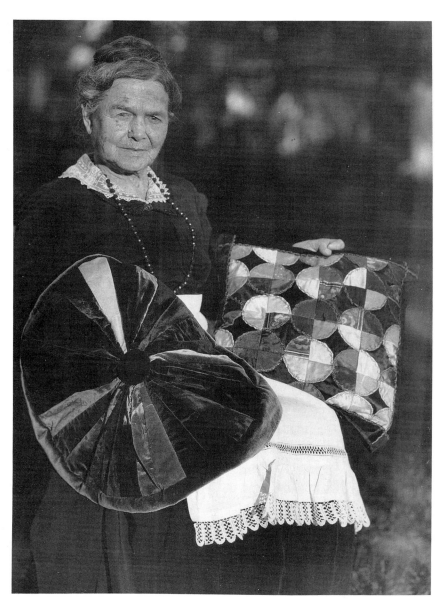

*Fashionable "poof" pillow, 1926, made with the same skills as old-fashioned quilts*

*Painted glassware, doll clothing, and stuffed animals — popular crafts entries, 1947*

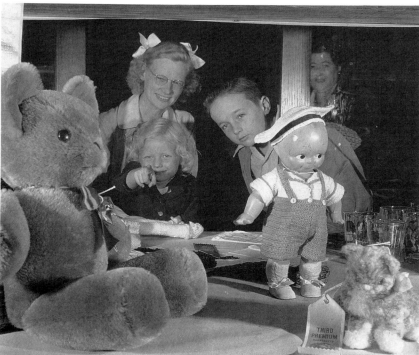

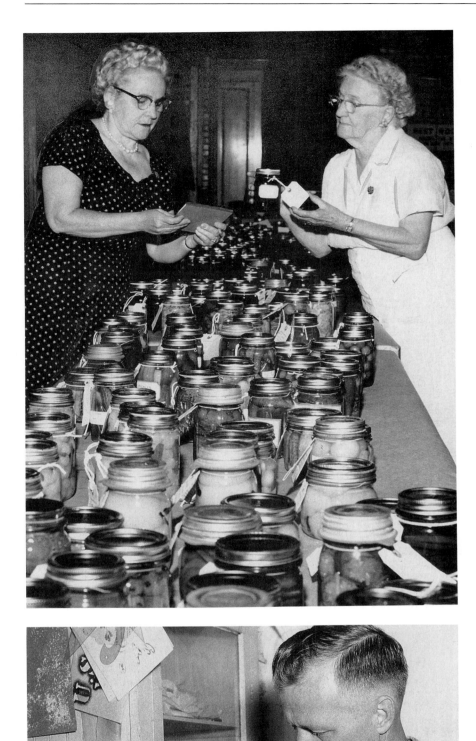

*Jessie L. Christopherson (left) and Frances L. Deebach evaluating the preserves, 1957*

*Everett Allen, North St. Paul, 1957, one of the many male competitors in the old Women's Division, soon to be renamed Home Activities and then Creative Activities*

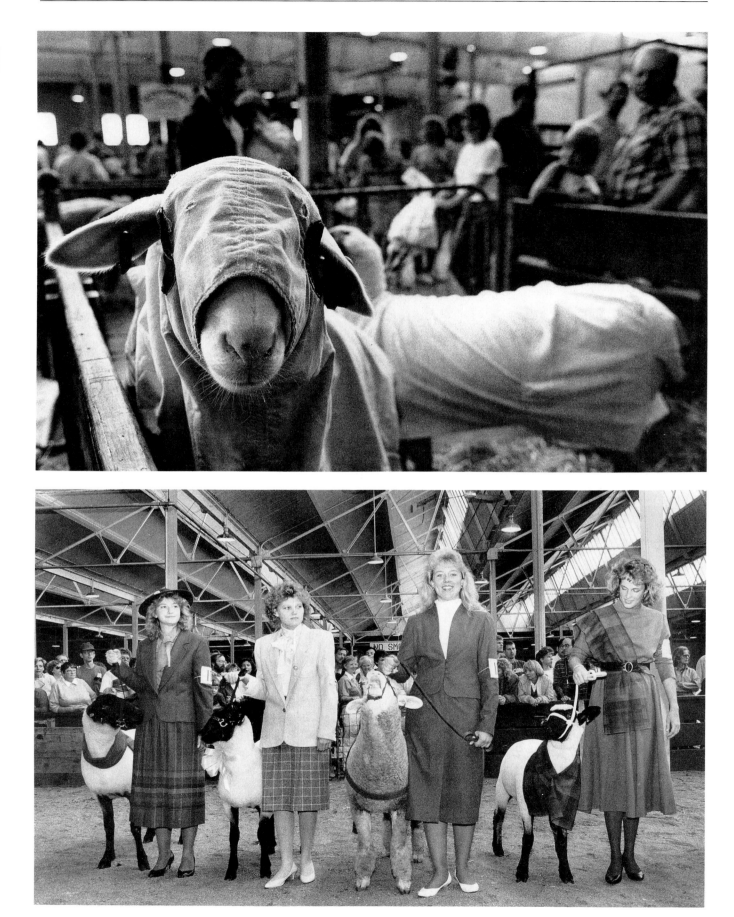

*The Ladies' Sheep Lead event combines the aesthetics of the show-ring with the flair of the style show and the skills of the sewing contest. Before the judging starts, sheep are costumed to keep their wool trim and clean, 1987.*

*Coordinated outfits are the rule, 1987.*

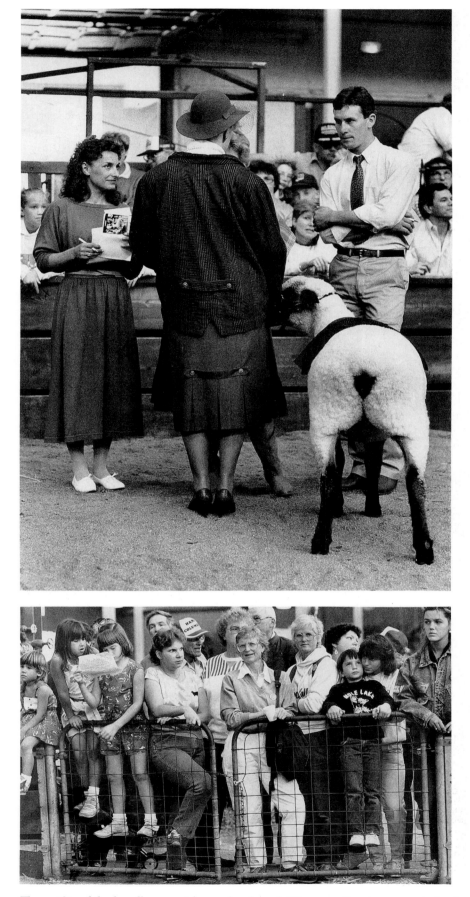

*The outfits of the handlers must be made of wool (75 percent); women are judged on poise, knowledge of wool, and a certain equipoise in handling their sheep, 1987.*

*The spectators, by turns intrigued and puzzled, 1987*

*Erik Magnusen of St. Francis, in his fifth season as a mini-donut man, pouring on the grease at the 1987 state fair*

CHAPTER SEVENTEEN

# CUISINE-ON-A-STICK

THE ARTFULNESS of those who produce the annual crop of prize cakes and pies is obvious. But there is also an art to the selection and consumption of the mouth-watering comestibles offered for sale on every side. In fact, acute indigestion has always been the leading medical emergency treated at the state fair infirmary because fairgoers seem particularly prone to stuffing themselves with foodstuffs as dissimilar as possible from their usual, stay-at-home provender.

Like orange juice for breakfast and turkey on Thanksgiving, the fair has its own special, ritual foods. Even before 1947, when the batter-coated, deep-fried wienie-on-a-stick known as the Pronto Pup was introduced, portable treats were a hallmark of state fair cuisine. The hot dogs, frozen bananas, pork chops, turkey nuggets, and candy apples dispensed on handy skewers point to the origins of the modern American fast food industry. Their eat-while-you-go convenience expresses the greater informality of postwar living as well as the image of speed and efficiency prized in a period that saw the invention of the TV dinner and the streamlined kitchen range.

Even back at the turn of the century, when frugal families toted their own lunches to the fairgrounds in willow baskets bulging with stuffed eggs, potato salad, and homemade sunshine cake, the prize cakes on display in the Woman's Building made fairgoers crave a taste of somebody else's home cooking. "We could sell everything we have a dozen times over," declared a weary attendant besieged with orders for a slice of the blue-ribbon chocolate cake of 1905. Most of the disappointed dessert seekers were city folks, who failed to understand the difference between a commercial bakery and a culinary competition. But their country cousins were also guilty of standing wistfully before the glass cases, yearning for a taste of a cookie that looked just like the ones their Aunt Amelia used to make.

"People seem crazy to buy the premium cakes and pies and they are willing to pay a good price for them. One woman begged me for just a taste of the lemon pie so she could see if it was better than she could make," reported another dignitary of the Baking Division. Despite the pleas of hungry visitors, however, the goodies were not for sale. Instead, they were quietly donated to residents of charitable institutions once the fair closed. The wisdom of that policy was demonstrated in 1915 after the director of one such agency thought it might be more lucrative to auction off slices of angel food and lemon meringue at a booth near the Grandstand and keep the proceeds; he thereby touched off what the newspapers described as a "near riot" among gluttonous fairgoers scrambling for a crumb of a genuine, prize-winning confection.

The customary fare for those who roamed the Midway and fought for

*Douglas Elofson, Minneapolis, and the ultimate state fair fast food: the Pronto Pup or corn dog, 1955.*

### "MAKE 'EM THIRSTY FIRST!"

Gale E. Brooke, a veteran state fair concessionaire who worked the Grand-stand shows, was persuaded to disclose the trade secrets of the beverage business in 1921. The key, he claimed, was to "make 'em thirsty first." As the show began, the vendors offered pea-nuts and popcorn — anything warm, dry, and salty. Next came the ice cream, with just enough moisture in it to tease parched throats. By then, of course, "you'd swap your happy home for something cold and wet." Voilà! Enter the lemonade, in big frosted gallon bottles.

But the canny concessionaire told his minions to carry the lemonade down front, to the box seats, resisting all entreaties from those parked in the higher rows. That way, the satisfied customers became advertisements for the product: "By the time my men have started back with empty bottles, everybody in the stands wants lemon-ade and they are almost willing to fight to get it."

The optimum temperature for sales, Brooke thought, was ninety degrees; the average spectator would then con-sume 8.5 cents-worth of his wares. For every five degrees below ninety, sales fell off by one cent. It was an exact science. Lemonade cost the customer ten cents a glass, of which 25 percent went for the privilege and 20 percent to the men who carried the bottles up

a shady seat in the Grandstand ran to items of a more plebeian kind. Peanuts, popcorn, candy (sold by "old girls . . . trying to look young and sweet"), watermelon slices, and sandwiches all answered the need for inexpensive sustenance that was easy to prepare and serve with a minimum of equip-ment and easy to eat on the fly. The vendors, who paid handsomely for the privilege of doing so, operated from a variety of stands and pushcarts clustered on the approaches to popular attractions. In 1897 some of the large commercial exhibitors complained that "it was almost impossible to get into" the principal exhibition halls "without running over or into somebody who was buying or selling watermelons or something else" to eat, and the "un-sightly row of cheap shanties along the main avenues" from which the caterers operated was a chronic eyesore. J. M. Underwood, in his first official decree as superintendent of the Horticultural Department, expelled the food sellers from the portico of his domain in 1898 and pushed for a system whereby the fair would construct tidy, uniform booths (in less conspicuous locations), which could be leased to the hawkers of victuals. Although these stands were not offered for rent until 1926, certain minimum standards for the design of eateries were put into effect without delay. The improvement must have been dramatic — fairgoers in 1899 took special note of both the new black-and-white color scheme adopted for the permanent buildings and the "picturesque" air lent to the grounds by the variety of different booths and cook tents, all constructed along strict guidelines specified by the board.

Such establishments, whether large or small, invariably sold something to drink. A favorite among thirsty fairgoers was pink lemonade, a beverage closely identified with festive public gatherings. (The usual lack of sufficient lemons could be masked by the pinking agent.) Most often compounded of tartaric acid and croton oil, with ample measures of coal-tar dye added to achieve the violent hue favored by small boys with nickels to spend, "doc-tored" lemonade was a constant problem to the management. Health inspec-tors disguised as ordinary patrons went from stand to stand taking samples surreptitiously. But sometimes confrontations between unscrupulous ven-dors and health officers took a dramatic turn. In 1909 an Inspector Graham was recognized as he purchased a glass of "off-color orangeade" at one of several Grandstand refreshment booths operated by F. B. Weeks of Mem-phis, Tennessee. Realizing his peril, Weeks dropped his apron and, with Graham at his heels, dashed the full length of the building to dispose of the adulterated stock secreted below the counter of another of his stands. The speedy inspector "got there first, by a nose, and got his evidence, but broke a 10-cent pitcher in the scramble with Weeks, who came in a close second" and was fined twenty-five dollars for his misdeeds. Weeks's defense? That he had just arrived from the Iowa fair in Des Moines, where there was no law against selling chemical preparations.

Just as annoying to those charged with maintaining good order at the fair were the lunch counters and "soft drink" booths on the Midway which, when approached with a wink, a password, and some folding money, sup-plied strong beer or spirits instead of the sarsaparilla, ginger ale, or root beer advertised. (As late as 1955, the operator of an ice-cream stand was arrested for selling pints of bootleg vodka!) Given the proliferation of blind pigs, it is perhaps understandable that drink-cure formulas and so-called temperance beverages enjoyed brisk sales, too. In the latter category was the mysterious potion sold by Mr. King at the 1915 fair under the banner of total abstinence until vigilant tasters discovered that it was really beer. Over his protestations of innocence, King's business was closed down and

his concession fee for the sale of a special nonalcoholic elixir declared forfeit.

Temperance drinks were very much in vogue in the years before the adoption of national Prohibition. But there had always been state fair food fads of one kind or another. In the 1880s it was hot peanuts, fresh from the roaster; in 1895, under the influence of successful "Old Tyme" kitchens that had operated at the Philadelphia Centennial and the Columbian Exposition, it was a New England menu of baked beans and brown bread; in 1906 it was the "cornucopias" and "cornets" of ice cream first introduced at the St. Louis world's fair of 1904. Whereas peanuts and beans and ice-cream cones became permanent features of state fair cuisine, other dishes — the Swedish meatballs of 1909, the suffragists' Susan B. Anthony Pie of 1911 — came and went (and sometimes, as in the case of ethnic foods, came back again). A 1902 attempt to stir up interest in genuine southern barbecue by roasting a whole ox every day in a tent designed to hold ten thousand potential gourmands was met with indifference, although southern fried-chicken stands prospered. But the major culinary battle of the turn of the century was the contest between the "red hot Frankfurter" and the "red hot Coney Island Hamburger."

Both sold for "5¢, mustard included" in 1906, the year in which the *St. Paul Dispatch* first took note of the waning popularity of the sausage. Prone to adulteration with nonmeat fillers and the artificial colorings that imparted the desired red-hot glow, the frank was being edged out of many prime locations by the hamburger "steak." Vendors had found the latter to be the better-paying proposition with discriminating diners. The burger's drawback, however, was its penetrating aroma, variously described as ambrosial or just plain "smelly," depending on the taste of the food critic. Thus, in 1909 the fair confined those who fried patties and onions to a district along the streetcar concourse known as Hamburger Row. The experiment was quickly abandoned when those who had once favored segregation now deplored the concentration of noise, bustle, and odors in one infernal spot. "The view from the front was not tempting," wrote a fastidious tourist, "but the rear view, which greeted the thousands who came from the Minneapolis cars was most offensive."

A garden was planted on the site and henceforth management contented itself with setting limits on how close purveyors of "the fragrant hamburger" might come to the portals of exhibition buildings, where fairgoers expected to savor instead the wholesome, outdoor smells of apples and cows. In any case, once the hamburger ceased to be a novelty it no longer seemed quite so smelly, and by 1913 or so the choice between a wiener in a long bun and chopped meat in a round one was no longer fraught with the partisanship of an earlier day. The young ladies of Wellesley College decided to raise money for the endowment fund by selling hamburgers at the 1921 fair, although kids plainly preferred the banter of the hot-dog men who importuned passersby to try a "warm puppy" and "listen to 'em bark." And it delighted a reporter to discover the young woman hired to play Helen of Troy (at two dollars a night) in the 1927 Grandstand show munching a hot dog while waiting, in full historical regalia, to be abducted by Paris.

Interviewed on the history of the grill wars of yesterday in 1927, "Hot Springs Blackie, the Hamburger King," who sold both dishes with even-handed impartiality, explained that they were just commodities, albeit necessary ones at state fairs. Of the two, the hot dog was the earliest on the scene but the hamburger had, perhaps, claimed the affections of a more interesting class of chef. The colorful Charley Billmeyer, a southern con-

and down the steps of the Grandstand all afternoon. "I get 12 glasses of lemonade out of a gallon. This brings in $1.20. For every gallon . . . I use six whole lemons, which cost me 19.98¢. I get sugar at $6.75 per 100 pounds and use one pound to the gallon, or 6.75¢ . . . . The cup itself and the labor of making the lemonade, including the equipment, wear and tear, averages 10.90¢ a gallon year in and out. My disbursements for the gallon of lemonade are therefore $1.03 or 17¢ profit on every gallon."

The psychology of the business was just as carefully calibrated. "Can't just let it go hit or miss. Feed 'em, boy — and then water 'em."

Ed Dickinson, self-styled "professor of lemonade psychology" and a state fair concessionaire for thirty-five years when he discussed strategic planning with the *Minneapolis Tribune* in 1947, endorsed his predecessor's procedures in every detail. But he also talked about quality. "Can anybody tell if it's good lemonade? If your teeth feel rough after you've had a drink, the chances are you've been cheated on sugar. And be sure to look at the color. Real lemonade has a nice yellow and it can't be faked."

It was a good business, the lemonade racket, Dickinson thought. "If you want to try your hand at it — get your old psychology book and come along."

☐

## THE AUTOMATIC EATER

One of strangest devices ever seen at the Minnesota State Fair was Batinger's Automatic Eater. A kind of mechanized restaurant, the Eater consisted of a 150-foot-long counter along which moved a procession of eighty-five wooden cars propelled by a system of cables embedded in a groove in the surface. The cars held food, and diners snatched for their favorite dishes as the train coursed past. Some cars had drawers filled with ice, to keep fruit or celery fresh; some were warmed with heated soapstones.

The ensemble was the invention of the Reverend J. M. Batinger, an Evangelical churchman, who stationed himself out in front with a megaphone to ballyhoo a new era in state fair dining: "Haba! Haba! Haba! This is the place to be merry. Eat! Eat! Eat! All you want for 50 cents; for without a full stomach you cannot enjoy the fair. Haba! Haba! Haba!"

The Automatic Eater cost Batinger more than one thousand dollars to build but, because of its novelty and the economies it permitted, the cafe more than paid for itself during a trial run conducted on the last few days of the 1920 fair. "Through the medium of the Automatic Eater," he stated the following summer, "I do away with all excess help and employ only one cook, a dish washer, and a woman to keep the train well stocked with food. I pay no attention to what my customers eat, how long they stay or how much food they consume." But there were healthy profits, which Batinger turned over to a St. Paul hospital.

Batinger's Eater was, in many ways, a perfect expression of the mentality of the automation-mad 1920s, obsessed with speed, technology, and efficiency. There were minor drawbacks to the system, however. Diners seated near the end of the line sometimes found that the only cargo left for the eating was boiled cabbage. □

cessionaire, was the man who first "put the business over," Blackie recounted. He was just a hot dog man, but he got the hamburger idea and he sold it to the public. Yes, sir, he certainly put it over. Poor old Charley! He's dead now—died in the pen. He got in a little trouble down in Macon, Ga., and he killed two men with one shot. The bullet went right through the first one and hit the second. That's what I call shooting! . . . I don't know how hot dogs started except that the kids gave them their name. You know, people used to say that sausages were made out of dogs and when we started selling 'em the kids started yelling, "Hot Dog."

Nobody was terribly surprised when food chemists on their annual rounds found dyestuffs in the red hots. August weather and careless food handling also contributed to periodic outbreaks of ptomaine poisoning, most common before the advent of electric refrigeration. And state fair diners who escaped outright poisoning were still apt to come away marveling at "how much indigestion you can buy for 25 cents." One of the most serious of the perennial complaints lodged against the fair was that the food was awful and the service worse. Choosing a restaurant, quipped one wit, was like spinning a wheel of fortune—"the nearest approach to a gambling device on the grounds." Another dyspeptic diner deplored the restaurant tents "rented from the fair . . . at high figures" in which greasy silverware, tablecloths used as communal napkins by the unmannerly, and the stench of elderly dairy products all conspired to ruin the appetite. And most of these dens of iniquity were run by churches whose pastors stood outside with megaphones luring the unwary to dine on dubious delicacies concocted therein by the members of the Ladies' Aid Society. "The gastric crimes which are committed on the fair ground in the name of religion" had been decried as early as 1899. "If that is their idea of Christianity," concluded a bilious patron in 1907, then the church in Minnesota was in a sorry state.

Nonetheless, the church cook tent and the agricultural fair were bound together in a symbiotic relationship that went back to pioneer days. In author Laura Ingalls Wilder's recounting of county fair going, the church dining room with its roasted turkeys, barrels of steamed potatoes, and racks of homemade pies—pumpkin, custard, vinegar, mince, raisin, berry, *and* cream—was as much a feature of the program as the horse race or the judging of exhibits. The ill-starred Owatonna fair in 1883 was plagued by a tornado, inferior dairy displays, and an influx of pickpockets, but among its worst recorded failures was the alleged mistreatment of the churches, which had paid large fees for the right to operate what turned out to be empty eating houses. The lack of patronage at Owatonna was a fluke, however. The appeal of eating "sacerdotal baked beans, cooked and served by benevolent ladies in the interests of Christ and a new carpet for the pastor's study" was a powerful one; those who did not seek out the Presbyterians, Methodists, or the Catholics for reasons of piety or charity did so because the food was apt to be of the homemade variety—familiar and filling. Whereas newfangled edibles like the hamburger attracted the diner who looked upon the state fair as a great adventure (culinary or otherwise), the church facilities made their pitch to a more conservative clientele seeking a substantial meal, not unlike those served in farm kitchens at harvest time.

Seated at a long table covered with oilcloth, serenaded by the rattle of dishes and the incessant ringing of the minister's bell, typical visitors to a 1911 dining hall paid fifty cents—in advance!—for a repast which, if they were lucky, might consist of vegetable soup, large helpings of hash, creamed potatoes and baked beans, a side dish of buttered corn bread, a slice of pie,

and a big glass of cold milk. For the same price, to be sure, one might also go away disappointed after a blue-plate special consisting of one thin slice of roast pork, a half-boiled potato, a minute order of string beans, bread and butter, pickles, pie, and coffee. And the sheer numbers of competing establishments made choosing the best spot for a real, just-like-home dinner difficult.

In 1896, for instance, the annual bidding for refreshment privileges elicited responses from the Merriam Park Trinity Methodist Episcopal and the St. Mark's Catholic churches of St. Paul and the Immanuel Baptist and Lyndale Congregationalist churches of Minneapolis. By 1903 there were eighty-nine such dining rooms at the fair, each of which paid a $125 fee to operate (one reportedly took in $4,300 during fair week), and most of which were run by religious groups. Gradually, churches that made an appearance year after year acquired a reputation among fairgoers. The Zion Lutheran tent was "always filled with a crowd who appreciate a clean meal." Up on Machinery Hill, the St. Peter's Church Dining Hall, manned by the Reverend Mr. Schutt and his wife was "the most popular place on the grounds" by virtue of the minister's famous loin roasts. Occasionally, as on one September afternoon in 1911, an impatient couple might even repair to its favorite cook tent for a wedding sandwiched in between the lunchtime crush and the start of the dinner hour. Sometimes, too, ministers who accompanied their flocks to the fair found themselves cheek by jowl with sin: the Reverend Mr. Habel of the Golgotha Lutheran Church of Minneapolis got a taste of vice when his parishioners opened a restaurant in 1921 opposite the tent of a pair of Gypsy fortune-tellers, whose removal he indignantly demanded.

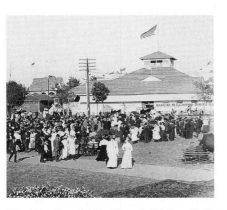

*The Hamline M.E. Church Dining Hall, perhaps the oldest continually operating church eatery at the fair, 1912*

Only sixteen church-run dining halls survived the Great Depression; in 1949 there were twenty-two of them, including a new blue-and-yellow Skandinaviska Stugan built by the men of St. Paul's Zion Lutheran congregation and staffed by the women, who claimed that the meatballs got their distinctive character from the addition of allspice freshly pulverized with an ordinary household hammer. By 1951 there were thirty-two such eateries at the fairgrounds; thereafter, the numbers fell off dramatically — to only nine in 1973. The reasons for the decline were several. The profits were especially tempting in the 1950s, when new churches were going up in the suburbs and low food costs made it possible for amateurs to succeed, but the work was demanding and greater leisure-time opportunities thinned out the ranks of volunteers willing to toil in kitchens wholly lacking in modern conveniences. Inexpensive, starchy staples became less popular with diners of the supermarket generation, who demanded larger helpings of rolled roast and baked ham instead. Rising meat prices erased the margin of profit altogether for several established dining halls in the 1970s, despite the addition of professional caterers and cooks to the staffs of cost-conscious operations.

As early as 1963 Mrs. Helling, the long-time chair of the Hamline Methodist Dining Hall, confessed to spending most of her summer in search of grocery bargains to keep the restaurant solvent. The "oldest and largest food concession operated by a St. Paul group," the hall served, on average, fifteen thousand meals a year throughout the 1960s. Although Hamline had made $7,750 during the 1962 fair ($900 of which went to pay for the privilege), much of that profit was realized because church members had been persuaded to donate homemade desserts in lieu of the bakery pies of previous seasons. While the money represented a substantial addition to

church coffers, Mrs. Helling believed that "The esprit de corps is more important than the profit. In a big city church, members of the congregation are often strangers to each other. Working together out here we become friends." Like eating at the fair, preparing the food for the state's annual celebration of the harvest had become a Minnesota ritual.

The fair's commercial food concessions have become traditions — and landmarks too. The all-the-milk-you-can-drink-for-a-dime booth where, in 1956, the record stood at twenty-three glasses. The taffy-pulling machine with the little mechanical man inside, first set up by Art Burke in a Minneapolis dime store in 1922 and transferred to the fair a year later. The honey-and-sunflower-seed ice-cream-cone counter alongside the bee exhibit, where it was still possible, at the height of the organic eating craze of the 1970s, to believe that ice cream was really a health food. The mini-donuts and the fried cheese curds in the Food Building, where the sizzling vats of fat dispel any such delusion. The cream puffs (vanilla or chocolate filling) concocted in a trailer parked between the Midway and Heritage Square. The World's Largest Milk Bar in the Dairy Building. The Minnesota Turkey Growers Association's cafe (known as the "Turkeyteria" in the 1950s). The Newman Center's homemade rhubarb pie which, at a dollar a cut, brought in almost twelve thousand dollars in 1983. Root-beer-flavored milk at a not-for-profit stand operated by a senator from Minnesota.

Following the lead of their churchly counterparts, some commercial vendors stuck to tried-and-true products. Katie Little, who had worked at the fair every summer since 1915 and owned a percentage of twenty-one prime "locations" at the time of her death in 1984, sold foot-long hot dogs and cotton candy exclusively. Others perfected their beans, their rainbow cones, or their patter: "See how long they are! — 30¢ to the foot, 90¢ to the yard! Local bread, pound o' meat,/And all the mustard you can eat!" But in the competitive atmosphere of the fair, entrepreneurs were often driven to desperate culinary experiments. Chilled fresh fruit and baked potatoes topped with "veggies," introduced in 1978, gained a small but loyal following among those able to resist the usual cholesterol-laden state fair diet. Pronto Pups still outsold bean sprouts by an unhealthy margin, however, and such novelties as frozen watermelon pulp on a stick (1958) and prepackaged soul-food dinners (1969) premiered and disappeared with alacrity. Yet since the late 1950s snacks with an ethnic flavor have been consistent winners in the fair's de facto taste contest.

Before World War I, ethnic food usually meant Scandinavian delicacies, heritage foods recalling the national origin of many fairgoers. After World War II, the same wave of internationalism that produced the United Nations brought rollmops, pilaf, kolaches, worst boordjes, and kola lota to the state fair, along with an ersatz Oriental dish (nowadays sold by the Minnesota Southern District of the Lutheran Church-Missouri Synod) called chow mein. But the biggest single factor in introducing spicy tacos and pizza to cautious Minnesota palates was the increasingly cosmopolitan character of Twin Citians who, in the 1970s, were suddenly eager to sample a whole new repertory of foodways. The nachos and tamales at the fair's Mexican Village, and the Middle Eastern falafel, Italian rigatoni, and Korean eggrolls in demand elsewhere marked a decisive end to the last vestiges of Minnesota's prairie isolationism. Taste, after all, tells!

Every summer the fair's rental services office tries to give the nod to something new and different to eat. In 1984 it was Austrian oblaten (crisp rounds of thin cookie filled with powdered almonds and sugar) and hot hoagie

## FACTS, FIGURES, AND FLIGHTS OF FANCY

Thank you for the world so sweet
Thank you for the food we eat
Thank you for the chance to sup
On a State Fair Pronto Pup.
— A Fairgoer's Grace Before
Meals, 1987

\*\*\*\*\*

Statisticians expected about 330 food and beverage concessions to set up shop at the 1986 fair, including twenty-two hot-dog-on-a-stick vendors, eighteen Sno Cone stands, twenty or more ice-cream stands, four mini-donut venues, twelve sellers of foot-long hot dogs (give or take an inch), and three makers of deep-fried cheese curds. The cheese-curd booth in the Food Building was mobbed, as it turned out, all day, every day. It was an ideal spot for taking the culinary temperature of the crowd. "That's too rich for me," announced one ample lady (clutching an ice-cream cone) as if to explain why she was edging past the cheese curds toward a new booth, selling giant, fragrant cinnamon rolls. "Good, good," gurgled a young father, carefully blowing on the sizzling curds before feeding them, by turns, to a toddler clutching at his pant leg and a babe in arms. "I bet you're trying to figure out our secret, aren't you?" chirped a teenage curd maker to a potential customer, stranded in a long line and mesmerized by the steady rhythm of the mixing and the dipping and the frying and the draining. The air was clotted with globules of deep fat. And the temperature downwind of the vats nudged into the low hundreds.

\*\*\*\*\*

*Question*: How do I get a permit or license to operate a food concession at the state fair?

*Answer*: First, fill out and return an application. These are available January 1 for the following fair. All new applicants are given equal consideration and contract holders from prior years also must reapply. Applications are evaluated and space assigned on a set of criteria including size and location requested, geographic and numerical balance of products on the fairgrounds, and date. ☐

\*\*\*\*\*

### STATE FAIR CALORIES

| | |
|---|---|
| Deep-fried cheese curds (1 cup) | 475 |
| Foot-long hot dog | 490 |
| Corn dog | 310 |
| Cook-tent chicken dinner (no pie) | 580 |
| Lemonade (12 oz.) | 120 |
| Mini-donut (1) | 60 |
| Peanuts in the shell (1 oz.) | 170 |
| Taffy (1 piece) | 42 |
| Cotton candy | 125 |
| Ice-cream cone (2 scoops) | 310 |
| Watermelon (1 slice) | 110 |

\*\*\*\*\*

"If all the hamburgers to be eaten at the fair this year were made into one big sandwich, it would cover the oval race track to a depth of six inches."
— 1937 state fair publicity release

\*\*\*\*\*

## THE TASTES AND SMELLS OF THE MINNESOTA FAIR: AN ENGLISH VIEW

"The state fair sprawled across a hillside and a valley, and at first glance it did indeed look like a city under occupation by an army of rampaging Goths. I'd never seen so many enormous people assembled in one place. These farming families from Minnesota and Wisconsin were the descendants of hungry immigrants from Germany and Scandinavia. Their ancestors must have been lean and anxious men with the famines of Europe bitten into their faces. Generation by generation, their families had eaten themselves into Americans. Now they all had the same figure: same broad bottom, same Buddha belly, same neckless join between turkey-wattle chin and sperm-whale torso. The women had poured themselves into pink stretch-knit pant suits; the men swelled against every seam and button of their plaid shirts and Dacron slacks. Under the brims of their caps, their food projected from their mouths. Foot-long hot dogs. Bratwurst sausages, dripping with hot grease. Hamburgers. Pizzas. Scoops of psychedelic ice cream. Wieners-dun-in-buns.

"Stumbling, half-suffocated, through this abundance of food and flesh, I felt like a brittle matchstick man. Every time I tried to turn my head I found someone else's hot dog, bloody with ketchup, sticking into my own mouth. . . . I was going down fast. The air I was breathing wasn't air: it was a compound of smells, of meat, sweat, popcorn, cooking fat and passed gas."
— Jonathan Raban, *Old Glory: An American Voyage* (1981) ☐

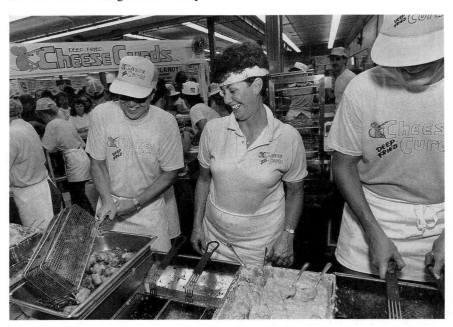

*Inside the Food Building, strictly a stand-up, deep-fried operation, 1980s*

sandwiches, Chicago style. In 1986 it was giant muffins, cheese-coated apples, flavored tofu, and Lynne's Little French Kisses—cubes of French toast topped with berries or maple syrup. Some such dainties melt quickly from memory but others, like Claudia Sutherland's giant, "gourmet," chocolate-dipped fresh strawberries ("They're not injected with steroids," vows Claudia. "If one more person asks me that, I'm going to rip their tongue out!") seem fated to become fair legends, as the rich tradition of hearty appetites, culinary curiosity, and eat-while-you-go continues. □

## EATING IS A FAMILY AFFAIR

State fair eateries tend to be memorable for one of three reasons: a prime location, the personality of the owner, or the unique character of the product. Stanton's Stall, much patronized at breakfast time by the horse and cow set, illustrates the benefits of a good location—in this case, a curbside spot on Judson Avenue, close to the barns. Pojar's Pantry, which used to stand just opposite the Coliseum, also prospered from propinquity to a rural clientele that appreciated the aroma of roasting sirloin; its principal asset, however, was Adeline Pojar, proprietor and chief cook. Until her death in 1987, Mrs. Pojar was a friendly fixture at the fair, appreciated as much for her company as for her home-cooked dinners. The giant green pepper, around the corner from Pojar's, is easy to remember from year to year on account of its distinctive shape. It is also one of the few places on the fairgrounds where hot Italian sausage is to be had and thus illustrates the third of the major prerequisites for success.

Few establishments can claim all three of these assets—except, perhaps, Danielson's (& Daughters) Onion Rings. A spindly green stand located on the strategic culinary pathway between the Food Building and the popular honey-ice-cream booth on the flank of the Agriculture-Horticulture Building, Danielson's lies in the heart of eating territory. And its onion rings—crisp, golden, delicate shells surrounding a core of tangy ecstasy— are justly famous among veteran fairgoers, some of whom try in vain to duplicate the formula at home using Bisquick. It doesn't work. "If you took that batter and put it on a grill, you'd have a pancake, but it's not Bisquick. It's made from scratch just like your grandma used to make," says Bill Danielson, who is not averse to keeping the secret in the family.

The Danielson clan of Maplewood has been selling food at the state fair since 1956, a date that coincides with the birth of the first of the three daughters mentioned on the sign above the lines of onion ring aficionados waiting patiently for their serving (and wondering, no doubt, if Bisquick wouldn't work just as well). Mary and Bill Danielson brought the kids into the business, along with assorted husbands, nieces, grandchildren, and others. "Anyone who marries or is born into this family gets an automatic lifetime contract to work the State Fair," notes the paterfamilias, whose own father once worked in the Grandstand ticket office.

The ebullience of the Danielsons may stem from the fact that they don't make onion rings all year long. Bill takes two weeks vacation from his regular job and organizes the business of painting the stand before the fair opens and putting it away afterward. The rest of the family—the ten adults, that is—coordinate their vacations so that everybody is free for the twelve days of the fair. The holiday atmosphere, it is tempting to believe, spills over into those onion rings and the good-natured smiles of the folks who make them.

"I've always loved being out here," says Bill. "It's the most exciting time of the year. There's a pervading spirit during the fair: carefree, fun, no worries, everyone having a good time. And when you are here, you become part of it." His wife agrees: "People who graduated with me from high school . . . or who I worked with stop by each year and chat . . . . Keeping in touch gives you a sense of belonging." Asked to describe the biggest pleasure of the business, all three daughters give the same answer—"people watching."

Why else risk yellow hands and an onion scent that clings to the hair for weeks? "It's a great vacation!" □

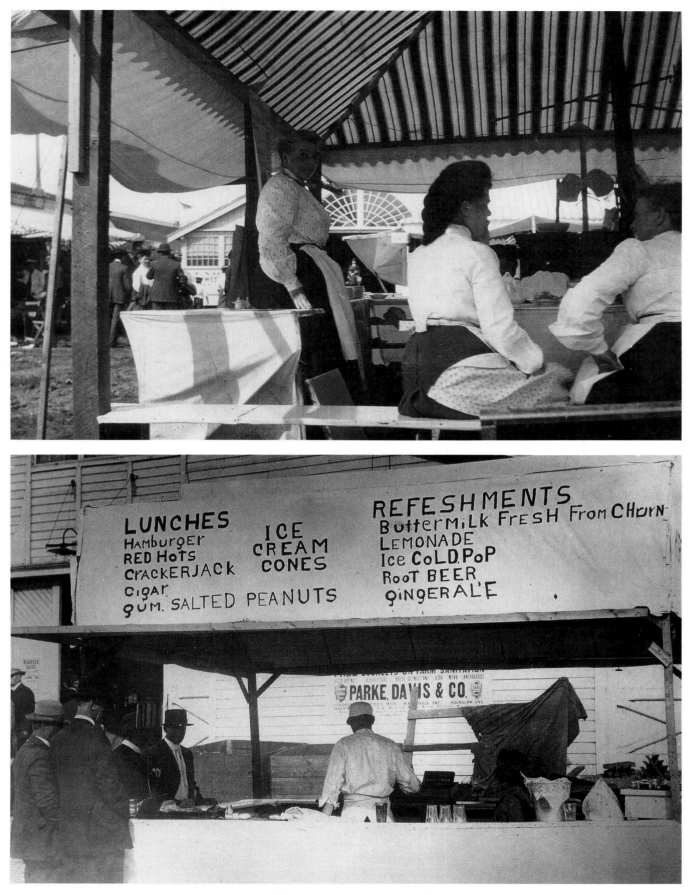

Cook tent operated by the Thori family, about 1905 or 1910

Grab joint, 1917; such crude stands gave the hamburger a bad name.

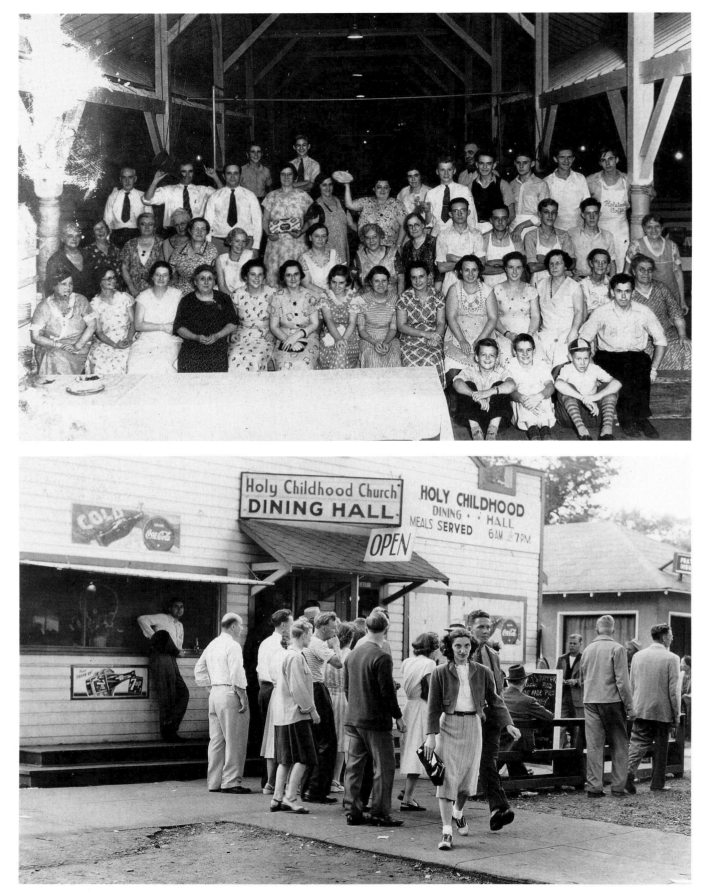

*Hamline church volunteers, 1930*

*Church-run establishment serving homemade pie for dessert, 1948*

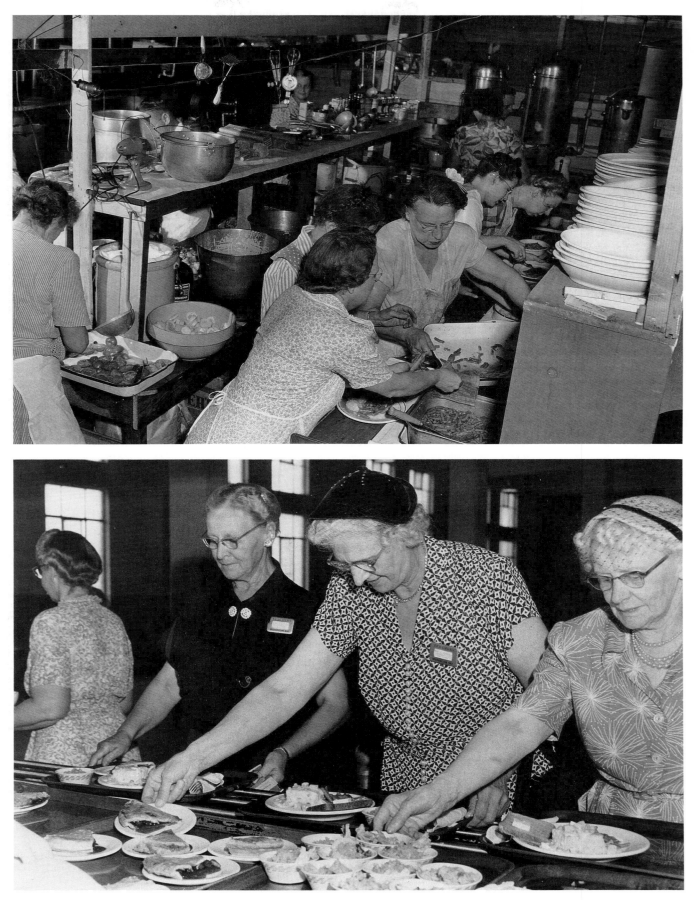

*Behind the scenes, 1947*

*Lunch break, with typical dining hall food, Teacher's Recognition Day, 1953*

270

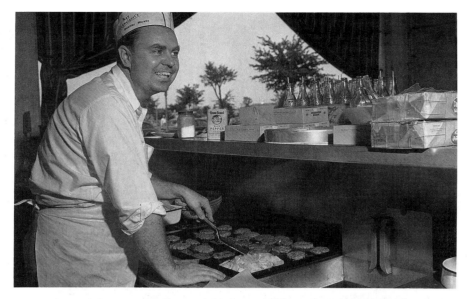

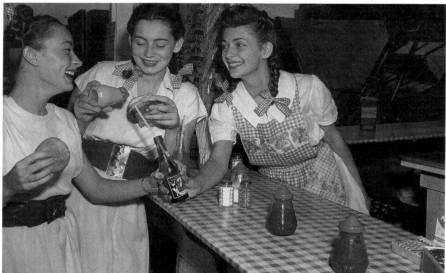

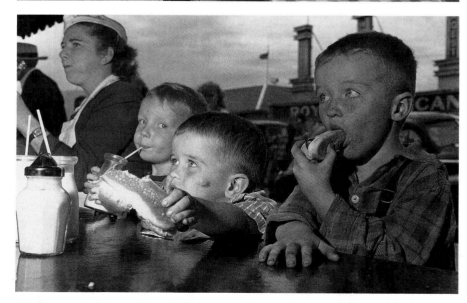

*Hamburgers vs. hot dogs, 1947*

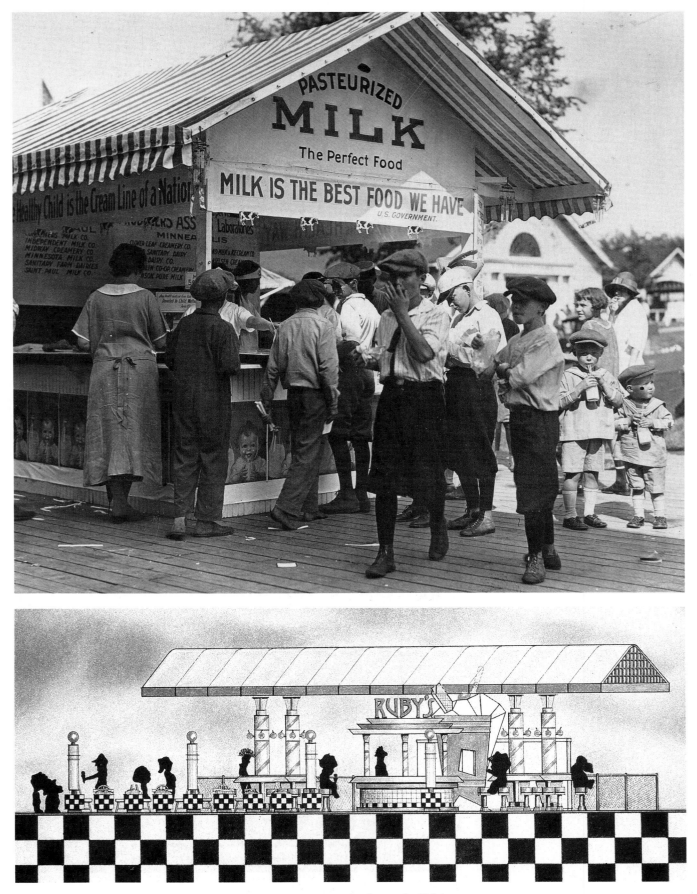

*Forerunner of the perennially popular all-the-milk-you-can-drink stand, 1924*

*New stand, proposed by Jay Isenberg and Ira Keer, 1987; although the Concession Department turned this one down, the fair tries hard to introduce new and different foods every summer.*

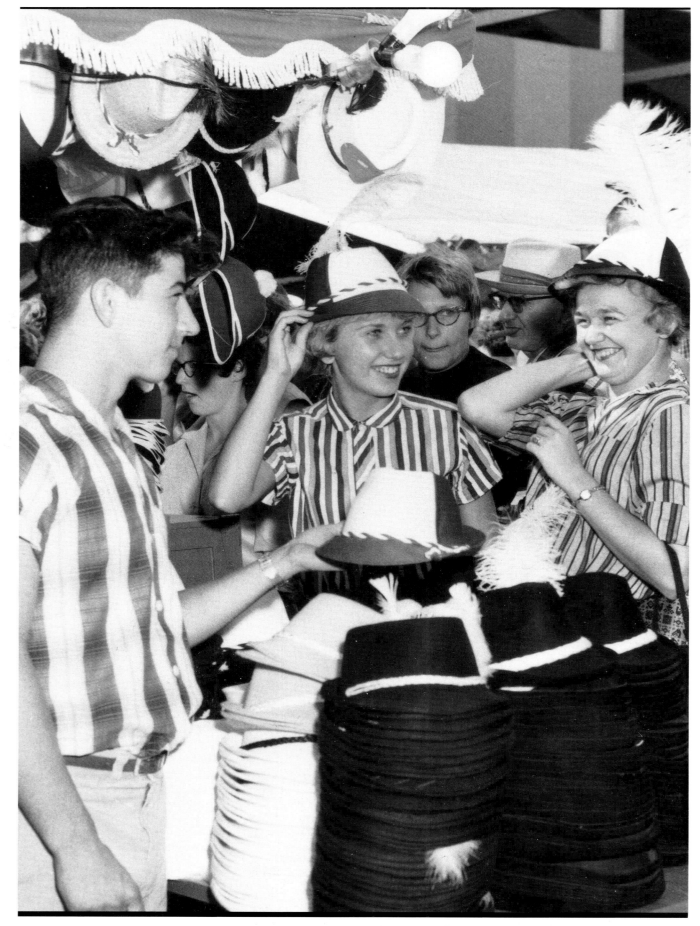

*Souvenir hats in jaunty style, somewhat practical and always popular, 1959*

# "STEP RIGHT UP, FOLKS!"

OF THE MANY CHANGES in the character of the fair brought about by World War II, none was more apparent to the casual observer than the dearth of commercial exhibits. Rationing and the diversion of materials to defense industries meant that many lines of civilian-consumer merchandise were no longer being produced; display spaces usually reserved for manufacturers and merchants were filled instead with patriotic propaganda from various government agencies. The absence of commercial products reminded Minnesotans of just how much of the available space had always been occupied by booths in which items ranging from potato peelers and spot remover to electric parlor organs were shown, demonstrated, and sold.

Boosters never failed to crow over the numbers of breeders and 4-H'ers expected, the amount of the premiums to be offered, the aggregate value of the exhibits. But the fact that many of those exhibits were manufactured items intended for sale, the fact that the fair was the state's single greatest outlet for wholesale and retail sales, was rarely mentioned. In 1928, near the peak of the national spending spree which the Great Depression would shortly bring to a shuddering halt, the director of the Ohio State Fair warned the members of the Minnesota State Agricultural Society that the fair of the future must "super-industrialize" and "commercialize" to succeed. Dramatic declines in exhibit and concession revenues after the collapse of 1929 showed just how commercialized the state fair had already become.

Accounts of the earliest Minnesota fairs are punctuated with descriptions of all manner of goods being hawked on the grounds. James Hough's reminiscence of the 1854 fair drew an important distinction between exhibitions — manufactured products on display without provision for cash-and-carry transactions — and concessions or privileges (sometimes exclusive), which amounted to a license from the fair to conduct on-site sales. Among the popular exhibitions of 1854 was a demonstration of a sewing machine, while the concessions consisted largely of refreshments. Thereafter, commercial exhibitors were usually either the big manufacturing concerns that came to the fair in hopes of stimulating future sales through their local jobbers and retailers or large retail establishments willing to write orders for outstate visitors. The concessionaires consisted, for the most part, of a roving band of sweet-talking pitchmen selling small, inexpensive, portable items by the gross.

Like the fortune-tellers, operators of shell games, and purveyors of highly alcoholic temperance drinks who set up temporary quarters on the fringes of the fair, these fly-by-night merchants were often accused of larcenous practices. Editorials in outstate papers warned fairgoers to beware of the "brilliant play of the fakirs" with their "genuine imitation pearls," fountain

*After home products, impractical souvenirs were the biggest sellers. Wooden puzzle set, 1906.*

pens at an amazing, today-only price of twenty-five cents, and "solid steel . . . instrument[s] that would cut, pare, shave, trim, gouge and dissect seven sorts of vegetables simultaneously."

Clustered around the entrances to the exhibition buildings, the "unsightly row of cheap shanties" was a sign of the merchants' popularity with the public. But the hucksterism was offensive to officials who feared a loss of dignity and decried the sales as a frivolous distraction from the fair's true agricultural mission. After 1900, when the outcry against the "fakirs" reached a crescendo, a number of regulatory mechanisms were tried and discarded: the fair built its own handsome concession stands for such dry goods; the board of the Agricultural Society raised the price for privileges to astronomical levels (in 1909 the fee for a novelty privilege was a whopping one thousand dollars); and finally, after nothing seemed to stem the tide of grassroots commerce, the grounds were rearranged "to prevent the promiscuous mingling of concessions and exhibits." But the trade in painless cancer cures, sewing-machine needles, ten-cent diamonds, and vegetable slicers flourished regardless. "Not one, not two, but all three of these useful and marvelous household assistants for just one plain old dollar," crooned the orators in sugary tones. "Caveat emptor," whispered the voice of common sense.

The list of privileges sold during the first thirty years of the fair's residence in the Midway district shows a remarkable resemblance to the peddler's merchandise characteristic of New England county fairs of an earlier day: cheap jewelry, collar buttons, silverware, mouth harps, and knives of such pure steel that the pitchman "whittles shavings off a wire nail with 'em and is particular to hand you the very identical knife he did it with." In 1892 small notions and pictures of the racehorse Nancy Hanks were the approved wares; in 1894, notions, magnifying glasses, silverware, a variety of knives and household cleaners, collar fasteners, reading glasses, and "optical toys"; in 1898, hair tonic, shoe polish, needle threaders, pancake turners, hat fasteners, heating irons, and baking powder. As late as 1915, the inventory remained essentially unchanged.

Even when the gadget merchants were regulated, taxed, and confined to special commercial zones, objections to their noisy presence persisted. There were two chief causes for complaint. One was the quality of the goods for sale. As one disgruntled superintendent who found his exposition building all but overrun with pitchmen protested, "Many of these small merchants are fakes, and should not be allowed to humbug and defraud the public in *any* part of the grounds." Other fair watchers, who also deplored the "swindling operations," were convinced that "people do not attend fairs to merchandize." Or perhaps, in the teeth of healthy sales figures pointing to the opposite conclusion, they believed the quasi-commercial exhibitions showing "the improvements in agriculture, machinery pertaining to the farm . . . and progress . . . in all other lines of business connected with agricultural interests" morally superior to the undisguised blandishments of salesmen of "the Famous Parrios Pearl."

Both kinds of display — the genteel and the sleazy — coexisted amicably enough throughout much of the fair's history. Visual evidence suggests that the balloon men and other trinket sellers were on hand from the very first, but so were the railroads, with their dazzling exhibitions of crops grown along the right-of-way and their corn and wheat palaces. These and other displays of Minnesota-made products were meant to lure immigrants and investment capital to the state. By the 1890s, however, a new class of commercial exhibition had come to occupy the middle ground between the

*Hawkers of beads and trinkets surrounding the gate, 1902*

manufacturers and the hucksters. Firms and individuals representing lines of "fine" cutlery, dental instruments, bronze and brass ornaments, carpets and draperies, ready-made clothing, and a host of similar items regarded as the final adornments of civilization were invited to purchase space in Main Building. "No better advertising agency exists" than the fair, wrote the officer in charge of the displays therein, "and judicious advertising is the basis of many fortunes."

Such appeals, pitched mainly at Twin Cities retailers and wholesalers, were given added punch by invocations of the long-standing rivalry between Minneapolis and St. Paul. Dan Moon, who was charged with securing enough exhibits to fill the cavernous Main Building in 1890, met his goal by flogging St. Paul merchants and businessmen in the pages of the *Pioneer Press*, accusing them of letting down the city and being "so consarned lazy that I wonder if they really had energy enough to get enumerated in the census. . . . We have no public-spirited furniture men in St. Paul," he added, having pointed out how a really nice display of parlor suites and sideboards would fill up most of the remaining empty rental spaces.

Roasting the businessmen got fast results: Smith & Farwell of St. Paul came forward to defend the honor of the furniture men, and other enterprises quickly filled the gaps between the railroad displays, the Pillsbury flour pagoda, and other slots assigned to the Century Piano Company, the White Sewing Machine Company, and a host of similar, national concerns. Throughout the 1890s, Main Building was a kind of midwestern bazaar in which the mighty Great Northern Railroad competed for the attention of the crowds with tinkling electric pianos, electroshock machines for rheumatics, local druggists with glass urns of mysterious preparations, bicycle and kitchen-range salesmen, a dentist prepared to give estimates on future work, a card writer from S. E. Olson's refined emporium in downtown Minneapolis, and complete room settings of "elegant" appointments from the New England Furniture Company.

By 1903, when Minneapolis retail merchants began to clamor for a building of their own, the department stores had become a major presence at the fair, with Powers Mercantile Company and Donaldson's Glass Block of Minneapolis pitted against Mannheimer Brothers and Schunemann & Evans of St. Paul. Strictly an exhibition, the profusion of goods shown by the local stores helped to prove "the commercial prosperity of the northwest" to skeptical visitors from other climes. But the business community was also aware of the dollars-and-cents benefits accruing to those who made a good showing at the state fair. W. L. Harris, president of the Retail Dealers' Association and the New England Furniture Company, cited the $2,500 spent by his firm to erect a small, Federal-style showroom on the grounds in 1902: the investment had paid for itself during the very first year in the number of fairgoers who had left their names and addresses for the mailing list. "The state fair," he concluded, was "a trade bringer" of extraordinary value, especially to those eager to do business with "our country cousins."

While the retailers contemplated the potential of the state fair for direct sales, the manufacturers, by and large, clung to the older idea of the fair as an advertisement, an investment in future sales, and an opportunity for public-spirited boosting on behalf of Minnesota. In 1904, with the help of a $30,000 appropriation from the state legislature, a Manufacturers' Building went up, in which only firms that made products in Minnesota were allowed to rent space. The displays were not geared to sales; instead, preference in the allocation of prime venues went to companies pledged to setting up

## SALESMEN HONORED

In 1888 a grand parade of 1,200 traveling salesmen from Minneapolis, St. Paul, and other municipalities met at the railroad depot and marched in formation to the bandstand where they were officially welcomed to the thirtieth Minnesota State Fair. The ceremony recognized the mutual interdependence of the fair and the salesmen who brought the new merchandise on display there to outstate Minnesota. □

miniature factories, showing the processes whereby their goods were manufactured. The technique corresponded to new educational theories that stressed demonstrations and other practical ways of involving the individual in the material at hand. (For the same reason, corn- and canning-club members broke away from the practice of exhibiting the end product to concentrate instead on teaching others how it had been grown, cooked, and packed.) Thus, the wheat palace and the pyramids of flour sacks gradually gave way to operating brick kilns and working machinery for making shoes.

The problem with factory-style displays was their high cost relative to the nebulous returns of boosterism. And so, despite the public's preference for live manufacturing processes over models of Minnehaha Falls made of canned goods, the Manufacturers' Building proved hard to fill, except with pyramids of soda bottles or sewer pipe. First, it was rented to cities eager to show off their industrial clout and finally, in 1908, assigned to the Women's Department. Except for the equipment firms on Machinery Hill, most major manufacturers left the fair before World War I, turning to magazines and other, more cost-effective forms of advertising. (Large corporations had swallowed up many of the old, regional makers of farm machinery, watches, precision instruments, and the like anyway.) Subsequent exhibits of the "Industrial and Liberal Arts" staged elsewhere on the fairgrounds were not product oriented, for the most part, but consisted of union members showing off their skills at baking bread, setting type, rolling cigars, or cutting sheet metal.

As the role of the producer waned, the seller came to dominate the fair, much to the discomfort of those who had formerly ministered to the needs of Minnesota's "country cousins." Merchants in some cities saw the annual gathering as a money-gobbling monster created by Minneapolis and St. Paul especially to siphon business away from Main Street. J. Henry Cross, addressing a meeting of the Red Wing Commercial Club in 1910, charged that whereas the state fair had always been "protected and fostered by the smaller towns of Minnesota" in the name of better agriculture, it had become "merely a trading excursion run in the interest of the Twin Cities." Some rural editors, publicly declining to give it any more free advertising, told their readers to "stay away from the state fair and spend your money at home." For the most part, however, outstate merchants were resigned to the fact that, fair or no fair, their customers would probably go to the Cities once a year to make certain major purchases. In its own appeals to potential exhibitors, the fair's board was always careful to note that displays of nationally advertised clothing and equipment led "the consuming public [to] tell their home merchants what they saw" at Hamline. The implication was, of course, that the ultimate sale would be concluded in Mankato, Redwood Falls, or Zumbrota.

But the uneasy truce between the state fair and the local store broke down completely in 1915. That summer, Sears Roebuck & Co. of Chicago rented a double booth in the Machinery Building staffed by two affable "young men who were kept decidedly busy handing out souvenirs of various kinds" in exchange for fresh names on the list for the company's mail-order catalog. Businessmen had tolerated the fair's once-a-year encroachments on their trade but saw no reason for cordiality toward an out-of-state company that would bypass all the customary avenues of buying and selling (and profit making) and ship goods directly to the rural customer. "These catalogue houses are leeches which are endeavoring to suck the surplus money from the state, and away from the merchants who are so great an aid in building

up cities and villages of the North Star commonwealth," howled the *Osakis Review*. The hardware and implement manufacturers of Machinery Hill were equally miffed by "this invasion by the forces of the enemy." Their trade journal called for "the retailer, jobber and manufacturer . . . [to] work consistently to show up the many shortcomings of the catalog house scheme of transacting business." And the Minnesota Retail Furniture Dealers' Association filed a formal protest with the Agricultural Society demanding protection from Sears's unfair competition.

Tabled in 1915, the protest was renewed the following spring by a consortium representing several groups, including Minnesota traveling salesmen, retailers, wholesalers, jobbers, grocers, jewelers, implement and furniture dealers, sellers of pharmaceuticals, and local editors whose ad revenues suffered when businesses bypassed the middleman. "The preservation of community interests," they argued, "demands the barring of these houses, which pay no taxes." For its part, Sears noted that it had contracts with eight other state fairs at which the company had operated without a whiff of controversy and expressed an ongoing interest in retaining space at the one in Minnesota. Since there were no legitimate grounds for barring Sears from renting booths, the board found itself in something of a dilemma. Fortunately, Sears decided to withhold its space request until the fair wished to receive it; without a formal application on the table, the issue became moot and the business of doing business at the fair proceeded as usual, minus the catalog companies.

Protests against the business practices of others have not been altogether uncommon. The Minnesota and Northwest Ice Cream Association tried to block the sale of frozen custard at the fair in 1934; despite mutterings about industry standards and ingredients, it is clear that, faced with a novelty of great proven appeal, companies without a comparable treat feared a decline in sales. A St. Paul shoe company took the fair to task in 1908 for allowing a salesman for a St. Louis firm to dress up like Buster Brown and perform a skit with a barking French bulldog named Tige. Those cartoon characters, from the trademark for a popular brand of shoes, had drawn crowds in the Main Building, but the method struck the local shoemen as undignified — the techniques of the seller of potato peelers and fake diamonds were not deemed seemly for those dealing in a better class of merchandise. "If the competition is to be along noise lines and not business lines," the angry St. Paulites declared, "let the management so notify us and we will start the ball rolling, but we do not think the purposes of a business exhibit are furthered by having a man out in front of it to 'holler' like a barker for a medicine show."

In general, protests from businessmen were couched in xenophobic terms. The Minnesota State Fair was expected to defend Minnesota firms from the wiles of outsiders using unfair sales strategies. Noncommercial protests, on the other hand, came from those with strong moral objections to the nature of the goods being sold. Among the most popular souvenirs on sale at public festivals in the late nineteenth century were badges or buttons. Such lapel ornaments, showing a building or an emblem associated with the event, were created in honor of the Minneapolis Exposition, most county, state, and world's fairs, and similar events; they marked the wearer as a booster or a fellow merrymaker and served as a keepsake in years to come. A newspaper description of the Midway in 1897 refers to "the peddlers of badges and other souvenirs" who were apparently well established in the cadre of state fair regulars by that date. During the sporadic attacks on the

## MERCHANDISE WHEELS

Wheels of fortune on the Midway generally gave "slum" to the winners; as the name implies, this was cheap, flashy stuff that looked appealing from a distance but often failed to please on closer inspection. During the Great Depression, however, merchandise wheels became popular. Instead of slum, the prizes were blankets, clocks, brand-name items just like those pictured in the ads, even bags of groceries. Honestly run, the merchandise wheel was a form of purchase — although a customer could get lucky and take home a blanket for a nickel, most players spent just about what the razor or the ham was worth to "win" their prize.

Merchandise wheels had been tried during the 1920s at fairs and carnivals in poorer sections of farm country, and local merchants often objected because the items offered as prizes were identical to the goods on their own shelves. Wheels were, they protested, an unfair form of competition. In 1933, after a year of debate and experimentation, the Minnesota State Fair allowed the popular wheels to operate. Like Dish Night at the local movie house, the merchandise wheel added a little guilt-free sparkle to drab lives during the depression years. After all, you did get something nice, something useful, for your hard-earned money. □

Midway, when pitchmen, barkers, three-legged calves, fat ladies, and all manner of sideshows were suppressed as "fakish" and crude, dispensers of certain kinds of cheap merchandise were also censored. "There was not a glossy cane to throw a ring at, there was not a glistening badge to buy from an oratorical vendor, there was not a souvenir that could be purchased or pilfered," wrote one chronicler of the sanitized 1911 fair.

Badges were the particular object of the censors' wrath. No longer content with the customary cows or wheat sheaves, manufacturers had begun to add snappy slogans, drawn from the repertory of current "hot" sayings, which would render the 1912 model obsolete in 1913. During a single hour in 1913, a sentry stationed at the door of Woman's Building counted 482 girls and boys under the age of fifteen wearing badges or ribbons bearing objectionable sentiments. "Oh, You Kid," "I'm Not Married," and "Let's Get Acquainted" were some of the milder slogans on the badges, pennants, and hatbands for sale everywhere. As a result of this survey, the state fair police banned certain "improper" badges from the premises: "Kiss Me Quick — I Like It," "Go To It, Kid," and "Put Your Arms Around Me" were the first to go. And, as a result of the ban, badges became the rage among rebellious young moderns. Boys liked the button reading "Hello Chicken!" and the more daring girls, "bedecked from head to waist with . . . catchy sayings," favored "Everybody's Doin' It."

The novelty badge emblazoned with topical sayings and designs was the 1910s equivalent of the T-shirt, against which censorship drives were directed in the 1970s and 80s. In 1972, for instance, the offending designs featured ersatz trademarks for marijuana and peyote; six of twenty booths selling shirts that year were cited for violating regulations stating that items "of a questionable nature or of a demoralizing tendency" were not allowed on the fairgrounds. "They always make us cover up the best ones," groused one entrepreneur, but others wondered "what took them so long. We've been open since last Thursday night and they didn't do a thing until Friday!"

In 1987 the issue was political indiscretion and an ingenious merchant's scheme to peddle Oliver North T-shirts out of an implement dealer's headquarters on Machinery Hill. (Lt. Col. North had just confessed in televised testimony to defying Congress by diverting funds to Latin American rebels.) Because exhibitors were contractually forbidden to sell merchandise not directly pertinent to their businesses, the sale was thwarted without a discussion of the ideological implications, which had drawn attention to the matter in the first place. "We're as nonpolitical as you can get," stated the fair spokesman charged with explaining the disappearance of the "Ollie North for President" shirts. In fact, booths promoting a wide variety of partisan and (to nonadherents) controversial causes have coexisted cheerfully for generations in the fair's commercial spaces. The Democrats and the Republicans are among the most venerable vendors of ideas to vie peacefully for followers. Nor was it considered remarkable in the 1970s when Save Our Unwanted Life Inc., an antiabortion group, set up shop within sight of the table where the Minnesota Coalition for Freedom of Choice was distributing its literature. Bottled vanilla, moral values, encyclopedias, and mops without wringers all competed in the arena of free enterprise that constituted one of the fair's principal attractions and a major source of its annual revenue.

However blatant this commercialism, officials of the Agricultural Society were usually discreet in their discussions of summertime capitalism at the state fair. But after World War II, pent-up consumer demand brought

## SMALL-TIME CAPITALISM: ON SALE HERE, LIMITED TIME ONLY

1961. H. A. McLinden, age eighty, came back for another summer at the fair. The retired proprietor of a Minneapolis confectionery store, McLinden specialized in candy shaped like meat — hams, sausages, bologna, roasts, and pork links made of sugar, chocolate, nuts, and butter. "I'm the only butcher who ever had a rabbi put a kosher stamp on bacon and ham," chuckled Mac. His new line for 1961: candy cheddar in pure buttercream.

1976. A Menomonie, Wisconsin photographer, John H. Russell, introduced a process whereby a picture of a loved one was mounted on a rock gathered from a beach along Lake Superior. Russell called his product the "People Pebble" and planned to use the fair as a test of its commercial feasibility. "If only one half of one percent of the estimated 500,000 people that will pass through the ground floor of the grandstand stop and take advantage of our services, we will have more [business] than we can handle," stated the hopeful entrepreneur.

1969. Al DuBach, senior sales representative for the VitaMix Corporation of Cleveland, returned for his twenty-eighth consecutive stand as a pitchman in the lower reaches of the Grandstand. His was a dying breed, DuBach admitted, a close-knit fraternity whose members looked one another up at each stop on the annual circuit of fairs. And the job wasn't something that could be taught easily: "You don't learn it. You just have to have a 'pitch sense.'" Loosely defined, pitch sense seemed to consist of a little showmanship, a little crowd psychology, and "a helluva lot of guts." The Minnesota fair was not the easiest sell in the world, either. The tips, or prospects, said DuBach, were the "roughest in the country" although, if properly softened up, "they'll rush to buy" a big, powerful-looking machine which, in the course of every twenty-minute pitch, ground whole grain, extracted juice from fruits and vegetables, and produced the customer's choice of hot soup or ice cream on demand.

1963. The three Perlman brothers of St. Louis Park — Mike, Steve, and Dave — opened the first Spin-a-Painting booth on the street outside St. John's Dining Hall. An idea born at New Jersey's Palisades Park, the do-it-yourself modern art mart had would-be abstract expressionists lined up six deep by 9:00 A.M. during its first summer. The business put the trio through college, although its popularity declined somewhat over the years as the concept ceased to be a novelty. But Spin-a-Painting survived into the 1980s as one of the traditions of fair going.

1951. Barkers touting kitchen gadgets were everywhere. "Are you having company for dinner? Are you out of potatoes?" shouted a blonde saleslady selling a slicer with which a single Idaho potato could be made into a long, continuous curlicue good for eight servings of French fries. At the pie crimper stand, a member of the audience who had bought a similar device a year before told a friend that it really didn't work all that well: "The edges of the pie fell down. I ended up fixing it with my fingers." But her confession did not make a dent in sales. Nearby, a metal cream whipper, said to take "all the bumps and lumps out of your gravy," was also heralded as ideal for mixing baby food, eggnog, malted milk, hot chocolate, and salad dressing. Outside the Rest Cottage, a reporter noticed a family gathered around a lunch brought from home. An elderly woman on the sidelines struggled with her brand-new tomato slicer. "Just a minute, just a minute," she told her hungry relatives. "If I can get this thing to work, you'll have your food in just a minute."

1964. Holder of concession registration no. 1, "Red" Neller (the King of the Kazoo) had been at the fair since 1931, moving his product by "honking and wheezing and singing 10 hours a day" from the collapsible stage attached to a homemade trailer parked outside the Grandstand. His stock consisted of a special line of aluminum whistles (1 1/3 pounds per 100 whistles) assembled in the off-season by his son — factories no longer made them because they wouldn't sell at all without the master's demonstration. A ventriloquist, Neller got his start as a pitchman with the help of a relative who ran a horoscope concession at the fair and had known a whistle man. □

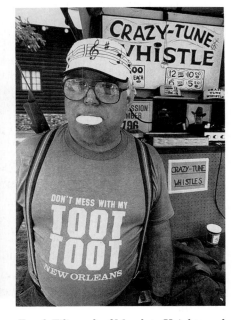

*Irene Meinen and her mother, Florence Schneiler, in their twenty-sixth season of fair-time shopping, 1987*

*Frank Filipczak of Mendota Heights and his whistle, 1987*

## HATS

When Englishman Jonathan Raban took his dyspeptic look at midwestern folkways in 1981, he commented on the numbers of Minnesotans who came to the state fair wearing caps emblazoned with insignia advertising cattle feed, "farm machinery, Holsum Bread, chemical fertilizers, pesticides, corn oil, cement and root beer." Until he learned that John Deere was a brand name, Raban believed that hundreds of fairgoers hailed from one enormous, paramilitary clan.

Feed hats have enjoyed a new vogue in recent years, but headgear has always been of concern to those planning an excursion to the fair. Until World War II, both men and women customarily wore hats, especially when the weather necessitated protection from the elements. But after the war, hats went out of fashion. Women wore them for church and then not at all, and in the 1960s President John F. Kennedy, who didn't own one, represented a whole, younger generation of hatless urban males. It was during precisely this period that the state fair settled upon a run concluding on Labor Day because weather data suggested a sunny, rain-free interlude. So heads baked in the sunshine and the sales of souvenir hats skyrocketed.

Sombreros and straw cowboy hats cost hard cash at the concession stands. Other toppers were free, providing one was not self-conscious about promoting a candidate, a cause, or a product. During a single afternoon, Republicans gave away eight thousand "I Like Ike" hats at the 1956 fair. (Democrats, for whom no Adlai caps had been provided, wore their Ike hats inside out.) Visors were also distributed by the St. Paul Chamber of Commerce, Speed Queen washers, Blue Cross-Blue Shield, Daisy Master Bread, Seaman's Tillers, and Lindsay water softeners.

Besides, part of the fun of the fair is doing the out-of-the-ordinary: eating forbidden foods, acting like a kid, even wearing a silly hat topped with cardboard piggy ears. □

*Funny hats with a variety of messages in a variety of styles, 1956*

fairgoers out in record numbers especially to see the wealth of new products on display. Stupendous attendance figures for 1950 were said to show "how strong a magnet are the . . . commercial exhibits." The 1962 fair witnessed "a complete sellout" of all commercial exhibit space. Rental fees in 1973 amounted to 27 percent of the fair's total operating income. Some critics, while acknowledging that fairs must sell simply to compete with the mall, the supermarket, and the TV set, nonetheless deplored the scale of the hucksterism. Shopping had become one of the chief delights of fair going.

Insofar as the state fair mirrors the larger reality of Minnesota, this new emphasis on entertainment through retailing is not surprising — it was in the Minneapolis suburbs, after all, that Southdale, the nation's first enclosed shopping mall, was constructed in 1956. Created by sophisticated advertising techniques, an emerging culture of consumption, and middle-class prosperity, the mall dramatized and ritualized the act of shopping and made the selection of merchandise into a highly pleasurable leisure-time activity, a notion later applied to vacations, festivals, fairs, and other similar events. The medieval fair had been a place where foreign merchants showed exotic wares for the amazement and delight of the kingdom; with its "dream houses of tomorrow," its space-age gadgets, and its strange and lovely things from faraway places, the state fair in the postwar era served much the same function.

Most interesting, perhaps, has been the subtle change in the character of the goods on display. In the 1950s, people *did* come to the state fair to inspect the exciting products they had only glimpsed in ads; the farm families who bought appliances, mechanical lounge chairs, and electric organs came looking for items that had not yet become a part of their everyday lives. But when the novelty wore off such goods, they became less interesting to look at. One senses that casual shopping at the fair today is less for the necessities than for peculiar, out-of-the-ordinary things seldom seen outside the fair. There are old-fashioned products, like Watkins vanilla, penny candy, and the brand of spot remover that grandmother used to use. There are bizarre, dream items, like a duck-shaped duck blind or a lipstick-pink hot tub with gilded faucets. And there are products simply not to be found elsewhere: freeze-dried chipmunks and miniature milking pails bearing the logo of the fair. ☐

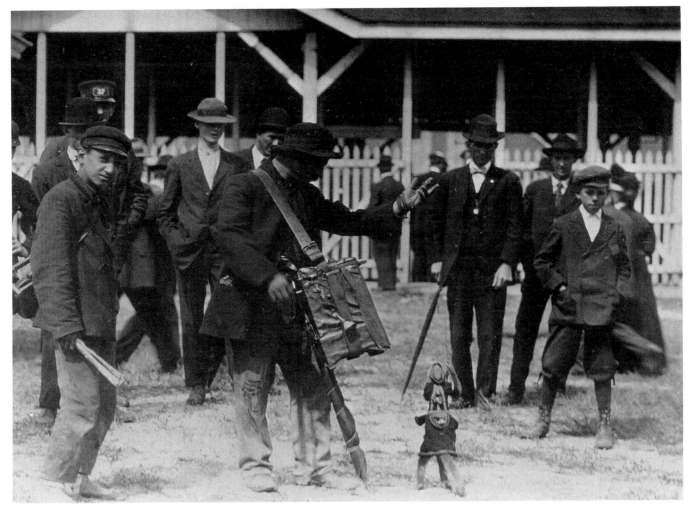

*Walkways alive with commerce: organ grinder and his monkey, about 1901.*

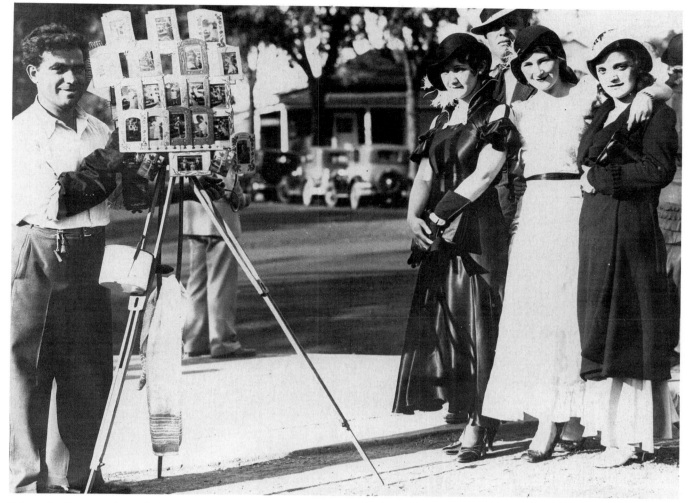

*Sidewalk photographer of the 1930s*

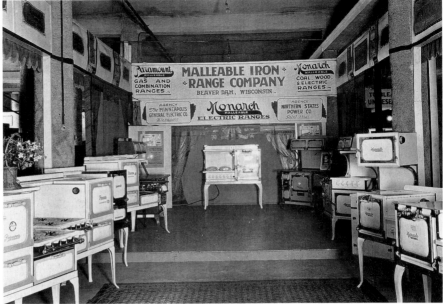

Housewares, representing the largest single category of products for sale, about 1922

Dayton's displays, miming the rites of gracious living, 1948

Displaying products a little out of the ordinary, 1940

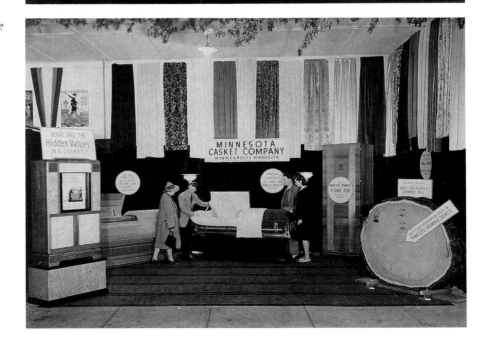

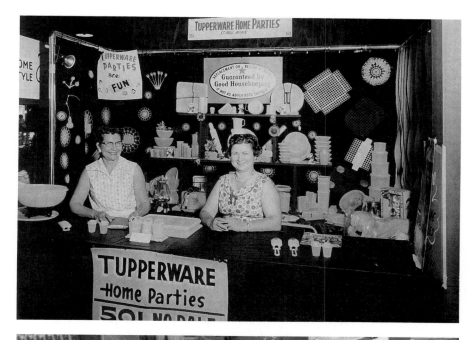

*Tupperware, the casual serviceware of tomorrow, in space-age, easy-care plastic, 1950s*

*The cavernous space under the Grandstand—shopper's heaven, 1985*

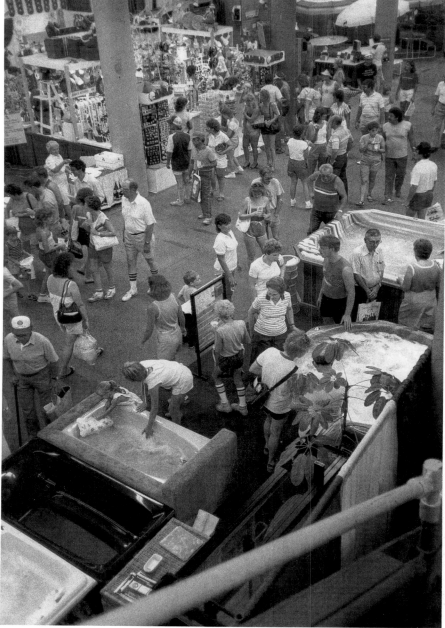

*And you can charge it!*

*Some concessionaires are deeply involved with their products: Skip Belfry loves his Minneapolis-made sauce, 1987.*

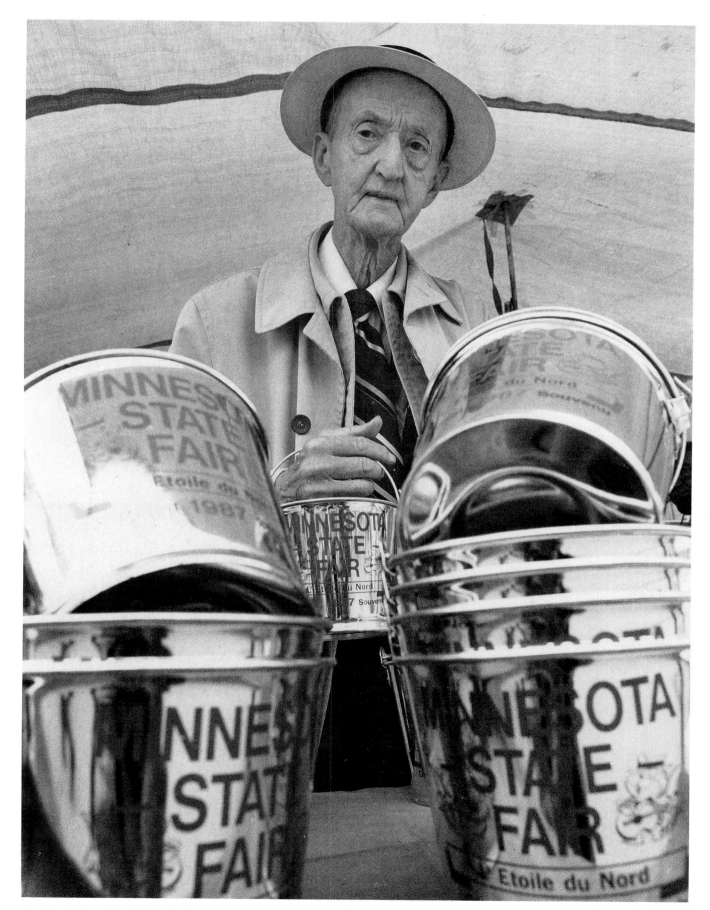

*A. W. Holte of South St. Paul, in his fifty-eighth season at the fair, 1987*

*Snazzy felt pennants, 1947*

*Souvenir shopping bags, useful for carrying all that loot, 1977*

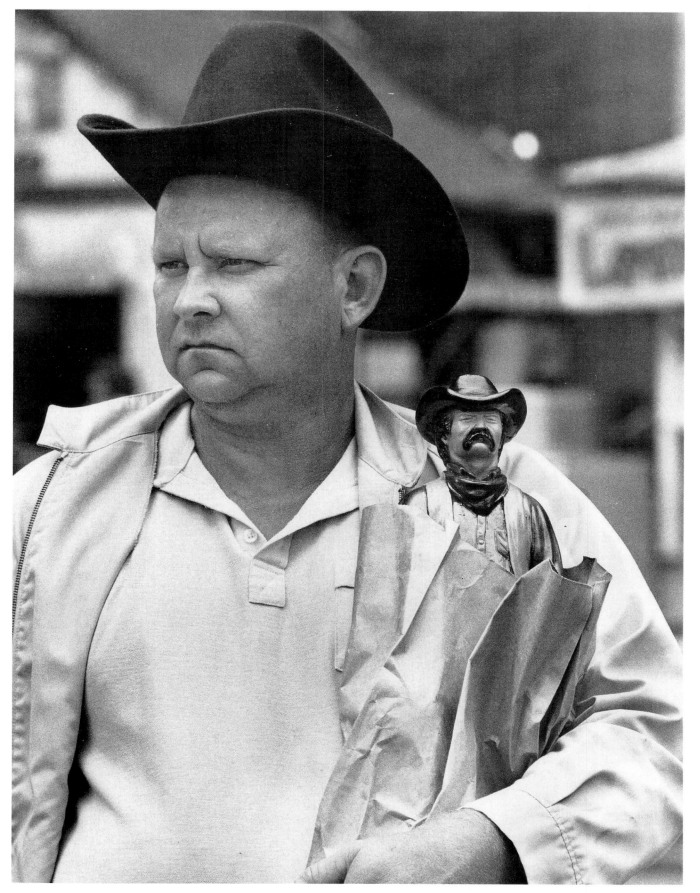

*Robert Dohrn of Lake City and his find, 1987*

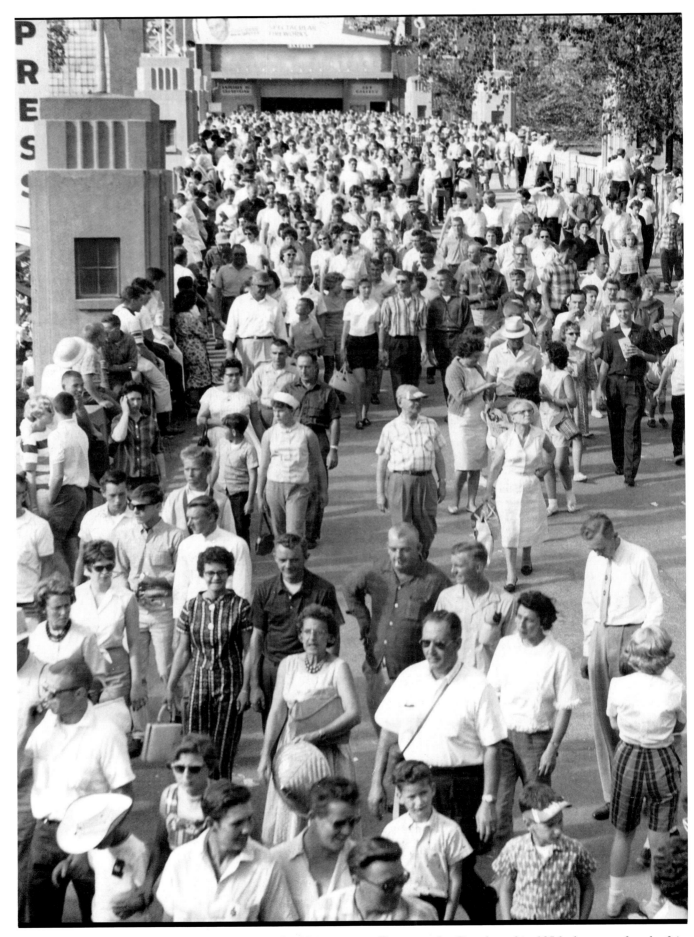

*A crush of fairgoers strolling near the Grandstand in 1956, the year after the fair first topped the one-million mark in attendance*

# THE BIGGEST – OR THE BEST?

IT HAS ALWAYS BEEN IMPORTANT to Minnesotans that their state fair rank high on the list of comparable spectacles. Because the fair represents the life and the interests of Minnesota so directly, regional pride is on the line whenever statistics on attendance or revenues are compiled, whenever judgments are rendered on the best or greatest fair in the land. Preoccupation with quantitative measures of success reached a modern apogee in the 1960s and 70s: during those years, local newspapers and journals of every description ran state fair attendance figures as banner headlines, compiled tables correlating admissions with the temperature, and obsessively compared the current year's take with past profits. It also became crucial, somehow, that precisely 1,250 members of 4-H (the second encampment) were bringing 1,100 head of livestock to the 1960 fair in 92-degree heat; that 7,000 kids attended a free Grandstand show by Neil Sedaka and Anita Bryant; that parking had been provided for 25,000 cars; that 180,000 apples had been consumed on the spot, washed down with 9,140 gallons of "all-you-can-drink-for-a-dime" milk; that 89 toddlers got lost on the grounds. The numbers – even enumerations of the fairgoers felled by heat prostration on any given day – proved conclusively and scientifically that this year's fair really was "bigger and better" than ever before, the "greatest and grandest in the 50 states," the nation's "largest agricultural exposition."

Statistics validated Minnesotans' delight in their accomplishments and their high hopes for the future. "An indication of the growth of Minnesota and its fair may be obtained by comparing the estimated 2,000 attendance at the first exposition in Minneapolis in October of 1855 with the anticipated one million visitors to the 1961 State Fair," wrote a publicist intent on making the point of his numerical evidence clear. The admission of the millionth fairgoer in a single season held particular symbolic meaning for statisticians and boosters alike. The one-million mark – first reached in 1955 and maintained or exceeded every year thereafter – confirmed the maturity and stability of an institution whose fortunes had risen and fallen spasmodically throughout the Great Depression and the war that followed.

The record gate of 1955 was all the more impressive because other big fairs suffered "disastrous reverses" that summer. Drought, a polio epidemic, the ravages of hurricane Ione, and a corn-crop failure were all cited as reasons why Minnesota's huge receipts were not duplicated elsewhere. But officials who remembered their history were quick to counsel restraint in the midst of the celebrations. They recalled, for example, Secretary Raymond Lee's report on the 1940 fair, at which "1,000,000 was the expected attendance [and] $100,000 the anticipated profit" – until the rains came, that is, eight cold and soggy days. Even more closely than in Ohio, Texas, and Illinois, the success or failure of Minnesota's fair has been tied to the weather.

*Bright, brash, and loud, 1918. The fair has never hesitated to toot its own horn.*

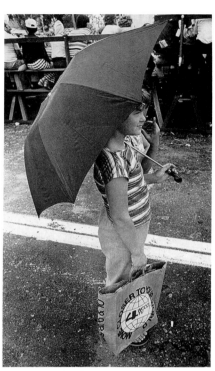

*Small rain clouds and an optimistic mood, about 1975*

Early fairs garnered public support because they were the means for proving that a state "on the border of the Esquimaux country" really could produce wheat, apples, sturdy stock, and gigantic vegetables. As an outdoor event, the fair also exposed visitors directly to the best and worst the climate had to offer. In 1895, with the International Agricultural Congress in conclave on the grounds, the awful heat drove the crowds from the buildings, and the orator of the day found himself minus an audience. "The superabundance of caloric in the atmosphere" was a serious problem in an era of corsets, suit coats, and stiff collars, yet rain was often the greater misfortune, since it turned pathways into wallows and since the number of roofed structures proved inadequate to shelter crowds comfortably. A downpour in 1896 also spoiled the all-important race program and other portions of the scheduled entertainment had to be canceled outright.

"Mr. Jupiter Pluvius" was politely invited to absent himself from Minnesota during fair week. The weatherman became an oracle, consulting rainfall and temperature records of previous fairs for a sign of auspicious conditions. On bad days, when hemlines and boots were apt to be spoiled by the mud, the management ran newspaper ads asserting that "Rain Or Shine the State Fair is all Right"; there were, according to the over-optimistic copywriter, "acres of floor space in the great buildings and the structures are connected by means of cement walks. The street crossings are kept free from mud by drainage." For the most part, rain was a minor inconvenience, but the late-summer storms common in the Upper Midwest sometimes posed a serious danger to life and limb. During the 1904 fair, already sodden from a steady downpour, a violent deluge reduced cook tents to rubble, sent concessionaires into hysterics, snapped telegraph poles, littered the ground with debris, and threatened to collapse the stables. Several days later the passage of a bank of dark clouds caused much alarm and scattered visitors, although that storm moved off quickly. When the rain finally stopped, it grew so cold that fashionable ladies shivered in their summer shirtwaists, while prudent gentlemen appeared in winter overcoats.

When the weather was "glorious"—not too hot, not too cold, sunny, dry—the fair did well and the natives were pleased to point out the climatic advantages of Minnesota to tourists. But the managers and officers still rankled at the uncertainty of their arrangements. No matter how thorough the planning, no matter how strong the farm economy, the financial health of the fair in any given year depended largely on the caprice of nature. Despite efforts to build more commodious covered spaces, to pave over surfaces prone to muddiness, to provide streetcar transit to the very heart of the grounds, and to inform the public of such amenities, the state fair remained far from weatherproof. Too often, "ideal weather" ushered in a spell of blistering heat that killed livestock and, on occasion, fairgoers of a fragile constitution. The 1908 fair, marked by sniffles and chills, was followed by a sweltering one that filled the hospitals with victims of heat prostration.

In 1911 came the worst weather in the fair's history: exactly fifty-five minutes of feeble sunshine from opening day until the morning of the closing day—a record still unbeaten. When the clouds finally parted around noon, "astonished citizens questioned each other . . . as to the nature of the dazzling burst of light." The fiery ball might come back, like Halley's comet, said one wag, "sometime after the state fair is over." Before "Old Sol" made his belated appearance, gumshoes, tarps, and mackintoshes were much in demand; only stands that stocked umbrellas prospered. As the rain continued, the few who had braved the elements became too dispirited to eat.

Restaurants stood dank and empty. Pink lemonade went begging. And then it snowed. "Little particles drifted through the air" and began to stick. Managers huddled to discuss a two-day extension in order to recoup anticipated losses. Attendance fell by 36 percent. A projected profit of $100,000 turned into a $17,801 deficit.

Response to the disaster took two distinct forms. Among Minnesotans, the 1911 state fair immediately became part of the half-boastful, half-mocking bad-weather lore usually reserved for tales of wintertime rigors. The board of the Agricultural Society adopted as its motto for 1912 a verse by James Whitcomb Riley that argued for accepting the inevitable with good grace: "When God sorts out the weather and sends rain, Then rain's my choice." "When God in his providence saw fit to bless the State of Minnesota with an abundance of rain throughout the entire week of the fair," wrote a spokesman for the board, it only stiffened the resolve to "hold the most comprehensive annual state exposition ever held in Minnesota, or any other state" in 1912.

While the report directed at Minnesotans confessed that the weather had been less than perfect, a pamphlet prepared by the Agricultural Society for external consumption treated the previous year's debacle somewhat differently. Only after declaring that "in the scope of its exhibits, in attendance and in earning power the Minnesota State Fair is admitted to lead the world" did the authors mention the disappointments. But such adversity, in their view, only served to enhance the greatness of the fair: "In 1911, with five days of cold rain out of six, the attendance was 242,145 and the total receipts were $168,167.33 — a showing that cannot be duplicated by any similar institution and one that proves the loyalty of the people to their state fair. Everything points to a banner fair in 1912. Given seasonable weather there will undoubtedly be . . . a new world's record." Although attendance figures did rise again under sunny skies, critics were always quick to see a bad season as a sign of imminent decline. And there were many envious eyes trained on Minnesota because, when disaster struck in 1911, the Minnesota State Fair was unquestionably the greatest such show in the United States, by whatever yardstick the observer chose to apply.

The drive to become the biggest and best of all fairs began in the 1890s with a flurry of publicity releases listing the number of out-of-state guests expected to visit the fair (from 150,000 to 300,000 in 1896), the amount of the premiums offered, the size of the contiguous territory served, the number of animals exhibited, the value and dimensions of the permanent buildings. By 1903 Cosgrove was claiming openly that his was "the greatest fair in America" and predicting "the largest annual attendance in the history of such exhibitions." The following year, Secretary Randall introduced figures to show that "the Minnesota fair is more than twice the size of its nearest competitor in the matter of attendance and . . . receipts." The gate for 1906 surpassed the total number of admissions to the state fairs in Illinois, Wisconsin, *and* Iowa. The Minnesota fair was, as its boosters asserted, "the biggest thing of the kind in the country."

The boasting and the bragging reached their peak in 1908, 1909, and 1910. In speeches and articles directed at a local audience, Minnesota's elected officials, officers of the Agricultural Society, and private citizens all took it as gospel that "the Minnesota state fair is the largest upon the continent." According to figures cited in national magazines, they were right: of the thirty-eight state fairs in operation in 1909, Minnesota's was the biggest — a third larger than the Iowa fair, its nearest competitor. Suddenly,

## FAIR WEATHER AND FOUL

No amount of calculating the trends and playing the odds can guard against the caprices of Minnesota's weather. In 1977 the fair endured the worst rains in thirty years and ended the season with a loss; in 1987, the sun shone every single day and profits soared. The correlation between sunshine and success is far from foolproof, however, and the behavior of the average Minnesota fairgoer is almost as unpredictable as the weather.

Warm, pleasant weather packed them in in 1924 and shattered the old Saturday attendance record. But a cool "tang in the air" was cited as the reason for large crowds one day in 1925, and the following afternoon the turnstiles gave a "merry click" despite a threatening sky. In 1926, with "the weather dark, cold, and gloomy" for most of the week, fairgoers nonetheless "beat the weather jinx" and jammed the Grandstand events. Perfect weather in 1928 was credited with attendance figures well above the 1927 level, yet neither temperatures above one hundred degrees in 1931 nor several days of bad storms in 1938 had any appreciable effect on the turnout. Apparently, a sizable number of state fair junkies will always show up.

Weather extremes during fair week have bred both comedy and tragedy. Over the years the heat has taken its toll on livestock and humans alike. In 1984 hot, unstable weather posed a threat to life and limb. On Sunday afternoon, four fairgoers were struck by lightning outside the Home Improvement Building and seriously injured; on Tuesday evening, fifty-five members of the marching bands performing in the daily parade were sent to area hospitals with heat exhaustion. On the other hand, in 1949 Gypsy Rose Lee's ballyhoo girls donned unseductive, woolly bathrobes between their turns on the platform when evening temperatures dipped into the forties. "I'm so cold my goose pimples got goose pimples," remarked one beauty, shivering in a spangled G-string. Among the outdoor entertainers that chilly summer, only the denizens of the Eskimo village looked truly comfortable. □

however, the emphasis on sheer magnitude yielded to a concern with quality, with intangibles more difficult to reel off in self-congratulatory speeches.

The shocking reverses of 1911 helped to steer the fair in a new direction. The size of the enterprise had long encouraged boosters to make grandiose comparisons between the state fair and a variety of other celebrated outdoor shows, including the St. Louis World's Fair, the Omaha and Portland expositions, and even Coney Island and Atlantic City. There was also talk — nipped in the bud by a parsimonious legislature — of holding a Minnesota Semi-Centennial Exposition of international dimensions on the fairgrounds in 1908. However gaseous, such discussions pinpointed real enough similarities between the state fair and other festive gatherings: like Coney Island, the fair was a summer resort, with rides and games and shows; like a world's fair, it showcased the best of the products of farm and industry and thereby served the cause of progress through education; like a regional exposition, it aimed to further the interests of persons doing business in Minnesota. Thus, it is not surprising that, when the Semi-Centennial notion died, the fair took over its florid verbiage. In the words of a "State Fair Creed" promulgated in 1911, the enterprise would henceforth be known as "the Minnesota State Fair and Exposition, a mirror of the state's greatness, a school for her citizens and a place where every one can come, to be entertained and see the results of the best thought and effort in all lines of endeavor."

A formal Boosters' Club was organized to spread the word and to "make Minnesota first in everything." The newly recruited boosters survived the deluge of 1911 but, after that setback, discourse about the fair quickly lost its competitive edge. Indeed, as early as 1909 both the *Eveleth Star* and the *Red Wing Republican*, in stating their opposition to a pseudo-world's fair at Hamline, had chided management for its single-minded pursuit of records. Why not "run intensively for a little while instead of extensively, by which we mean to try to make it better instead of bigger?" asked the editors. Why not make the biggest state fair the *best* one of all?

For the remainder of the 1910s, it sufficed that Minnesotans believed theirs to be "the leading American State Fair . . . from the standpoint of quality . . . a well-balanced show, educational, recreational and inspirational," some elements of which (notably, the cattle show of 1915) were also the world's largest displays of a given item. In 1921, reflecting a kind of restrained boosterism tempered by considerations of innate worth, publicist Ray Speer and General Manager Thomas Canfield began to call their show "The World's Greatest Fair" or "The World's Greatest State Fair." The catchphrase, adopted during a period in which other fairs — at Columbus, Detroit, Indianapolis, and elsewhere — were spending liberally on new exhibition facilities and flashy off-season amusement parks, acknowledged that Minnesota could no longer hope to compete with more populous areas on a regular basis if attendance was the sole criterion of success. Instead, ads for the Minnesota State Fair stressed a dazzling array of things to see and do, each one of them massive, unprecedented, grand, or otherwise outstanding in its own right.

The 500,000 visitors to the World's Greatest State Fair ("WGST" for short!) of 1926, for example, were enticed to the fairgrounds with promises of a "mammoth" fireworks show, livestock "worth $1,500,000.00," a machinery show "covering 80 acres," a "wonderful agricultural exhibit by more than forty counties," and a "gigantic exhibit by state departments" in addition to the world's most famous auto racers, a half-million-dollar art

## FAIR WEEK

Early agricultural fairs in America tended to be held late in the growing season so that farm families would have the leisure to attend. The matter of scheduling became more important when fairs expanded from a program of one or two days to the week-long runs common in the Midwest, where the distances involved in reaching state and county fairs made short meets impractical.

In the first years of this century, the six- or seven-day fair was the norm. But a directory of fairs issued in 1939 shows a growing number of deviations from that pattern. The Kansas Free Fair in Topeka and the Ohio State Fair in Columbus were still scheduled for week-long periods, but Illinois, Missouri, and Wisconsin had opted for nine-day events and the Iowa State Fair was slated for ten.

The pressure for stretching the traditional week came from several sources. Exhibitors of stock and merchandise, concessionaires, and amusement operators with a heavy investment in the materials they took from fair to fair favored extended periods in which to recoup their transportation expenses. Midways even negotiated with operators of short-term fairs to permit rides and games to open in advance of the other attractions. In Minnesota the Midway often ran at full tilt on Preparation Day, when other concessionaires were setting up and the animals were just arriving.

Before World War I the Minnesota State Fair always opened on Labor Day and ran for six days. But, because "the fair [had] become so much of an exposition," the eight-day show was introduced in 1919 to answer the demands of commercial exhibitors. Opening day was moved to the Saturday before the holiday, taking in the crucial weekend period. In 1939, based on a study of climatological data showing that the driest time of the summer fell at the end of August and the beginning of September, the Agricultural Society opted for an expanded ten-day run ("A Week So Big It Takes Ten Days!") concluding on Labor Day. An eleventh day was added in 1972 "to combat the effect of early school openings and to ease the weekend crush." On the same warrant—preventing weekend gridlock at the fairgrounds—a twelve-day schedule was adopted in 1975.

Besides alleviating the crush of visitors, extended runs also allowed fairs to compete with other forms of entertainment. The motoring family of the 1920s and 30s no longer came to the fair by train, stayed the week, and regarded the trip as the year's outing. When movies, clubs, amusement parks, and distant resorts were accessible even to rural Americans, a fair of greater duration let visitors squeeze in a turn on the Midway or a night at the Grandstand between other engagements. Supplemental days also allowed for special contingencies, such as the Minnesota Twins' 1961 home stand against the New York Yankees that coincided with nine of the fair's ten days. And, although experts had chosen the optimal period for the fair, nature did not always cooperate with science. In 1973 it rained on seven of the eleven state fair days, prompting the staff to speculate on the potential for financial disaster, had it not been for four extra mornings of sunshine. The longer the fair, the greater its competitive edge. □

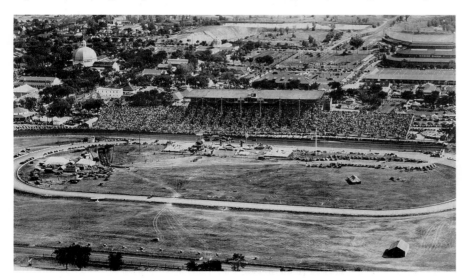

*After World War I fair attendance boomed, through good times and bad. Grandstand crowd, 1937.*

show, and any number of other attractions characterized by a volley of breathless superlatives. The thrill shows of the 1930s, with their shocking and never-before-seen stunts, represent the end point on this hyperbolic tangent. So many depression-era fairgoers flocked to the shows that the WGSF began to boast once more that it had bested the eight-day attendance records of the Dallas and Toronto expositions and had surpassed the figures for any similar period during the two-year lifespan of Chicago's Century of Progress fair.

In the late 1930s, however, it became increasingly difficult to make a just comparison among the various ongoing and special fairs of North America. Managers had begun to jockey for position again by adjusting their starting dates to the school calendar and predicted periods of fair weather or by adding a day or two to the annual run. In 1939 Minnesota extended fair week to ten days and cut admission fees in half in order to move back into contention for the title of largest fair. "Folks here call it not only the biggest," reported the *Christian Science Monitor*, "but the first of all State fairs. In any event," the skeptical correspondent added, "it truly is large and it was among the early ones organized."

The reporter also learned that Minnesotans were quick to defend the superiority of their fair on historical grounds if statistical ones were wanting, citing Dan Patch's 1905 record and claiming precedence in auto racing and aviation demonstrations. In the 1910s and 20s state fair boosterism had an anxious, defensive edge of midwestern Babbittry. Ardent supporters tended to measure the superiorities of the fair against the defects of more famous shows "out East." But in the 1930s and early 40s assertions of greatness took on a desperate edge as the ongoing vitality of the fair held out hope that Minnesota would survive the Great Depression. "Perhaps at no time in the history of the state would a visit to the state fair mean more to the average individual," wrote a commentator in 1932. "The Fair," he continued, will "reassure him, in the face of an all too common pessimism, that men are at work, that progress is being made in the face of adversity, and that success still crowns the efforts of those who strive. The fair offers that opportunity."

In a climate of anxiety, the size of the crowds was taken as an index of economic trends, a sign of better days ahead. And even with the return of prosperity, attendance tallies continued to be monitored for clues to the mood, the health, the sentiment of the body politic. The goal of a one-million gate, first set in 1946, was calculated to "top anything that any other state in the union" might achieve. But the figure also stood for the heightened expectations of the postwar period, in which Minnesotans looked forward to full employment, a booming farm economy, a rising birth rate, and a wealth of new consumer products. In the 1950s, as attendance reached and passed that mark, the experience of being part of a gigantic human throng—a novelty for many rural and suburban Minnesotans—was often listed as one of the best reasons for going to the fair. In 1986, with the help of ideal weather, an abundance of free shows, an attractive Grandstand program, increased competition for premiums, a twelve-day run, and a state law that delayed school openings until after Labor Day, the Minnesota State Fair topped the 1.5 million mark for the first time. The fair really was, as the slogan termed it, the "Great Minnesota Get-Together."

But was it the biggest, the best state fair in America? The World's Greatest State Fair? During the 1960s and 70s, it was and it wasn't. Boosters and publicists called it "the nation's largest agricultural exposition," thus moving the fair almost imperceptibly into a class by itself and avoiding invidious

## "WE'RE NUMBER ONE!"

In 1982 General Manager Mike Heffron seemed to have bid farewell to the days of the World's Greatest State Fair when, with a modesty uncommon among showmen, he called the Minnesota fair "the single most popular event in the Upper Midwest." But a motion passed unanimously by the Minnesota State Agricultural Society at its 125th annual meeting in January 1985 reads:

RESOLVED: THAT WE BELIEVE THE MINNESOTA STATE FAIR TO BE THE FINEST INSTITUTION OF ITS KIND IN NORTH AMERICA. □

comparisons with the larger Canadian National Exhibition and the Texas State Fair which were, at best, quasi-agricultural. There were those, too, who insisted that a twelve-day show could not be judged by the numbers against seventeen- or eighteen-day extravaganzas in Ohio and Texas. Yet strict constructionists were forced to admit that, on the basis of statistics alone, Minnesota's fair actually stood "among the four largest . . . in North America." The 1986 directory of the International Association of Fairs and Expositions ranked the five major North American fairs according to admission figures:

1. State Fair of Texas, Dallas.     3,959,098
2. Ohio State Fair, Columbus.     3,683,165
3. Canadian National Exhibition, Toronto.     2,143,936
4. Minnesota State Fair, St. Paul.     1,565,349
5. Illinois State Fair, Springfield.     1,059,464

But to Minnesotans who love their fair, it remains — whatever its minor failings in bulk — the greatest of them all. ☐

## BY THE NUMBERS

State fair statistics, firsts, and astonishing facts of all kinds have held an enduring fascination for reporters, boosters, officials, and ordinary fairgoers. A potpourri:

- Completed in 1906, the $100,000 Hippodrome was said to be the "*largest* show building in America."
- The farmers of Pine Island created for the 1911 fair a cheese they believed to be the "*largest* in the world." Made from 300 wagonloads of curds (or 70,000 pounds of whole milk — the one-day output of 3,300 cows on 250 local farms), the cheese weighed 6,000 pounds; 8 feet in diameter, it stood 4 feet 6 inches high. Eighty square feet of cloth were required for its wrapping, 190 feet of steel for hoops, and 700 feet of lumber for casing. The finished cheese was called "the *greatest* feat ever performed in the dairy industry."
- The so-called "*oldest* document of American history" — the Kensington Runestone — was placed on exhibit at the fair in 1909 and again in 1929. Containing an account of a purported visit to Douglas County in 1362 by a party of three Swedes and twenty-two Norwegians, the stone was said to have been "accepted as authentic by the *finest* archaeologists of the world."
- The superintendent of the dairy department at the 1903 fair predicted that "the *finest* butter ever exhibited" in the world would be on display in Minnesota. He based his prognosis on the fact that a Minnesota butter maker, Samuel Haugdahl, had recently taken the sweepstakes prize at the Paris Exposition. Haugdahl, one of the butter judges for the year, would also display his medal at the fair.
- The "*leading* dirt track drivers of the world" were scheduled to compete at the 1921 fair, the venue of "the *first* auto race ever held by any fair in the world, almost fifteen years ago."
- According to T. H. Ahrens, 1956 president of the Agricultural Society, "*more* United States presidents have visited the Minnesota State Fair than any other fair in the nation." Furthermore, "the U.S. Patent Office regards our Machinery Hill as the *best* place in the nation for its agents to make firsthand observance of the development of agricultural machines."
- With completion of an addition to the Agriculture Building in 1912, the Minnesota fair could boast "the *largest* permanent building devoted to the exhibition of agricultural products in the entire world."
- No one challenged the grounds crew's claim that the Minnesota fair was "the *best maintained* event of its kind in the United States" in 1948.
- The Royal American Shows Midway enjoyed its *best* single day in its history at the 1967 Minnesota State Fair.
- In 1921 the Minnesota State Fair claimed to have "staged the *first* fireworks display ever put on by any fair in America. It introduced fireworks as a fair amusement. . . . Since then it has never failed to lead in the formulation of its fireworks program. You are getting the best when you attend the World's Greatest State Fair." ☐

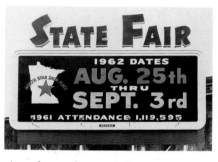

*Attendance figures, always a special point of honor*

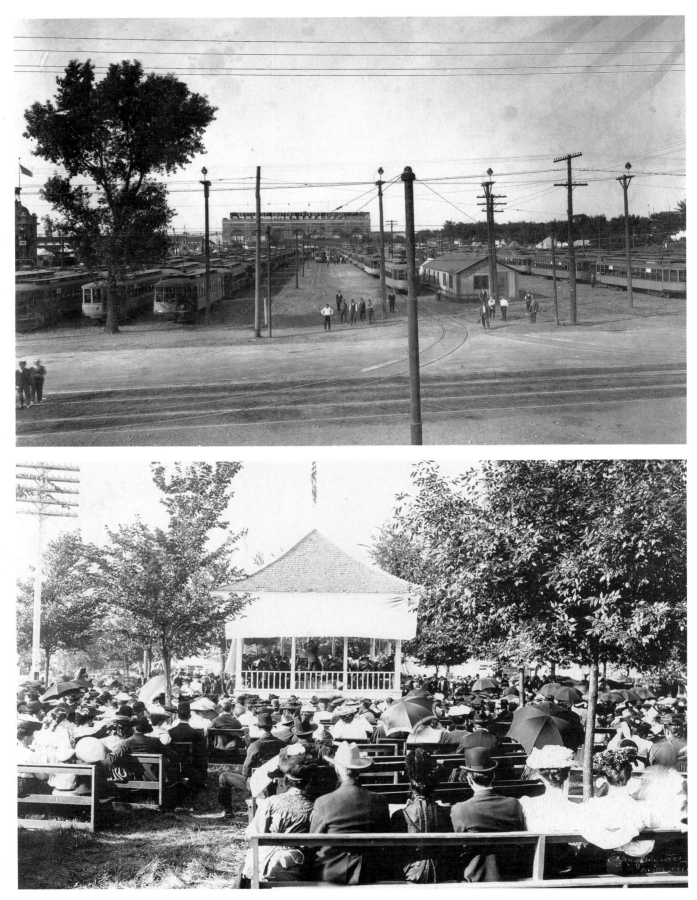

*Convenient trolley service, right to the gates, 1919*

*Umbrellas to ward off sunshine at a band concert in perfect weather, 1905*

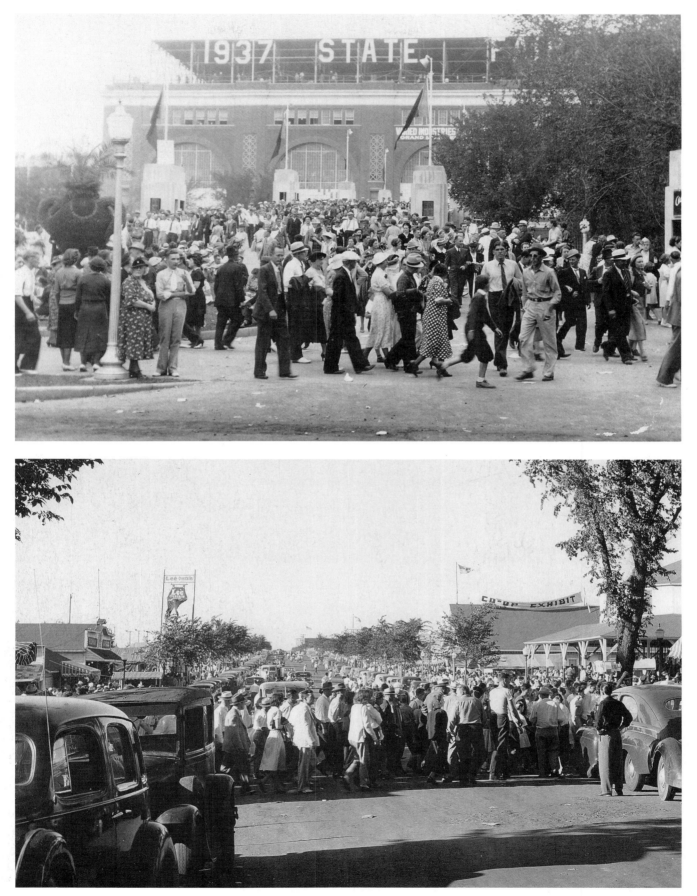

*Crowds poured out of the Grandstand, 1937.*

*They jammed the streets, 1947.*

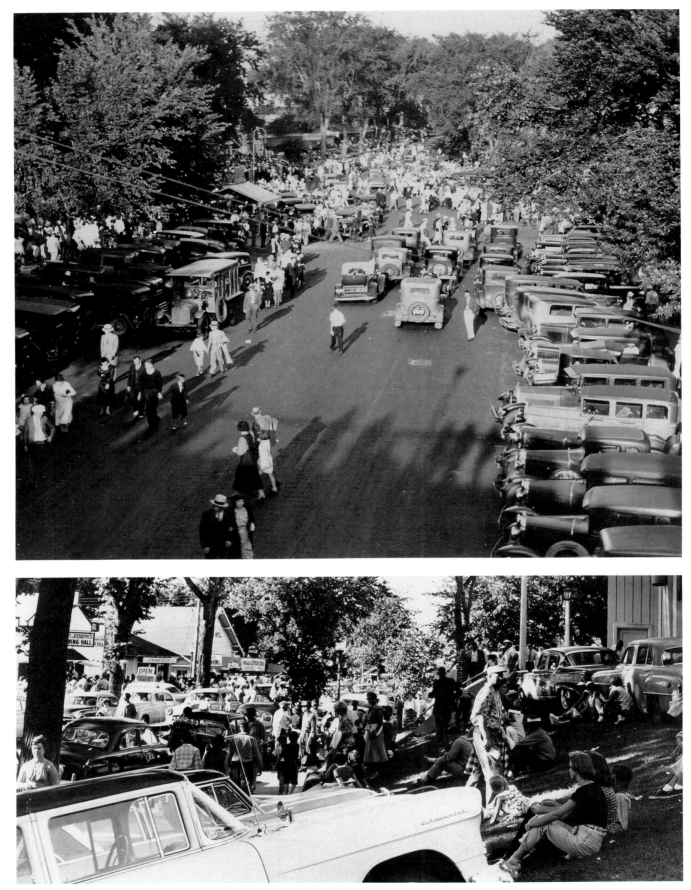

*Cars aplenty, too, even during the Great Depression*

*Jamming the grassy slopes below the Agriculture-Horticulture Building, 1956*

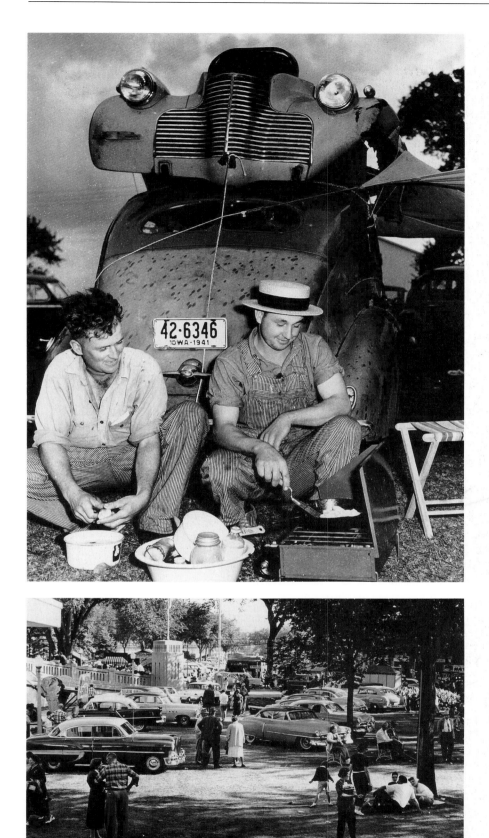

*Drivers often slept, cooked, and ate near—or in—their chariots, 1941.*

*Cars crept right up to the Grandstand, too, 1956.*

*The hordes milled about, jamming the street outside the new Coliseum, 1951.*

*They filled the staircases and the Grandstand approach, 1970s.*

*They sat in the sun and ate, 1986.*

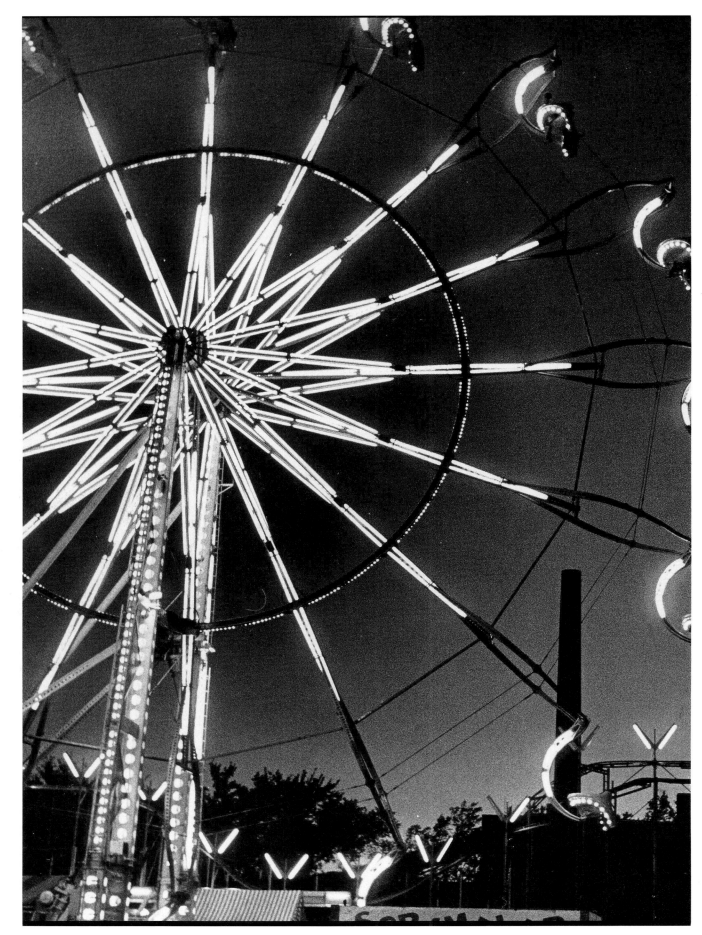

*Midway rides whirl and twinkle like heavenly bodies temporarily come to Earth.*

CHAPTER TWENTY

## "GOODNIGHT, GOODNIGHT, GOODNIGHT"

HOT, IRRITABLE, BEWILDERED by their strange surroundings, the animals are grateful to bed down for the night as the afternoon sun begins its long, slow descent. In the office, the tally of the day's attendance winds down, too; a new record will be posted in the morning. The exhibition buildings close at 9:00 P.M., and the superintendents of needlecraft and seed art and Minnesota apples begin to drift homeward. The Grandstand show, meanwhile, is well under way, the comic and the lead singer soon to be eclipsed by the boom and flash of the traditional fireworks finale. For several generations, the last glittering effect was a giant farewell, written in fire against an inky sky: "Goodnight, Goodnight, Goodnight."

But for some fairgoers, the evening has just begun. Tawdry and crude in the merciless light of day when the livestock barns are still the cool, sweet center of attention, the Midway becomes a place of magic by night — crowded, noisy, alive with neon, romance, adventure. By night, wrote F. Scott Fitzgerald of his ramble down the Minnesota Midway, "the substance of the cardboard booths and plaster palaces was gone, the forms remained. Outlined in lights, these forms suggested things more mysterious and entrancing than themselves, and the people strolling along the network of little Broadways shared this quality, as their pale faces singly and in clusters broke the half darkness."

The rules say that no concession may be open after 12:30 A.M. and the gates are supposed to close at midnight, but in practice the lights twinkle out slowly on the Ferris wheel and the Tilt-a-Whirl as the refuse trucks begin to grind their way through heaps of sticky cotton-candy holders and paper napkins smeared with mustard. Back in Fitzgerald's day, the agricultural journals were already complaining about low types who left the "remains of lunches and lunch boxes and baskets, old papers — even cast off articles of clothing" on the grass. "Why, in fact, should indiscriminate lunches be allowed anywhere on the state fair grounds?" asked one foe of litter long before the advent of fast-food culture.

The realists who manage the state fair have chosen to cope with the inevitable detritus. At nine or ten at night, the sanitation crew begins to fan out across the parks, the streets, the barns, and finally, the Midway. Rubbish is loaded, dumped, and loaded again — three or four tons of it to a shift. The pavement is flushed. High-school boys on their first summer jobs swab the concrete floors under the Grandstand. Garbage rigs circle the cookshacks in the wee small hours. The barns are cleaned and disinfected just about the time the first sleepy cow demands a predawn milking.

En route to its final stop, the open-air bus collects the last load of strag-

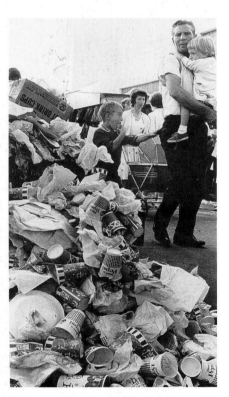

*Towers of trash, 1964*

glers bound for the far corners of distant parking lots, now all but deserted. The day is really over. The fair prepares for sleep. It takes a special overnight badge to stay on the grounds so late, but a few diehards always remain: the minister roasting the meat for tomorrow's blue-plate special; the frightened carnie girl, far from home, tossing fitfully on a cot behind a painted front that calls her "Electra," the galvanic woman; the hungry cat on the prowl among the chickens, in search of a cage with a broken hasp.

There was a time when fairs closed up tight at dusk, when all activity ceased at twilight. The reasons for the curfew were both philosophical and practical. When the state fair was primarily an agricultural gathering, it ran according to the rhythms of the farm: the sun, the moos, squeals, and cock-a-doodle-doos of the livestock. And, because the farmer was at liberty in town during the fair, the daylight hours sufficed to inspect the exhibits, take in a speech, and bet on a horse. Besides, to light up Floral Hall after dark presented formidable technical problems: flames of any kind were dangerous in the predominantly wooden exposition buildings and potentially lethal in the barns.

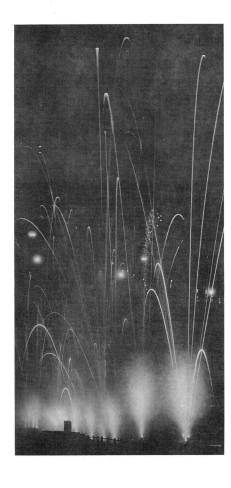

Arriving in Owatonna for the 1883 state fair at 7:00 P.M. after an all-day train trip, David Maxwell Fyffe managed to catch a glimpse of the stock only because the animals were housed in "old-fashioned" open sheds "running around the outside of the ground[s]"; for the rest, he had to wait until morning. Even agriculturalists like Fyffe sometimes chafed under such restrictions. When the Minnesota State Fair began its series of farmers' institutes in the 1890s and brought farm families to live in a tent city on the fairgrounds so they could attend the sessions more easily, the problem arose of how to amuse the scholars after supper. In 1892 evening lectures on entomology (with stereopticon slides) and sheep husbandry were interspersed with the "sweet melodies of a colored quartet." That bit of minstrelsy was the first night entertainment known to have been held at the Minnesota State Fair.

By 1899, however, the fair was offering a complete program of nighttime entertainment based on the novelty and beauty of artificial light. Fireworks figured heavily in the new after-dark Grandstand show that season and pyrotechnic comedy was also attempted in a series of vaudeville acts — a monkey acrobat, a dancing elephant — simulated in colored light. The illumination of the racing oval by 250 fixed lights allowed for bicycle and chariot races after dark, too, climaxed by the appearance of a diving horse who plummeted from a forty-foot platform into a lighted tank below. And, so that "the night visitors may not be disappointed in seeing the exhibits," the principal buildings had also been lit by costly acetylene fixtures.

The nocturnal revolution of 1899 was not something the fair undertook lightly. To study the feasibility of using "chained lightning," arc lights were installed at the racetrack in 1898, along with an electric sign over the main gate. Although extensive shows were not offered that summer, the management announced plans to begin them and opened the grounds from sunset until eleven o'clock to test and to show off the lighting scheme. Rival firms were encouraged to install decorative arches of light and gas plants in the various buildings so that the relative merits of each system could be evaluated. Meanwhile, a new kind of extra-brilliant, Japanese daylight fireworks was tried out on "astonished farmers" between the heats of the afternoon races at the Grandstand.

Darkness was banished from the Minnesota State Fair by several independent forces that suddenly converged on Hamline at the end of the 1890s.

One was the drive to light up cities. The intense rivalry between Minneapolis and St. Paul was expressed in the sums expended on more and better fixtures for the special illuminations mounted on festive occasions. Even after the fair settled in the Midway district, such illuminations continued to accompany the festivals each of the Twin Cities put on during fair week to attract visitors. From time to time, the Agricultural Society protested these activities. But fairgoers had nothing better to do at night, and illuminations proved lucrative for the local businesses that financed them. The question loomed: Why should the fair lend its hard-won constituency to the merchants of downtown Minneapolis or St. Paul if gaslights would keep them in the Grandstand?

The same logic held true for fireworks spectacles. In 1898, as the fair edged closer to staging such dramatic conflagrations, the St. Paul summer carnival capped off the usual illuminations and torchlight parades with the Pain company's stirring pyrotechnic rendition of the Spanish-American War, entitled "Cuba." It is no accident that the Minnesota State Fair inaugurated the night program a year later with another rendition of that war, "The Burning of Manila" by Porter's Minneapolis Fireworks Company. Nor that after 1900 the rival Pain company provided the fair's pyrotechnics. "Dewey's Fleet in the Battles of Manila" (1900) was followed by "The Last Days of Pompeii" (1901) and "The Fall of Pekin" (1902). "The Burning of Rome" (1903) was answered by "The Destruction of St. Pierre" (1904), a re-creation of the recent eruption of Mt. Pelee. "The Fall of Port Arthur" (1905), an incident from the current Russo-Japanese War, was enacted by a cast of "real" Japanese. After "The Burning of Moscow" (1906) by the "Reds" came the biblical "Siege of Jericho" (1907). Even Minnesota's brief history was recounted in smoke and rockets in "Fort Ridgley in '62" (1908) and "Minnesota at Gettysburg" (1909).

Pain got his start at the great Chicago fair of 1893. There, however, even the most dazzling fireworks had been overshadowed by the battery of floodlights that played by night over the lofty buildings of the White City. Those lights used three times as much electricity as the rest of Chicago put together, a statistic that shows just how miraculous bright, consistent, every-night urban lighting — as opposed to special "illuminations" — must have seemed. The Chicago fair was meant to demonstrate how modern technology could transform American life, and the notion that night could be made into day was one of its most potent lessons.

Lighting was a symbol of technological mastery, of modernity; as such, it rightly found a place at the Minnesota fair, the state's proving ground for advanced ideas. Yet artificial light also disclosed new and disturbing aspects of the modern condition. By choice and by necessity, those who lived in the city of the 1890s went abroad by night. The rhythm of the old agricultural day was not the tempo of modern times. It is significant, then, that in testing general illumination of the grounds in 1898, the fair justified the $12,000 novelty by reference to the urban fairgoer. Nighttime hours, an official announced, "will give the great army of clerks and laborers who are busy during the day a chance to the see the fair" for the first time and in its entirety — horse races, music, vaudeville, exhibits, and all.

After 6:00 P.M. admission was half-price, except for the Grandstand show, the increasingly grandiose character of which commanded top prices. Although not as "wildly exciting" as the daylight version, a horse race became a melodrama all its own by night and, once the animals got used to it, managers were delighted to learn that records were being made under the

## LIGHT UP THE NIGHT

The opportunities for evening diversion at the state fair are many, varied, and ever changing. No longer in bed by dark, 4-H'ers moved their Dress Revue and Talent Show to glamorous night-time hours after World War II and engaged popular radio announcers as emcees. The first Night Thrill Show under the lights was staged in 1950, starring the Joie Chitwood Auto Dare-devils; it set a new after-dark attendance record. In the 1960s the Grand-stand went "show-biz" with a parade of headline acts and celebrities. But the fireworks program with which the big night show began in 1899 remains the only truly satisfying finale to a day at the Minnesota State Fair.

Discussing the function of entertainment at a fair with his superiors in 1915, state fair publicist Ray Speer noted that "the love of fireworks is primitive, instinctive and elemental":

Not many centuries ago fire was man's most effective protection against wild beasts, a central fireplace the principal part of his crude home. "The fire in an open fireplace," a prominent student of recreation has said, "creates the family 'circle' and promotes a deeper understanding and sympathy among its members." The fireworks spectacle at the Minnesota State Fair is the community fireplace, a center of sociability and play for all the members of the larger family circle of the Northwest. . . . The hissing, shooting flames, the bursting bombs, the strange riot of color in fire . . . all seem to present an unusual appeal to the young. Nor could it be said that it has lost any of its attractiveness as far as the old are concerned.

In 1984, in celebration of the institution's one-hundredth year at the old Ramsey County Poor Farm, the fair spent a record $25,850 on fireworks. The annual expense is more than justified by a tradition that itself stretches back nearly a century. Fireworks bring Minnesotans together to gaze in wonderment at the heavens and remember just how beautiful nature is. Fireworks startle and surprise, as the fair has done, every summer since 1855 — or was it 1854? And the fireworks at the state fair tell us that it's all over for another year, that winter is coming, that the time has come to say "Goodnight!" "Goodbye!" □

stars. The most routine acrobatic act became an exercise in tension and suspense when performed within the quavering oval of a spotlight trained on an aerial perch. Ordinary high divers smeared themselves with gasoline and became daring fire divers, greeted by the shrieks and screams of a horrified audience. And, as Peking and Rome and Jericho fell in ever more thrilling crescendos of fire, fairgoers clamored for more. In 1902, just four years after the first evening show, better than fifty thousand spectators turned out to watch the Minnesota fair light up the night.

Inevitably, the size of the lighting plant became another piece of ammunition in the war with rival state fairs. In 1912 those who amassed such figures noted that, with the 10,000 incandescent lights (not counting those in the sideshows), 127 arc lights, and three 22,000-candlepower marine searchlights, "a city of 72,000 inhabitants would not consume the amount of electricity used for lighting the state fair grounds each night." The sideshows were omitted from the count because they carried their own generators, but the Midway offered, perhaps, the most striking use of lighting to be found at the fair. Whereas the general illumination displayed at the Chicago World's Fair offered practical inspiration to cities everywhere, the purely decorative style of lighting used to outline amusement attractions with strings of single bulbs created an atmosphere of fairy-tale wonder and ethereal delicacy widely copied in the outdoor amusement business.

Luna Park, built on Coney Island in 1903, traced the complex forms of its spires and towers with more than a quarter of a million separate electric lights; the tents and flats that the Gaskill Carnival Company erected at the Minnesota State Fair in 1904 were outlined in precisely the same manner. The workaday applications of the technique were not apparent at the time (in the 1980s, bulb strips were revived to adorn retail establishments specializing in "festival" or recreational shopping). Its very impracticality and loveliness suited contour lighting to the world of the Midway, where the rules of ordinary life were suspended in favor of pleasure, thrills, and fantasy.

Because Midway visitors and fairgoers in general were in a holiday mood, they did not always exercise the caution that nighttime justifies. While the fair had always had its share of pickpockets, their numbers multiplied under cover of darkness. It was the tired crowds departing at night who were the prey of notorious thieves like Mickey Lynch and Moe Cohn, despite the best efforts of the Pinkertons to catch the evildoers. At night, too, it was easier to lose one's bearings, to disappear into the shadows. That was the temporary fate of Arthur Penny, a small boy from Minneapolis who failed to come home from the fair one night in 1903. He had vanished, somehow, during the Grandstand show, although his family was not unduly alarmed—the evening was mild and Arthur had fifty cents in his pocket. The sight of strange shapes glimmering in the dark has proven a powerful magnet over the years, especially to little boys in search of adventure. There is danger in the night, but there is also glamour and mystery.

The glitz and glitter of the lights made the nighttime fair particularly appealing during the 1920s, when jazz babies and motion-picture fans began to demand livelier forms of entertainment. To this day, the "show-biz" competitions, like the talent contest and the Princess Kay pageant, take place at night in the glare of the footlights. The long-standing but somewhat vague association between light and fast-paced, toe-tapping modernity was made explicit by the electrified pylons that adorned the buildings of the 1933 Century of Progress Exposition in Chicago. Like so many rockets to the moon,

## TEARDOWN

According to the rules of operation, "persons not involved in the . . . teardown of exhibits at the State Fair may be prohibited from entering the Fairgrounds" during that period. Most of the animals are already gone when teardown day begins, the open-class livestock back to farms or to new owners, the 4-H prize winners off to slaughter. The quilts and the jelly will not be picked up for another week. But there is still the Midway to disassemble, the cookshacks to close up, the amazing gadgets to be loaded into trailers bound for the next stop on the fair circuit.

Most of the work is hard. Questioned about their state fair jobs in 1959, several boys complained that girls got soft duty, selling jewelry or cotton candy, whereas they got the heavy, dirty work—like teardown, for which slots were still available to applicants on the last day of the fair. □

the columns of colored light made the towers seem to move and strain and rise above the earth. The Minnesota State Fair tried out a pattern of variegated, tinted light on the dome of the old Horticulture Building in 1934 (the thirty-fifth anniversary of full electrification of the fairgrounds) with highly satisfactory results; in 1947, with the opening of the new Agriculture-Horticulture Building, the pulsating tower of light became the norm for new construction. All but useless for lighting exhibits or warding off pickpockets, the pylon was a jewel of great price set off against a black velvet sky. Its tall, glowing form flashing red and blue and green in the darkness stood for transformation, for aspiration, for the pull of unknown worlds beyond the confines of the fairgrounds in St. Paul, Minnesota.

But in some important ways nighttime still calls to mind the enduring meaning of the old agricultural fair. Fairs come at the twilight of the year, when the harvest is in and the year's work is almost done, when the land prepares for its long winter's sleep. The final event of the departing summer, the Minnesota State Fair marks a time of celebration, a time of optimism and satisfaction with a job well done. Like a warm, soft Minnesota night, it is a time of rest and play and renewal, a time for learning and contemplation and wonder, a time for dreaming. "Goodnight, Goodnight, Goodnight." □

## NOCTURNAL MISCHIEF

Nighttime presents its own unique set of problems at the fair. Tempers sometimes fray at the end of a long, hot day; 3.2 beer takes its toll, especially on drinkers unfamiliar with its effects. Darkness emboldens those whose daylight decorum is unexceptionable. Such was the case in 1960, when the fair was marked by a series of nocturnal confrontations between the authorities and roving gangs of "young toughs."

It all began around eleven o'clock on a Saturday night. Sixty young men, between the ages of sixteen and twenty, damaged some concessions as they swarmed through the grounds, intent on "breaking up" the Club Lido, a Midway girlie show. The police managed to intercept the column and break it into several smaller groups, which were easily herded out the gates. Once outside, however, the gang repeatedly threatened to return on Sunday, and the police called in reinforcements.

Things remained relatively quiet until Tuesday, when a free-for-all between two gangs broke out around 10:30 P.M. near the Grandstand, within sight of the police station. While attempting to quell the outburst, a special policeman was jumped by several teenagers and had to be sent to Bethesda Hospital suffering from a possible concussion. Two of his attackers, ages nineteen and twenty, were jailed for assault and five others detained for questioning.

Meanwhile, the atmosphere of violence bred more disturbing incidents. A teen on his way home from the fair was set upon by persons unknown at one of the gates and needed seven stitches in his upper lip. Police were also searching the Midway for a "dark, handsome" man attempting to pass himself off as a Hollywood talent scout. Four girls reported that he had approached them and tried to make dates for "interviews" in his room at the Dyckman Hotel after hours. The interviews, they were told, would lead to movie contracts. □

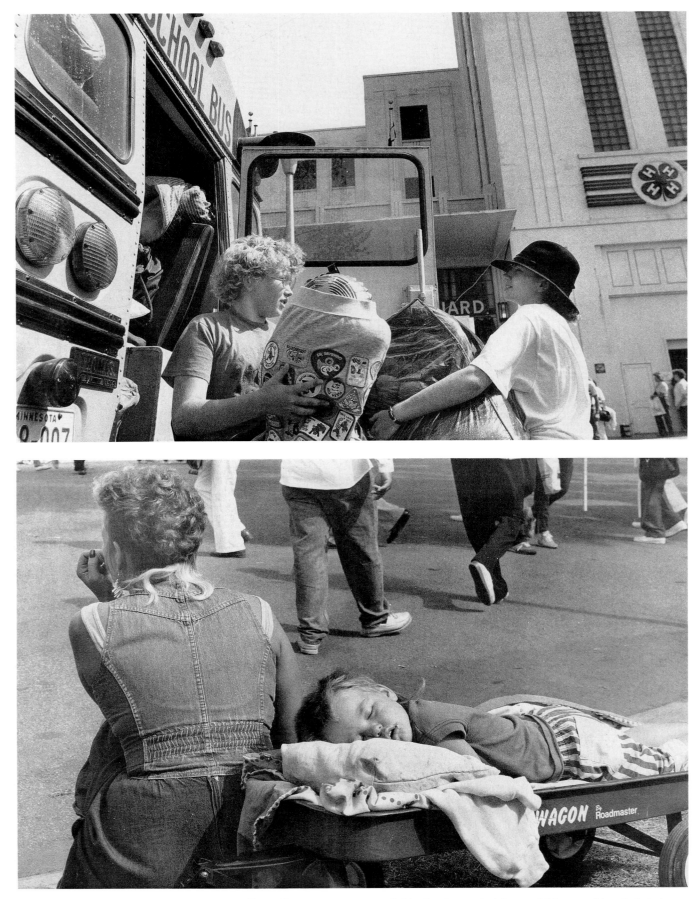

*Late afternoon, as some activities begin to wind down: 4-H'ers packing their belongings for the long ride home, 1980s.*

*Nap time, 1980s*

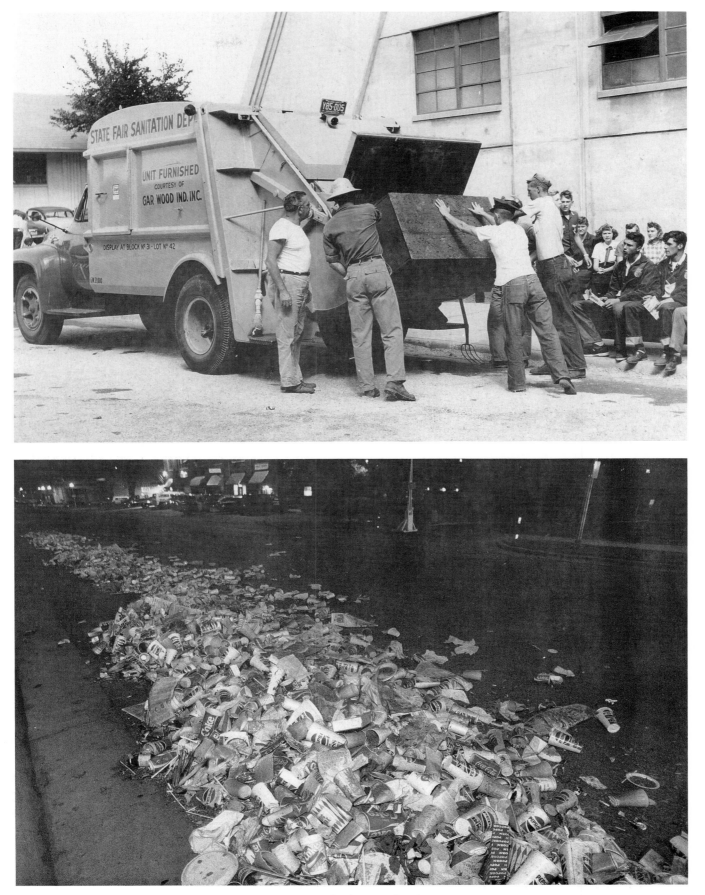

*Sunset at the fair, when the thrills of the glittering Midway beckon, is also the time
of the garbage truck, 1954.*

*Rivers of garbage, 1980s*

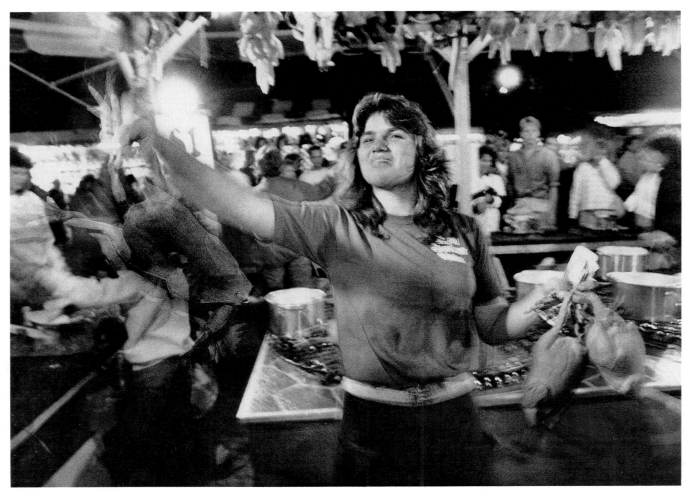

*When the sun goes down, the lights come up on the 1987 Midway. Try your luck at Flip-a-Chick!*

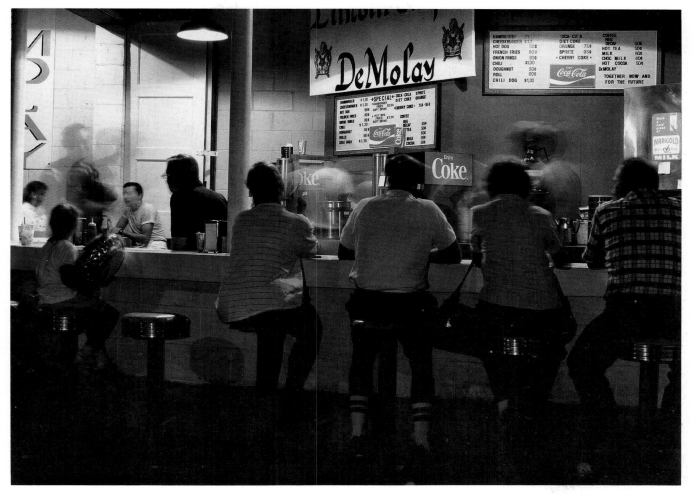

*Night cafe, 1980s. Night can be a strange and lonely time at the fair.*

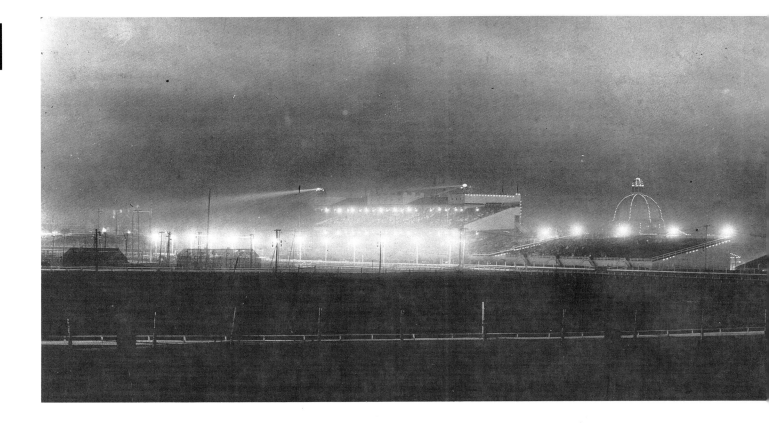

*It can also be beautiful beyond all telling; buildings outlined in lights became fairy-tale castles, 1909. "Goodnight, Goodnight, Goodnight."*

# A NOTE ON SOURCES

WHEN THIS BOOK WAS first submitted for publication, it was almost twice as long as the present version. All those extra pages were devoted to long lists of the several thousand newspaper articles that constituted the raw materials on which the text was largely based. The decision to eliminate these footnotes in the interests of space and readability was not made lightly; researchers wishing to check a given fact or to run down a particular article may consult a copy of the manuscript at the Minnesota Historical Society. But readers wishing to understand the Minnesota State Fair are better advised to go straight to their local libraries and explore what their own hometown papers had to say every July, August, and September, when journalists in every corner of the state traditionally have found the topic almost irresistible.

The newspapers become all the more important in the absence of analytic studies of the fair and its history. Merrill E. Jarchow, in "Early Minnesota Agricultural Societies and Fairs," *Minnesota History,* 22 (September 1941): 249–69, provides the first substantive treatment of the topic but, as the title suggests, the study ends in the nineteenth century. Two existing books about the Minnesota State Fair also stop well short of the present era. The first, Darwin S. Hall and R. I. Holcombe, *The History of the Minnesota State Agricultural Society from Its Organization in 1854 to the Annual Meeting of 1910* (St. Paul: McGill-Warner Co., 1910), was compiled from the annual reports and minutes of the fair's parent body and reflects a keen interest in the Agricultural Society, its early leaders, and its policies. The second, Ray P. Speer and Harry J. Frost, *Minnesota State Fair: The History and Heritage of 100 Years* (Minneapolis: Argus Publishing Co., 1964), mirrors the interests of its authors, who were professional publicists for the fair. It is a miscellany of noteworthy facts and figures culled from the press releases generated by the fair's public relations department.

The source materials consulted by these historians remain accessible today. The fair's annual reports, including the edited minutes of the Agricultural Society's meetings, have been issued in bound volumes. In addition to its premium lists, the fair has also produced, at irregular intervals, "official programmes" of its attractions, and, during the 1920s, a handsome journal entitled *Minnesota State Fair News*. These publications may all be found in the collections of the Minnesota Historical Society and in many local libraries.

Whether shaped by earnest publicists or the tide of events, descriptions of the fair were a staple item in Minnesota newspapers beginning in the 1860s. As noted above, this book relies heavily on stories that appeared in papers ranging from the *Minneapolis Star Tribune* and the *St. Paul Pioneer*

318

*Press Dispatch* (and their distinguished predecessors) to the *Anoka Union,* the *Faribault Democrat,* the *Fergus Globe,* and the hundred-odd other dailies and weeklies whose reports found their way into the press collection of the Minnesota State Fair. Consisting of scrapbooks of fair-related clippings — one huge book per year, beginning in 1935 — the press collection is an invaluable source of anecdotal and statistical information, as well as editorial opinion, recipes, poetry, trivia, advertising, and hard news about the fair, its personnel, and its visitors.

From 1916 until 1921, Ray Speer published an annual series of articles about innovative programs at the Minnesota fair in *Western Magazine. The Minnesotan,* the short-lived journal of the state's Fine Arts Commission, ran important articles about aspects of the arts at the fair in 1915 and 1916.

Ideas pertinent to an understanding of the state fair are included in T. A. Erickson, *My Sixty Years with Rural Youth* (Minneapolis: University of Minnesota Press, 1956), the memoirs of Minnesota's first 4-H leader, and in Patrice Avon Marvin and Nicholas Curchin Vrooman, *Till the Cows Come Home* (Zumbrota, Minn.: Wings/Hands & Co., 1985), a delightful history of the Goodhue County Fair.

Fine fictional descriptions of the Minnesota State Fair appear in Grace H. Flandrau, *Being Respectable* (New York: Harcourt, Brace & Co., 1923) and F. Scott Fitzgerald, "A Night at the State Fair," in Arthur Mizener, ed., *Afternoon of an Author: A Selection of Uncollected Stories and Essays by F. Scott Fitzgerald* (New York: Charles Scribner's Sons, 1957). The fair provides the setting for a mystery in "State Fair Murder," in Frank Gruber, *Brass Knuckles: The Oliver Quade, Human Encyclopedia, Series* (Los Angeles: Sherbourne Press, 1966). Laura Ingalls Wilder, *Farmer Boy* (New York: Harper & Row, 1953) contains a word sketch of a county fair in New York State not very different in character from early territorial and state fairs.

Foreign chronicles of a day at the Minnesota State Fair range from the ecstatic to the disgusted. For the former, see Henri Troyat, *La Case de l'Oncle Sam* (Paris: Table Ronde, 1960); for the latter, Jonathan Raban, *Old Glory: An American Voyage* (New York: Penguin Books, 1982).

Studies of American agricultural fairs in general are also sparse. Among the histories, Wayne C. Neely, *The Agricultural Fair* (New York: Columbia University Press, 1935) and R. W. Morrish, *A History of Fairs* (Chicago: International Association of Fairs and Expositions, 1929) are landmark works, although badly out of date. Donald B. Marti, *Historical Directory of American Agricultural Fairs* (Westport, Conn.: Greenwood Press, 1986), attempts to fill the gap with short sketches of many fairs, emphasizing their variety and regional differences. Leslie M. Prosterman, "The Aspect of the Fair: Aesthetics and Festival in Illinois County Fairs" (Ph.D. diss., University of Pennsylvania, 1982), offers a new methodological framework for looking at the modern fair in a broad cultural context. This same effort to see the fair as a key component of the culture of the heartland seems to underlie Chris Rasmussen's unfinished dissertation on the Iowa State Fair, now in progress at Rutgers University.

Finally, although it, too, deals with Iowa rather than Minnesota, the best feel for what it's like to be at a big fair — the sights, the noises, the wonderful smells — is provided by Philip D. Stong's great regionalist novel, *State Fair* (New York: Century Company, 1932). □

# INDEX

## PICTURE CREDITS

The illustrations in this work appear through the courtesy of the individuals and institutions listed below. Within the institutional collections, the names of the photographers, donors, or special collections, when known, are given in parentheses. The following abbreviations indicate placement on pages that contain more than one illustration: T (top), M (middle), B (bottom), L (left), and R (right).

### MINNESOTA STATE FAIR
Frontispiece; pages 4, 9T, 13, 14B, 15T, 15B (Mel Jacobsen Commercial Photography), 23T, 26, 28, 34, 35, 51L (detail), 60, 61, 68, 72T, 75, 77 (detail), 79, 84, 85, 86, 87, 88, 89B, 103B, 104B, 105T (Northwest Photo), 105B (Kenneth M. Wright Studios), 106B (Hasco Photographic Studio), 113 (Fred Anderson), 115, 118, 119, 120T, 121T, 122B, 123B, 125T, 126, 129, 133, 137, 139, 142B, 143B, 144B, 145T, 145B (Northwest Photo), 146B, 147T, 148, 150B, 152, 162T, 163B, 164T (Jacobsen), 174, 177, 178B, 179B, 183, 189, 191, 197T, 199, 200T, 201, 202, 204, 209R, 210, 211, 213T, 216B, 217T, 218, 219, 220T, 220B (*St. Paul Dispatch*), 221, 222T (Anderson), 222B, 223B, 224M, 224B, 225T (Hasco), 225B, 227, 235, 237 (Wright), 238, 239T, 244, 245, 250B, 252 (Hasco), 253 (Bruce Sifford Studio), 255, 259, 263, 268B, 280, 284M, 285T, 290 (Hasco), 292, 295, 297, 299, 300, 301, 302T (H. M. Schwang Photo Co.), 302B (Jacobsen), 303 (Jacobsen), 304, 305, 306, 311T; endpiece

### MINNESOTA HISTORICAL SOCIETY
pages vi (map, Alan Ominsky), 5 (Museum Collections), 9 (C. P. Gibson), 11B (*Minneapolis Tribune*), 16, 17 (*Minneapolis Journal*), 24 (*St. Paul Pioneer Press*), 25T (Harry D. Ayer), 25B (M. C. Tuttle?), 29 (Reference Library), 30, 36 (*Journal*), 37 (Museum), 39, 41 (Museum), 43, 44, 45T, 45B (*Pioneer Press*), 47 (Museum), 48 (Library), 54–58T (Library), 58B (Elgin R. Shepard), 59 (Shepard), 65, 66 (Shepard), 67 (*Tribune*), 69 (C. J. Hibbard), 70T (Hibbard), 71T (Shepard), 72B, 73T (Hibbard), 74 (Edmund A. Brush), 76, 80 (Library), 94, 95 (detail), 96, 100 (*Pioneer Press*), 103T, 104T (Shepard), 107, 108, 109T (Museum), 109B, 110, 111T, 116 (detail), 120B (Shepard), 121B, 122T (*Journal*), 123T, 124T (Shepard), 124B (*St. Paul Daily News*), 125B (*Minneapolis Star-Journal*), 127 (*St. Paul Dispatch*), 128, 130, 136L (*Dispatch*), 136R (*Star-Journal*), 138 (*Dispatch*), 142T, 143T (Potter-Hibbard Photo Co.), 144T (*Star-Journal*), 146T, 147B, 150T (*Tribune*), 151T (Museum), 161T, 161B (Gibson), 162B (*Tribune*), 163T (*Tribune*), 166, 167 (Horton), 176, 178T, 179T, 180, 181T (*Journal*), 185 (*Star-Journal*), 193, 195T, 195B (Shepard), 196T, 196B (*Star-Journal*), 197B, 198, 200B (*Tribune*), 205 (Museum), 206, 207, 209L (Kenneth M. Wright Studios), 213B (*Star-Journal*), 214, 215T, 215B (Gibson), 216T, 217B (Potter-Hibbard), 223T, 224T (Hibbard), 226 (Wright), 229 (Wright), 236 (M. Nowack), 240 (Shepard), 241 (Museum), 249, 250T, 251 (Hibbard), 254T, 254B (*Tribune*), 267T, 267B (*Dispatch*), 269T (*Tribune*), 269B, 270 (*Tribune*), 271T (*Journal*), 272, 273 (Museum), 274 (Shepard), 282, 283, 284T (Gibson), 284B, 288T (*Tribune*), 291, 298T (Gibson), 298B (Shepard)

### ANOKA COUNTY HISTORICAL SOCIETY
page 73B (Goodrich and Jennings)

### HENNEPIN COUNTY HISTORICAL SOCIETY
pages 23B (Edward A. Bromley), 38, 314–15

### HARPER'S WEEKLY
pages 27 (detail), 33, 46

### BILL BEATTIE
pages 10, 11T, 91, 149, 156, 256, 257, 286B

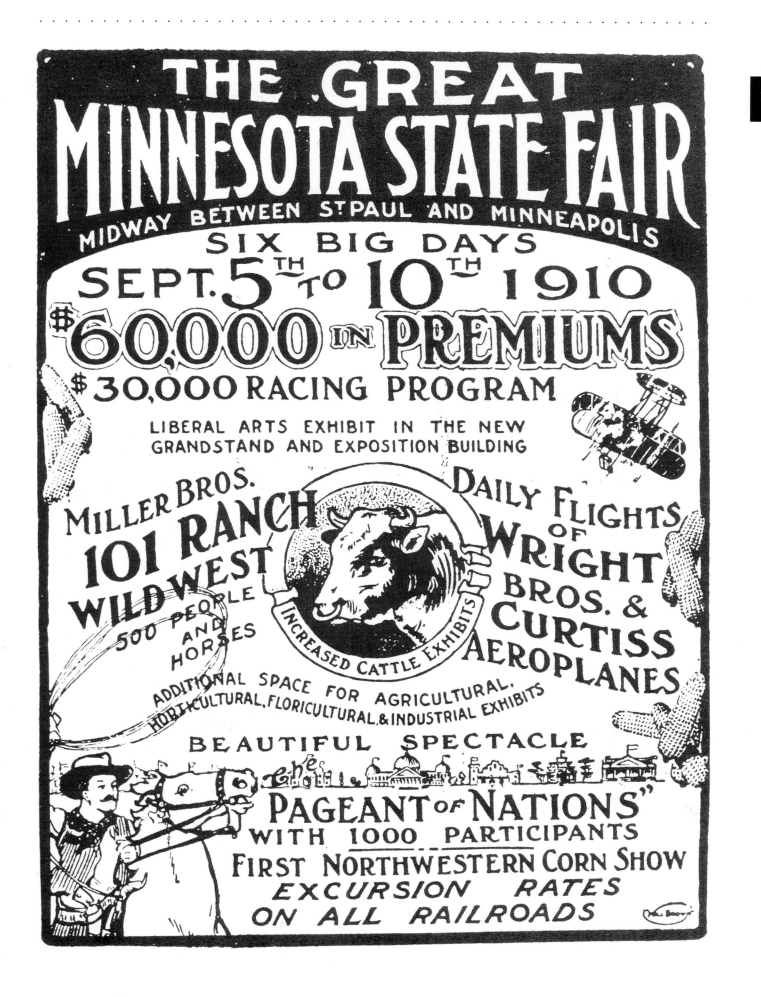

## COLOPHON

The cover and interior of this book were designed by Judi Rettich. The text was set in Times Roman, the sidebars in Times Roman Demibold, and the chapter headings in Helvetica Bold Condensed by Peregrine Publications on a Compugraphic system. The book was printed on Warren's Patina paper and bound by Edwards Brothers, Incorporated. Color separations and composite negatives for the cover and jacket were executed by Control Graphics.